NEOCRAFT

MODERNITY AND THE CRAFTS

The Press of the Nova Scotia College of Art and Design was established in 1972 as a vehicle to publish books by and about leading contemporary artists. Between 1972 and 1987, twenty-six titles by such artists as Michael Snow, Steve Reich, Gerhard Richter, and Yvonne Rainer were published. Re-launched in 2002, The Press has once again established the University as a source for the publishing of primary documents and scholarly works in the fields of contemporary art, craft, and design.

NSCAD University is a university of the visual arts singularly dedicated to the pursuit of excellence in the training of professional practitioners, in the conducting of research and in the production of works of art in all media.

Ceramic Millennium: Critical Writings on Ceramic History, Theory, and Art
Edited by Garth Clark

3 Works
Martha Rosler

Complete Writings 1959–1975
Donald Judd

Raw Notes
Claes Oldenburg

Artists Talk: 1969-1977
Edited by Peggy Gale

Modernism and Modernity: The Vancouver Conference Papers
Edited by Benjamin H.D. Buchloh, Serge Guilbaut, and David Solkin

Conceptual Art: The NSCAD Connection 1967-1973
Edited by Bruce Barber

In This Place: Black Art in Nova Scotia
Harold Pearse and David Woods

The First Hundred Years: A History of the Nova Scotia College of Art and Design
Donald Soucy and Harold Pearse

Rough Edits: Popular Image Video Works 1977-1980
Dara Birnbaum

Marsden Hartley and Nova Scotia
Edited by Gerald Ferguson

Mining Photographs and Other Pictures, 1948–1968
Leslie Shedden

Les Couleurs: Sculptures and Les Formes: Peintures
Daniel Buren

Handbook in Motion
Simone Forti

The Standard Corpus of Present Day English Language Usage Arranged by Word Length and Alphabetized Within Word Length
Gerald Ferguson

Écrits/Writings 1942–1958
Paul-Émile Borduas

Limited Edition Lithographs

Raw Notes (2005) Deluxe Edition
The Office. A Typewriter Print. Ghost Version.
Claes Oldenburg

Page 141 Lithography
Garry Neill Kennedy, C.M.

NeoCraft

Modernity and the Crafts

Edited by Sandra Alfoldy

NSCAD UNIVERSITY
THE PRESS

The Press of the Nova Scotia
College of Art and Design

The Press of the Nova Scotia College of Art and Design
5163 Duke Street
Halifax Nova Scotia Canada B3J 3J6

Editorial Director: Susan McEachern
Manager: Christopher McFarlane
Graphic Design: Arthur Carter, AustenHouse
Printed and bound in Canada

Available through D.A.P./Distributed Art Publishers
155 Sixth Avenue, 2nd Floor, New York, N.Y. 10013
Tel (212) 627-1999 Fax (212) 627-9484

The Press of the Nova Scotia College of Art and Design gratefully acknowledges the support of the Canada Council for the Arts which last year invested $20.1 million in writing and publishing in Canada.

Canada Council Conseil des Arts
for the Arts du Canada

This book has been published with the help of a grant from the Canadian Federation for the Humanities and Social Sciences, through the Aid to Scholarly Publications Program, using funds provided by the Social Sciences and Humanities Research Council of Canada.

Library and Archives Canada Cataloguing in Publication
 NeoCraft : modernity and the crafts / edited by Sandra Alfoldy

Bruce Metcalf, Larry Shiner, David Brian Howard, Grace Cochrane, John Potvin, Beverly Lemire,
 Joseph McBrinn, B. Lynne Milgram, Janice Helland, Elizabeth Cumming, Alla Myzelev, David
 Howes, Tanya Harrod, Love Jönsson, Mike Press.
Includes bibliographical references and index.
ISBN 978-0-919616-47-9
 1. Decorative arts—Philosophy. 2. Design—Philosophy.
I. Alfoldy, Sandra, 1969- II. Title.
NK792 N46 2007 745.01 22 C20079034306

TABLE OF CONTENTS

PREFACE

It has always seemed to me that the crafts sit at the most interesting of conjunctions in the visual arts. They ride across the boundaries of populism and elitism; while being fundamentally global, they are crucial for our understanding of locality and ethnicity; they are key to the gender issue; they operate at all levels of the economy; they are at the core of many museological debates; they have been the most fundamentally interdisciplinary of all the visual arts; and they reside in the most complex of spaces between archaism and modernity.

Rather tragically, this most fascinating of positions has not, over the last decades, resulted in consistent quantities of historical and theoretical study. With some confidence, however, we can predict that the twenty-first century will result in a blossoming of the literature, as the extraordinarily fragmented and globalized condition of culture renders the crafts more interesting than at any point in recent decades.

This book will prove to be an important landmark. It deals with all of the issues cited above, and boasts contributions from some of the most talented historians we have.

It is fitting that it has been produced by NSCAD University. For generations, the faculty and students at NSCAD have maintained a powerful culture supporting the production and study of the crafts. NSCAD boasts ceramics, metals, jewellery, textile, and fashion programs that are among the most impressive in Canada; and it was the first university in Canada to appoint a professor of craft history. Fittingly, Dr. Sandra Alfoldy, who is professor of craft history at NSCAD, is the editor of this volume.

Paul Greenhalgh
Director and President
Corcoran Gallery of Art and College of Art and Design

ACKNOWLEDGEMENTS

NeoCraft: Modernity and the Crafts would not have been possible without the support of many individuals and institutions. This book is a collection of essays by leading thinkers who are engaging with craft concerns; however, it is linked by name and theme to the NeoCraft conference held at NSCAD University in Halifax, Nova Scotia, 23-25 November 2007. The Canadian Crafts Federation, Canada's national craft organization, conceived the idea of Craft Year 2007, and I was delighted to be approached to organize an academic conference for the crafts. NSCAD University's former president Paul Greenhalgh was most supportive of the idea, and he must be credited with originating the *NeoCraft* title, and with encouraging an academic book on the topic. I am indebted to the Press of the Nova Scotia College of Art and Design, particularly editorial director Susan McEachern and Press manager Christopher McFarlane, for taking on the book, and for their interest in publications that support the crafts. My thanks also go to Ulli Walker for meticulously copyediting the manuscript, and to Arthur Carter the designer and production manager of the book. Thank you to my peers in the Historical and Critical Studies Division for their support, and to the administration of NSCAD University who have unfailingly supported the book and the conference. I am deeply grateful to the magnificent Heather McKean for her organizational skills and constant good humour. My research assistant, Michaela Cochran, provided invaluable feedback on the essays in this collection, as did the Press's editorial intern, Denise Dooley. Thanks to both of them for their excellent suggestions.

This project would not be possible without the outstanding authors who contributed to the book. They are leaders in their field, and it was a privilege to have them agree to be part of *NeoCraft: Modernity and the Crafts*. The field of craft discourse is advancing rapidly, thanks to their innovative research, theoretical expertise, and critical writing. The *NeoCraft* book and conference would not have been possible without the generous financial support of the Canada Council for the Arts and the Social Sciences and Humanities Research Council of Canada. It is a tribute to these organizations that they lend such strong support to craft history, theory, and critical writing.

Finally, I owe everything to my wonderful husband, Christopher, who is downstairs playing with our sons, Viktor and Nicholas, so I can get this written. Thank you boys for your patience and support.

FOREWORD

NEIL FORREST

For the purposes of teaching in my medium of ceramics, I have followed a three-sided geometry to categorize the historic and modern streams. The three sides are simply these: pottery, sculpture, and architecture as the prime destinations for skillfully created objects made of clay. These are categories that intertwine and are often pursued under the same roof. The limitation of my geometry is evident though: it provides no grouping of ideas or approaches to making things in postmodernity. It simply places us everywhere.

As the twentieth century dawned, the powerful ingredient of utility would seem less absolute for craft objects. Ceramics, a charismatic medium used for millennia in forming objects, would see competition from newer media as well as a diversification of its own subject matter in fine arts. But despite the paucity of theoretical and scholarly nourishment, or perhaps because of it, we revived the "old media" in the art academy with vigour and unfettered enthusiasm.

This acceleration of interest in craft media since World War II has led to a more assertive historical and critical analysis in the craft disciplines. Paul Greenhalgh would define modern craft as a consortium of genres characterized by decorative and vernacular attributes as well as maintaining the political badge of "handmade." Greenhalgh curates the reality of craft practice by extensive lists (ethnicity, amateurism, technology, morality, domesticity, etc.) and discursive analysis as a way to sew together an almost unmanageable menagerie.[1] In comparison, Edmund de Waal takes an academic approach to twentieth-century ceramics, compiling the many dialogues within ceramics to present an historian's arc of the most significant artistic actions within the modern form.[2] Underpinned by the likes of Gottfried Semper and Ernst Gombrich, David Brett's unorthodoxy blends perceptual psychology with aesthetic experience as he works toward a theory of decoration based on a poetics of workmanship—an admirable if untidy project.[3] The word "craft" is elusive, conflicted, and burdened by so many meanings depending upon the user, that it must be constantly questioned and qualified. I use the word "craft," therefore, with hesitation in these remarks. I anticipate that *NeoCraft: Modernity and the Crafts* will shed light on the changing power structures, generational and ideological positions, and the interdisciplinary

realities facing emerging artists in craft, and perhaps the concept of craft itself.

It is clear that many younger ceramicists continue to be motivated by the traditional fabric and domain of pottery, with its expressive potential and its axiomorphics. Clement Greenberg's essay "Modernist Painting" of 1960 may be of use here. He says of Modernism's "self-criticism," that;

> It quickly emerged that the unique and proper area of competence of each art coincided with all that was unique to the nature of its medium. The task of self-criticism became to eliminate from the effects of each art any and every effect that might conceivably be borrowed from or by the medium of any other art. Thereby each art would be rendered 'pure' and in its 'purity' find the guarantee of its standards of quality as well as its independence.[4]

In his lecture "Art/Craft Problematics," NSCAD professor emeritus Dennis Young suggested that the notion of Kant's "autonomous aesthetic object" has been applied to functional craft objects as an alternative reading to that of *use value*. Furthermore, he recommends to those who commit to a specialized media, that they should remain within their "fellowship of discourse" to advance their theoretical and critical positions in unity and with an aesthetic purpose.[5] Léopold Foulem's notion of "ceramicness," which provides that ceramics "has its own language and proper concepts" is in accord with Professor Young's.[6] And finally, in a more recent essay, Glen R. Brown writes:

> Often the importance of ceramic sculpture within the context of a ceramics tradition—something distinct within the broader history of art—goes entirely unexamined, and as a consequence many truly profound and challenging works are patronized by critics as attempts to update a conservative craft medium through naive outfitting in the trappings of high art.[7]

These quotations tend to support the autonomy of a set of largely media-specific practices and their historical typologies.

The perceived value in craft objects of the modern era has largely been understood in terms of skilled authorship and aesthetic properties, and in the case of pottery, for example, acting as a remedy for the disengaged industrialized object. Those who see this as therapeutic are not incorrect, but we understand this as a cultural mediation. There also exists an empathy with the craft artist who is understood to enjoy private pleasure during

the creation of familiar historical forms. As a final point, craft objects have the effect of orienting viewers/consumers towards authenticity and beauty in a world where such concepts are increasingly uncertain. Yet the insights of current craft writing will frustrate some younger artists in the field who have not witnessed the ascent of the crafts, but a plateau. This frustration may be on several levels: limited access to important exhibitions, price ceilings compared with other arts, less grant money, few media-specific galleries or the like. Perhaps the most problematic, though, is an artistic plateau.

Some younger artists in craft media want full access. They know there is no agreement on style, content, or role in the arts—it is the "expanded field" of Rosalind Krauss and well beyond.[8] As the word "craft" and its concepts are ever pushed, stretched, and perhaps discarded, we are looking at an increasingly differentiated set of practices and a heterogeneous future. New craft artists may not feel the need to act within, nor will they support the evolution of the current structures. In fact, they may see them as unnecessary or false. Almost universally, artistic investigation based upon "purity" and "essence" seems less promising. From our sister arts to the hard sciences, we witness many degrees of crossover activity and even hybridity. Younger artists in the craft fields encounter an artistic plateau, but also an establishment that seems to have settled on firm discourses and theoretical positions that circle inward to find subject matter and an audience. This may not be surprising in the open forum of ideas. Yet, young artists in all disciplines want a substantial share of contemporary writing to be an examination of peer content rather than supplying general context to their field.

Rather than debating the content of craft, today people are asking the more useful question, what is the content in which I am interested? In the future, this question will be answered in less predictable ways. My point is that craft artists, if this is a useful designation, live in a sophisticated artistic neighbourhood, and the company they choose will influence the result. Today, we see young ceramic artists committing to specialist practices in utilitarian pottery and still others in ceramic sculpture, and neither may be advancing ideological positions; rather, they have fit into previously articulated ones. Many potters and sculptors in clay will continue to engage the void left by the abandonment of the aesthetic object in the fine arts, an observation advanced by Dennis Young. On the horizon, though, profound changes may be anticipated.

The underlying tenet that craft artists must engage in a media-specific practice is already answered by a generation of makers who have said otherwise, and a powerful question for the current generation of practitioners who have dramatically broadened their interests beyond established craft discourse will be: How will our medium be positioned

and taught in the academy? I now circle back. What will the new and much richer geometry be as compared to the one offered at the outset? Is the idea of a collective self-inquiry within a medium becoming antiquated? Even if this is so, many aspects of existing discourse will be useful for particular streams within each of our media, and the idiomatics (characteristic forms and achievements within the discourse) and axiomorphics (forms appropriate to the purpose of the structure) of craft media will long be engaging.

I came into the ceramics scene during the 1970s, inspired by the new ethos in the United States, the United Kingdom, and Canada. There was an explosion of images unconstrained by inherited knowledge or dogma, and fuelled by a remarkable abundance of exuberance, permissiveness, and intuition. In this emerging millennium, those qualities may still exist, but the new practitioners are sophisticated, art-knowledgeable, and ambitious.

They know several conditions have changed for their generation:
- ❍ Fixed positions and artistic regionalism appear obsolete.
- ❍ Metamorphosis, hybridity and immersive experiences are ascending.
- ❍ New technologies will be accessible to many arts.
- ❍ The environment, ecology, and sustainability will be foregrounded.
- ❍ Domestic or personal consumerism is constantly re-shaped by both a "mass personalization" from the digital/internet revolution and the uncertainties of global security.

Those who engage with this transforming landscape will ask/seek the next set of answers. Teaching institutions retain the opportunity to respond to critical developments, yet have tended to breed narrow artistic outcomes. Craft has not strategically prepared itself for a world in which material and spatial innovation is commonplace. However, if we consider broader notions of institutional research, we can develop hybrid applications for our craft that maintain an emphasis on materiality and even utility, but with different outcomes. Innovative results are naturally derived from an interdisciplinary and team approach to research. The new and wider research platform will involve a host of art, humanities, science, and engineering specialties.

ENDNOTES

1 Paul Greenhalgh, *The Culture of Craft*, ed. Peter Dormer (Manchester: Manchester Press, 1997) 20-52.

2 Edmund de Waal, *20th Century Ceramics* (London: Thames & Hudson, 2003) 7-19.

3 David Brett, *Rethinking Decoration, Pleasure & Ideology in the Visual Arts* (Cambridge: Cambridge University Press, 2005).

4 Clement Greenberg, "Modernist Painting" (1960) in eds. D. Harrison & P. Wood, *Art in Theory 1900-1990* (London: Blackwell Publishers, 2001) 755.

5 Dennis Young, "Art/Craft Problematics," NSCAD University lecture, 1991.

6 Léopold Foulem, "Ceramics Paradigms and Paradigms for Ceramics," Third Annual Dorothy Wilson Perkins Lecture, Schein-Joseph International Museum of Ceramic Art at Alfred University, 24 October 2000.

7 Glen R. Brown, "Ceramics, Multiplicity and the Limitations of Criticism," *Temperature Magazine*, Switzerland Dec. 2006, 15-22.

8 Rosalind Krauss, "Sculpture in the Expanded Field," *October* (Spring 1979): 30-44.

INTRODUCTION

SANDRA ALFOLDY

What, exactly, is "NeoCraft"? NeoCraft, as it is used in this book, introduces an alternative model for assessing craft, where the diverse interdisciplinary methodologies used to discuss craft are united to work together in solidifying the discourse of craft history, theory, and critical writing. The overarching theme that connects contemporary writing on the crafts—regardless of whether it relates to craft, design, art history, anthropology, philosophy, history, women studies, or fashion (all disciplines represented in this volume)—is a continuing engagement with issues of modernity.

NeoCraft: Modernity and the Crafts is the first book consciously to seek out craft writing from a broad range of disciplines. The result is an exciting mix of essays that are varied in both their attitudes toward craft, and their methodological approaches. Some employ theory, some use the research tools of anthropology, while others foreground the primary research techniques of history. What they all share in common is a deep respect for the important role craft plays in contemporary life, and the collective desire to understand the social and cultural position of historical craft.

In Canada there has been a long struggle for the inclusion of craft in our institutional histories. While we are slowly gaining ground in developing methodologies specific to Canadian craft (thanks to the support of institutions like NSCAD University, the first in Canada to hire a full-time craft historian), we must be aware not to overlook the multiplicity of approaches linking the crafts to broader discussions that are already in existence. While there is a tremendous amount of Canadian craft that remains unexplored, we must be aware of the international, interdisciplinary efforts underway. *NeoCraft: Modernity and the Crafts* recognizes the rich writing surrounding the crafts.

Throughout the essays in this book certain themes recur in relation to modernity. While the five themes (Cultural Redundancy; Global Craft; Political Economy; Utopian Ideals; and the Senses and New Technologies) were selected because they linked contemporary craft with modernity, they necessarily overlap. For example, the tension between the sensory nature of craft materials and the virtual, or supposedly non-sensory realm, sets up a dialectic that is repeatedly addressed. Although there is collective agreement that the binarism between the visual and haptic senses was initiated during the Enlightenment, our Western

perspective can be strengthened by understanding that many non-Western cultures oper-ate outside this hierarchy. As well, it is impossible to label one set of craft production as "global" when all craftspeople operate in a globalized economy. Instead, it is often an Anglo/Eurocentric or post-industrial privileging that is brought into play. It seems that the key determinant in categorizing a craft as "global" is a lack of individual authorship, an assumption once again predicated on the Western classical ideal of art.

One theme that is purposefully excluded from the five sections is gender. Feminist the-ory must be credited with opening up the discussion of the crafts in the latter part of the twentieth century, and we are now well aware that domestic crafts and the idea of women's work are no longer a novelty in art historical discussions. It stands as a testament to how far both feminist theory and craft discourse have developed that it is no longer suf-ficient to marginalize gender or craft; instead, feminist investigations extend across all five themes in *NeoCraft: Modernity and the Crafts*.

Crucial to this book is the idea of modernity; however, it would be smug to think that our contemporary concern with this theme is new. If we accept that the French Revolution and the power of Enlightenment humanist thought served as the marker connecting the traditional and modern periods in Western history, then we must link our discussion of the crafts back to this period.

In 2000 the American art historian Isabelle Frank published a collected volume of writ-ings on the crafts and design entitled *The Theory of Decorative Art: An Anthology of European and American Writings 1750-1940*. This book makes a tremendous contribution to the crafts by exposing readers to the historical theories that led to our contemporary understanding of craft. The popularly accepted notion that Enlightenment philosophers like Immanuel Kant broadsided the crafts and initiated their marginalization, is refuted in *The Theory of Decorative Art*, where Frank demonstrates that philosophers seriously consid-ered the crafts, or "mechanical arts,"[1] in the eighteenth century. It is upsetting to the com-fortable position of craft as the anti-modern, marginalized outsider to accept that craft has been complicit in the emergence of Western modernity. In fact, in 1620, prior to the Enlightenment, the English philosopher Francis Bacon acknowledged that the history of the mechanical arts was "the most important branch of true philosophy."[2] In 1751 the French philosopher Denis Diderot and his partner, the French mathematician and scientist Jean le Rond D'Alembert published their *Encyclopedia*, dedicated to understanding "Les sciences, les arts libéraux, et les arts méchaniques."[3] This was revolutionary for the crafts in that they received recognition there, alongside the trades and other arts. In Diderot's essay "Art," he expressed frustration over the fact that "[v]ery often little is known of the

origin of mechanical arts and not much more of their history. This is the natural outcome of the contempt felt in all ages and by all nations, whether scholarly or warlike, for those who engage in them."[4] This sounds frighteningly similar to some of today's writers who acknowledge that this disdain still exists. Bruce Metcalf's essay "Replacing the Myth of Modernism" provides a contemporary perspective on the marginalization of craft, and a call for craftspeople to rally against the continued effects of capital "M" artistic Modernism, a movement he argues, is based on the contempt discussed by Diderot. Beverly Lemire's chapter, "Redressing the History of the Clothing Trade: Ready-made Apparel, Guilds, and Women Outworkers, c.1650-1800," is a fascinating account of how women suffered during this period with the rise of industrialization and the loss of powerful guilds. Lemire's research reveals that Diderot's discussion of the scorn for "those who engage" in the mechanical arts was particularly harsh on women.

By the end of the eighteenth century, philosophers had clearly demarcated the boundary between the utility of the mechanical arts and the beauty of the fine arts. This separation contributed not only to the art/craft debate that raged throughout the twentieth century, but to the lingering hierarchy of the senses that privileged vision. German art theorist Karl Philipp Moritz made explicit the disconnect between beauty in art and the non-visual senses in 1785, when he wrote of a well-made knife: "If the object serves its external purpose, it does not matter what it looks like…. Nor do I notice whether the…blade of the knife, please[s] my eye or not." However, for Moritz, it was the reverse for beauty in the fine arts: "It is not just that we look at it in so far as we need it, we need it in so far as we look at it."[5] It is undeniable that all the senses are necessary to fully enjoy craft objects; however, as David Howes's chapter "Sensory Basket Weaving 101" demonstrates, today we are aware that Moritz's Eurocentric idea of beauty is too limiting. Love Jönsson's essay "Rethinking Dichotomies: Crafts and the Digital," Mike Press's chapter "Handmade Futures: The Emerging Role of Craft Knowledge in Our Digital Culture," and Tanya Harrod's text "Otherwise Unobtainable: The Applied Arts and the Politics and Poetics of Digital Technology," highlight that in the three centuries since Moritz speculated on the sensory split, we have entered into a new virtual space that requires a massive paradigm shift in our understanding of the role of the senses. As Press notes, today craft operates as a specific knowledge base, not simply as a tacit experience.

It was during the nineteenth century that the modern understanding of craft as marginalized practice was fully articulated. The "mechanical arts" gave way to the terms "handicrafts," "minor arts," "lesser arts," and "applied arts," and the eloquent writings of the design reformers Augustus Pugin, John Ruskin, and William Morris laid the foundations for

the twentieth-century craft movement. Augustus Pugin, the architect and designer credited with popularizing Britain's Gothic Revival, recognized that certain crafts had become fully excluded from the discussion of the arts. In 1841 he wrote, "Like everything else [in the handicrafts], silver work has sunk to a mere trade, and art is rigidly excluded from its arrangements."[6] Part of Pugin's goal for his Gothic Revival, sometimes known as Neo-Gothic, was to bring a modern perspective to bear on the aesthetic and moral strengths of Gothic architecture. The crafts would serve as a reminder of the ethical purity possible through the satisfaction in labour, an idea expanded upon by John Ruskin. Ruskin was radical in that he applied the ideal of beauty to the crafts. Unlike Moritz, who carefully separated beauty from utility, Ruskin asked "Must not beauty, then, …be sought for in the form which we associate in our every-day life?"[7] Ruskin was an outspoken supporter of equality between the crafts and the other arts, arguing, "Get rid, then, at once, of any idea of Decorative Art being a degraded or a separate kind of art."[8] While he believed that all art served a decorative function, it should be remembered that much of Ruskin's support for the crafts was due to his opposition to nineteenth-century industry. For his successor, William Morris, the crafts became conflated with an anti-industry position, and were perceived as the ideal tools to chip away at the capitalist political economy. Through his poetry and prose Morris romanticized the crafts as links to a rural medieval past. He worried over the fact that it was "not uncommon to hear regrets for the hand-labour in the fields, now fast disappearing from even backward districts of civilized countries…. People interested, or who suppose that they are interested, in the details of the arts of life, feel a desire to revert to methods of handicraft for production in general."[9] The only way to stem the tide of urbanization and industrialization was through a return to cottage crafts. Many essays in *NeoCraft: Modernity and the Crafts* explore how this concern was manifested through William Morris and the Arts and Crafts movement. Elizabeth Cumming's "Pure Magic: the Power of Tradition in Scottish Arts and Crafts"; Janice Helland's "Making it Irish: The Politics of Embroidery in Late Nineteenth-Century Ireland"; and Alla Myzelev's "Ukrainian Craft Revival: From Craft to Avant-Garde, from "Folk" to National," each take a different perspective on how Morris's ideals of joy in labour, anti-industrialization and the realities of crafts within late nineteenth- and early twentieth-century economies played out. In each of these essays, the crafts are read as the apparatus through which national identity is formed.

We should not underestimate the powerful role William Morris played in shaping our contemporary understanding of the crafts. While he may be criticized for overly romanticizing medieval craft production or the socialist utopia of the future, he was well aware of

the importance of relating the crafts to larger social concerns. Morris argued that when discussing handicrafts, "it is impossible to exclude socio-political questions from the question of aesthetics."[10] Morris's interest in Marxism is evident here, and the crafts provided the solution to the problem of a public, "grossly ignorant of all the methods and processes of manufacture as a result of industrialization and machine-systems."[11] The objects of daily life were too far removed from a knowledge of their making, and only crafts could overcome the isolation of modern consumers.

We still rely on this philosophy initiated by Pugin and Ruskin and clearly articulated by Morris. In the West, craft is about individual control, and political economy is inseparable from our understanding of craft practice. Beverly Lemire's chapter "Redressing the History of the Clothing Trade," provides us with the earliest example of political economy in this book, a theme built upon by Janice Helland's essay "Making it Irish," where she underscores the nineteenth-century hierarchy that separated gentlewomen in distress as makers and gentlewomen of means as consumers. Joseph McBrinn's chapter "Handmade Identity: Crafting Design in Ireland from Partition to the Troubles," outlines how a romanticized idea of craft, combined with the political and economic needs of an Ireland in crisis, promoted essential ideas of "Irishness." John Potvin's piece "Lost in Translation?: Giorgio Armani and the Textualities of Touch," reminds us that we still trade in these ideas today, while B. Lynne Milgram's essay "Entangled Technologies: Recrafting Social Practice in Piña Textile Production in the Central Philippines," illuminates how collective non-Western craft practices expand upon the accepted definitions of the political economy of craft put forward by Morris.

The concept of the medieval craftsperson enjoying "little or no division of labour…work[ing] for himself [sic] and not for any capitalistic employer,"[12] pitted modernity against craft and set the stage for the twentieth-century separation between artistic movements based on modernity's support of new technologies and the avant-garde, and craft. Machinery, the focus of interest for many artistic movements, soon became perceived as the polar opposite of craft. However, this is a misrepresentation. Even Morris himself was not as anti-machine as all that, writing in 1888: "As a condition of life, production by machinery is altogether an evil; as an instrument for forcing on us better conditions of life it has been, and for some time yet will be, indispensable."[13] We continue to debate the merits of machinery in relation to craft. The new technologies of the twenty-first century are causing equal levels of concern: Are they an evil condition of life? Do they further debase the crafts, robbing us of knowledge of traditional techniques? Do they privilege design over craft? Love Jönsson's chapter, "Rethinking Dichotomies," Mike Press's essay

"Handmade Futures," and Tanya Harrod's "Otherwise Unobtainable," take positive positions regarding the relationship between craft and new technologies; while Grace Cochrane's text "Australia and New Zealand: Design and the Handmade," shows us how new technologies develop relations between craft and design and connect geographically isolated regions and centres of production. Larry Shiner's chapter, "The Fate of Craft," examines how Morris's legacy, the realities of the interplay among design, craft, and new technologies are challenging the very notion of craft.

Although the crafts have long been maligned as anti-modern and anti-machine, these essays indicate that the reality is far more complex, and that craft is inextricably linked to modernity and technology. This is not necessarily new thinking. For some, like Gottfried Semper and Frank Lloyd Wright, machinery and ideas of the modern opened up exciting possibilities for the crafts. As early as 1852, the German architect and art critic Gottfried Semper enthused about new technologies in relation to the crafts, writing: "Machines sew, knit, embroider, paint, carve and encroach deeply into the field of human art, putting to shame every human skill. Are these not great and glorious achievements?"[14] The American architect and designer Frank Lloyd Wright went as far as to accuse William Morris of having "miscalculated the machine," by not appreciating that "the machine is capable of carrying to fruition high ideals in art—higher than the world has seen."[15] By the time of the establishment of the Deutsche Werkbund in 1907, the role of machinery within "modern applied art" was being celebrated. The German architect, and member of the Deutsche Werkbund, Hermann Muthesius, urged craftspeople to break free from the restrictions of the past to create a new language for the applied arts. The only way to do this was by appreciating developments in new technologies. This new language was intended to stand, "in opposition to [the] old." Moreover, this new language would have "nothing in common with that of the old applied art, which was in its heyday in the 1880s and 1890s. A fundamental change of aim has taken place…. [T]here is an effort to speak a new, autonomous artistic language."[16] Larry Shiner's chapter, "The Fate of Craft," explains how craft missed the enormous opportunities laid out in Muthesius's urgings. Shiner identifies the overlaps and intersections between art, industry, and design that have occurred, and he questions why there have not been more. David Brian Howard's essay "Making Space for Clay?: Ceramics, Regionalism, and Postmodernism in Regina, Saskatchewan," underscores the powerful possibilities for craft contained within high Modernist art, again raising the point that twentieth-century craft may have missed opportunities by moving away from Muthesius's idea of a new, autonomous artistic language toward a re-entrenchment of Morris's romanticized, rural ideal.

While there are many good reasons for vilifying high Modernism in relation to craft—namely the continued marginalization of craft within many cultural institutions—the rush to demonize supporters of high Modernism means that craft writers have sometimes overlooked the potency of Modernist ideas. Take the example of Le Corbusier. Le Corbusier asserted in his 1925 essay "The Decorative Art of Today," that "modern decorative art is not decorated."[17] Although he reinforced Enlightenment ideas that separated art as the application of "knowledge to the realization of an idea," from crafts as tools belonging to "the world of manufacture, of industry,"[18] Le Corbusier did not seek the death of craft. Instead he sought the death of decoration. The same can be said of Adolf Loos, whose infamous essay, "Ornament and Crime" (1908), is often used as the rallying point for the crafts to occupy an anti-modern position. Both Le Corbusier and Loos used crafts in their architecture. It was over-ornamentation they avoided. Instead of dismissing these two modernist architects and designers, it is time that craft reconsider the reality that contemporary craft production still adheres to the pared-down aesthetic modernists espoused. Alla Myzelev's chapter, "Ukrainian Craft Revival," provides a refreshing take on the interplay between traditional Ukrainian crafts and the modernist concerns of Russia's emerging avant-garde, demonstrating that we need not set up craft in an "us or them" position vis-à-vis modernism. On the other hand, Bruce Metcalf's "Replacing the Myth of Modernism" presents a passionate articulation of the reasons why the crafts must remain wary of simply collapsing their concerns into those of high Modernism, specifically with regard to the lingering effects of the Abstract Expressionist movement in the United States.

If Le Corbusier and Loos have been read as opposed to the applied arts, then Clement Greenberg has come to be seen as the sworn enemy of craft. Bruce Metcalf's "Replacing the Myth of Modernism," David Brian Howard's "Making Space for Clay," and Larry Shiner's "The Fate of Craft," all reference Greenberg but use completely different approaches. This demonstrates that craft discourse is still wrestling with how to situate the high Modernist criticism of Greenberg. In his 1939 essay "Avant-Garde and Kitsch," the essay most often applied to the crafts, Greenberg examines the relationship between aesthetic experience and individual, social, and historical contexts. He quickly falls back into the Enlightenment privileging of the visual and conceptual over the other senses, and by extension, craft; but Greenberg's goal was to establish that the birth of the avant-garde as part of European revolutionary thought set it apart from the markets of capitalism and bourgeois society.[19] In this regard, he shared William Morris's concern for the revolutionary potency of art, but unlike Morris (whom Greenberg never mentioned), he took pains to separate everyday objects, including utilitarian crafts, from avant-garde art. The essays in *NeoCraft: Modernity*

and the Crafts, remind us that it is time to rethink our easy dismissal of critics like Greenberg, and our association of crafts with all things anti-modern. Although Greenberg marginalized the crafts through neglect (he never spent much time specifically considering the crafts in his art criticism), what we have forgotten is that many of Greenberg's high Modernist peers, like the art critic Harold Rosenberg, and the director of the MoMA Rene d'Harnoncourt, supported the crafts and invited them to become participants in the experiment of artistic modernity.

In briefly tracing the relationship between the crafts and artistic modernity since the Enlightenment the omissions become glaringly obvious. While the crafts continue to fight against marginalization, we must be aware of the hierarchies operating within the Western discourses of craft.

We need to question the position of craft in relation to class. Are we still talking about objects created for the capitalist markets of the bourgeoisie, the same objects that so frustrated William Morris's ideals? Who has access to the materials, never mind the finished products, of Western craft? Who can enter into the debates surrounding craft discourse? And how should we discuss the uneven relationship between Western and non-Western craft? We may know better than to use the Eurocentric terms employed by many of the historical writers like Gottfried Semper, Adolf Loos, and Karl Phillip Moritz; but we have a long way to go before we can discuss the differences between individual and collective craft production, authored and anonymous craft objects, and how to level the playing field for crafts in our globalized economies. Furthermore, although feminism and craft can claim a shared triumph in entering postmodern discussions of culture, we face the daunting question of whether simply inserting female artists or craftspeople into the accepted story of art history is enough.[20] I believe that the strength of the writing in relation to the crafts, with its own set of concerns and approaches, indicates that we are in the process of developing our own unique discourse.

There is no doubt that the field of craft history, discourse, and theory is advancing at a rapid rate. As the essays in *NeoCraft: Modernity and the Crafts* reveal, examining the future of craft—the new, the modern—means opening up the discourse to the diversity of interdisciplinary approaches from around the world. They reveal the next stage in developing methodologies surrounding craft and our existing ideas of modernity. Exciting times lie ahead.

ENDNOTES

1 It is important to note that the term "mechanical art" encompassed a far greater range of material production than our modern understanding of the crafts. It included things like gunpowder, compasses, and the machine manufacture of tools.

2 Denis Diderot, "Art" (1751), in - Isabelle Frank, ed., *The Theory of Decorative Art: An Anthology of European and American Writings 1750-1940*, trans. David Britt (New Haven and London: Bard Graduate Center for Studies in the Decorative Arts and Yale University Press, 2000) 140.

3 Denis Diderot and Jean Le Rond D'Alembert, *L'Encyclopédie* (Paris: Inter-Livres, 2002, reprint of 1751) 1.

4 Denis Diderot, "Art," 141.

5 Karl Phillip Moritz, "Preliminary Ideas on the Theory of Ornament (1785)," in Isabelle Frank, ed., *The Theory of Decorative Art*, 30-31.

6 Augustus Pugin, "On Metal-Work" (1841), in Isabelle Frank, ed., *The Theory of Decorative Art*, 154.

7 John Ruskin, "The Lamp of Beauty" (1849), in *The Lamp of Beauty: Writings on Art* (London: Phaidon, 1959, 1995) 216.

8 John Ruskin, "Modern Manufacture and Design (1859)" in Isabelle Frank, ed. *The Theory of Decorative Art*, 48.

9 William Morris, "The Revival of Handicraft" (1888), in ed. Gary Zabel, *Art and Society: Lectures and Essays* by William Morris (Boston: George's Hill, 1993) 127.

10 Morris 128.

11 Morris 128.

12 Morris 130.

13 Morris 131.

14 Gottfried Semper, "Science, Art and Industry" (1852), in Isabelle Frank, ed., *The Theory of Decorative Art*, 167.

15 Frank Lloyd Wright, "The Art and Craft of the Machine" (1901), in ed. Isabelle Frank, *The Theory of Decorative Art*, 201.

16 Hermann Muthesius, "The Significance of Applied Art" (1907), in Isabelle Frank, ed., *The Theory of Decorative Art*, 74.

17 Le Corbusier, "The Decorative Art of Today," in Isabelle Frank, ed., *The Theory of Decorative Art*, 213.

18 Le Corbusier 213.

19 See Clement Greenberg, "Avant-Garde and Kitsch (1939)," in *Art and Culture:Critical Essays* (Boston: Beacon Press, 1961) 3-21.

20 Griselda Pollock argues that we need to completely shift the paradigms surrounding art, rather than try to rectify the existing hierarchies by merely slotting women into the canon. The same issue exists for the crafts. See Griselda Pollock, "Feminist Interventions in the Histories of Art: An introduction," in *Vision and Difference* (London: Routledge, 1988, 2003) 1-24.

CULTURAL REDUNDANCY OR THE GENRE UNDER THREAT

BRUCE METCALF

LARRY SHINER

DAVID BRIAN HOWARD

SECTION ONE

...how can a field support that which it perceives as its enemy?

Introduction

Sandra Alfoldy

For over two centuries, it has been popular to declare that the crafts are on the verge of extinction. Whether in reaction to the death of the guilds, the threat of the Industrial Revolution, or the supposed "disinterestedness" of high Modernist critics like Clement Greenberg, the crafts have often formed a tight community that resists larger cultural and economic forces. The supposed reluctance of the crafts to embrace the causes and philosophies of modernism informs popular perceptions of craft and shapes the core of craft's defiance. After all, how can a field support that which is often perceived as its enemy? This section of *NeoCraft: Modernity and the Crafts* explores various perspectives on the reality behind the supposed cultural redundancy of the crafts. Can one simply juxtapose the crafts and modern art, technology, and economics or do the crafts occupy a more complicit role in the story of modernity? The differing views of the American jeweller Bruce Metcalf, the American philosopher Larry Shiner, and the Canadian art historian David Brian Howard raise important questions. Have the crafts missed any opportunities as a result of their insularity? Has the genre ever been under serious threat? What positions do the crafts occupy today?

REPLACING THE MYTH OF MODERNISM

BRUCE METCALF

Author's Note: This article was first published in the February/March 1993 issue of *American Craft* magazine. It was the culmination of an extended effort to disentangle craft from Modernist formalism. For several decades, ambitious craftspeople had tried to trim crafts to fit into a formalist pigeonhole, and I found myself more and more annoyed. "Replacing the Myth of Modernism" was my effort to sort through the problem. While many of my remarks are now dated, and formalism is no longer the dominating force it once was, I believe the central analysis remains sound.

There's a movement afoot to declare that the conflict between art and craft is dead, that the struggle has been won, that craft *is* art. We can all congratulate ourselves and go home happy. But art has its own rules, and its own language, which make implicit claims to dominance over all other codes. If you want to join the club, you have to speak, act, and think like the club members; and they are not particularly interested in being challenged. If craft wants entry into the temple of art, it had better change its clothes—and be very polite.

The thesis of this article is simple: craftspeople should stop trying to make modern art. Assimilation into art is deadly to craft and should be avoided. After twenty years of observation and a dozen years of teaching, I believe that there are important distinctions between craft and art. The clearest evidence I can point to is that when craftspeople and sculptors make sculpture, the results are different. Craft-based sculpture tends to be more decorative, more richly visual, more respectful of material and process, but also less cog-

nizant of the history of sculpture and art world issues. I can only conclude that craft constitutes a different class of objects and also springs from a different set of values and a separate historical consciousness. These differences are essential to craft, and they are in peril of being lost.

In its broadest outline, art in the Western world is characterized by limitlessness. Since Marcel Duchamp's urinal, art is constituted by the authority of the artist. If a convincing argument is made, the thing he names or points to is newly understood as art. Duchamp pointed at the urinal and the bottle rack, and they became art. Joseph Beuys painted his face gold, walked around a gallery explaining paintings to a dead rabbit in his arms, and it was art. Warhol filmed the Empire State Building for eight hours straight, and that was art too. *Anything* can be art in this intellectual climate, and such permissiveness is not necessarily bad. The limitlessness of art acts as a metaphor for freedom, disturbing or frightening as that may be. But not anything can be craft.

Craft—the kind of craft this book explores—is defined by four simultaneous identities. First, craft is usually made substantially by hand. This is the primary root of all craft, the wellspring and reference point for everything else in the field. Additionally, craft is characterized by references to three traditions that evolved before the advent of mass-production. Craft is medium specific: it is always identified with a material and the technologies invented to manipulate it. For instance, ceramics can be defined as the use of clay and proficiency in skills like throwing or handbuilding. Woodworking, metalsmithing, weaving, and glassblowing are all disciplines specific to a medium and its mastery. These materials are only incidentally industrial; most have been used since the beginnings of civilization, and many of the skills are equally ancient. The pre-industrial roots and traditional medium specificity of craft create a number of gray areas: is neon sign making a craft? Is machining on a lathe?

Third, craft is defined by use. Craft disciplines are traditional groupings of functions—jewellery, clothing, furniture. Clothing, for example, has irregular boundaries, and no direct correspondence to material; jewellery refers to objects used to adorn the body; furniture consists of movable objects used for domestic purposes, like sitting or storing goods, and so on. None of these categories specifies a material, however. So, even the narrowest Eurocentric jewellery tradition can include glass, ceramic (as faience), coal (as jet), even human hair (in memorial lockets)—a greater range than the precious metal and gemstones that conservative practitioners claim as the exclusive and proper material for jewellery. Similarly, furniture and clothing are all made of wide varieties of materials. Most of these functions were established under pre-industrial conditions. While our idea of furniture has

accommodated uses not even dreamed of fifty years ago, like computer tables and television stands, the sphere of craft does not include manufactured objects like small appliances, airplanes, or telephone equipment.

Craft is also defined by its past. Each of the craft disciplines has a multicultural history that is recorded mostly in the form of objects, many from societies that have long since disappeared. The history of each craft is far richer and older than that of painting, in spite of the way art history has been taught. A huge body of objects serves as an enormous reference library for craftspeople.

Thus, craft is a series of limitations suggested by tradition. By nature, craft looks backwards, which is no longer supposed to be a virtue. But all those ancient usages provide a sourcebook from which craft can clarify its essential distinction from fine art. Once that is done, craft can develop its own conceptual approach.

At present craft is sandwiched between two imposing neighbors. On one side are the mass-production technologies that have been superseding it for the last three centuries. The ongoing Industrial Revolution rendered most of the subsistence crafts obsolete. Pottery, yardage weaving, basketry, boat making, and hundreds of other crafts became marginal. Others were killed off: carving figureheads, fabricating wooden coaches, or making hatboxes are among the many that have vanished. Craft production, once representing most of material culture, was replaced by manufactured goods.

Mass production, in turn, stimulated the rise of consumerism, which Edward Lucie-Smith defines as "the liberation of desire to own from strict claims of necessity."[1] As factory-made objects flooded the marketplace to be purchased by a growing middle class, these items no longer had to serve the demands of survival: articles made strictly as decoration, once the exclusive property of the rich, became commonplace. Then, in a great irony of history, craft re-entered the marketplace in response to consumerist values. Today, gifts and home furnishings constitute the most significant market for craft. No longer marginal, craft now competes in these markets on an even footing with industry.

The other neighbor of craft is modern art, along with its history and theory. Craft teachers and craft students—the majority of whom are non-production craftspeople—have long envied the status enjoyed by modern art as well as its financial rewards. This wistful desire for loftier status has created confusion, frustration, and guilt. The common strategy to achieve art's prestige has been to adopt the style of any recently certified art movement, from Abstract Expressionism to performance art. Yet, to perceive art as a parade of visual styles is an error, for modern art is principally an ongoing debate about the value and purpose of visual experience.

Where modern art is defined by theory, postwar craft has avoided it. Few critics have developed careers writing about craft alone, and even fewer ideas have emerged specifically from craft practice. Most writing in the field borrows ideas uncritically from painting and sculpture, without questioning how appropriate they are to a craft object. Most writers on craft assume that the language of art criticism fits craft like a comfortable old pair of pants, no alterations necessary. One has only to read the words "expression" or "concept" repeated ad nauseam in articles about craft to see how the myths of modern art are applied indiscriminately. How can a pot be expressive? How can an object be minimalist and decorative at the same time? Which concepts are appropriate to jewellery, and which are not? Such questions are rarely asked.

A pervasive anti-intellectual bias exists in the craft world. In books on craft, photographs dominate: two of the more recent surveys of twentieth-century jewellery had a combined total of 51 pages of body text and 260 pages of photographs.[2] The few monographs on established craftspeople read like extended publicity releases. Seldom is heard a discouraging word. Perhaps the know-nothing attitude is most nakedly revealed in this statement from jeweller and teacher David LaPlantz: "*Metalsmith* [magazine]…has been boring, uninteresting and filled with…pieces that once I read I did not understand or even care to understand. Actually, I have stopped reading *Metalsmith* and now just skim the pages for interesting images and advertising."[3] Such an attitude discourages critical thinking of any sort and does not bode well for the future of crafts.

The paucity of thinking and writing on craft has led to a vacuum of both debate and standards. Teachers offer their students no clearly articulated direction; collectors and curators have no standards of quality to guide acquisitions; and the field lacks a distinct language to describe its own practice. The implication is that any craft object is as good as any other, and that quality is chiefly a matter of star status.

If craft claims to be art, it will have to examine its ends and means more closely. Even in the current atmosphere of freewheeling pluralism, craft will not be taken seriously until it can demonstrate genuine significance and relevance. Tom Wolfe in *The Painted Word* is right: nobody sees art unless it comes with a text.[4] For better or worse, craft must develop its own theory about the meaning of handmade objects in this late industrial era. And the task must begin with understanding the theory that has thoroughly infiltrated contemporary craft: Modernism.

MODERNIST THEORY: THE DISINTERESTED GAZE AND THE AUTONOMOUS ART OBJECT

There is a distinction between modern art with a small *m* and Modernism with a capital.＊ The term Modernism encompasses a group of ideas and the works that emanated from them. It is not a vague label for all the art made in the twentieth century. The Modernist art object was made to support aesthetic contemplation, which was limited to a highly specialized set of conditions. While the decline of Modernism has been loudly proclaimed for the past fifteen years, the status accorded to the fine art object has yet to be overthrown. Postmoderns might admire strategies like appropriation and social engagement, but they remain reluctant to admit a potter or a weaver into the Whitney Biennial. All the old prejudices remain intact, and those prejudices are inherent in the theories of Modernism. At the same time, the doctrine of formalism and the concept of autonomy—two of the keys of Modernist theory—are taken as basic assumptions by many of the most respected craft practitioners. Ironically, contemporary craft is one of the last bastions of faith in Modernism.

Modernism emerged from the ashes of the First World War. The alienation that intellectuals felt from the self-destruction of European culture molded their ambitions for art and design. The new art was to be utopian. Proponents of Futurism, De Stijl, Constructivism, and the Bauhaus envisioned a new society which radically rejected the bourgeois values that supposedly caused the war. The new society would embrace machine production, it would be completely redesigned to be efficient, and it would be ruthlessly modern. To accomplish all this revision, the Modernists had to cut themselves off from the past, from all but one tradition. More than anything else, the new world would be *rational*, and in that respect, Modernism is firmly anchored in the mainstream of Western philosophy and aesthetics.

While Modernism is not a single, unified narrative, some critics insist that it still presents the most cogent theory of art, mostly because all the others are even less rational. Modernism is part of a search for transcendent absolutes and precisely delineated categories. Modernism is also regarded by many as a series of claims that constitute an ideology, that is (in feminist terms, for example), a narrative that empowers one group at the expense of another, while explaining that inequity as natural or logical.

＊ "Modernism" in this essay has been capitalized, in keeping with Bruce Metcalf's distinction between these two terms.

The cornerstone of Modernist ideology is the idea of the autonomous art object. Here, the word "autonomous" describes a state of being self-contained, existing without reference to or influence from anything else. The autonomous object was intended to do one thing only—to support an aesthetic experience. This thinking is grounded in Western philosophy, in which art is distinguished from other categories of objects. Broadly, this desire for extreme clarity is a variety of essentialism: an effort to find the irreducible essence of a category of experience (or object). But there were insoluble problems with categorizing art objects as being distinct from all other classes of objects, so philosophers resorted to examining the experience of art instead. Again, the essentialist maneuver: the question What is the essence of the art object? was restated as What is not duplicated in any other type of experience? Western aesthetics thus became a process of exclusion. The separation was completed by the notion that art creates a special experience like no other. If an observer had an aesthetic experience, he must be in the presence of art.

In his *Critique of Judgement* (1790), Immanuel Kant declared that the aesthetic experience could occur only when the observer had a "disinterested" attitude. He did not suggest that viewers should not be attentive and emotionally open, but that they should not expect any type of profit or self-improvement from the experience. Artworks had to be savoured only for the pleasure of beauty, and experiencing art must be entirely self-rewarding. An attitude of mind that looked for artwork to be good for any other purpose diverted attention away from the art, and toward this other "good," which Kant declared was outside the aesthetic experience. Any aspect of an artwork which spoke to an ulterior motive was not concerned with beauty, and thus was disqualified from causing an aesthetic experience. Using a similar logic of exclusion, Kant also rejected sensory pleasure and emotional appeal from the realm of the aesthetic. Art could only be good for being art.

The idea of disinterestedness distinguishes between a non-aesthetic "content" and the formal means of aesthetic contemplation. As Harold Osborne, an enthusiast of high Modernism, explains in his introductory text, *Aesthetics and Art Theory*:

> We may appreciate works of art as vehicles for nonaesthetic values—moral, social, religious, intellectual, and others; and the experience will be the richer for it. But if we respond directly to those other values (so the doctrine of disinterestedness or psychical distance maintains), we are not appreciating the object aesthetically as a work of art. … In artistic contacts, so long as they remain in the aesthetic sphere, there must necessarily be restraint from full commitment to the urgencies and values of ordinary life…. All

these attitudes and emotions are foreign to aesthetic contemplation (although they may of course enter into the content of a work of art toward which we take up the aesthetic attitude of attention).[5]

The disinterested attitude mandates that any component of experience that appeals to "the urgencies and values of ordinary life" is not properly aesthetic. This is the logic that excludes craft from the realm of art. According to this theory, using a bowl to eat your oatmeal is not, in itself, an aesthetic experience. Expecting any gain—in this case, nourishment—puts the viewer in a frame of mind in which an aesthetic experience, by definition, cannot be encountered. You would have to stop using the bowl before you could perceive it aesthetically. Any type of use, any religious content, any political propaganda or critique, any commentary on the real world—all were held to be incapable of supporting a true aesthetic experience.

Kant admitted that aesthetic judgments are subjective: they can't be proven to be true or false but are ultimately based in the viewer's state of feeling. There is no measurement in aesthetic judgments, none of the objectivity of science or mathematics. On the other hand, Kant could not admit that aesthetic pleasure might be completely relativistic, residing strictly in the taste of each individual. To claim that "beauty is in the eye of the beholder" placed the aesthetic experience outside the purview of philosophy, and demoted aesthetic judgment to the same status as raw emotion. This was clearly unacceptable.

So Kant performed a nifty trick. Since aesthetic attention is possible only in a state of disinterest, where no trace of personal desire remains, Kant asserted that every true judgment of beauty contains an implicit claim to universal validity. That is, a person in a state of total disinterestedness is actually operating in a free state of cognition that does not vary from person to person. Kant was claiming that a disinterested attitude is identical in all individuals and all cultures, and is inherent to human nature. Kant called this, of all things, "common sense." The aesthetic experience was thus defined as occupying a middle ground between objectivity and subjectivity—between the cool distance of scientific observation and the messy heat of human emotion. Furthermore, the aesthetic experience, being a special type of cognition, was universal.

This marvelous mental sleight of hand is Modernism's chief claim to authority. Kant's "common sense" cannot be tested—it is not measurable—but it claims to be identical for every sensitive person, regardless of sex, education, class, or cultural background. In contrast, anthropological research suggests that very few visual experiences are understood

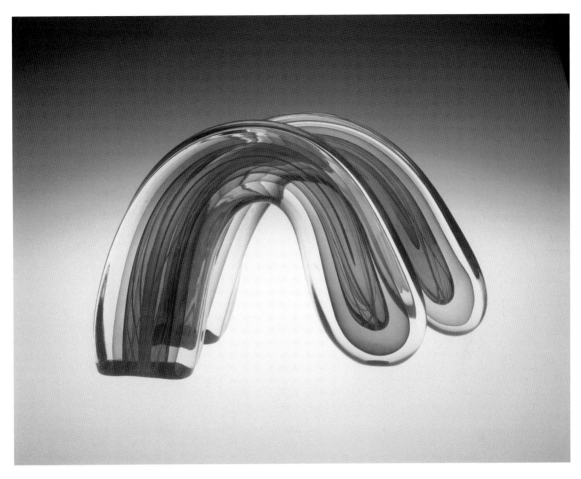

Harvey K. Littleton, *Blue Paired Arcs*, 1983. Barium/potash glass with multiple cased overlays of Kugler colours, 33 x 50.8 x 7.6 cm and 35.6 x 50.8 x 7.6 cm.

the same way in every known culture, and might be limited to the smile, the scowl of anger, and the frown of anxiety, and a few other primeval facial expressions of emotion. Untestable truth is a powerful intellectual weapon. It's no wonder that most Modernists accepted Kant's logic at face value.

In Modernist ideology, only one kind of visual phenomena supports the aesthetic experience—the formal elements of art. Colour, line, plane, mass and void, composition cannot speak to self-interest and thus qualify as able to stimulate valid aesthetic experiences. Only the formal elements of art qualify for universality. This is the doctrine of "formalism," and it explains why abstraction—colour and form disconnected from content—became the most significant mode of art making by the mid-twentieth-century. Abstraction satisfied all the demands of Kantian theory.

Art devoid of content, utilizing only formal elements, was said to be "autonomous." That is, it was designed solely to create an aesthetic experience, and therefore became a standalone phenomenon, disconnected in every other way from the rest of the world. To some critics, autonomy became a necessary precondition for an object to be called modern art. Pure art for art's sake; art about art and nothing else. No use, no meaning, no impurity, no messy world to intrude.

Several corollaries follow from the logic of autonomy. First, any object embedded in tradition, or made for physical use, is art only to the degree to which tradition and use can be ignored, and the work's formal qualities attended to instead. Second, it was held that these formal qualities, by stimulating an aesthetic experience, could cause the viewer to "transcend" immediate material existence. The metaphysical place one transcended to was never specified, but it was usually located either in Plato's domain of pure absolutes or in a moment of superior, refined pleasure. The term "transcendence" is a Modernist buzzword intended to argue for the philosophical and moral superiority of the autonomous art object.

And so, the ideology of high Modernism is complete.

Ultimately, Modernism redefined art. Once its assumptions are accepted, it follows that valid art *must* be autonomous. Anything else—the *craftness* of craft, the social and psychological uses of an object, the meanings that people project upon the things they love—does not fall within the realm of art. And if it's not art, according to the rules of Modernism, it cannot cause an aesthetic experience, it's not worth looking at seriously, and it's not really worth doing.

Modernist theory established the look and feel of credible art, a look that was immediately legible, if poorly understood. And craft—especially craft rooted in traditions of skill,

material, function, and history—did not have the proper look and feel. As Clement Greenberg, the foremost spokesman for high Modernism, intoned, "Craft is not art."[6]

DAMAGE DONE: MODERNISM'S EFFECT ON CRAFT

Craftspeople have long wished for the privileges of modern art: clean, white galleries; those museum collections; amazing prices. Once craft practitioners were relegated to non-artist status by Modernist ideology, it was not surprising that they would envy the prestige that art commanded. They concluded that the perks were awarded for the condition of autonomy: standing apart from the world and serving no other function than to be regarded.

Status-hungry craftspeople treated the theory of autonomy like a new religion, accepting its claim to authority uncritically and never examining its supporting logic. The two fundaments of Modernist theory—the autonomous art object and the language of formalism—were perceived as basic elements of fine art, and craft adopted them for the sake of credibility. Instead of making decorative or functional objects, or exploiting other traditional craft contexts, craftspeople tried to make modern sculpture. In attempting to assert equal status by adopting Modernist rules, craftspeople revealed their "cultural cringe"—an implicit sense of inferiority about the traditional roles of craft.

More frequently than not, "star-quality" crafts are autonomous objects made from craft media. Harvey Littleton's glass, Bill Daley's ceramics, Heikki Seppa's metalsmithing and thousands of other objects closely follow Modernist prescriptions. The many social implications of craft have been amputated without ceremony. Elements of design, material, and technology are attended to visually without concern for social meanings. Littleton manipulates form and void in space, as if he were Henry Moore in miniature. The properties of glass—transparency, reflection, and refraction—are the only remaining craft content in Littleton's work. Daley concerns himself with the tension between inside and outside of the ceramic vessel, a focus that falls neatly inside the boundaries dictated by formalist principles. Seppa makes bizarre abstract forms in space. Otherwise, there is no content at all, exactly as the theory of autonomy prescribes. Apparently these craftspeople have not examined the reason for making craft jump through the hoop of autonomy. Theory became myth, and craftspeople obediently believe. Either unfamiliar with or dismissive of the logic of the disinterested aesthetic experience, they try to make their work look like autonomous art. Modernism is taken as a style rather than an idea. The result of such

superficial mining is a widespread confusion, because the essential characteristics of craft are denied.

In trying to make autonomous art objects, craftspeople enshrine uselessness. The non-functional object has become the standard of achievement, especially in ceramics, glass, and fibre. No one questions the logic of making a formalist sculpture out of craft media, because nobody questions the logic of autonomy in the first place. In a bid to gain respect, otherwise sensible craft practitioners call their work fibre art, art furniture and art jewellery, as if the terms weaving and furniture and jewellery lacked dignity. Only a few of these aspiring artists, however, have had the courage to simply call their work "sculpture" and leave the unthreatening arena of crafts.

Another legacy of Modernism is a distrust of skill and fine craftsmanship. The history of modern art records a gradual abandonment of the traditional crafts of painting and carving, partly as a symbolic rejection of academic taste and, ultimately, of bourgeois culture. By the late 1940s, Jackson Pollock could pour house paint on a canvas, throw his cigarette butts onto it, and be heralded as the hero of American painting. The uncrafted gesture now stands for authenticity and raw emotion, and has, ironically, been converted into dogma in university art departments. It becomes increasingly difficult for teachers to insist on control and discipline because they would seem to be arguing against the apotheosis of American art: Abstract Expressionism.

Craft has embraced other Modernist assertions: the insistence on rupture from the past; the celebration of newness and rejection of the familiar; stress on originality; the silly military metaphor of the avant-garde. Another of Modernism's insidious influences on craft is the implication that innovation and originality can be realized most effectively outside of craft traditions. The most art-aspiring among craftspeople reject all the traditional strengths of handcraft: pride in skill and craftsmanship; utility; familiar shapes refined in centuries of production; and social and psychological applications.

When craft is forced to aspire to a condition of autonomy, several unresolved problems develop. The theories of autonomy are questionable at best, and are no longer as persuasive as they used to be. To accept autonomy as a necessary precondition for craft, the craftsperson must agree with a system that denies aesthetic value to the very things that make craft distinct. Transforming the craft object into autonomous art denies the ways that craft relates to real life. The craftsperson is then left with "art guilt" about making *merely* a pot, a chair, a knife, a coat, or an engagement ring. Those simple objects are no longer enough like art.

CRITIQUES OF MODERNIST THEORY

Modernist theories do not stand uncontested. Several schools of thought, including Marxism, feminism, and the study of material culture, contend that autonomy is an illusion and that artwork is inevitably entangled with the larger world. Those holding such views point to a broad sphere of political, economic, sexual, and psychological meanings that sometimes constitute the true value and meaning of the artwork, and which the doctrine of autonomy only serves to camouflage. I refer to these many connections as "contingencies," and for the purposes of this discussion, I will show how craft is contingent on the larger world. While Modernist theory acknowledges that such implications are present in the artwork (recall that Osborne called them "content"), they are denied aesthetic status. Recent criticism challenges this restrictive distinction and suggests that contingencies can have aesthetic value.

To illustrate a negative example of contingency and to show the way that claims to high-minded aesthetics can obscure actual social content, I like to choose an easy target: Alexandre Cabanel's *La Naissance de Vénus* (*The Birth of Venus*), 1863. Cabanel depicts the nude, newborn Venus lounging on the surface of a wave, representing the ideal of feminine beauty. The concept of ideal beauty, which referred to classical Greek statuary, justified the painting to its viewers in the mid-nineteenth-century Paris Salon. But to the our eyes, something else is going on. The depiction of a nude woman, posed with her pubic region centered in the composition to imply her sexual availability, now appears to be offensively sexist. What was originally conceived as the essence of a sensual, modelled object is now understood as soft pornography—the submissive female available to the owner of the painting. Most serious critics and curators today would challenge such bad taste. While not abstract and thus not the product of Modernist theories of autonomy, the painting offers an instructive case of how the subtext may be the genuine subject of an artwork, and how the aesthetic theory can disguise nasty realities.

The New York School paintings that Clement Greenberg touted as superior autonomous art, designed exclusively for sustained aesthetic contemplation, had their dirty little secrets too. First, they were shown for sale in galleries, immediately becoming commodity objects. In fact, they became resoundingly successful as investments, and some of those heroically disinterested objects made millions for their owners. Second, they were quickly deployed by the United States government as propaganda to demonstrate the cultural superiority of capitalism over communism. In the same exposition that featured the famous "kitchen debate" between Nixon and Khrushchev, the United States exhibited a

ALEXANDRE CABANEL (1824-1889), *BIRTH OF VENUS*, 1863. OIL ON CANVAS.

group of Abstract Expressionist paintings, the implication being that the American economic system was responsible for the best new painting in the world.[7] And last, feminists have pointed out that the female Abstract Expressionists like Lee Krasner and Elaine de Kooning were every bit as innovative as the men, but were accorded fame and fortune only decades later. How could a truly disinterested critic, feminists ask, discern the sex of the artist? They conclude that dealers and critics invoked supposedly impersonal standards, buttressed by theories of autonomy, to disguise a very different intent: to lionize men and marginalize women.

It's now obvious that Modernist paintings were caught up in social practice. Postmodernists, going one step further, claim that the ideal of total disinterestedness is an illusion. Art became successful commodities, tools for propaganda, and vehicles for sexist behavior—roles that intrude into the clean, dispassionate aesthetic space that Modernists claimed. Indeed, once these external factors are recognized, an informed viewer can't forget them. The knowledge disrupts disinterestedness. A few diehard Modernists continue to insist that one can look at a Pollock painting and forget how famous he was, how expensive the painting is, and how the artist once pissed into Peggy Guggenheim's fireplace. But the proposition that one can willfully disregard all knowledge in the contemplation of art is not taken seriously anymore. Such monumental forgetting isn't credible. The idea of disinterestedness that underlies the theory of autonomy has been undermined, and all of aesthetics are left open to revision.

The notion that art is necessarily contingent is not new. Marxism insists that art emerges from the larger society, particularly from economic conditions. In this view, art is regarded as "instrumental," a tool for a social agenda. Art becomes a vehicle for purposes that high Modernism excluded, and the criteria for aesthetic success shifts: art can be judged by the efficiency with which it achieves its goal and the nobility of the goal itself. Generally, instrumental art takes social change as the most desirable outcome. Of course, most Marxists insisted that Communism was the only suitable goal, and the proletariat, the only suitable audience for art. Because art under Communist regimes was usually restricted to serving repressive governments, theories of instrumentality are not greatly respected in the United States.

A more American version of contingency emerged from feminism. The civil rights movement and protests against the Vietnam war suggested that, contrary to the doctrine of disinterestedness, social criticism in art was both possible and necessary. A small group of artists called for direct action against social ills, and the call was answered by women who felt that truly female visual art was being suppressed. Early feminist artists like Judy

Chicago and Miriam Schapiro pointed out that the art world ignored injustices—particularly discrimination against women—because the discourse of autonomy diverted attention from the social aspects of art. Despite Modernism's roots in revolution and imaginary utopias, feminists claimed that the Modernism of the 1950s and 60s passively accepted corruption and inequities of power. In opposition, they proposed an art that referred to life, and actively sought to restore dignity to women's lives. Furthermore, feminists proposed that their activist art was aesthetically valid. In a sense, they sought a middle ground between formalism and instrumentality. A monument to these attempts to revise art theory is Judy Chicago's *Dinner Party*, one of the most ambitious craft objects produced in this century.

While the doctrines of autonomy might be discredited, they continue as a powerful mythology. Standing in opposition to Modernism are theories of instrumentality and contingency, which stress art's relationship to the world. There are conflicts between the two approaches. Modernism posits the metaphysics of transcendent absolutes, of clean theoretical perfection, and of art as a self-rewarding, self-referential activity. Contingency presupposes life-as-lived, knotty problems of cultural difference, art as caught up in social practice. An aesthetic war follows: between Modernist abstraction and social realism; between defenders of the established order and radical political critics; between formalism and decoration; between art and craft.

CRAFT AS CONTINGENT ARTFORM

The idea of contingency can help us focus on ways that craft is enmeshed in the processes of living, not separated from them by aesthetic distance. My thesis is that craft is inherently a contingent artform, and its aesthetic value must be located in the ways craft is intimate, useful, and meaningful. Craft should not presuppose disinterestedness in order to justify itself. Efforts to dispense with contingency also dispense with craft, until all that's left is attractive, timid, mediocre sculpture.

Again, I choose an easy target: Harvey Littleton, a founding father of studio glass. In his loops and arcs, widely held to be a pinnacle of craft accomplishment, all the rich social resonance of traditional craft has been carefully edited out. Any "craftness" that survives resides in the material and its manipulation, and nothing else. What remains is a slick, facile sculpture that follows the theoretical confines of the autonomous art object. Conceptually, the object is empty: the difficult groundwork of abstract sculpture was prepared long

before by the Constructivists, Henry Moore, David Smith, and others. Littleton lets them take his risks. His sculpture is made with a repertoire of proven techniques like casing transparent colours, bending, and slicing. None of the adventure and variation of form that makes Moore or Smith so interesting remains. Littleton makes autonomous art objects disguised as craft, and he exploits the glow of artistic credibility that 1950s art theory projects on his work. He reduces Modernism to a limp formula, and he has been wildly successful in the marketplace.

Craft must avoid such easy imitations of Modernism. If it wants to build a conceptual foundation and distinguish itself from the other arts, it must turn away from Modernist aesthetics and begin to examine the ways in which its practices are contingent on social life. Craft objects can stand back and offer commentary, propose reforms, advocate traditions, or simply try to help people get by. But craftspeople can no longer afford to produce objects that do nothing but sit on a pedestal and look pretty. If that practice continues, the ultimate price of will be the reduction of craft to a poverty-stricken colony of the art world.

We in craft must start by examining the varieties of contingency and by discovering meaning within them. These may have little to do with art (as defined by both Modernism and postmodernism), but they are often the traditional roles of craft. Craft theory must look not to art, but to craft, and how craft refuses to conform to art theory. In fact, the project of reconstructing the meaning of craft will culminate in rewriting Western aesthetics, ultimately forcing the "art" category to become more tolerant and inclusive.

Craft is defined by tradition, after all. Where Modernism stipulated a rupture between present and past, craft proposes a seamless continuity. Craft looks to the past for techniques, visual cues, meanings, and ideas. Even today, craft depends on the continuous revival of pre-industrial technologies. Most craft practitioners reenact a process that has been in use for thousands of years, whether it is throwing on the potter's wheel, hammering a sheet of metal into a hollow form, spinning and weaving fibre, or blowing glass. Craftspeople also look to historical production for reference and inspiration, the way that Bernard Leach held Southern Sung Dynasty pottery to be a paradigm of excellence, or the way that jewellers now look at African and Oceanic body adornment as a source of vigorous, wearable form. Historicism and eclecticism were standard practices in the crafts long before postmodernism provided a theoretical justification.

This open relationship to tradition rejects modernity as an absolute value and denies the claim of early Modernists that art must reflect only the most recent conditions. The Futurist romance with urbanism and high technology is rarely re-enacted in the crafts. Modernism's flaw was to demand an entirely new world, filled with new art, architecture, and mass-

produced design based on formalism and functionalism, while arrogantly ignoring the human need for rootedness. By contrast, craft looks at society as a continuum, not a new invention. A firm connection to the past is both possible and desirable. This stark difference from the stance of Modernism is occasionally asserted but rarely examined. To affirm the value of tradition suggests a view of society in which the familiar is recognized and valued, not rejected out of hand. To craft, tradition is not necessarily backward, corrupt, or a restraining force in civilization; it is not an anchor, but a rudder.

The contest between innovation and tradition illuminates a larger question about craft's relation to society. Modern art positioned itself as an adversary to mass culture, struggling to maintain the lamp of true enlightenment against the darkness of ignorant, bourgeois society. Modernists assumed the mantle of leadership, but they held their audience in contempt (read Greenberg's early writings, like "Avant-Garde and Kitsch," 1939, for evidence). As an antithesis to Modernism, craft offers no radical critique of bourgeois culture or capitalist economy, and not since the days of William Morris has it claimed the moral authority to build a utopia. Generally, craft is an advocate, not an adversary. The bourgeoisie are seen as a marketplace, not a class of criminals. Craft adheres to a middle-class view of the middle class, acknowledging bourgeois taste as a marketing parameter and recognizing capitalism as a cultural given. Service and acceptance, not agitation and criticism, are central to the ethos of craft.

Typically, craft objects are accessible, fitting comfortably into life-as-lived rather than interrogating or challenging it. Craft usually observes humanistic practices: self-employment in low-impact capitalist businesses, modest incomes, ecological preservation, dignity through honest labour. Pointed commentary is not foreign to craft—the ceramicist Howard Kottler and Michael Frimkess, or the jeweller J. Fred Woell are well known as social critics—but its stance is more that of a loyal opposition, unlike early Modernism's alignment with Marxist revolution, or with T. S. Eliot's sour metaphor of modern life as a wasteland.

The strong Marxist influence on art criticism leads many writers to dismiss crafts as being hopelessly uncritical.[8] Such views naively assume that the supportive role of craft is less dignified and important than the adversarial role of some fine art. Most of the Marxist governments have been overthrown; one can only wait for the dimwitted prejudice against the "working-within-the-system" stance of craft to undergo the same fate.

Anonymity and Identity

Craft retains one crucial oppositional stance. The hand-made object is widely understood as the antithesis of mass-produced anonymity, and it offers the middle class one of its few defenses against the early Modernist's authoritarian dream of total design.[9] Combining ideas of universal form, standardization, elimination of decoration, rejection of historical prototypes, and the enthusiastic embrace of the machine age, Modernist design theorists largely ignored cultural differences and the perplexing psychology of subjectivity. At no point did theory account for personal experience or the need for self-identity. The utopia envisioned by Le Corbusier and Walter Gropius turned out to be sterile, boring, and devoid of comforting symbolism. For the past thirty years, it has become increasingly obvious that objects designed according to "rational" standards precipitated a mass identity crisis: people could not relate to their environments. Alienation inevitably followed. The abject failure of the Pruitt-Igoe housing project in St. Louis is only the most conspicuous example of the dismal record of Modernist reform.

Modernism once proposed a brave new world of unified design and high-tech manufacture, but craft resists. Craft objects reinforce personal identity. American consumers intuitively read the uniqueness of the handmade object as a tangible analogue of their own singularity: the marks of hand fabrication symbolize the uniqueness of an individual life. Subtle variations of handmade form and the textures of handmade surfaces resist simulation, and thus cannot be incorporated into the vocabulary of industrial design. Glaze effects, the irregularities of handweaving, or hammer marks on a planished bowl all become fingerprints in an otherwise perfect environment. These glitches and blips, inevitable by-products of pre-industrial technologies, not only become antidotes to the sameness and predictability of mass-produced objects, but they return visual complexity and a sense of the individual's connection to the home. People use handmade pottery, weaving, jewellery, and even macramé to prove they're not just another number. Craft has been enlisted in an intuitive rebellion against the "improvements" of Modernism, and this is why the market for it has exploded in the last three decades.

For the middle class, the symbolism of uniqueness takes place in the margin between too much sameness and too much difference. Too much weirdness indicates poor socialization and solicits rejection, as anyone who has ever worn a Mohawk haircut to a job interview can confirm. Crafts that are different enough from mass-production but related to the traditions of Western decorative arts are most often used to stave off the anxiety of anonymity. The familiarity of craft forms complements the uniqueness of hand production.

Made for a particular person and occasion, a craft object like an engagement ring can serve as a specialized symbol. A generically designed, mass-produced, and nationally distributed ring cannot carry the same meaning, because the consumer knows that hundreds or thousands of identical rings are given and received. As a consequence, handmade objects are often used to mark important milestones: births, comings-of-age, marriages, anniversaries, deaths. Not surprisingly, in this country, crafts are used as gifts much more frequently than as necessities.

SOCIAL AND PSYCHOLOGICAL FUNCTION: MEANING AND USE

In Modernist theory, function was defined as limited to physical use. The study of the function of any useful object could then be treated as a quasi-science, measuring the human body and its parameters of movement. One could objectively study how a chair supports the human body, or how a teapot holds and pours tea. But defining function in this manner deflects attention away from the possibility of meaning. Entranced by formal principles of composition, new industrial materials, and the study of ergonomics, designers forgot that people also require meaning and tradition. Indeed, the early Modernists consciously tried to erase all meaning from design—with the possible exception of symbols for progress and utopian socialism.

To contrast the difference between the objective stance of Modernism and the more traditional attitude that sees an object is a vehicle for meaning, imagine a comparison between a Bauhaus teapot and an elephant mask from the Bamikélé chiefdoms in Cameroon. The teapot, made to appear as if it was produced by machine, consists of carefully composed geometric forms. Each part of the design serves a physical function—spout, insulating handles, lid, body of the container—as well as satisfying the demands of formalist aesthetics. It symbolizes nothing of the past; in fact, it stands for the absolute break with tradition that Modernism specified. It was supposed to read as a rational, mechanical icon of the new age, and nothing more.

The elephant mask is not an abstract sculpture. It is worn every two years at the meetings of societies associated with the Bamikélé ruling council, or upon the death of the ruler, called the *fon*. When the mask is seen, it means an important ritual is taking place. The mask can be worn by members of only two societies out of eight, so it is exclusive. The image of the elephant symbolizes power, representing both the animal and the *fon*. Further, the elaborate beadwork represents wealth, power, and prestige; the glass beads

are ancient barter money. The function, to mark a ritual, is overlaid with multiple and simul-taneous meanings based on honoured tradition. To apply ergonomics here would be absurd, and to demand a radical rupture from the past would be destructive.

In the United States, most ceremonial and ritual objects have fallen into disuse, but not all are obsolete. Within the craft traditions of metalwork are marriage rings; baby's spoons; Catholic chalices, patens, and monstrances; Judaic kiddush cups and menorahs; gold watches for retirements. In each case, the physical function is joined to widely understood social meaning. The object communicates through a social code, learned like a language by members of the culture that produced it.

Enchanted by the spell of Modernism, "artistic" temperaments today usually believe ritual and ceremonial objects are too tradition-bound to be suitable vehicles for self-expression. But self-expression needn't be the highest goal of the craft practitioner. In a secular world, craft can serve others by offering a medium for personal meaning—a recep-tive screen upon which to project significance. Instead of conveying total self-absorption in expression, a craft object can perform a service. Instead of celebrating the artist's ego, the work can discover the unanswered needs of the user. Craftspeople can move into areas of subject matter that art and design have declared to be irrelevant for almost a century, and in so doing, they become socially responsible.

North Americans today are starved for authentic meaning. Status symbols and TV images fail to satisfy a growing number of people. One manifestation is the explosion in popularity of body piercing and tattoos, which many youth see as an uncontaminated emblem of rejection of the mainstream, and a voluntary embrace of outsider status. The permanence of the tattoo underlines its authenticity. Surely, such drastic alterations must be motivated by a genuine hunger; and while they might seem extreme, the point is that many psychological needs are not answered either by mass-market design or by fine art. It remains for the craftsperson to become a scholar of the niche market, to discover vacu-ums of meaning (and they are many), to study them carefully, and then to make objects that contain—or can take on—appropriate meanings.

The site for most of this meaningful work is not in the gallery or the museum, but on the body and in the home. The meaning of craft operates in humble places, but it's as site-specific as a Richard Serra sculpture. The coded language of craft speaks from the body, with jewellery and clothing—and the home—with furniture, pottery, fabric, lighting, and decoration. Once the craft object is isolated on a pedestal, like autonomous art, it loses most of its power to be invested with an intimate and ongoing personal meaning.

Redirecting the ambition of craft from galleries to homes does not mean that craft objects must necessarily be less profound or less satisfying than modern art—they merely serve a different agenda. Of course, to suggest that a simple pot may be as good as your standard art masterpiece is profoundly subversive. What would happen if we had to take all those pots seriously? Museums would be required to go to craft fairs, buy pots and weavings and jewellery, and place them next to those expensive paintings. The canon would have to be rewritten, and hordes of craftspeople admitted into the temple of art. But most revolutionary of all would be the notion that good art could be widely available and cheap—forty dollars (or less!) could get you into the elite. Of course, few mandarins of culture would be likely to allow it.

Unfortunately, most contemporary craft practitioners do not consciously address social and private meaning. Discourse about function is directed toward physical use, exactly as Modernism dictates. Craftspeople who wish to claim the more exalted position of "artist" are distracted by the foolish idea that the functionless object is innately superior. The possibilities of craft serving psychological uses goes uninvestigated. This is sad—a betrayal and a loss.

Craft and Conditions of Production

The basic concepts of Modernism—disinterestedness, formalism, the autonomy of art—specifically address the way that a person is supposed to look at art. The conditions surrounding the making of art are not given much attention. Such matters as how the artist thinks and feels, and how society influences the artist, get swept under the rug. While expressionist theory examines the emotional life of the artist, Marxism offers a slant on economic factors, and feminism analyzes power relations between the sexes, the complex network of social impact on personal experience is largely ignored. Most critics have assumed that craft is uncritical,[10] so they never imagine that craft represents a collective, intuitive reaction to industrialization. When it comes to "conditions of production," craft has profound implications.

William Morris, the English reformer who saw how the handmade object could be made relevant in an industrialized society, laid the foundation for today's crafts movement. To Morris, craftwork performed a social critique. It could counteract the degradation of factory labour, he claimed, if only English society would turn back the clock and return to a craft-based economy. Workers would take pride in their labour and at the same time be

freed of capitalist exploitation. Objects in everyday life would become beautiful, informed by the loving touch of impassioned labour. Finally, art and craft would become unified. Of course, the theory did not work. Morris's company and a few other workshops ultimately produced luxury goods for the wealthy, and industrialization proceeded undisturbed. Nonetheless, Morris was the first to imagine that pre-industrial technologies should be preserved for their social usefulness, and thousands of people followed his teachings. In the United States, Arts and Crafts societies and some universities took up the cause to preserve craft skills. Enough institutions and teachers survived to germinate the post-World War II craft revival.

Today, craft in this country represents a collective response to social conditions as well as an implicit social critique. Most craftspeople intuitively respond to hand labour, finding it satisfying and somehow fitting. Often, when people first take up a craft, they are surprised at the unpredictable and visceral nature of their feeling. As a teacher, I observed many times how directionless and unmotivated students come alive once they put their hands on metal, fibre, or clay. Unexpectedly, they find an activity that conforms to an innate sensibility and answers an unarticulated need. For some of these students—as happened with me—the craft becomes their life's work.

The choice to devote one's life to a craft is a conscious rejection of the way this society has devalued physical labour. Generally, Western societies are patterned after the classical Platonic hierarchy in which the mind, being closer to the realm of pure absolutes, is held to be superior to the body, which is rooted in lowly actuality. Brain work is accorded higher status than physical work: the bureaucrat is paid more than the factory hand, and so on. It is quite remarkable for college students—so close to becoming qualified to work behind a desk—to choose to work with their hands. Ultimately, it's a quality of life issue: what work is going to be most satisfying? That a craft continues to be an attractive option in the age of computers and bureaucracies proves that human animals still value their hands, and that these most sensitive of instruments still modulate the world in powerful ways. The hand molding clay, hand holding a mallet and chisel, the hand touching fabric, the object taking shape when before there was nothing but formless mud or wood or thread—craft diverts experience back to the physical. The choice of craft is not anachronistic. It is a statement that we still live in a body rich in potential. In a sense, craft always tries to perform a metaphysical revision: the return of labour to equal status with thought.

FRANK KLINE, *TORCHES MAUVE*, 1960. OIL ON CANVAS, 305.1 X 206.1 CM.

The Symbolic Value of Craftsmanship

All this relates to question of technical virtuosity. What is the value of mastery of a craft? In the fine arts world, virtuosity has been regarded with intense suspicion ever since Manet intentionally employed rough painting to criticize the mindless polish of Academic styles. Today, critics continue to use words like "raw" and "tough" to applaud sloppiness for its presumed authenticity. The same school of thought attacks fine craftsmanship as an end in itself that distracts the artist from becoming more creative and original. Until recently, a basic article of faith in the Modernist academy was that careful, controlled work has no aesthetic potential. But in the crafts world, fine workmanship is regarded either as a known quantity to be manipulated like a tool, or as a worthy and self-rewarding goal. Conservatives in the field hold that fine craft has intrinsic value. They see mastery as a purpose of object making, to be valued and encouraged for its own sake, and they enjoy the challenge of difficulty, regarding skillful work as evidence of rare achievement.

On the other hand, the art-craft faction asserts that skill merits admiration only insofar as it's justified by another agenda. They refute the argument for virtuosity by pointing to any number of well-made but derivative craft objects, like the hundreds of imitation Scandinavian-modern teapots cranked out by American silversmiths in the 1950s and 60s. Most were technically competent, but lacked the innovation of the Danish originals. Because the end result was compromised by lack of originality, it is argued that craftsmanship alone could not improve the object. By logical extension of the Modernist argument, virtuoso technique has no aesthetic impact.

If Modernist criteria are put aside, however, fine craftsmanship takes on a different meaning. In Japan and Korea, mastery of technique is understood as evidence of spiritual maturity. To a Buddhist, work spent on attaining skill necessarily contributes to higher awareness. It is regarded as a spiritual discipline to have repeated the same act thousands of times, to have paid careful attention in years of work, and finally to have achieved perfection. Virtuosity is admired not just for its own sake, but because it demonstrates a religious accomplishment.

Even if North Americans don't have the same respect for patience, mastery, and spiritual discipline, fine work can still prove that the maker cares passionately about his or her work, and refuses to compromise standards. Concern for a job well done and steadfast refusal to surrender to expedience show an integrity that is increasingly rare in this society. Anybody who has had their car repaired by a careless mechanic or a faucet fixed

by a sloppy plumber is vividly reminded of the need for rigorous standards. While technique alone cannot rescue an ill-considered design from mediocrity, the effort should still be honoured.

Tactility: Engaging the Senses

Some of the most pervasive and least examined aspects of craft are its sensuous qualities, especially its appeal to touch. Reductive Modernism restricted aesthetic experience in the visual arts to sight alone, as if no other pleasures were possible. But craft objects, because they are used in so many ways, engage all the senses but taste. When a pot is held, it conveys weight, balance, and density. Lifting a heavy, thick-walled pot is very different from holding a thin, light one. The surface texture of clay and glaze is experienced at the same time, and offers a distinct pleasure. Weavers and garment makers are conscious of the feel of different fabrics, from silk to denim. The material controls how the garment feels, how appealing it is, how well it will insulate, and how it will drape and weigh on the body. None of these experiences rely on sight, but all of them have an aesthetic component.

Certain types of jewellery, like chainmail, have properties of weight, motion and temperature change that can only be understood when the object is worn. Sound is also part of the craft experience: the clink of a fork on a plate; the chime of a glass; the tiny note of a dangling earring that only the wearer can hear. Some potters will ring the rim of a pot like a bell to test the fit of clay body and glaze. And, of course, there's the immensely seductive feel of polished and oiled wood, or the perfect fit of a dovetail joint.

Richard Wagner regarded his operas as a composite of all the arts: music; literature in the libretto; painting and architecture in the set design. He aimed for a totality of sensual experience that he called synesthesia. While craft may not be able to encompass the entire catalogue of senses in one object (Wagner ignored smell and taste too), it is clear that craft engages a great deal more than sight. So far, however, most people seem content to remark that such phenomena occur, and do not consider how sight, touch, and hearing can be organized in a unified composition. Craftspeople intuitively make judgments of how sound or touch intersects with the visual but never think much about it. Here is another conceptual field, ripe for exploration.

THE MEANING OF DECORATION

You can always tell a true Modernist by the way he uses the word "decorative"—as a pejorative. Modernism abandoned decoration in a fit of righteous indignation early in this century. The harshest opponent of ornament was the Viennese architect Adolf Loos, who set forth his principles in "Ornament and Crime" (1908). According to Loos, all ornament can be traced to childish graffiti—sexual images smeared in fecal matter. The same impulse is manifested in the present day as tattoos (Loos claimed that only savages and criminals bear tattoos). Decoration represents only the lowest of human impulses, so it must be stripped from art and design, especially from useful objects. While Loos's argument seems laughable today, for the past eighty years Modernist designers have behaved as if it were true.

The upshot is that craft is profoundly uncertain about the legitimacy of decoration. Given that craft has traded in decoration for thousands of years, it is peculiar that this central purpose is currently called into question. When decoration is applied to a craft object, it is usually justified in formal terms. A potter, for example, relying on the language of Modernism, might speak of enhancing the form of the pot with painted glazes. Since formalism was invented to describe the pure autonomous art object, using those ideas to explain decoration is problematical.

A rigorous interpretation of disinterestedness would insist that decoration is aesthetically valid only to the extent it is purely formal. Any inherent meaning or use would not qualify. And then, strict formalism would demand that all decoration be essential to the composition (remember, perfect design having no extraneous elements), which immediately disqualifies anything *applied* to a form. Of course, most decoration *is* applied, literally and figuratively. Any craftsperson who attempts to justify decoration with Modernist theory is stretching the limits of credibility.

If we see craft as a device to address psychological need, however, decoration makes more sense. Decoration is a signifier. In cultures all over the world, ritual objects, dwellings, the body, and even cars and trucks are decorated as signs of individual and social identity. Most ornamentation speaks in commonly understood visual language, so people live in a dense continuum of meaning. For example, tattoos are not the badge of savagery that Loos claimed them to be, but texts that everybody in a society can read. Scarification, masks, costumes and jewellery serve similar purposes. In most societies, decoration is a social code; to go without it is to go naked and stripped of meaning.

Modernism's insistence on rational, formal relationships has managed to make decoration seem superfluous. But in the real world, the effects of Modernist architecture suggest that people suffer in sterile, unornamented environments. A study showed that after Scotland Yard moved from its fussy Victorian building to a new, theoretically correct Modernist office, morale plummeted. A visit to any college dormitory would reveal that most students react to long, featureless corridors and blank walls by plastering their rooms with posters, signs, slogans, and advertisements. The workers who moved into Le Corbusier's housing project in Pessac wasted no time before nailing on shutters and adding pitched roofs to their Modernist boxes. Refusing to be brainwashed, they applied decoration that symbolized "home." The evidence suggests that the impulse to adorn is neither primitive nor childish.

Clearly, decoration can still convey meaning. (It can also be completely arbitrary and meaningless.) It is unfortunate that most artists and designers have abandoned decoration so thoroughly. A vacuum of meaning has opened up, filled, by default, with merchandise from K-Mart and Sears. At the same time, craftspeople seem unable to explain the purpose of decoration. If craft has any ambition to communicate, and especially to ameliorate the alienation and social ills that cause so much pain, ornamentation would be a perfect vehicle. If craftspeople could overcome their art guilt, look respectfully at decoration and study its social functions, they could recover their heritage. If craftspeople understand ornament as a play of meaning, not a thin veneer of style, then perhaps the demon of Modernism could finally be exorcised.

In Summary

The ideas I have set forth involve contingencies—the many ways a craft object can be connected to the real world. To pursue any one of them would require that the basic rules of Modernism be put aside, and notions as to what is properly aesthetic be repudiated. Fine arts have turned away from Modernist ideology. It is fashionable now to talk about politics, AIDS, relations with the third world, or feminism in art. These subjects presuppose an art intimately connected to the world, not isolated in a gallery. And yet, most painting, sculpture, video and performance still claim the status and privileges of Modern art, and are reluctant to enter the homes and personal spaces of ordinary people. Those sites remain the province of craft.

It should be clear that I am no friend of Modernism. I believe its ideas have done much damage. Certainly, there is a place for pure, unalloyed visual pleasure, and Modernist theories describe how to judge an object intended for that purpose. But those kinds of objects have surrendered many of art's—and craft's—important purposes: to remind ordinary people of their position in the cosmos; to point to meaning; to be used; to help; to heal; to entertain. Those functions were discarded in the name of the self-rewarding aesthetic experience, and it is high time craftspeople reclaim them. Craft once played all those roles, and, to some extent, it still does. But the criteria so dear to Modernists have narrowed and stunted craft, asking it to fit into the same straightjacket that painting and sculpture once willingly strapped on. The more I consider it, the more I think craft practitioners should give up the pursuit of Modernist art entirely. Either that, or craftspeople should have the courage to simply declare that they are sculptors, and then be prepared to fully engage in the art world's contentious discourse.

Given these choices, it seems best, in my view, to relinquish art envy and stop aspiring to the alleged nobility of fine art. It is equally noble to communicate with people and to produce objects that personalize rather than alienate. The traditional roles of craft offer rich possibilities, if only they can be reshaped to be relevant to social conditions today. What craft has always done is its strength. The challenge is to consciously and carefully build upon tradition. The project is no less creative, no less difficult, than any agenda in modern art.

ENDNOTES

1 Edward Lucie-Smith, *The Story of the Craftsman's Role in Society*, (Ithaca, NY: Cornell University Press, 1981) 271.

2 Barbara Cartlidge, *Twentieth-Century Jewelry* (New York: Harry N. Abrams, 1985), and Peter Dormer and Ralph Turner, *The New Jewelry: Trends and Traditions* (London: Thames and Hudson, 1985).

3 *SNAG Newsletter* 100, June 1992.

4 See Tom Wolfe, *The Painted Word* (New York: Farrar, Straus and Giroux, 1975).

5 Harold Osborne, *Aesthetics and Art Theory, An Historical Introduction* (New York: E.P. Dutton, 1970) 160-161.

6 Greenberg made this statement in April 1992 at the conference, Critical Studies in the Craft Arts: Crossings, Alignments and Territories at New York University, which the author attended.

7 The American National Exhibition in Moscow, 1959.

8 John Bentley Mays, "Comment," *American Craft*, December 1985/January 1986: 38-39.

9 Jan Tschichold, a Bauhaus student and promoter of *Die Neue Typographie*, wrote in 1946 that Modernist typography "conforms to the German bent for the absolute, and its military will to regulate, and its claim to absolute power reflect those fearful components of the German character which set loose Hitler's power and the Second World War." Quoted in Philip Meggs, *A History of Graphic Design* (New York: Van Nostrand Reinhold, 1983).

10 See John Bentley Mays, "Comment," 38-39.

THE FATE OF CRAFT

LARRY SHINER

In October of 2002, the fifty-year-old American Craft Museum in New York, one of the premier venues for exhibiting contemporary craft, threw in the towel and changed its name to "Museum of Arts & Design" explaining that people associate "craft" with hobbies or fairs.[1] A year later, the prestigious California College of Arts and Crafts dropped the word "Crafts" from its name to become the California College of the Arts. But all was not bleak for craft. In the same year, the American Craft Museum decided to call itself a Museum of Arts and Design, and a sprightly book of essays appeared in Britain under the title, *The Persistence of Craft*, although the editor, Paul Greenhalgh, confessed that the "descriptions of crafts as something which is (or is not) art, is (or is not) design, as technophobia…as lifestyle…and most emphatically, as victim of an unloving world, have ground us down."[2] How had the name of a great social and aesthetic movement that began with Ruskin's and Morris's call to restore honour to the crafts and reunite them with the fine arts come to this pass? And how are we to interpret its predicament? I want to look at some exemplary moments in the history of the idea of craft before showing what can be gained by examining craft's position between design and art, rather than the usual art-versus-craft polarity.

The fine-art-versus-craft polarity is so familiar that it is easy to forget that both categories are relatively recent, fine art going back only to the eighteenth century and craft only to the late nineteenth.[3] Of course, the use of "craft" for skill, whether in cunning deceit or careful making, is quite old and until the eighteenth century, "craft" was a near synonym for "art." But "art" also included a division between the liberal arts of the mind and the mechanical arts of the hand, so that when the new category of fine art (painting, sculpture, architecture, poetry, music) came into being around 1750, the fine arts were also

defined in opposition to the mechanical arts, a distinction based partly on the criterion of pleasure versus utility. Once the category of fine arts was established, little critical or philosophical attention was paid to the undifferentiated area left behind. Yet, as the new category of fine arts spread in the early nineteenth-century, phrases such as "decorative arts," "applied arts," "minor arts," and "industrial arts," gradually came into use to differentiate work within the mechanical arts that required artistic skills.[4]

Near the end of the nineteenth century the term "craft" itself began to be widely used for handmade decorative arts, primarily through the influence of Ruskin, Morris, and the Arts and Crafts movement. Ruskin inveighed against both the industrial division of labour that enslaves the worker and the ugly "perfection" of identical machine-made objects, compared to the beauties of handcrafted works that bear the variable marks of the human maker. He and Morris called for a return to something like the medieval guild system in which they (falsely) imagined each worker was both designer and maker and found fulfillment in their work.[5] They also believed that the fine art versus decorative art division was wrong in principle and disastrous in its effects, and proposed in its stead the image of a unified art that would bring beauty into the everyday lives of all social classes. The social reform aspect of their vision was famously captured by Morris in his call for an "art made by the people and for the people, a joy to the maker and the user."[6]

Ruskin's and Morris's ideas on the decorative arts were an unstable compound of social reformism and aesthetic revisionism, and the multi-faceted movement that emerged from their teachings reflected this. At one end, there were small production workshops, like C. R. Ashbee's Guild of Handicraft, whose spirit of mutuality, leisurely pace of work, profit sharing, and group excursions were meant to show an alternative to mind numbing industrial production. At the other end, were groups like the Century Guild, made up primarily of designers, whose aim was to restore the decorative arts "to their rightful place beside painting and sculpture…to emphasize the *Unity of Art*."[7] The use of the term "crafts" for the decorative arts only came to prominence after 1888, when another group, planning to organize an annual exhibition of "The Combined Arts," changed the title to "Arts and Crafts," thereby giving an entire movement its name. The Arts and Crafts Exhibition Society sought works not only from small workshops but also from commercial firms, requiring each piece to bear the name of both designer and maker in order to assert the claims of "decorative designers and craftsmen to the position of artist."[8] Although the Arts and Crafts movement had largely spent its force by the time of World War I, two vital tendencies emerged from it: one was the studio craft movement, with its individual ateliers and small workshops; the other was the idea of total design, closely linking the decorative arts

to architecture and industry. Over the next half century, studio craft and design would emerge as the two leading approaches to the broad area of the applied or decorative arts.

But what happened to Ruskin's and Morris's call to reunite the decorative arts with the fine arts? Since the visual aspect of the fine arts had been defined both in terms of a set of genres (painting, sculpture, architecture) and by criteria such as pleasure versus use in order to separate them from the mechanical arts, there was a parallel tendency to define the crafts as a set of genres (weaving, pottery, woodworking, etc.) and to invoke criteria such as hand made versus machine made in order to distinguish them from industrial goods. In Europe, separate museums were established for fine arts and the decorative or applied arts, but in the United States and Canada, most art museums simply developed distinct departments.[9] The leading characteristic of the studio crafts was that craftspeople designed their own works, even if the designs were often based on traditional forms. As the twentieth century got underway, the studio crafts could have theoretically gone in three directions. They could have allied themselves with new movements in the fine arts, they could have allied themselves with design for industry, or they could have remained a separate artistic domain. By the end of the 1920s, the studio crafts seemed well embarked on this third course.

An exemplary moment occurred in 1920s Britain, when Roger Fry and Clive Bell used their formalist aesthetic to interpret the decorative arts along the same lines as painting or sculpture.[10] Following their lead, Bernard Rackham argued that "pottery can indeed be plastic sculpture in a purely abstract form," and ceramicists like William Staite Murray exhibited with painters in prestigious art galleries.[11] As Julian Stair suggests, "between 1924 and 1930, studio pottery was at the core of Modernist critical developments in the Fine Arts, breaking most of its associations with Arts and Crafts ideology."[12] By the early 1930s, however, few critics bothered commenting on pottery, and one who did remarked

that Staite Murray "has lately been in danger of forgetting that a pot is after all a pot."[13] Stair believes that one cause for this falling off, was the influence of the potter, Bernard Leach, a spokesman for the Arts and Crafts values of function and service, who complained that "artist potters" were supported primarily by the "arty" crowd rather than "the normal man or woman."[14] This remarkable episode shows that the earlier tension between the "unity of arts" and the social reform ideals of the Arts and Crafts movement had led to deeply opposed views of what the studio crafts should be. One form increasingly taken by the studio movement in Britain—and in North America—was that of a middle-class return to the simple life, imbued with the ideals of Ruskin and Morris, sometimes supplemented by ideas from Japan.

Japanese ideas came into the studio crafts tradition primarily through Sōetsu Yanagi, founder of the Japanese "folk craft" (*mingei*) movement. Ironically, Yanagi's own rediscovery of the beauty of Japanese folk crafts was partly the result of his acquaintance with the writings of Ruskin and Morris and his friendship with Leach, who lived in Japan from 1909 to 1920.[15] On visits to Britain and the United States, Yanagi tirelessly spread the message of what he called "Buddhist aesthetics"—non-dualism in life and art and the beauty of irregularity, simplicity, and humility, or "natural material, natural processes, and an accepting heart."[16] These qualities, Yanagi believed, were especially manifest in folk craftspeople, enabling them to produce beauty almost automatically.

Whatever one may think of Yanagi's Buddhist aesthetics, he was on firmer ground challenging the Western dualism of art versus craft, which had been imported wholesale into Japan. The Japanese language did not separate art (*gigei*) into fine versus decorative until the 1890s, when Western influence led to distinct terms for fine art (*bijutsu*) and craft (*kōgei*). Later the term craft itself was sub-divided into "art crafts" (*bijutsu kōgei*) and "common crafts" (*futsü kōgei*).[17] The term "art crafts" was initially used for the finest work of master craftspeople, but after World War I, it was applied to the Japanese studio crafts. Yanagi was never enthusiastic about the artist-craftsperson, whom he saw as pursuing an individualistic aesthetic rather than resting "in the protecting hand of nature" like the folk-craftsperson.[18]

Our detour via Japan has called attention to a moral and spiritual dimension that often came to be fused with the studio craft movement's reformist side—craft as a way of life. Although only some craftspeople have embraced the spiritual dimension of craft practice—others are indifferent or even hostile to it—the sense of community and spiritual quest is palpable in many craft institutions. As Stuart Kestenbaum, the director of the Haystack School of Crafts on Deer Isle, Maine, has remarked, craft works have "deeply rooted mean-

ings in handmade objects that become the most deeply human objects because of their spiritual nature."[19] Reading descriptions of the Haystack or the Penland experience, one can understand why some speak lovingly of the "craft community" and others disdainfully of its "self-isolation."[20]

"Self-isolation" refers to the way the studio crafts came to organize themselves not only in opposition to design and industry (craft as handmade objects produced in the small workshop) but also in contrast to the fine arts (craft as useful objects made in decorative arts materials). Signs of opposition to design for industry already appeared in the period 1910-1915 as many of the commercial firms withdrew from the Arts and Crafts exhibitions, and the society itself split over the issue of opening a salesroom, with those who favoured closer connection to industry withdrawing to form the Design and Industries Association. As for the contrast with fine art, a typical example is the establishment of the American Craft Council in 1943 to provide advocacy and support for the studio crafts, defined primarily in terms of the now craft-identified materials. The various material-based crafts became communities of practice, each with their academic departments, professional organizations, workshops, exhibitions, and journals.

By the 1960s, the larger craft community was divided by the "crafts-as-art" movement. In the United States, this new direction was partly the result of the post-World War II influx into university art programs where craftspeople studied alongside fine art students and absorbed the excitement of the new art movements. Soon some studio craftspeople began borrowing from Abstract Expressionist or Pop Art styles and adopted unusual forms that made their vessels or furniture deliberately useless. Within a decade people were speaking of "ceramic sculpture" instead of pottery or "fibre arts" instead of weaving, and the hallmark of art-crafts had become cups you couldn't drink out of, chairs you couldn't sit on, books you couldn't open. The art-crafts approach came to dominate the leading craft organizations, journals and art schools and by the 1980s many craftspeople saw themselves as artists who just happened to use materials traditionally associated with craft. Yet the debate within craft communities over whether this was the right direction continued, with some people proudly calling themselves "potter" or "weaver" instead of "artist." Although there are many intermediate positions, the pro-art party has tended to dismiss traditional craftspeople as technicians and nostalgics, whereas the pro-craft party has charged the art side with selling out a tradition of service.

Ironically, crafts-as-art pieces seldom received much attention from mainstream art galleries and the art press, partly because they were often too beautiful and well made to interest an art world that placed conceptual challenge ahead of creating objects. The art

world's lack of concern for "craft," in the narrower sense of facility in the handling of material, can be traced back to the Neo-Dada, Pop, Minimalist and Conceptual art movements of the 1960s and 1970s, and on back to Duchamp at the turn of the century. Duchamp's rejection of painting in favour of readymades implied that painting itself was only a species of handcraft. Duchamp's move made sense to a later generation of artists who were in revolt against Abstract Expressionism and Clement Greenberg's formalist interpretation of it that said each art must pursue the essence of its own medium. Not only have many artists since the 1960s given up working in a single medium, but many no longer even bother to make their own works, preferring (or needing) knowledgeable craftspeople to do it for them. Of course, the installation approach to art that is now so pervasive, often requires no special skills. In such a context, artists who still make objects and work in a single medium need to be on their guard lest they be mistaken for craftspeople. It is striking that in almost any area but the visual arts today the term "craft" in the sense of technique—"the craft of fiction," "the craft of poetry"—is a term of honour, not aversion.

If the studio crafts have found it difficult to gain acceptance by the art world, they have been even more seriously challenged by design. One of the central ideals of Ruskin and Morris was the need to revive the lost unity of designing and making; but even in many of the Arts and Crafts workshops, including Morris's own company, designer and maker were separate. Yet the ideal of the designer-maker was still powerful enough to inspire Walter Gropius to declare in his Bauhaus manifesto of 1919: "Let us create a new guild of craftsmen, without the class distinctions, which raise an arrogant barrier between craftsman and artist."[21] Initially, the Bauhaus organized its design workshops with two instructors: an artist for form, a craftsperson for materials and skills.[22] But within a few years the craft teachers were let go and a single artist-designer taught each workshop.[23] The Bauhaus not only spread its curriculum and modernist style around the world, but the long-term result of modernist design has been (if not exactly Morris's "art of the people for the people") furniture, utensils, and fixtures that are admired as works of art, yet sold at far more affordable prices than the handmade products of craft workshops. The steady rise in the status of design and designers over the past seventy-five years has been such that even some mass-market discount stores feature the names of well-known designers on in-house brands and some art museums have departments of design and offer major designers retrospective exhibitions.

Today, the crafts seem to be caught between art and design, between an art world that has only a secondary interest in handmade objects and a design world that, by nature, eschews making and has effectively taken over the ideal of useful art for the people. One

implication of craft's position between art and design is that the traditional art-versus-craft polarity that has dominated the thinking of philosophers from Kant through Collingwood to Danto may now require rethinking in terms of a tripartite relation. For Kant, fine art was the spontaneous creation of genius intended for aesthetic contemplation, which he contrasted to craft (*Handwerk*) as rule-bound construction done for pay and intended for use.[24] Similarly, Collingwood made "art proper" the outcome of an imaginative process of creation and discovery in stark opposition to craft which, he said, merely used technical procedures to get a preconceived result. For Danto, art is a self-referential embodiment of ideas, whereas craft is the merely well made. I think it fair to say that none of these philosophers has been particularly interested in exploring the crafts for themselves, but has primarily used them as a foil for defining art. Yet historically, the craft-design relationship has been, if anything, more important for understanding the nature of craft than the craft-art relation, since design and craft had once hoped to enter the sacred precincts of Art, hand in hand.

Given the turbulent 150-year-history of the idea of craft, it might seem foolhardy to attempt a formal definition of craft practice in terms of necessary and sufficient conditions. But I believe we can reasonably attempt to draw together some of the main characteristics that we have encountered so far. For convenience, I will give these elements rather lapidary names and then briefly suggest how each relates to craft, art, and design. They are: 1) *hand* 2) *material* 3) *mastery* 4) *use*.

1) The *handmade* versus machine made opposition has been perhaps the most familiar motif in discussions of craft since the time of Ruskin. But "handmade" is highly ambiguous, so recourse is usually had to "substantially handmade," a condition that lies somewhere between simple hand tools and full automation. In fact, a great deal of work in genres such as weaving or metal work can now be done using computer aided design (CAD) to test certain forms before actually making them. In today's art world, artists are no longer required to use their own hands but can have others fabricate the object. Design even more clearly excludes the requirement of the hand, thanks to computer modelling that has eliminated the need for hand-drawing skills, and computer-guided machines (CADCAM) that can now make prototypes.[25]

2) Certain *materials*—wood, clay, metal, glass, fibre—have been historically identified with the crafts, but the type of material or medium is not what is essential to the process of craft making. What is distinctive about craft practice is its focus on exploring and exploiting a particular medium or area of materials, often over a lifetime. Artists, by contrast, are viewed primarily as generators of ideas, which they are free to embody in any material or

no material at all. Nor is design essentially tied to a particular material: the designer chooses or is given a problem to solve, for which any number of materials might be used or new ones invented.

3) I have chosen the term *mastery* over the more obvious "skill." Skill primarily suggests dexterity, whereas true craftsmanship consists in a union of imagination, facility, and judgment in working with materials.[26] Mastery in the crafts is a matter of mind and hand working instinctively together, a kind of practical know-how or tacit knowledge.[27] In the fine arts, of course, mastery, like handwork and material, are now optional rather than essential aspects of practice. Designers need no mastery of materials in the sense of handmaking, but only of the software that is their principal design tool.[28]

(It should be apparent that these first three characteristics are closely intertwined. Mastery is not just the integration of mind and hand in a general "know-how," but the mastery of how to use one's hands—and tools—in working with a particular material. The integration is especially close in areas like glass blowing, where the steps in the process of making must flow together very quickly.)

4) I prefer *use* or "utility" to "function," although both terms are ambiguous. Craft works have typically been addressed to specific bodily needs such as eating, sitting, or clothing and adorning ourselves. Moreover, traditional studio craft making has understood use as something to be united with beauty in works intended to enrich the lives of ordinary people. Of course, the art-craft direction within the studio crafts has rejected use as an essential element in craft in favour of an emphasis on innovative form and personal expression. The fine arts were originally separated from the mechanical arts on the basis of pleasure versus use and, even today, remain mostly addressed to the eye and the mind. Design, on the other hand, has from the beginning been concerned with industrial products destined for some specific end. Naturally, any work of design, art, or craft may also serve one or more general functions; for example, providing aesthetic satisfaction, challenging our perceptions or beliefs, signaling good taste or social status.

What conclusions can we draw from this brief look at some main of the characteristics of craft practice as they emerge in relation to art and design? With respect to craft itself, it is clear that if we require all four characteristics as sufficient conditions, only the creation of handmade objects for use, from a deep mastery of a specific material, would truly be "craft." If we say that the first three characteristics—hand, material, mastery—are sufficient by themselves, then the making of art-craft objects will qualify as craft, although it is not clear why those who make them should care, since they really want them to be art.

Looking at the way our four characteristics position craft in relation to art and design, it is clear that in today's pluralistic art world, none of the four necessary conditions for being craft are also necessary conditions for being art, although none of them, including "use," are excluded from art. That is why works of art-craft that are the product of hand mastery in a specific material could, in principle, be art works. But it is also why simply making one's craft work "useless" does not automatically turn it into art. The studio crafts missed their opportunity to be assimilated into art under formalism in the late 1920s, but by the time of the second formalism in the 1950s, the crafts were established as a separate group of genres, and formalist critics like Greenberg were not about to treat them as art. Then, after the new conceptual emphasis of Neo-Dada, Minimalism, and Conceptual Art supplanted formalism, critics tended to ignore the crafts because they were organized as a separate domain; but if these critics had confronted works of art-craft, they would likely have found hand mastery of materials retrograde.

With respect to design, only one of our four characteristics, "use," plays a defining role. Traditional studio craft work aiming at use might seem similar to design insofar as the craftsperson is the "designer" as well as the maker. But in actual craft practice—and contrary to Collingwood's caricature of craft—the craftsperson seldom has a completely worked-out design in mind, but pursues a rough idea through a dialogue of discovery with the material.[29] This split between design and studio craft is, in some ways a replay of craft's historic relationship to design within the decorative arts. Despite a certain amount of talk in the Arts and Crafts movement about uniting designer and craftsperson, in most production the two remained separate. The importance of the studio craft movement was precisely in its affirmation of the unity of "designer" (in the special sense we just described) and maker in one person. The separation of the studio crafts from design for industry resulted in craft and design each developing their own institutions and identities, thereby becoming competing ways of producing decorative arts for the people (a competition design won long ago).

Our three-way comparisons have shown some specific ways that craft is pulled by its own essential conditions toward art on the one side and design on the other. But developments within both art and design in recent decades have also pulled art and design toward some aspects of craft. As a result, the terms art-craft-design today designate an increasingly overlapping set rather than three distinct areas of practice.

Before considering the ways art and craft have begun to overlap, we should recall that there is one area of current art practice where an invidious hierarchical relation has been maintained: when some artists have their works fabricated by others, the craftsperson's

share, if even mentioned, is considered merely incidental to the artist's concept. Despite the art world's focus on concept over execution, increasing numbers of art-craft works have made it into fine art galleries, and there have been some sensational ascensions into the art world such as that of Dale Chihuly. But most craft artists who have successfully entered the art world, have adapted to its conceptual emphasis. Betty Woodman, one of the best known craftspeople to have made the transition, was trained as a potter and even did utilitarian ware, but moved to New York, took up the conceptual challenge, and has had one-person shows at the MoMA and the Metropolitan. She has said of her transition from craft to art: "Functional concerns have really become conceptual. Vases are now about vases."[30] Although no artists that I know of have decided to call their work "craft," the multi-media approach to art making long ago opened art to previously craft-identified material, and feminist influences then led to the acceptance of forms and motifs formerly associated with certain craft genres. Today, an artist like Faith Ringgold is celebrated for her wall hangings based on quilt forms, and she uses quilt motifs mixed with various art-historical and political references. Another artist, whose art approaches aspects of studio craft, is Martin Puryear, who focuses on a specific medium and is an undoubted master at constructing beautiful wood sculptures, although he once deflected a compliment on his "consummate craftsmanship," as if realizing he had gone so far in the direction of craft that it might put his art status in jeopardy.[31]

The craft-design relationship has produced even more interesting interactions than the craft-art relationship. From the craft side, there are people who accept design commissions for industry while still producing individual works, and many other craftspeople produce innovatively designed utilitarian objects, such as dinnerware or handbags, that find niche markets.[32] From the side of design, some designers with craft training have formed small companies that make things like furniture and do both design and batch production. If they hit a particularly responsive market nerve, they can still sell their design and prototype to a manufacturer.[33] Such designer-makers of small runs of furniture are hard to tell apart from the craftsman-designers of small runs of leather handbags. An even more complete overlap of design and craft is the approach of a contemporary weaver like Ann Sutton, who creates new textile designs on the computer and then runs the loom itself from the computer through an interface, her only handwork being to thread the loom before pressing the start button.[34] Even further removed from traditional craft work is the metalsmith who uses CAD to refine his ideas, then lets computer-aided lathes and tools make the object while he returns to the computer to create another design.[35] Both weaver and metalsmith work in traditionally craft-identified genres, and their approach fits three of our four essen-

tial conditions for craft—material, mastery, and use—and yet they seem more like designers than craftspeople, mostly, I believe, because their dialogue with material is largely virtual rather than hands-on.

These interactions among craft, design, and art are a sign of the vitality and openness of craft practices today. But in terms of verbal labels, most of the actual border crossings have been one-way. Artists borrow materials or forms from craft and designers make things by hand; but they want to maintain the title of "art" or "design" for what they do, whereas craftspeople are more inclined to drop the label "craft."[36] One craft writer has opined that the crafts "stand at a crossroads, and it looks like we might scatter in different directions."[37] As craftspeople increasingly identify with art or design, is the use of "craft" and "the crafts" as general categories fated to disappear? In this light, the decision of the American Craft Museum to become a Museum of Arts and Design might seem eerily prescient. Yet, apart from the historical accident of having being called "crafts" instead of decorative arts at the end of the nineteenth century, and the subsequent self-segregation of the crafts from art and design during most of the twentieth century, what *do* ceramics, furniture making, textiles, metalwork, and glass blowing have in common? Paul Greenhalgh put it well when he said that the crafts, as a "consortium of genres," have "no intrinsic cohesion."[38] The "consortium" could dissolve piecemeal over a long period, just as it came into being piecemeal.

But what about "craft" as the name of a kind of practice whose four conditions we have examined? First of all, "craft" as the name for a practice is not intrinsically tied to "craft" as the name of a particular set of genres. One can take a craft approach to painting, for example, which is exactly what most medieval and Renaissance painters did. Conversely, one could take an art or design approach to any of the so-called "craft" media. Consider our weaver armed with a computer-guided loom. She could spend one week as a craftsperson (making a single table runner with some hand-needle flourishes added), the next week as a designer (selling her resulting program and prototype to industry), and the next week as an artist (making a wall hanging whose patterns and textures offer an ironic comment on weaving itself).[39] "Craft" as the name of a practice, therefore, could in principle survive the disappearance of "craft" and "the crafts" as names for a collection of genres. But would it?

Craft practice, as we have described it, is itself as much a historical construct of the nineteenth century as the genre category "the crafts." Craft practice brings together ideas derived from Ruskin's anti-industrialism (hand) with the traditions of the workshop (mastery of material) and the claim to art status by the nineteenth-century designers of deco-

rative arts (use). These elements of craft practice were united in the studio craft movement were, in some cases imbued with reformist and spiritual beliefs, producing a small but significant chapter in the history of art that is not yet closed. But as we have seen, all four elements do not have to remain together. Obviously, the art-craft segment of the studio movement has already treated "use" as non-essential, and the art-craft people may, over time, completely merge into the art world (which itself could recover an interest in object making). On the other hand, as we saw in the case of our weaver and our metalsmith, the element of handmaking may be dropped from craft practice while retaining mastery, material, and use, resulting in a practice more like design.

Is there any place left for traditional craft practice? Many people have celebrated the uniqueness of traditional craft works for the way they combine the visual, tactile, and useful with "marks of the hand." I am attracted to this idea. But the well designed industrial object also combines the visual, tactile, and useful, and—thanks to Computer Aided Design (CAD) and Computer Aided Manufacture (CAM)—each piece could be designed to show the slight irregularities typical of the hand made. One could probably even program in a thumb print. Given that CADCAM can now simulate almost any conceivable hand crafted object, is there any reason to engage in the arduous and time consuming task of learning a traditional craft practice? For the maker, the reason may lie in the intellectual and physical satisfactions of making itself, and for the receiver, in the satisfaction of touching and using something made by another human being whose name we can know. But that is a great deal.[40]

ENDNOTES

1 Carol Vogel, "In New Name, Museum Goes Contemporary," *New York Times* 3 October 2002.

2 Paul Greenhalgh, *The Persistence of Craft: The Applied Arts Today* (London: Victoria and Albert Museum, 2002) 1.

3 For a detailed discussion of the history of the concept of art see my *The Invention of Art: A Cultural History* (Chicago: University of Chicago, 2001).

4 As Élisabeth Lavezzi has shown, neither the concept or phrase "decorative arts" existed in the eighteenth century and its first appearance in a French dictionary was in 1877. "The *Encyclopédie* and the Idea of the Decorative Arts," *Art History* 28.2 (2005): 174-75.

5 There was far more mechanization and division of labour in the medieval and early modern periods than their evocations implied. See Edward Lucie-Smith, *The Story of Craft: The Craftsman's Role in Society* (New York: Van Nostrand Reinhold, 1981) 12-15.

6 William Morris, *William Morris: Stories in Prose, Stories in Verse, Shorter Poems, Lectures and Essays* (London: Nonesuch Press, 1948) 564.

7 Peter Stansky, *Redesigning the World: William Morris, the 1880s and the Arts and Crafts Movement* (Princeton: Princeton University Press, 1985) 99.

8 Stansky 203.

9 On craft in North American museums see Jonathan L. Fairbanks, "Crafts and American Art Museums," in Marcia Manhart and Thomas Manhart, eds., *The Eloquent Object: The Evolution of American Art in Craft Media Since 1945* (Tulsa: Philbrook Museum, 1987) and Sandra Flood, *Canadian Craft and Museum Practice* (Hull: Canadian Museum of Civilization, 2001).

10 Clive Bell, *Art* (New York: G.P. Putnam's Sons, 1958) 17.

11 Julian Stair, "Re-inventing the Wheel: The Origins of Studio Pottery," in Greenhalgh *Persistence of Craft* 51.

12 Stair 52.

13 Stair 59.

14 Stair 57.

15 Yuko Kikuchi, *Japanese Modernisation and "Mingei" Theory: Cultural Nationalism and Oriental Orientalism* (London: Routledge Curzon, 2004).

16 Sōetsu Yanagi, *The Unknown Craftsman*, (Tokyo: Kodansha International, 1972) 200.

17 Kikuchi 81. Yanagi's coinage of mingei, or "folk crafts," was not in current use until the 1920s.

18 Yanagi, *Unknown Craftsman*,135, 200.

19 Quoted in Margaret Mackenzie, *Words and Worth: An Anthropologist Looks at the Crafts* (Deer Isle, ME: Haystack Mountain School of Crafts, 1995) 2.

20 Karen Livingstone speaks of the damaging effect on craft's status of its "endless self-analysis, determined self-isolation, and a self-conscious anti-modernism" in "Art Manufacturers of the 21st Century," in Greenhalgh 37. As for Haystack, itself, it is anything but isolated, hosting regular sessions on the latest technologies and problems affecting the craft arts.

21 Cited in Gillian Naylor, *The Bauhaus* (London: Studio Vista, 1968) 50.

22 Walter Gropius, *The New Architecture and the Bauhaus* (Cambridge: MIT Press, 1965) 52-53.

23 Magdalena Droste, *Bauhaus, 1919-1933* (Berlin: Bauhaus Archiv, 1998).

24 The scope of *Handwerk* in Kant's time was not the same as "craft" today. Stefan Muthesius, "Handwerk Kunsthandwerk," in Tanya Harrod, ed., *Obscure Objects of Desire: Reviewing the Crafts in the Twentieth Century* (London: Crafts Council, 1997) 317-323. This linguistic nuance should alert us to the very different terminologies and statuses of craft outside the English-speaking world.

25 Neal French, "CADCAM and the British Ceramics Tableware Industry," in Peter Dormer, ed., *Culture of Craft* (Manchester: Manchester University, 1997) 158-167.

26 David Pye, *The Nature and Art of Workmanship* (Cambridge: Cambridge University Press, 1968) My description of the characteristics of mastery has some similarities to Pye's "workmanship of risk."

27 Peter Dormer, "Craft and the Turing Test for Practical Thinking," in *Culture of Craft* 147.

28 Jeremy Myerson, "Tornadoes, T-squares and Technology: Can Computing be Be Craft?" in *Culture of Craft* 176-186.

29 Keith Cummings, "Glass Making and the Evolution of the Craft Process," in *Persistence of Craft* 74.

30 Janet Koplos et. al, *Betty Woodman* (New York: Monacelli Press, 2006) 24.

31 Arthur Danto, *Embodied Meanings: Critical Essays & Aesthetic Meditations* (New York: Farrar, Straus and Giroux, 1994) 289.

32 Karen Livingstone, "Art Manufacturers of the 21st Century," *Persistence of Craft* 41.

33 Julian Secondo, "Poor Materials Imaginatively Applied: New Approaches to Furniture," *Persistence of Craft* 117-127.

34 Dormer 145.

35 Dormer 145, 150.

36 Secondo 124.

37 Paula Owen, "Labels, Lingo, and Legacy: Crafts at a Crossroads," *Objects and Meaning* (Scarecrow Press Inc. 2005) 33.

38 Greenhalgh 1. The practices of glass blowing or throwing vessel forms on a wheel are closer to art practices (where artists actually make things) whereas much weaving and metal work today can be closer to design as is furniture making, which, in addition, is not tied to a particular material.

39 See a similar point by Peter Dormer in "Craft and the Turing Test" 151.

40 For a small group of receivers there would also be the satisfaction of participating in the craft tradition itself. These satisfactions, of course, also belong to some amateur craft practices. Regrettably, space does not permit discussing that important relationship.

MAKING SPACE FOR CLAY?: CERAMICS, REGIONALISM, AND POSTMODERNISM IN REGINA, SASKATCHEWAN[1]

DAVID BRIAN HOWARD

From what vantage points are we to understand the various guises, meta-morphoses and reconfigurations of historical and contemporary capitalisms? How might we simultaneously apprehend both the global and transnational forms of capitalist accumulation and the symbolic forms, the local discourses and practices, through which capitalism's handmaidens—commodification, massification, and exploitation—are experienced, interpreted, and contested? How are…multiple modernities…worked and reworked, fashioned and refashioned, against a backdrop of global, transnational forces?[2]
Allen Pred and Michael John Watts

What becomes crucial here is to recognize the proliferation of non-articulated spaces, interstitial spaces of no-man's land at the limits of established fields. These sites provide the potential for local struggles as nodal points of articulation that can subvert the established fields at their margins.[3]
George Hartley

In the aftermath of World War II, the words "freedom" and "regionalism" in the North American art world meant diametrically opposed positions in terms of both aesthetics and politics. Regionalism, especially in the North American context, with its dependence on

realism and political didacticism, had quickly been discounted in the postwar period as incapable of defending freedom in the Cold War. Both regionalism and realism became conflated with the dangers of totalitarianism, as represented by both the fascism of Nazi Germany and the version of communism that was extolled by the Soviet Union. According to influential critics, such as Clement Greenberg, the defense of freedom could best be expressed by the abstract forms of art and the cosmopolitan outlook that were associated with the Abstract Expressionist avant-garde of the late 1940s and 1950s. In this context, the modernist avant-garde distanced itself from both realism and regionalism, an achievement which Greenberg lauded as the hallmark of the defense of freedom. As a result, New York wrested the leadership of the art world from Paris, as Serge Guilbaut has demonstrated in his book, *How New York Stole the Idea of Modern Art*.[4]

However, beginning in the late 1960s and continuing up until the present day, postmodern critiques of modernism and modernity have examined the premises that permitted a universalizing modernism to encompass the entire globe.[5] In particular, these critiques have targeted the fetishization of time over space within the Enlightenment tradition, a binary opposition which pitted the imperatives of progress against the particularities of place. The Regina clay movement began in the early 1960s at the University of Saskatchewan, Regina, when California funk ceramics met with the open-mindedness of prairie ceramicists like Marilyn Levine, Jack Sures, and Victor Cicansky. Soon Saskatchewan became a centre for Canadian craft that supported the development of such important international clay figures as Levine, Sures, and Cicansky, along with their peers David Gilhooly, David Thauberger, Ann James, Russell Yuristy, and Joe Fafard, among others. Because the rise of the clay practices of Regina coincided with this radical re-examination of the traditional inferiority of space vis-à-vis time, the impression was momentarily created that the inversion of this artificial hierarchy would greatly enhance the personal freedom of the artist, as well as function as the basis for a revolt against the tyranny of a homogenizing modernism.

As critics began to identify the cosmopolitan values of modernity, not with the advance of human freedom and autonomy, but rather with a new phase of the rapid expansion and insertion of capitalism into more and more aspects of daily life, the traditional linkage between regionalism and totalitarianism began to buckle. Regionalism, given its newfound distance from the narratives of nationalism and cosmopolitanism, therefore gained currency as a challenge to the perceived authoritarianism and colonizing hegemony of Western modernism and modernity. The "heightened pressures of commodification,"[6] which were increasing exponentially at the end of the 1960s, injected into the cultural dynamic of the

period a radical alteration in the relationship between time and space, as well as in the relationship between culture and the economy. These older categories, which postmodernism eagerly sought to deconstruct and exploit, became reconfigured, but in a manner unforeseen by the postmoderns. Nonetheless, as the interstices on the margins of Western culture and politics became identified as the critical terrain upon which to stage a revolt against modernist orthodoxy, ceramic practitioners in the United States and Canada found a space to establish the integrity and criticality of their art practices.

In the context of Saskatchewan, the foremost exemplars of this modernist defense of freedom and autonomy were the Regina Five, a group of non-representational painters, who through the aegis of the Emma Lake Artists' Workshops, had succeeded in inviting many of the leading practitioners of postwar modernism to visit Saskatchewan.[7] However, by the late 1960s and early 1970s, Regina had become the focal point for the rise of a variety of clay-related practices that stood in stark contrast to the universalizing and now formalized exercises of abstract painting in modern art. In particular, the profile and success of the abstract paintings of the Regina Five, who helped to vault Saskatchewan to the forefront of the Canadian art world, now appeared to many artists in Saskatchewan as characterizing the worst excesses of the

REGINA FIVE, 1964. FROM LEFT TO RIGHT: RONALD BLOORE, ARTHUR MCKAY, DOUGLAS MORTON, KENNETH LOCHHEAD, TED GODWIN.
PHOTO COURTESY OF THE UNIVERSITY OF REGINA ARCHIVES

modernist criticism that was extolled by Clement Greenberg and his Canadian disciples, such as Terry Fenton and Karen Wilkin. One of the most outspoken advocates for the relationship between ceramics and Prairie regionalism, Joe Fafard, denounced the implied colonizing of the cultural community of Saskatchewan by cosmopolitan modernism. By contrast, Fafard endorsed the virtues of the local community:

> Well, he [Clement Greenberg] wasn't part of the community as I try to define community; the "anti-Christ" of that community, the figure that frac-

tures the community. I feel that Clem's influence in Saskatchewan has been destructive of our creative spirit, because as doctrine it has plastered and papered over our own sensibility. It seeks to prevent us from feeling our own self and expressing that which is really ourself.[8]

Under the pressure of such criticism, Greenberg's concept of the modernist avant-garde could no longer represent the liberal cosmopolitan ideal of freedom in the Cold War. The de-centering of Greenberg's modernism provided an unparalleled opportunity for artists in heretofore marginalized locations and mediums (such as the ceramicists who were active in Regina in the late 1960s and early 1970s) to win a newfound legitimacy for redefining the role of the visual arts. Not just in Regina but also across North America, the virtues of the local, particular, and vernacular were now regarded as a sufficient basis for making a sophisticated, critical, and humorous regionalist art. Once regionalism was no longer associated with the authoritarian practices of the pre-World War II art world, it could be reconfigured as the cutting edge of the democratizing and decentralizing impetus of Cold War liberalism in the 1960s.

CLEMENT GREENBERG AND CLASS, EMMA LAKE, SASKATCHEWAN, 1962.

PHOTO: KENNETH LOCHHEAD, COURTESY OF THE UNIVERSITY OF REGINA ARCHIVES

However, this reformulation of regionalism as a central component of the post-Greenbergian art environment was, in turn, heavily influenced by the new regionalism that was advanced by pragmatic liberal intellectuals of the late 1950s, who gained access to power with the election of President John F. Kennedy in 1960.[9] The new regionalism sought to undermine the threat to nationalism as well as the universalizing pretensions of Soviet communism by promoting a geographically diffused popular culture at the expense of the high culture that emanated from New York and the Northeast, thus decentering the hierarchy of high and low culture and re-organizing the politics of space within the United States. To the chagrin of Western Canadians who sought to advance their own regionalist voices in opposition to the federal government, the regionalism that was advocated by Prime Minister Pierre Elliott Trudeau was consistent with its American variant: regional elites in both Canada and the United States were expected to have a loyalty to the liberal premises of the centre, while at the same time representing the emergence of a renewed regionalist voice.

This seemingly paradoxical centralizing of the regionalist impulse neutralized any residual liberal anxiety within the federal government that an emphasis on regionalism would inadvertently support desire for more regional autonomy in Western Canada, or even separatism in the case of Quebec.[10] Ironically, in the United States and Canada it was often the same liberal proponents of a universalizing modernism in regionalist clothing, such as Arthur Schlesinger Jr. and Trudeau, who were at the forefront of advocating a renewed role for regionalism in art and society, as a means of facilitating democratization and the decentralization of capitalist modernization on the new battlegrounds of the Cold War in the former European colonies of the third world. While Greenberg's theory of a modernist avant-garde was appropriate to winning the hearts and minds of the liberal elites in Western Europe to the cause of freedom in the late 1940s and early 1950s, by the late 1950s and into the Kennedy era, the extension of the Cold War across the far reaches of the third world meant that more readily understandable and regionally based art forms were required to compete against the spread of Soviet influence outside of Europe. Therefore, the question immediately arises as to whose interests were being served by this reorientation of regionalism within North American culture at the dawn of the postmodern era. One may also raise serious questions about the renewed profile of regionalism in cultural models of resistance in the postmodern era. These enormous questions cannot be answered in such a short essay but I believe that serious research on the questions of regionalism, postmodernism and the clay practices of Regina, which this essay explores, must confront this troubling contradiction. The implications of this analysis, which provides

a case study of the relationship between regionalism and craft practices, resonates far beyond the borders of Saskatchewan. This analysis furthers our understanding of the relationship between diverse material practices and regionalism, a relationship which arose, in reaction to modernism, in the 1960s. Regionalism, as emblematic of the assertion of a spatial politics of difference under postmodernism, was implicated in the processes of the Western universalism as much as the more easily caricatured notions of Greenbergian modernism. Were the new regionalism and the artistic practices that it helped to promote an integral moment in the new logic of capital, as opposed to a counter-discourse moment of resistance within modernity?

JOE FAFARD, *CLEM*, 1980. CLAY.

The late 1960s was a period of profound penetration of the economic logic of late capitalism into the cultural arena.[11] For leading social critics, such as Fredric Jameson, the extent of this penetration of the economic into all areas of life fundamentally alters the relationship between culture and the economy of capitalism. John O'Kane, professor of cultural studies at the University of Southern California, explains: "This is because Jameson grasps the convergence of systemic changes in capitalism and postmodern culture as revealing the effects of a 'break,' a transformation produced from existing forces having reached a 'certain threshold of excess' in the late 1960s."[12] O'Kane also notes, however, that the totalizing implications of Jameson's argument are mollified by the perception that "culture's enhanced social functioning seeds the potential for unforeseen appropriations and the possible evasion of capital's power."[13]

Emerging at this threshold between a declining modernism and an emergent

postmodernism, these clay-related practices of Regina signalled, for many, an opportunity to dismantle the modernist hegemony of Greenberg and his perceived disciples. The concept of freedom could no longer rest on the secure foundations of universality and abstraction, but rather it needed to be reoriented in a more complex, and arguably problematical, approach. For a very brief moment in time, the diverse clay practices of artists such as Joe Fafard, Victor Cicansky, Russell Yuristy, David Thauberger, Marilyn Levine, David Gilhooly, Ann James, and Jack Sures radically problematized and proclaimed the break with modernist orthodoxy. Their emphasis on locality, irony, and humour, emanating from an intense regionalism (which was more geographical in nature for some ceramicists than for others) stood in marked contrast to the universalism and teleological orientation of orthodox modernism.

Often the narrative of such a conflict culminates in a triumphant assertion of clay practices as an active participant in a counter-hegemonic postmodernism celebrating the triumph of an integral moment of local resistance to an inauthentic universalism. However, as Maria Elisa Cevasco has written:

> Beyond lamentation or celebration, a more fruitful exercise for cultural critics would be to try an exercise in cognitive mapping, seeking to establish not only a position from which to assess globalization beyond the many layers of ideology which covers current appraisals but also to discern the specific forms a resistance to this new version of the old world order may take.[14]

I would argue that, in the future, such an approach will undermine the comfortable narrative of lament and celebration that has framed the Regina Five and the ceramicists of Regina; it is a settled narrative that has sunk over time into the quagmire of the modernism-postmodernism debates. To initiate a move beyond this stalemate would require not only a strategy of cognitive mapping vis-à-vis the Regina ceramicists but also one that would apply to the legacies of Clement Greenberg, the Regina Five, and the Emma Lake Artists' Workshops.[15] This approach would help to unravel the oversimplified narrative of an authoritarian modernism being supplanted by a politics of difference and hybridity, as demonstrated by the Regina ceramicists, that would have a destabilizing effect on current postmodern narratives within the writing of craft history as a whole. In the context of postmodernism, localism or regionalism attempts to provide a crucial breathing space for a critical individuality that is beholden to neither universal aesthetics nor any specific geograph-

ic location. However, the dilemma for all the clay practitioners of Regina at this time is reflected in the anxiety of the noted geographer Doreen Massey:

> We need to think through what might be an adequately progressive sense of place, one which would fit in with current global-times and the feelings and relations they give rise to, and which could be useful in what are, after all, political struggles often invariably based on place. The question is how to hold on to the notion of geographical difference, of uniqueness, even of root-edness if people want that, without it being reactionary.[16]

The Regina ceramicists are exemplars of this strategy of relocating a critical art practice on the periphery, while being cognizant of the need to avoid succumbing to the authoritarian allure of pre-World War II forms of regionalism. However, the emphasis on particularity, which is central to the anti-Greenbergian modernism of the Regina clay movement, raises a troubling question. As George Hartley writes:

> The foregrounding of the particular at the expense of the Universal lies at the base of rightist politics (which is ultimately the target of the postmodern critique of essentialism). The foregrounding of the empty Universal, on the other hand, lies at the base of the Enlightenment liberal tradition…. Where, then, does a properly leftist position find its base? [17]

Once again, the relationship between freedom and regionalism is problematized beyond a simple binary solution.[18] The question of regionalism in contemporary postmodern theory, with its emphasis on locality and the particular, is characterized by the widespread usage of spatial metaphors, which, as geographers Neil Smith and Cindi Katz argue, appears to result from a "decentering and destabilization of previously fixed realities and assumptions" that can leave space which is "largely exempt" from "skeptical scrutiny."[19] Dennis Cooley, for example, in his book, *The Vernacular Muse*, refers to this overthrow of modernism as a "de-centering," which enables the reassertion of the vernacular: "The measure of speech, then, sub-versively conceived, resides with you, rises out of what you know most immediately, an intimate sense of your place and your people—the words you feel most at home with."[20] Within this narrative, terms such as "region," "place," and "local" denote a radical reorientation away from the modernist preoccupation with "universals," "abstraction," and "time," especially as exemplified by Greenberg in the conclu-

sion to his famous essay "Avant-Garde and Kitsch" of 1939, in which the temporal objective of the modernist avant-garde is defined as keeping culture moving in a time of ideological confusion and violence. However, the question arises as to whether the mere inversion of a symmetrical logic, by which time is valorized over space, unintentionally reasserts the authority of that logic. More specifically, to what extent can one ask whether the response of an artist, such as Joe Fafard, to the colonizing universalism of Greenberg results in the creation of a straw man that enables the emergence of the local, but at the expense of a critical dialectical engagement with the modern?

The ensuing revolt of the postmodern era against the power of dominant art centres and critics to dictate the aesthetic merit of modern art to the periphery was clearly enunciated by Fafard in 1970, when he argued that artists should "make art out of their own experiences, from our own feelings about things, and that they should be coming straight out of life, instead of from a lot of intellectual garbage that is sounded by art critics and leading artists…. [Art] should be coming straight out of life."[21] Therefore, Fafard argues, "we should abolish the reverence that we have for outsiders [and authority]."[22] Peter White, who co-curated an exhibition of Fafard's work with Matthew Teitelbaum, notes, "To Fafard, Greenberg was the flashpoint for alienating tensions and divisions within his own community, an 'anti-Christ' whose message, made without compromise, was that community is irrelevant to art."[23] Teitelbaum observes: "What Fafard feared—no, resented—was a sense that judgments about works of art could be made without regard for the particular, the intimate, or the personal. He questioned judgments which could be made only on the basis of theoretical or universal principles; he questioned the outsider's authority."[24] While Fafard's emphasis on the regional particularity of Regina and Saskatchewan as a counterweight to the hegemony of New York is not consistent with all of the Regina clay artists, Fafard does draw our attention to the fact that the issue of regionalism was, in part, based on geography; but, in another measure, it was also based on the particular voice of the artist to disavow the aesthetic standards of modernism in favour of a more individual and particular approach to representation. Thus, these two tangents to the idea of regionalism, as expressed by Fafard, provide a flexible example, though certainly not the only one, of a regionalism whose broad definition could encompass many of the Regina ceramicists, even those disavowing any particular loyalty to a specific geographic region but affirming the role of the subjective artist within the environment of late capitalism.

Ultimately, it could be argued that the rapid expansion of clay practices in Regina at the end of the 1960s and the early 1970s was a response to an earlier moment of modernist hegemony, which had already been usurped by the cultural logic of late capitalism that was

emerging at the same time. Greenberg, the Regina Five, and the Emma Lake Artists' Workshops provided convenient straw men for postmodern regionalism to oppose. The social critic Slavoj Žižek, in a critique of postmodern practices of deconstructing the "essentialism" and "fixed identities" of modernism, notes: "Far from containing any kind of subversive potentials, the dispersed, plural, constructed subject hailed by postmodern theory…simply designates the form of subjectivity that corresponds to late capitalism." For Žižek, the radical "deterritorialization" of modernity under late capitalism enabled the regional and local voices of the margins to achieve exposure. However, it was also the "ultimate power" that undermined "the traditional fixity of ideological positions (patriarchal authority, fixed sexual roles, etc.), [which in the current historical epoch had become] an obstacle to the unbridled commodification of everyday life."[25] Despite the exaggerated quality of Žižek's prose, he does raise the possibility that the optimism which underlies many of the cultural strategies of resistance to late capitalism is unwittingly complicit with a process of radical deterritorialization that passes as one of the hallmarks of criticality within the postmodern era. For a moment, however, what the clay practices of Regina did embody (in a very different manner from the Regina Five and the Emma Lake Artist's Workshops) was an attempt to articulate and bear witness to the collective nightmare that Žižek has described as "the unprecedented homogenization of the contemporary world."[26]

However, in conclusion, I find that Žižek's heightened state of pessimism overlooks the more nuanced and critical, though perhaps equally austere, stance of the legacy of critical Marxism, as embodied not by Clement Greenberg, but rather by another cultural critic, Theodor Adorno. Adorno's famous adage, "Both [modernism and mass culture] are torn halves of an integral freedom, to which however they do not add up,"[27] can be applied to the dilemma of modernism and its postmodern opponent in the age of late capitalism. These dire arguments take a necessary critical umbrage at any effort to escape the historical dilemmas of the current age by either retreating solely into "Art" or seeking a premature sublation of art into life. The inclusion of these arguments is potentially disruptive to the celebratory character of much recent craft history, interjecting the troubling reminder that the "heightened pressures of commodification," which emerged under modernity and now arguably flourish within a problematic postmodernity, can swiftly overtake even the most bitter of modernism's opponents.

ENDNOTES

1 This is a revised version of an essay originally published in *Regina Clay: Worlds in the Making* (Regina, Saskatchewan: Mackenzie Art Gallery, 2006) and is reprinted here with the permission of the Mackenzie Art Gallery.

2 Quoted in Caren Kaplan, *Questions of Travel: Postmodern Discourses of Displacement* (Durham, North Carolina: Duke University Press, 1996) 20.

3 George Hartley, *The Abyss of Representation: Marxism and the Postmodern Sublime* (Durham, North Carolina: Duke University Press, 2003) 205.

4 Serge Guilbaut, *How New York Stole the Idea of Modern Art*, trans. Arthur Goldhammer (Chicago: University of Chicago Press, 1983). For a useful discussion of the transition from regionalism to modernism in the United States, see Erika Doss, *Benton, Pollock and the Politics of Modernism: From Regionalism to Abstract Expressionism* (Chicago: University of Chicago Press, 1981).

5 For a good introduction to the rise of spatiality within postmodernism see: Edward W. Soja, *Thirdspace: Journeys to Los Angeles and Other Real-And-Imagined Places* (Oxford: Blackwell Publishers, 1996); and Edward W. Soja, *Postmodern Geographies: The Reassertion of Space in Critical Social Theory* (London: Verso Press, 1989). See also Elizabeth Deeds Ermarth, *Sequel to History: Postmodernism and the Crisis of Representational Time* (Princeton: Princeton University Press, 1992).

6 John O'Kane, "Postmodern Negative Dialectics" in Sean Homer and Douglas Kellner, eds., *Fredric Jameson: A Critical Reader* (New York: Palgrave Macmillan, 2004) 154.

7 The Regina Five included Arthur McKay, Ronald Bloore, Kenneth Lochhead, Ted Godwin, and Douglas Morton. It was their international profile that led to the connections with leading critics like Clement Greenberg, who led the Emma Lake Artist's Workshop in the summer of 1962.

8 Quoted in Matthew Teitelbaum and Peter White, *Joe Fafard: Cows and Other Luminaries 1977-1987*, exh. cat. (Regina and Saskatoon: Dunlop Art Gallery and Mendel Art Gallery, 1987) 50.

9 For further discussion of the relationship between pragmatic liberalism and the new public arts funding of the 1960s, see my article, "Between Avant-Garde and Kitsch?: Pragmatic Liberalism, Public Arts Funding, and the Cold War in the United States," *Canadian Review of American Studies* (Vol. 34, No. 3, 2004) 291-303.

10 Canada's linguistic duality, which differentiated it from the United States, was particularly suited to an inclusive cultural strategy that balanced regionalism and regional elites within a national confederation. Attempting to walk a fine line between internationalism and nationalism, especially with the threat of a Quebec separatist movement, many Canadian liberals, along with Trudeau, turned (perhaps not surprisingly) to the closest model of governmental aid for the arts that was at hand: the National Endowment for the Arts (NEA) in the United States. The obstacles to the establishment of a federal funding agency for the arts in the United Sates, including the charge that state-supported culture was too socialist, were bypassed by measures introduced under the aegis of the Kennedy administration.

11 See Ernest Mandel, *Late Capitalism* (London: Verso Press, 1972).

12 O'Kane 154.

13 O'Kane 156.

14 Maria Elisa Cevasco, "The Political Unconscious of Globalization: Notes from the Periphery," in Sean Homer and Douglas Kellner, eds., *Fredric Jameson: A Critical Reader* (Hampshire, UK: Palgrave Macmillan, 2004) 102.

15 The process of re-mapping the history of the Emma Lake Artists' Workshops, as well as involvement of Clement Greenberg with the Regina Five and Saskatchewan, was begun, in part, with an exhibition that was curated by art historian John O'Brian. See John O'Brian, ed., *The Flat Side of the Landscape: The Emma Lake Artists' Workshops*, exh. cat. (Saskatoon: Mendel Art Gallery, 1989).

16 Quoted in Kaplan 180.

17 Hartley 266.

18 Social theorist Fredric Jameson has argued that the antinomial logic of space and time that is pilloried by many postmodernists as a reflection of the binary bias inherent in modernity is still present within postmodernism itself. John O'Kane has noted that for Jameson, "The mutual exclusion of these empty, a historical categories is a construction which legislates incommensurability, an absolute inability to connect and synthesize contraries." See O' Kane, 161. The implication of this argument I have used to question the valorization of space over time.

19 Quoted in Kaplan 145.

20 Dennis Cooley, *The Vernacular Muse: The Eye and Ear in Contemporary Literature* (Winnipeg: Turnstone Press, 1987) 204.

21 Interview with Joe Fafard recorded in John D. H. King, "The Emma Lake Workshops, 1955-1970: A Documented Study of the Artist's Workshop at Emma Lake, Saskatchewan, of the School of Art, University of Saskatchewan, Regina from 1955 to 1970," bachelor's thesis, University of Manitoba, 1972. 193.

22 King 319.

23 Teitelbaum and White 23.

24 Teitelbaum and White 10.

25 Slavoj Žižek, quoted in George Hartley 289.

26 Quoted in Hartley 269. In this regard, cultural historian Andreas Huyssen has written, "The American postmodernist avant-garde, therefore, is not only the end game of avant-gardism. It also represents the fragmentation and decline of critical adversary culture," cited in Kenneth Frampton, "Towards a Critical Regionalism: Six Points for an Architecture of Resistance," in Hal Foster, ed., *The Anti-Aesthetic: Essays on Postmodern Culture* (Port Townsend, Washington: Bay Press, 1983). One of the key Canadian theorists of Western Canadian prairie regionalism is George Melnyk, who argues in a 1981 publication for a linking of regionalism to the progressive socialist tradition. See George Melnyk, *Radical Regionalism* (Edmonton: NeWest Press, 1981) 20-21.

27 Theodor Adorno, "Letter to Benjamin," in Charles Harrison and Paul Wood, eds., *Art in Theory: 1900-1990* (Oxford: Blackwell Publishers, 1993), 522. Writing at the end of the postmodern era and eighteen years after the publication of his book, *Radical Regionalism*, George Melnyk notes that his hope for a radical and socialist conception of regionalism in Western Canada "had fallen by the wayside with a whole grab bag of leftist ideologies from social democracy to left-wing nationalism to communism." Thus he concludes, "The quest of radical regionalism and the creation of a society based on an ideology of indigenous socialism has become history." See George Melnyk, *New Moon at Batoche: Reflections on the Urban Prairie* (Banff Centre Press 1999) 142.

GLOBAL CRAFT

GRACE COCHRANE

JOHN POTVIN

SECTION TWO

*Rich histories of
craft production are
lost and ignored by
not expanding beyond
the Anglo/European
worldview.*

INTRODUCTION

SANDRA ALFOLDY

The history of craft frequently follows a Eurocentric model. The Greeks and Romans had no divisions between the crafts and other arts; the Middle Ages witnessed the might and strength of the crafts in the guild system; the Renaissance introduced the hierarchy among painting, sculpture, architecture, and the crafts; the Enlightenment cemented the position of the craftsperson as a manual skilled labourer rather than a conceptual artist; John Ruskin and William Morris started to fight against this categorization of the crafts, a struggle that continues today. While this version of events is widely accepted, it is arbitrary and reinforces a post-industrial model of progress. Rich histories of craft production are lost and ignored by not expanding beyond the Anglo/European worldview. Although this section of *NeoCraft: Modernity and the Crafts* is relatively small, with only two essays, it is designed to provide an alternative to the reductionistic model that categorizes non-Western craft as an ethnographic curiosity. Instead, the Australian curator Grace Cochrane and the Canadian art historian John Potvin demonstrate in their essays the complex interconnectedness between craft producers and consumers around the world; a relationship indicative of the globalized realities that face us all.

ROBERT FOSTER, *F!NK WATER JUGS*, 2006. DESIGNED 1993, BODIES MADE IN CHINA; ANODISING, FINISHING, POLISHING, HANDLE, AND ASSEMBLY BY F!NK AND CO., QUEANBEYAN, AUSTRALIA. PRESSED AND ANODISED ALUMINUM, WITH POWDERCOATED ALUMINUM CAST HANDLE, EACH 30 X 10 CM.

PHOTO: RUSSELL PELL

AUSTRALIA AND NEW ZEALAND: DESIGN AND THE HANDMADE

GRACE COCHRANE

In the last fifty years, the benchmark for success in the crafts has been primarily in their acceptance as art. Although, for many practitioners, making objects in limited series is very much a part of both their history and their work ethic, craftspeople have tended to shun associations with processes that imply the impersonality of industrial manufacture. Both in making and using objects, we want evidence of the unique hand of the maker; and we enjoy emotional attachments to objects made by someone we can identify.

A strong infrastructure supports this approach to the crafts: galleries, dealers, educational institutions, publications, collectors, public and private philanthropists, and an informed audience. At the same time, a new hierarchy has developed around "design," which has its own infrastructure of brands, promotion, and identity—where designers can be superstars—in a system not dissimilar to that of the art world. But design implies links with manufacturing through industry, and for some time, both the nature and location of manufacture has been changing rapidly.

What then, these days, has the handmade to do with design and industry? In Australia and New Zealand, the local marketplace for art-craft is supportive but comparatively small, and we are a long way from bigger population centres. Mass markets are also far away, and our large local industries have already long gone. The reach of industry is increasingly global, and the handmade is, well, so personal and local. Or is it?

New technologies, new manufacturing centres, and changing marketplace preferences are encouraging some craftspeople to revisit ideas to do with design, industry and the handmade. Silversmith Robert Foster is a good example. Alongside his own one-off works, he runs a successful business, F!NK and Co, working mainly with aluminum. This allows

him to offer design opportunities to others while he also manufactures one range in China:

> I don't draw an ideological line between my one-off works and F!NK.... I have learned to see them as notions of operation, that dwell on a sliding scale between objects only made possible via handmaking, through to the objects only made possible by manufacturing technology.[1]

To address these ideas, in March 2007 Sydney's Powerhouse Museum mounted the exhibition *Smart Works: Design and the Handmade*, and held a three-day symposium on the topic. The project proposal was the successful contender for an initiative of the Visual Arts Board of the Australia Council, the federal funding agency for the arts. *Smart Works* looked at the decisions that around forty Australians and New Zealanders were making in putting handmade work into production. This essay is adapted from that originally published in the book associated with the event and includes examples from some of the case studies.[2]

CURRENT CONTEXT

In 2005 business leader and cultural advocate Evan Thornley spoke about innovation in the Australian workplace and the critical need for investment in education, skilled labour, and infrastructure for a sustainable approach to Australia's industries. He pointed out that:

> We're one of the smallest and by far the most isolated economy in the developed world. Logically we'd need to be one of its best exporters.... Put simply, in a global economy, the big get bigger and the meek do not inherit the earth. ...Without scale...the game gets hard. And for Australia, that means exports, because we can't get scale in our domestic market alone.[3]

For those working on a small scale, one solution is to enter that global manufacturing and marketing system in some way. Another, more likely, option is to offer something that is of higher value and produced in smaller runs that reach a particular discerning market both at home and elsewhere. And the game *is* hard, but often rewarding and distinctive. And there are many parallels in other fields, as Ewan McEoin points out in an essay enti-

tled "Slow Design," referring to the popularity of the "slow food movement."[4]

Arguably Australia's best-known example of a globally active designer, Marc Newson started making objects by hand, graduating in jewellery and sculpture in 1984 from Sydney College of the Arts. "I was always interested in process and materials," he says. "I'm not really that interested in the process of creation so much as the process of learning about how things work and function."[5] His design practice now spans small companies and large industries, and includes forms as varied as door stops and aircraft interiors. Yet he continues to value and acknowledge his hands-on approach to design: "My work is about a direct link between my head and my hands."[6]

For the designers and makers featured in *SmartWorks*, understanding materials and technologies is essential to the success of their designs. Audiences who seek their work also want tangible personal associations with objects, through the way they look and feel and through knowing who made them. These makers value their skills; and many have made lifelong commitments to a materials-based practice, often making one-off or limited series work for a specialized marketplace at home and overseas. However, they also like to design objects for production; and there are many different ways in which they have researched solutions and made their decisions regarding production practices. This project looked at the choices open to these designers and makers and at the ways they meet the challenges and opportunities of their relatively small local markets, their distant location from others, and the varied manufacturing capabilities of their geographic region.

It is possible for these two sides of the coin to come together. As well as providing pleasure and satisfaction to the maker and designer, a practice also has to be a sustainable, viable reality, and successfully find its marketplace. Today, a number of new factors now affect the choices that are possible.

SHIFTS AND CHANGES

In recent years, a number of commentators have been tracking the potential pathways for the crafts in art and design in the early twenty-first-century. In design, some critics question design as a celebrity activity, while others explore the marketing potential of "design for emotion," where much new design has the look, if not the reality, of the handmade. In the United States, gallery director and author Garth Clark celebrates the success of major museum acquisitions of art-ceramics, but also said in 2006 "I think the craft-design mar-

riage is what will save the crafts from dying out…. Functional pottery has to reinvent itself or it will be gone in a decade."[7]

In 2003 an article in British *Crafts* magazine entitled "The Shape of Things to Come" presented a number of points of view from around the world including that of Paul Greenhalgh of Nova Scotia, Canada. He said: "[I]f the applied arts are to mean anything, they desperately need to engage with the concept of modernity in a considered way…. Crucially understanding the history of individual disciplines, and manipulating their meanings, will provide us with a clear route to the future."[8] Sir Christopher Frayling of the United Kingdom added:

> The crafts will be increasingly confident about their place within contemporary interiors and the lifestyle pages of culture/style magazines…. At the avant-garde end, they will continue to make more or less esoteric comments about the rest of the crafts world. But the heartland of the crafts will lie with contemporary interiors and the makers will work more and more closely in teams with interior designers, architects, product designers, computer interaction engineers and installation people.[9]

Meanwhile, large crafts-based industries are closing in Western countries that were once famous for their ceramics, metal, glass, textiles, fashion or furniture. They are moving to other countries where manufacturing is cheaper, notably in Eastern Europe and beyond. For industries based in Australia and New Zealand, these global workshops are in Asia—places like China, Taiwan, Thailand, India, and Pakistan, although we also make connections in Italy, Eastern Europe, Africa, and Mexico.

In a series of radio programs for the British Broadcasting Corporation's (BBC's) *In-Business* in 2005, British broadcaster Peter Day identified some of the implications of "the BRIC factor." It is expected that, by 2050, emergent industrial nations such as Brazil, Russia, India, and China may take over global economic and political power from, for example, the United States, the European Union, and Japan. Countries like China will dominate manufacturing, while those in the West will lose their old skills and industries and have to redefine themselves not only economically, but also culturally, where their identity had been associated with values of manufacturing aesthetics and working ideologies.[10] In 2005 a report on the impact of China's development on Britain was carried out by the Smith Institute, an organization set up to assess the changing relationships between social val-

ues and economic imperatives. The report is one of many that discusses issues of consumption, education and the environment within China itself as it manages rapid social and economic change.[11]

As manufacturing increases in developing regions, the sustainable use of resources, like water, timber, and fossil fuel also becomes a global design issue. But, of developments in Australia, Brian Parkes, from Sydney's Object Gallery, points out:

> What is truly exciting… is that we're starting to see the same kind of inventiveness that Australian designers have had to develop to make a career in design viable here, being applied to make a positive contribution to the world by bringing issues to our attention, making us think more, reducing our impact on the earth or tackling social issues.[12]

Marc Harrison, through his company, Husque, in Queensland, has developed a unique range of vessels using the recycled husks of the indigenous macadamia nut. He is continuing to research his materials, investigating mixing cellulose and plant-based polymer resin, which Husque can use as a binder for injection-moulding. "The resins we use now are petroleum-based," he says, "but the aim is to use as much waste material as possible while being 100% organic."[13]

Many questions are asked and concerns expressed about cultural and economic exploitation in the "new" manufacturing centres, where skilled artisans, often with traditions stretching back many centuries, now work from designs from elsewhere. Equally, there are also some extraordinary collaborations that help bring social and economic benefit to those same people, many of whom are poor and are seeking to improve their own conditions. Handweaver Liz Williamson has been involved in several development projects in Asia, working with skilled weavers in Vietnam, Cambodia, India, and Pakistan. The purpose of these projects is to revive and recreate traditional woven textiles for employment and income generation. One group is the "Milanangan" (meeting place) group of weavers, formed in West Bengal in the late 1990s. Williamson assists them to extend their own range of woven products and materials to contribute to their income and employment. At the same time, she employs them to convert her own woven one-off wraps and scarves to a production range.

Cath Braid and Kirsten Ainsworth now live in the remote Chitral valley of Pakistan. Their vision in establishing their Caravana fashion label is to empower, through employment,

Marc Harrison, *Husque set—Pinch, Wax, Frag* and *Husque* (from top), 2006.
Made by Husque Pty Ltd., Moorooka, Queensland, Australia. Moulded
recycled macadamia nut shell and polymer; bowl, 22 x 19 x 8 cm.
Photo: Florian Groehn

women who are talented embroiderers but who live in a very isolated environment. From a small start, Caravana has built a network of ten centres, working with a local non-government organization. Each has a female manager and employs some 500 skilled women. As Christina Sumner says:

> [T]he Pakistani women's designs had become stagnant while local understanding of the Western market was virtually non-existent…. Through the women workers' individual interpretation, each garment and accessory is then imbued with the unique quality of the handcrafted.[14]

While changes in global manufacturing bring new choices and opportunities for designers and manufacturers, there are also questions to ask about the future in those Western countries where skills are being lost. What does it mean to lose industries that have provided a form of cultural identity? Denmark's Georg Jensen industry, where all training in metalsmithing has been focussed for generations, has relocated considerable amounts of its manufacturing capacity to Thailand. In Sweden and Finland, some of the famous glass, ceramic, and furniture industries are downsizing or being sold to larger foreign groups, while many designers now work for factories in the East. The United Kingdom, so strongly identified with skills-based industries, no longer has the large ceramics industries of Stoke-on-Trent or the metal industries of the Midlands. Conversely, in some countries where qualities associated with natural materials and hand skills in industrial manufacturing have become identified with "national" characteristics, writers like Kerstin Wickman and Widar Halén are today questioning the burden this legacy might place on contemporary design identity. They explored this idea in their exhibition, *Scandinavian Design Beyond the Myth: 50 Years of Design from the Nordic Countries*, in 2005.[15]

Jim O'Neill, economist in the international investment bank Goldman Sachs, suggested a future where Europe may lose its industries to the extent that its economic future may well be as a tourist attraction for an industrial and cultural past.[16] Across Australia, power stations, railway workshops, jam factories, cargo waterfronts, and meat markets are among those earlier industrial sites that are now re-born as cultural and museum sites to lost skills and industries.

EDUCATION AND TECHNOLOGIES

What effect might these changes in manufacturing have on countries in the southern hemisphere? How do Australian and New Zealand designers place themselves in such global developments?

New technologies for communication and manufacturing make these big changes quicker and easier. Designers and makers now have the opportunity to make their work more accessible through personal and market websites. Digital technologies are also central to changes in designing and making processes in all media. Many craftspeople, like visual artists and designers, have successfully incorporated new tools into their working practices. New technologies for rapid prototyping offer many possibilities for mass-customization or making complex one-off items. These technologies are amazing tools that can transform an idea into an immediate working reality. But a number of designers argue that there are limitations to designs that take their form only on the screen; they demonstrate that their designs are more successful when they are integrated with ideas that grow out of a working knowledge of a materials-based designing and making process.

Jonathan Baskett is a skilled glassblower, but he licences some of his designs to be produced elsewhere, currently in Mexico. He uses computers every day for media and graphic purposes and also for digital rendering of his designs, but his conceptual work always starts as "scribbling" and drawing. While he acknowledges that computers are "handy tools," he also says "it is frustrating when you are a maker and want to design through the materials." He makes clay models of his forms and often draws on skilled colleagues to make prototypes in glass, clay, or metal. Of his working relationship with those in the distant factory he says, "I can send emails for months and then go there for just one afternoon and sort it all out. I value them, and also like to challenge them; they give 200% to their job."[17]

A concern in Australia and New Zealand, also shared by other countries, is whether our education systems will keep pace with new needs and conditions. Tertiary education institutions must increasingly find more of their operating costs through sponsored partnership programs and foreign fee-paying enrolments for both local and off-shore campuses. Despite closures and amalgamations of courses and departments in art and design schools, there remain some strong centres of excellence that are recognized internationally. Yet there are also contradictions. The practical experience of learning all the fundamentals of a field is now condensed into a shorter staff contact time at undergraduate level; but, since tertiary art and design education has moved into universities, there are now also

new opportunities for extended research through higher degrees. However, as art school director David Williams notes: "[I]n the original merger of art and design schools into universities not enough consideration was given to appropriate art and design weightings and the metrics that guide government funding arrangements…. As a consequence, the discipline is disadvantaged in the sector."[18]

Art and design schools do offer both old and new technologies in parallel with one another, and students do move across them. There is, however, a real likelihood that skills and knowledge based on hands-on experience with materials will be lost or difficult to retrieve. *Smart Works* suggested that these kinds of material experiences do lie behind the creative process, whether invested in one person or as the result of collaboration among an artist, craftsperson or designer, and skilled people in industry.

New Directions

In the wake of large industrial closures and transfers, some responses include setting up small specialist businesses producing handmade products for a high-end market.

In Birmingham, Professor Norman Cherry, head of the University of Central England's School of Jewellery, draws attention to the many small workshops that have emerged in the old jewellery quarter in the city, once the home of large industries employing many hundreds of people.[19] A similar pattern is evident in Copenhagen, where there are now many small studio-workshops within a few blocks of the city centre, a result of the decisions made by well-established metal and porcelain industries to shift some areas of activity to other countries. The organization Crafts in Dialogue was formed in Sweden to address a future for the crafts in design, as industrial opportunities for artists and designers change.[20] In Italy, whose world-famous design reputation has been underpinned by the existence of extraordinary crafts-based manufacturing workshops, Dr. Filippo Chiesa is one who has looked at the impact of globalization on those workshops (including competition from neighbouring countries in Eastern Europe) and is advising on solutions.[21]

In 2004 London-based New Zealander Jeremy Cole began hand forming and slip casting porcelain components, and firing and assembling them into spectacular suspended and standard lamps in his living room in Kew, London, Evolving quickly to studio manufacture, the Aloe collection was inspired by the leaves of the succulent agave and aloe plants. After initially outsourcing much of the actual making to skilled workers from the defunct ceramics industries, Cole is now bringing it all back in-house in order to maintain

Jeremy Cole (NZ), *Aloe noir blossom* suspended lamp *Aloe* series, 2005-06. Made in Jeremy Cole's studio, Kew, London. Hand-cast porcelain, with transparent acrylic sub-structure and polished aluminum fittings, and stainless steel suspension system, 150 x 53 cm (large).

Photo: Xavier Young

quality control through personal oversight of the production process.[22]

In many countries no longer able to compete in traditional manufacturing markets, "creative industries" have emerged as new kinds of design services "which have their origin in individual creativity, skill and talent and which have a potential for wealth and job creation through the generation and exploitation of intellectual property." As traditional skills are lost, "it is often argued that, in future, the ideas and imagination of countries like the United Kingdom will be their greatest asset."[23] Consequently, many government initiatives in the UK support links among design education, research, and industrial development; and these connections are often also assisted, especially in regional areas, by funds from European Regional Development Funding. Those European funds also support countries newly entering the European Union, making them even more competitive and potentially self-sufficient in design as well as in manufacturing.

Dr. Ned Rossiter, an Australian teaching in Ulster, Northern Ireland, has researched international comparisons and interpretations of creative industries. In a discussion with Su Tong, executive director of Created in China, an organization responding rapidly to the needs for creative industries in the lead-up to the Beijing Olympic Games, he notes that Su Tong highlighted:

> the importance of regional craftspeople skilled in traditional ceramics whose unique designs are illustrative of IP [intellectual property] generation special to regional cultural traditions that are developing entry points into international markets…[acknowledging]…the contradiction between IP compliance as a condition set out by government and supranational trade agreements on the one hand, and the necessity for cultural production to retain a capacity to be shared and open in order to make possible the creation of new forms and ideas.[24]

In fact, in these "new" manufacturing countries, industries are finding that while they have the skills, even their domestic markets want a different, often Western, design aesthetic. They send their young people to train elsewhere, and are also investing seriously in local education. Douglas Tomkin, professor in design at the University of Technology, Sydney, reported in 2006 that China, one of the sources of our international students, now has 400 design schools producing 25,000 graduates annually.[25] Many wonder if very soon the education currently being offered in Western institutions, now substantially dependent on foreign fee-paying students, may no longer be necessary. However, Chinese-born pro-

fessor of architecture, Xing Ruan, working in Australia, argues that, in their desire for modernity, people in China will continue to want to maintain contact with cultures in the West. His research into the imaginings of modernity and new architecture in China has resonance for craftspeople and designers interested in China's rapid manufacturing developments.[26]

At the same time, many industries commission designers from the West, sometimes from factories that have closed or downsized, to design both for export and for their own markets. In 2002-03 Australian ceramic artist Janet DeBoos was invited to work at the Huaguang Company's bone china design group, in Zibo, China. Commissioned to design a tea set for the Chinese domestic market, she made sketches to scale and produced handmade prototypes, working with a team of expert model and mould makers:

> This project is very "hands-on" and I work closely with both the mould makers and factory workers as the pieces are produced and adjusted. I have been particularly interested in the way that the change in material (porcelain to bone china) affects changes in the product, and how "design" has created a resonance between the handmade and the factory ware.[27]

Similarly, Prue Venables was invited to design tableware to be manufactured for the Japanese domestic market following her involvement in a design competition held at the Oribe Design Centre at Gifu City, Japan. The aim of this competition was to bring new designs to Japan, to revitalize local industries, and to counteract the influx of cheap imports from China. Venables worked in the Centre to develop tableware made in "greenlife" recycled porcelain for one of the local porcelain manufacturers She says:

> I quickly realised that I needed to understand more about traditional Japanese ways of serving and eating food and the effects that these would have on "Western style eating" in Japan. Just to make a dinner set that I would have used at home would not be appropriate; putting many kinds of food on one large plate was almost incomprehensible in Japan. Handles on cups are generally unfamiliar and often ignored.

And it is not just the work of designers and educators that contributes to these new economies but also the intellectual property of designs themselves. The practice of copying designs that would be protected by copyright or trademarks in other countries seems

at times to be impossible to control. A number of designer-makers have both anticipated and experienced these issues.

INITIATIVES IN AUSTRALIA AND NEW ZEALAND

Within this broad framework of change, many Australians and New Zealanders are already resourceful designers and makers and are experienced in small manufacturing at home. The large potteries, woollen mills, and glass factories that developed in the nineteenth century were generally too cumbersome to either change flexibly for small production or reach a broad enough market to be sustainable. Most are already long gone. There are now several generations of studio craftspeople and designers working alongside one another and, for them, the notion of the designer-maker is not new. Already equipped with reputations for fresh approaches to a number of traditions without being bound by them, they also benefit from decades of experience in education, travel, and exchange.

One particular characteristic of the present time is the emergence of highly skilled specialist industries to which designer-makers can turn with confidence. Skilled artisans are developing unique businesses that focus on a particular technology, such as laser or water-jet cutting, digital printing and prototyping, resin prototyping, metal casting and pressing, or computerized textile weaving and printing. *Smart Works* uncovered many exemplary and unusual collaborations with smart industries and agents in Australasia as well as elsewhere in the world, who are enjoying the exchanges that develop, and who appreciate having their skills and knowledge valued. Some of these professional working relationships have taken so long to establish that designers regard them as a form of intellectual property.

Oliver Smith specializes in hand forging metal, and is particularly interested in making flatware. He started with hand-forged prototypes of spoons and knives in silver, and now works with a company that uses a ceramic shell-casting process, to make them in stainless steel. He now outsources more parts of the process to related industries and completes the process by doing the hand finishing and polishing himself. As he says, "I need to be there to check the results, but at each visit I'm also learning." He has made many changes through better understanding how each process works. "Ultimately," he says:

> working collaboratively is about making the whole greater than the sum of
> its parts…. I look for opportunities where I can do what I do well and unite

it with the strengths of another process, material or individual. I find the high level of skilled craft existing within industrial settings make me seek opportunities where it could be given greater expression.[28]

Oliver Smith, *Arc* cheese knives and *Dorsal* serving blades (right) OSP (Oliver Smith Products), *Generation II* series, 2006. From silver handforged prototypes, manufactured in cast stainless steel by Hycast Metals, NSW, industrially rumbled by Mass Finish, NSW, handfinished by Oliver Smith, Canberra, ACT, Australia. 316 stainless steel (marine grade), 23 cm.

Photo: Ben Manson, 3blindmice

Scottish-born Australian, Jill Kinnear, interprets Scottish textiles as expressions of place, history, and identity in her recent work *Diaspora: Mapping Migration in Textiles*. To make her printed silk shawls, garments, and textile lengths of "tartan," Kinnear conceptualized a symbolic link between historic textiles and the airport as a modern gateway of migration. "The airport," she says, "has become the present-day place of embarkation and disembarkation, a no-man's land of arrival and departure."[29] Catherine Reade describes the process involved in Kinnear's work:

She began the process by producing metal structures of paisley and tartan patterns, which she passed through the X-ray baggage machine at Brisbane International Airport. The resulting digital images were saved to CD and manipulated extensively to create repeat patterns. In 2006 she contracted Longina Phillips, a Sydney textile design studio, which printed her patterns onto silk shantung.[30]

Melbourne-trained textile designer, Vivienne Jablonski, is experienced as a handloom weaver, but during 2006 worked in Auckland, New Zealand, at the industry Inter-Weave, designing textiles to be woven on contemporary, computerized jacquard looms. Jablonski was given access to the equipment for her own designs, based on her Polish heritage, and then used elements for a repeating design for the company's clients. This particular kind of technology is generally only available to those working in the industry, which is why access to programs like the Centre for Advanced Textiles Research in Montreal is attractive to those wanting to make large one-off woven works.

As changes in technologies, industry, and the marketplace open up new challenges and opportunities, a number of government-funded initiatives and partnerships with industry and education are also supporting and encouraging new directions. As long ago as the mid 1970s, the government-funded centre, JamFactory Contemporary Craft and Design, was established in Adelaide, South Australia, with the intent of creating crafts-based industries through production and training workshops. Nick Mount ran his own production glass business for many years, and also managed the glass workshop at "the Jam" for some time. Now he makes artwork and special commissions from his own studio, hiring time and skilled assistance from the JamFactory when he needs it:

> I think the future is in making best use of existing facilities.... I am sure that
> it is easier to be creative and adventurous with design when there is a group
> of people working together with a wide range of skills and aesthetic ideas,
> where the responsibility for the running, maintenance, scheduling and costs
> of the studio are not down to one or two people alone and where commu-
> nication and generosity is encouraged amongst a group of creative people
> working with a similar attitude.[31]

In New Zealand, furniture and lighting designer David Trubridge combines his experi-ence as a naval architect with his strong knowledge of timber and complementary com-

DAVID TRUBRIDGE, *NEW SLING* ROCKING RECLINER, 2006. CNC ROUTER CUT, STEAM BENT, ASSEMBLED BY DAVID TRUBRIDGE LTD. AND CICADA WORKS, WHAKATU, HAWKES BAY, NEW ZEALAND. AMERICAN WHITE ASH, HOOP PINE PLYWOOD, STAINLESS STEEL SCREWS, 60 X 237 X 59 CM.

PHOTO: DAVID TRUBRIDGE

puter skills to make pieces like the *Body Raft* and the *New Sling* rocking recliner. The CNC (computer numerical control) router-cut timber pieces of his Kina and Coral lights can be flat-packed for distribution and assembly elsewhere. In a large space within a decommissioned meatworks, Trubridge and a group of wood and metal businesses share premises and skills in Cicada Works, alongside a "design incubator" facility for young designers, who are provided with mentoring and some real employment from the group.[32]

Crafts-based workshops have also been set up in some Indigenous centres for similar economic and cultural purposes: Ernabella Arts in northern South Australia, for example, has operated since the late 1940s. Ernabella is well known for its silk batiks, and, in recent years, the centre's artists have developed skills in making and decorating ceramics, now using locally managed slab-rolling and moulding technologies, while a further project saw batik designs of personal and traditional motifs developed into rugs and made in China.

In recent years a number of new initiatives from funding bodies, state crafts and design organizations, and universities have resulted in innovative collaborations between education and industry. More practical in their application than the "creative industries," as they are commonly understood, they include effective mentorship programs and development initiatives.[33] In Western Australia, working with industry, universities, and government, the organization FORM developed a specialized product and business development program, Designing Futures. This program provides practitioners, often with many years' experience, with mentoring, training, and access to expert advice in order to nurture better creative and business skills. The Visual Arts Board of the Australia Council's Maker to Manufacturer to Market (MMM) program supports design projects growing out of the handmade, while Austrade (The Australian Trade Commission) encourages export projects. In New Zealand, Creative New Zealand and New Zealand Trade and Enterprise support a range of initiatives, recognizing the importance of small, excellent, art and design-based enterprises.

A number of designers acknowledge that these opportunities take years off research and development time by sustaining the design process at appropriate moments. Jon Goulder developed and made the prototype of his *Leda Seat* by hand, and it is now manufactured and distributed by Arne Christiansen's Woodmark International, located in Western Sydney. Goulder and two associates then created a company with the intent of developing designs and prototypes to test Asia's capabilities for making plywood forms and to extend his marketplace. Supported by an Australia Council "new work" grant, Goulder developed a range of forms related to the *Leda Seat* (and also to his earlier plywood *Stak* stool) using similar laminated ply technology. Gouder and his associates invested in a new laminating press for one Chinese company, and Goulder worked with the factory through training its workers. It is difficult to communicate from a distance and to maintain quality control, and he is interested in looking at other options. But, as he says:

> by us going there and taking business, we are improving their company and their skills; we recommend people who show initiative and they quickly move up the factory ladder. We communicate by drawing and by actually making prototypes together; the language of making needs no interpreter.... [I]t is about developing relationships.

These craftspeople come from very different starting points, and their diverse paths reflect the global issues discussed in this essay. Some make everything by hand, working in their studios and sometimes hiring in skilled assistance, or renting workshop time, while

EDNA RUPERT, *RUG*, 2004. FROM BATIK DESIGN BY EDNA RUPERT, ERNABELLA ARTS INC., SOUTH
AUSTRALIA, ORIGINALLY COMMISSIONED BY PAMILLE BERG CONSULTING PTY LTD. FOR THE STATE
LIBRARY OF SOUTH AUSTRALIA; MADE IN CHINA BY TAI PING, HONG KONG, THROUGH KORDA BROS.,
SYDNEY, AUSTRALIA. HAND-TUFTED WOOL, 270 X 200 CM.

COLLECTION: ROMALDO GIURGOLA AO
PHOTO: MARINCO KOJDANOVSKI, POWERHOUSE MUSEUM

a number find their solution to production in providing local employment. Most combine traditional skills with a wide range of new technologies, and many have devised or adapted their own tools and technologies.

An increasing number of people who have always made all their components, now contract out parts to a specialist local industry. Some have developed amazing liaisons with skilled industries, who themselves have become fascinated with the new challenges, and some have even established their own industries to produce materials that others can use. Others now make prototypes and collaborate with skilled people in other countries. And many are involved in the mentorship of younger generations or are engaged in formal education.

Most noticeable is the passion and determination of these people to develop their skills and to pursue their interests and dreams while recognizing the reality that they must develop viable and sustainable businesses or working practices. Equally impressive is their remarkable and engaging willingness to meet skilled industry halfway: to listen to and learn from those particular specialists, and to respond to the mutual challenges that emerge as their design ideas become objects.

ENDNOTES

1 Robert Foster, in *Vast Terrain: Exploring Uncommon Ground*, exhibition catalogue (Perth: FORM Contemporary Craft and Design, 2005).

2 Grace Cochrane, "Smart Works: Design and the Handmade," in *Smart Works: Design and the Handmade* (Sydney: Powerhouse Publishing, 2007).

3 Evan Thornley, founder of the Internet search company LookSmart, The Alfred Deakin Innovation Lecture, no 2, "Big Ideas," ABC Radio National, 2005.

4 Ewan McEoin, "Slow Design," in Grace Cochrane, *Smart Works*.

5 Marc Newson, quoted in *Monument* magazine 2000 in Kevin Murray, "Design & Craft: A Discussion Paper," *Ceramics Today*, 20 Mar 2003, accessed 10 Oct 2006, <http://www.ceramicstoday.com/articles/craft_design.htm>

6 Alice Rawsthorne, "'An Australian in Paris'," *Blueprint*, (February 1994) 78.

7 Garth Clark, in "Speak," *Object Magazine* 51, (November 2006) 11.

8 Paul Greenhalgh, in "Shapes of Things to Come: What Does the Future Hold for the Crafts?" *Crafts*, No 181 (March/April 2003): 17.

9 Sir Christopher Frayling, in "Shapes of Things to Come" 29.

10 Peter Day, "The Changing Face of Global Power," BBC radio, first broadcast, September 2005, <http://news.bbc.co.uk/1/hi/programmes/documentary_archive/4287124.stm>

11 In Hugo de Burgh, ed., *China and Britain: The Potential Impact of China's Development* (London: The Smith Institute, 2005). See also <http://www.smith-institute.org.uk/publications/china-and-britain.htm>

12 Brian Parkes, "Freestyle: New Australian Design for Living," in *Object Magazine* 50 (Aug.-Nov. 2006): 26.

13 Marc Harrison, quoted in Grace Cochrane, "Marc Harrison," in *Smart Works*.

14 Christina Sumner, quoted in Grace Cochrane, "Caravana," in *Smart Works*.

15 Kerstin Wickman and Widar Halén, exhibition curators for *Scandinavian Design Beyond the Myth: 50 Years of Design from the Nordic Countries*, Stockholm, 2003.

16 Jim O'Neill, interviewed by Peter Day, in "The Changing Face of Global Power."

17 Jonathan Baskett, quoted in Grace Cochrane, "Jonathan Baskett," in *Smart Works*.

18 Professor David Williams, "Speak," *Object Magazine* 50 Aug.-Nov. 2006: 10.

19 Professor Norman Cherry, University of Central England, Birmingham, correspondence with author, 2005.

20 Love Jönsson, ed., *Craft in Dialogue: Six Views on a Practice in Change* (Gothenburg, Sweden: IASPIS/Craft in Dialog, 2005). See also <http://www.iaspis.com/craft/en2/publications.html>

21 Dr. Filippo Chiesa, in correspondence with author, 2006, and speaker at *Smart Works* symposium, March 2007.

22 See Philip Clarke, in Grace Cochrane, "Jeremy Cole," in *Smart Works*.

23 The UK Government Department for Culture, Media and Sport (DCMS) define the Creative Industries. See "Creative Industries," *Wikipedia, the free encyclopedia*, 27 Feb. 2007 <http://en.wikipedia.org/wiki/Creative_industries>

24 Ned Rossiter, quoted in "Interview with Su Tong: Created in China," <www.fibreculture.org/pipermail/list_fibreculture.org/2006-May/000172.html>

25 Professor and head of design, Douglas Tomkin, University of Technology, Sydney, speaking at D-factory talk at Powerhouse Museum, Sydney, October, 2006.

26 Xing Ruan, *New China Architecture* (Periplus/Tuttle, 2006).

27 Janet DeBoos, quoted in Grace Cochrane, "Janet DeBoos," in *Smart Works*.

28 Oliver Smith, quoted in Grace Cochrane, "Oliver Smith," in *Smart Works*.

29 Jill Kinnear, Ph.D. Proposal, University of Southern Queensland, Toowoomba, December 2005.

30 Catherine Reade, quoted in Grace Cochrane, "Jill Kinnear," in *Smart Works*.

31 Nick Mount, correspondence with author, October 2006.

32 Philip Clarke, quoted in Grace Cochrane, "David Trubridge," in *Smart Works*.

33 See listing of Craft Organizations Australia at: "Australian Craft and Design Organisations (ACDO)," Craft Australia, 27 Feb. 2007 <http://www.craftaus.com.au/coa/acdo.php>

LOST IN TRANSLATION?: GIORGIO ARMANI AND THE TEXTUALITIES OF TOUCH

JOHN POTVIN

> Touch. My energies are concentrated in my hands when I touch fabric.
> I think that my constant, almost maniacal research on fabrics is one of the
> reasons behind my success. To model a fabric around a body is one of the
> most sensual experiences on earth. You have to feel it, it has to become one
> with the body, it is like arranging drapery with pins. They even say that my
> hands have a magical quality when I am working.
> *Giorgio Armani* [1]

Definitively seductive and decidedly sensual, textiles insinuate and initiate a markedly different experience than vision can provide for the embodied subject in its relationship to the world. So seductive and sensual are textiles, in fact, that designers like Giorgio Armani—known around the world for his use of rich yet minimalist fabrics—have been endowed with the aura of a magician or alchemist, transforming raw "materials" into objects of desire, seduction, and luxury. A significant part of what makes Armani's textiles and designs so alluring and sensual is his repeated and often direct referencing of exotic "Oriental" sources and his subtle cross-gender pollination, both of which make for a unique yet highly digestible aesthetic program for the Western consumer. From the outset, I wish to make clear that I am not suggesting that Giorgio Armani is the only Italian or Western designer in the 1980s and 1990s to have borrowed or appropriated textiles and patterns from the East, nor is he the most obvious choice in terms of a discussion of the

period's gender-bending fashion. Rather, what makes Armani distinctive, I contend, is his global sartorial influence and cultural pervasiveness, as well as his consistent—if at times subtle—use of "difference" as a self-reflexive strategy to set himself outside the fashion system.

This essay is concerned with the potentialities and possibilities of translation. Texture, textile, and text share much in common, not the least of which is an identical etymological origin. Taken from the Latin *textere*, meaning to weave, these three terms are here inter-woven as a means of elucidating the deep, thick, and rich texts that textiles reveal across textured surfaces. This essay intersects the socio-cultural modalities of gender, class, and ethnicity to explore how Armani, and those who have espoused his aesthetic program, attempt to collapse boundaries through an act of translation. Therefore, I wish to work simultaneously with two definitions of the verb "to translate" provided by the *Oxford English Dictionary*: first, "to express the sense of (words or text) in another language" and second, to "move from one place or condition to another." To give materiality to these def-initions, "[f]abric speaks to us, and its language is…seductive and current."[2] More specifi-cally, what is folded into the act of translation is the haptic, the sense of touch. Derived from the Greek, *haptein*, meaning to grasp, the haptic, in my proposal, translates meaning through the very simple and yet highly physical act of grasping the textiles themselves. This marks textiles as a sort of narrator acting through the grasping subject.

At first glance, fashion might appear to be an odd inclusion in a volume devoted to craft, especially the work of a renowned, global manufacturer of prêt-à-porter. Fashion, and in particular high fashion, is generally seen as neither craft nor art and, as such, occupies a liminal space neglected because of fashion's ties to industry and crass consumption, and of course, because of its vagaries and fickleness (qualities traditionally identified with the feminine). Fashion straddles the realm between high art in the form of high fashion on the one hand, and craft performed by hand by an indigenous craftsperson on the other. Textiles, in particular, I wish to suggest, bridge these seemingly divorced worlds as they fuse new technologies with tradition.

However, I wish to negotiate the treacherous terrain marking out materiality and the sensory by thinking through ways we might experience being in a global environment. My approach is necessarily experiential and theoretical, and rather than anything definitely quantitative, it is meant as a provocation to *touch* on the interstices among the haptic, tex-tiles, and difference (and all that the latter rather loaded term might suggest to my reader). To achieve this, I look at the Italian designer's oeuvre as a whole, framing it as a continu-ous and incomplete narrative. I wish to query how Armani translates ethnic sources and

moves across borders to occupy other contexts and spaces through sartorial and textile choices. If "materials in his designs are self-expressive, never deformed into shapes antithetical to their weight or weave" then what can we learn through the haptic about the complex modalities of difference in Armani's work?[3] Is Armani's aesthetic amenable to translation for a much wider audience or for a constituency like home sewers? Apart from the obvious global ramifications of designer fashion, can textiles bring the world closer, literally or at least figuratively?

MAKING WORLD CULTURES MODERN

In 2000 New York's celebrated Fifth Avenue bastion of modern art, the Guggenheim Museum, staged one of the largest fashion exhibitions ever held in an art gallery. This exhibition honoured the work of Giorgio Armani. While the exhibition opened with much fanfare, it was also not without much criticism. In "World Cultures," one of eight sections in the exhibition, Armani's elusive translation of various ethnographic influences from the material and visual cultures of Pakistan, India, Polynesia, Japan, China, the Middle East, Mongolia, and North Africa was explored in his own designs. Armani has been celebrated for his ability to translate, through adaptation, "traditional dress into his own ideas of elegant comfort and modernity." In other words, Armani appropriates styles from non-Western cultures and reinterprets them only to resell them gradually to the very countries from which he has borrowed them as he continues his global expansion. Tunics from Pakistan; collarless shirts from the Punjab; pajamas from Mughal, India; caftan-like dresses from Africa; and sarongs from South Asia, all comprise a significant syntax within Armani's aesthetic lexicon. As the exhibition notes state: "[t]he juxtaposition of East and West, of historical and contemporary, of high and low, not only reflects Armani's masterful command of fabrics and patterns but also his vision of a broader world sensibility."[4]

In 2003 the white walls of Frank Lloyd Wright's modernist gallery, serving as the venue for the initial Armani show, were exchanged for London's Royal Academy of Arts' newly inaugurated Burlington Gardens. Sandwiched between Bond Street and Savile Row, this ornately Victorian site was formerly the Museum of Mankind and the British Museum's Department of Ethnography. Clothing as artifact has always been collected and has formed an integral part of ethnography since its inception. Ethnography in the service of colonial knowledge evolves into imperial expansionism in the service of commerce and culture. In the Burlington Gardens of the Royal Academy, Armani's diaphanous tunics and pareos reit-

"WORLD CULTURES" INSTALLATION VIEW FROM GIORGIO ARMANI; SOLOMON R.
GUGGENHEIM MUSEUM, NEW YORK, 20 OCTOBER 2000-17 JANUARY 2001.

PHOTO: ELLEN LABENSKI
© THE SOLOMON R. GUGGENHEIM FOUNDATION, NEW YORK

erated the relationship between past and present, craft and industry, ethnography and modernity. The Armani exhibition brought to this space its own study of world cultures through a postmodern ethnographic *bricolage* in which:

> Indian gurus' jackets are transformed into embroidered golden vests worn over flowing pants, or become overcoats cut like frock coats, opening over wide, ruched skirts. The "guru" collar then moves to China, and the body of the jacket becomes wider. On to Japan, and the sleeves deepen to form a kimono, with old pottery patterns serving as decorative motifs printed on silk or taffeta.[5]

Here Armani travels the world through textiles, design, and shapes; yet he definitely returns to his Italian roots with his emphasis on Italian craftsmanship and tailoring.

Given the notoriety of the Italian cultural preference for touch, is it any wonder they can boast one of the most successful textile industries in the world as well as one of the most powerful industries in Europe? Since the middle ages, textiles have not only played a significant role in the economic and cultural life of Italy, but have created an aesthetic avenue through which cultural exchange between East and West has flourished, weaving a silky narrative across geopolitical and cultural borders. As Caroline Rennolds Milbank suggests, Eastern patterns and shapes had a modernizing effect on Western tailoring, and she reminds her readers of the effect that Turkish trousers had on reformer Amelia Bloomer, for example.[6] However, more than any other European nation, Italy has placed itself as the leading manufacturer of textiles.

Armani's repeated use of sarongs, pareos, tunics, caftans, and harem pants conjures vague, exotic hot climes. One must also consider, if only briefly, that while Armani's exotic and ethnic influences may have defined many of his fabric choices and patterns, his advertising campaigns have often been shot on location in definitively "foreign" and exotic locales. In his Spring/Summer 1994 campaign, for example, beautiful blond models pose in front of an archaeological dig. In a rather facile interpretation, the dig seemingly references Armani's "digging" in foreign lands for inspiration, and alludes to the past traditions of these cultures from which Armani has "unearthed" his designs. Used as a point of departure, however, culturally specific influences are translated into elegant modern garments sported by the models in this advertisement. More significantly, by referring to a purported "romantic past,"[7] the advertisement conjures up an imperial present. It covertly references a very fraught relationship between the industrialized West and the Islamic

East, a relationship embodied in the continued antagonism between the United States and Iraq throughout the 1990s. Here, clearly, is an interaction between the ethnic past and Western modernity. The spatiality of many of Armani's advertising campaigns, including this one, directs the viewer back to the source of inspiration, emphasizing to his consumer the act of translation entailed in his patterns and textiles.

Over the past two decades, fashion designers, as a way to compete in a global market, have undertaken to construct distinctive lifestyles, and images complete enough to encourage identification without much thought. What this suggests, once again, is the ascendancy of vision over the other senses. What, then, are the implications of adapting and adopting the textiles, shapes, and patterns of another country and then transforming them into objects of luxury to be bought and sold in a new global market? Are the original locations and ideas translated to the new consumer? Do indigenous craft practices and textiles, such as those from rural Mongolia, India, or Japan, signify or figure in the act of consumption or is it lost in translation? For, after all, "the original garments are never quite identifiable."[8] Does this translation presume to create an aura of authenticity, a cultural purism, or a pillaging of tradition by global fashion tycoons? While it might be easy to judge the appropriation of textiles, shapes, processes, and patterns as a new form of imperialism under the aesthetic auspices of glamour, textiles have traditionally been traded between cultures and groups, without any real regard for boundaries. As Colin Gale and Jasbir Kaur have demonstrated throughout their extensive study of the culture of textiles, textile exchange has been common practice since the development of the earliest trade routes. In a late capitalist context, new technology, consumer demands, and tradition increase the experience of coming together—like the crossroads of the silk trade.

In Armani's collections, Western historical references are usually displayed side by side with ethnic styles and references, as seen, for example, in his Fall/Winter 1990/91 collection for women, which was divided into three separate themes: 1930s European bohemianism, Imperial China, and rural Mongolia. In a collection such as this, class difference is also seemingly collapsed in Armani's use of ethnic sources, as he "is drawn most often to the simplest of Eastern wear, the subtleties of rough, plain, coarse, worn peasant clothing having more appeal (and more workable modernity) than court clothes."[9] However, it is important to note that more often than not, ethnic styles, adopted and adapted, belie the contemporary realities of these cultures. Gale and Kaur have argued, with reference to Yves Saint-Laurent's use of African, Moroccan, and Indian themes in various collections, that "[i]t's probably safe to say that the elevation of these ethnic-inspired fabrics to catwalk status has stimulated renewed interest in the traditional textiles crafts of the countries

"WORLD CULTURES" INSTALLATION VIEW FROM GIORGIO ARMANI; SOLOMON R. GUGGENHEIM MUSEUM, NEW YORK, 20 OCTOBER 2000-17 JANUARY 2001.

PHOTO: ELLEN LABENSKI
© THE SOLOMON R. GUGGENHEIM FOUNDATION, NEW YORK

mentioned."[10] I suggest this appropriation might also be coupled with the haptic experience of these garments, an experience that—as the body rubs up against and is protected by these foreign textiles—expands the self's knowledge of ethnographic difference. They might, I like to think, provide a way to close the gap that marks out self and other on the map of difference.

Referring to Armani's Spring/Summer 1993 collection, *Harper's Bazaar* reported that what Armani "showed encompassed influences from faraway places: Indian gauzes glistening under embroidery, silken paisleys, translucent Polynesian prints, simple shapes and fastenings that contain an echo of ethnic dress."[11] As Armani said of the collection: "The whole collection followed the idea of the mix between Western and Oriental."[12] He explains that what he is trying to achieve "is to make those influences wearable for a Western woman. The point is to make clothes that you can move in easily, that have a natural, relaxed feeling."[13] It would seem that this approach coupled with his ability as a translator was so successful that *Harper's Bazaar* reported a forty-percent increase in sales for this collection alone. In this same collection, Armani included very graphic patterns depicting various scenes of life from an imaginary Polynesian island, while other fabrics directly alluded to artist Paul Gauguin's pictures of the region. Fabric transformed into a wearable garment constitutes a transitional experience through the body, time, and space. Often Armani's textile sources are peasant and nomadic, possessing deeply tactile qualities, ideally suitable to his modern aesthetic. If as Judy Attfield argues, textile "materialises the connection between the body and the outer world," what, then, do we make of the social relations between those in the West who consume Giorgio Armani and those who originally inspired the material objects themselves?[14] Does the woman who consumes these frocks support a colonial past, which artists like Gauguin aesthetically perpetuated? And what do we make of the many examples in which traditional quotidian men's trousers (seen in many parts of the Islamic world) have been transformed into elegant, fluid, and luxurious trousers for women?

In the 1990s Armani's inspiration came from "a vague Islamic Orient" regarded as embodying "terms for the expression of an idea of simplicity and interior, spiritual wealth in the west." This is an atmosphere which, with a few touches, alludes to a man who knows how to be gentle, and to a woman who knows her own mind." Armani states that his "interest in the Orient is not a stylistic whim." Rather, "it is based on a certain spiritual affinity for the East and its cultures."[15] But, as Amy de la Haye has argued in her discussion of ethnic minimalism in the work of Shirin Guild, "[i]n times of economic and social

fragmentation 'advanced' industrialized societies often romanticise and make fashionable" aspects of cultures deemed "undeveloped." [16] De la Haye notes that certain decades in the twentieth century, like the 1990s, placed greater "emphasis upon the cut of non-Western clothing and hand-crafted textiles." [17] While it is important to remember that since Armani's earliest collections in the 1970s, the designer has consistently gathered inspiration from various Eastern cultures, in the 1990s he derived his inspiration from a vague pan-Islamic aesthetic, a region of the world his primary international market knew only through constant media reports. In this context, it would seem that a minimalist aesthetic becomes a necessary method by which to translate the exoticism of a location violently under attack for a Western constituency that is politically detached, geographically removed, and psychically distanced.

MINIMAL INTERFACING: OPTICS VERSUS HAPTICS

Lynn Yaeger, one of the most outspoken critics of the Giorgio Armani exhibition, has noted how "the museum-goers viewing these displays don't seem to know quite what to make of the stuff. They gaze hard, then turn to each other and say things like 'Don't you have pants like that?'" [18] I suggest that Yaeger's purposeful inclusion of these visitors' dialogue smacks of disdain for the purported banality of looking at trousers or frocks, and for the "ordinariness" of clothing itself: that is, for the status of garments as objects outside of the gallery system in which viewing marks a (critical) distance, a distance which is not afforded by a pair of trousers owned and worn by the gallery's visitors. One of the most controversial aspects of the exhibition (and there were many) was how, seduced by the myriad textiles and textures, the visitors insisted on touching and grasping at the clothes, defying all propriety and defying as well the logic of an art museum whose performative culture is governed by the laws of optics and not the requirements of the haptic.

Harold Koda, the co-curator of the Armani exhibition, argued that the reason for excluding many garments from Armani's early years (that is, from the 1970s) had to do with the fact they were too fragile and would have required to be displayed under glass, thereby further distancing the viewer from the object (read: textiles). This ideal of bringing the viewer closer to the objects endeavours to collapse the distance inherent in the visual ethos of the art gallery, the ideals of Kantian disinterest, and the desire to remove the cultural or aesthetic object from the viewer's everyday life. Material culture—clothing especially—

calls out to the viewer to come closer, to examine its decorative excesses and inscriptive surfaces. In an altogether different context, a collapse like the one I am suggesting here is akin to Rosemary Betterton's distinction between embodiment or touch (and hence feminine) experience on the one hand and the masculinist optical realm of vision and visuality on the other. Given the historical distinction between the "higher" sense of vision and the "lower" sense of touch, it seems apropos—in a discussion of how the subject understands being in the world of sensual objects—to introduce a parallel discussion which reasserts the centrality of touch as well as the centrality of the "lesser" arts of craft— namely textiles.

"Simple," "pure," and "clean," are terms often used to describe Armani's silhouettes, in as much as the "garment conveys a modernist impulse, revealing an essential feature of the cloth itself. Materials in his designs are self-expressive, never deformed into shapes antithetical to the weight or weave."[19] Mandated in this strategy is a "reliance or compliance to the fabric itself," an integrity defined by the material. As the exhibition notes read: "his is a minimalism of visual and tactile richness which in its impulse toward the ascetic retains an undeniable sensuality," and through the traditional "simplicity of cut and stitching typical of African and Eastern" garments, Armani can more readily activate and enhance his minimalist aesthetic, making his textures and textiles thicker, richer, and deeper than those provided for in the West.[20]

While Armani created a "power suit" with fluid and supple fabrics for women, he simultaneously adopted more supple and malleable fabrics, such as wool crepe, for men. Armani ushered in, through his minimalism, unstructured slouch jackets at a time in North American history when the New Man was seemingly more sensual, sensitive, approachable, and perhaps even more vulnerable. While soft fabrics may be comforting, they also connote the "indulgence" of a luxurious use of fabrics. By removing the padding, adding fabric, and concealing the suit's structure, Armani ironically provided men in the West with a more "humble posture" and understated, hidden luxury.[21] What has been consistent for both sexes is the suppleness of the fabrics, the fluidity of the shapes, and the way forms forgivingly adhere to the natural contours of the body. Movement is necessary within the realm of the haptic whereas it is a hindrance in the realm of the optic. By removing all additional and unnecessary inner layers of structure in the jacket, in particular, Armani invoked the importance of movement and the haptic, the gliding of the hand on the surface of the garment to reveal its truth, luxury, and pleasure.

Tiffany Field has eloquently remarked: "Touch is our most social sense."[22] Touch suggests deep and profound opportunities for the self to engage with others. But, as Field reit-

erates, cultures markedly differ in their customs of touching, that is, the intensity, degree, and frequency with which people touch each other. The haptic experience marks the territory where we might negotiate the world of objects, of things, of people. Since the eighteenth century, as exemplified in the writings of Immanuel Kant, the visual has superseded all other senses, allowing the image to take hold of our sensual experiences and our understanding of the material world. The image on the computer screen overrides the tedium of our fingers' constant tapping against the hard plastic, a material ubiquitous to our routine experience of the contemporary world. Armani's fabric offers an antidote to the increasing haptic sterility of North American culture, where pleasure of touch is reinforced by fabrics that "move, whisper, flow like water: wool crepe, linen, tweeds, viscose blends, silks, velvet, cashmere, faded-but-elegant plaids and stripes, fabrics with discreet textures—sometimes flat, sometimes spongy, never thick of stiff—and always fabrics that feel good, fabrics that are luscious, elegant, and understated."[23]

BRINGING ARMANI HOME: HOME SEWERS AND ARMANI MADE EASY

Beginning his design career with the eponymous menswear label Nino Cerruti, Armani worked closely with Italy's textile mills, where he began his long love affair with fabrics and learned how they could be worked and reworked to suit the body. Despite his elite stature and the hefty price tags attached to his prêt-à-porter garments, Armani's work marks an important alliance with modern avant-gardism. As advanced by Marxist theorist Georg Lukács, a true avant-garde praxis is one made so accessible that it evokes a lasting relationship with the general public. Armani has often openly criticized the spectacle of the fashion system, asserting that "leafing through fashion magazines that think they are promoting change or indicating new paths, that believe they are presenting the avant-garde, supporting the vacuous self-assertion of certain decidedly useless trends ... the idea that every collection must break the rules clears the way for all sorts of foolishness."[24] Peter Bürger has advanced the idea that the avant-garde is constituted by an awareness and critique of the "productive and distributive apparatus,"[25] that is, the institutional parameters, and states that art (or in this case fashion) must be integrated into the life of the people.

In the late 1970s, when Armani was being slowly introduced to the United States, his aesthetic was a rather hard sell to American middle-class men, America's answer to the "masses." Special "product-development coordinators," such as Edward Glantz of Barney's in New York, were called in to:

"ARMANI AND HOLLYWOOD" INSTALLATION VIEW FROM GIORGIO ARMANI; SOLOMON R. GUGGENHEIM MUSEUM, NEW YORK, 20 OCTOBER 2000-17 JANUARY 2001.

PHOTO: ELLEN LABENSKI
© THE SOLOMON R. GUGGENHEIM FOUNDATION, NEW YORK

"translate" some Armani designs into wearable clothes for the American man. ... What the translating will entail is hard to tell, but it will probably involve some substitution of fabric and a tendency to smooth out a bit some of the Armani rumple to suit the more permanent-press American sensibility.[26]

After *American Gigolo* hit movie theatres in 1980, men wanted a piece by Armani, whose clothing featured as prominently as Richard Gere's sexy, well-toned physique. Through films like *American Gigolo*, Armani could bring his visual aesthetic to the masses. This aesthetic quickly became the texture of everyday life in both North America and Europe, and Armani was credited by American fabric designers and those in the industry

"as the originator of the more sophisticated sport jacket color and styles" that were "moving into mainstream America" in the 1990s.[27]

In his now famous aesthetic lexicon, commonly referred to as "Armaniology" and recorded in "Armani Disarmed," Armani contended that "[h]igh fashion for the wealthy and the very rich still exists, but the rule is that the articles shown on the runway with a few corrections and a few modifications, must be capable of becoming clothes for everyone." Coincidentally—and in keeping with Armani's self-professed democratizing ethos—*Threads*, a magazine devoted to "home sewers," published a series of four descriptive "how to" articles between 1990 to 1999 in an attempt to systematically translate Armani's fabrication and design for a broader audience of women capable of crafting their own Armani-inspired versions of his famous jackets and trousers. Noteworthy is how the four pieces of clothing, in terms of both pattern and fabric, make no direct or indirect references to Armani's Eastern influences. According to Ann Hyde, despite Armani's use of exclusive fabrics, similar textiles, equal in quality, are available to home sewers. Hyde adds the proviso for her North American readers that price, location (generally limited to major urban centres), and availability bear considerable weight in the final selection of the fabric. After examining numerous jackets and suits, she contends that "[b]ecause he [Armani] subtracts the underpinnings, his fabrics must also be of stand-alone quality, capable of expressing his message without stiffeners or backing."[28] Through a simplified, pared down design strategy, textiles provide and define meaning. Armani's "garments have been stripped only to the essentials and not beyond. Armani's genius as a craftsman lies in knowing where to stop."[29]

Textiles alone provide the interface between the body and the outside world. Articles such as the one written by Hyde for a magazine like *Threads* reinforce the need to focus on design and fabric as well as on the individual's need to construct his or her own versions, that is, the materiality of the Armani image allows for an embodied agency separate and yet as a result of global manufacturing aesthetic. To her home sewer readers, Hyde suggests a trip to an Armani boutique, if only to "feel the fabrics," Hyde's recommendation is not to *see* the colours, shapes, or textiles per se, but rather to *touch* the fabrics. Touch thereby engenders *a* or rather *the* requisite knowledge for the home sewers; through the haptic they are able to translate Armani's manufactured aesthetic into that of the domestic realm by crafting their own versions of his suits. According to Hyde, the suggested visit to an Armani boutique provides "the best way to experience Armani's exquisite fabric judgement."[30] Again, by treating textiles and texture as revealing texts and activating these texts through the experience of the haptic, aesthetic discernment is communicated, ascer-

"Armani Palette" Installation View from Giorgio Armani; Solomon R. Guggenheim Museum, New York, 20 October 2000-17 January 2001.

tained, and possibly even translated into other self-crafted garments. Hyde continues her article by taking apart, as it were, a jacket from the designer's Spring/Summer 1990 collection. This is significant because, through the fabric (in this particular case a woven check) the author is able to discern the "grain of the ultra-light jacket, making it easier to see the actual shape and orientation of seam lines."[31]

I wish to conclude by posing what might have been a better opening question: Why choose an iconic fashion industrialist like Giorgio Armani as a legitimate interest in a volume devoted to craft and new ways of approaching its study, cultures, and future? Perhaps Marco Romanelli stated it best in his brief article on the designer in *Domus*. In his exploration of Armani's various stages of the design process, he posited that an Armani garment, despite being a "manufactured object,"

has a technical and communicative valency so as to permit … a renewed capacity for dialogue with an unspecified number of users. Users who can personally re-interpret the object itself, taking possession of it and so making it ineffably and infinitely different. That is why Armani. Because in his work it is possible to see a sign of this attainable Utopia which today is politically and poetically forgotten. Armani's prêt-à-porter as a paradigmatic "design series," in contrast to a high fashion which is the equivalent of high craftsmanship (neo-craftsmanship or antique craftsmanship, with no substantial difference) and a current prêt-à-porter which oscillates between an excess identifiable with high fashion and a basic condition of low production.[32]

This perception of Armani's niche between low production and the excess of high fashion places the designer squarely within a modernist paradigm. Armani's self-professed modernist vision can be reduced to the notion of repetition, a term made current by Rosalind Krauss in her now infamous essay, "The Originality of the Avant-garde." Krauss contends that within the aesthetic economy of modernism, repetition is suppressed in favour of originality, a continuous and—dare I say—pathological desire for difference on the part of the avant-garde. However, within Armani's vision, seriality and minimalism facilitate ethnographic translation. As Romanelli also clearly suggests, users, wearers, and consumers translate textiles and garments for themselves, altering them to fit their own needs. Unlike many of his contemporary's work, Armani's garments do not overwhelm the identity or body of the wearer, but simply extend their boundaries, if only slightly, as if his clothes were a seemingly neutral, second skin. A skin, however, equally difficult to shed.

ENDNOTES

1 Giorgio Armani, "Armani Disarmed," *Emporio Armani Magazine*, no.14 Fall/Winter 1995-96: iii.

2 Simona Segre, "The Material Speaks for Itself," in Valerie Steele, ed., *Fashion: Italian Style* (New Haven and London: Yale University Press, 2003) 126.

3 Researched online at "Giorgio Armani," *Guggenheim*, <www.giorgioarmani.com>. This research was carried out in 2006.

4 Researched online at "Giorgio Armani," *Guggenheim*, <www.giorgioarmani.com>. This research was carried out in 2006.

5 Franca Sozzani, "On Womenswear," in *Giorgio Armani* (New York: Guggenheim Museum Publications, 2000) 79.

6 Caroline Rennolds Milbank, "The Sands of Time: Historicism and Orientalism in Armani's Designs for Women," in *Giorgio Armani* (New York: Guggenheim Museum Publications, 2000) 159.

7 For Milbank's use of "romantic past," see "The Sands of Time" 163.

8 Milbank 163.

9 Milbank 158.

10 Colin Gale and Jasbir Kaur, *The Textile Book* (Oxford and New York: Berg, 2002) 101.

11 Armani quoted in Sarah Mower, "Armani After Dark," *Harper's Bazaar* Feb. 1993: 143.

12 Mower 143.

13 Mower 143.

14 Judy Attfield, *Wild Things: The Material Culture of Everyday Life* (Oxford and New York: Berg, 2000) 124.

15 "Armani Disarmed," *Emporio Armani Magazine* No. 14 Fall/Winter 1995-96: vii.

16 Amy de la Haye, "Ethnic Minimalism: A Strand of 1990s British Identity Explored via a Contextual Analysis of Designs by Shirin Guild" in Nicola White and Ian Griffiths, eds., *The Fashion Business: Theory, Practice, Image* (Oxford and New York: Berg, 2000) 64.

17 de la Haye 64.

18 Lynn Yaeger, "Elements of Style: Pantsuits at an Exhibition, Armani at the Guggenheim," *The Village Voice*, (14 Nov 2000) 15 Mar 2007 <http://www.villagevoice.com/specials/0543,50thyaeger,69303,31.html>

19 Researched online at "Giorgio Armani," *Guggenheim*, <www.giorgioarmani.com>. This research was carried out in 2006.

20 Researched online at "Giorgio Armani," *Guggenheim*, <www.giorgioarmani.com>. This research was carried out in 2006.

21 See Ruth de la Ferla, "Sincerely Yours," *New York Times Magazine*, 8 April 1990: 44.

22 Tiffany Fields, *Touch* (Cambridge: MIT Press, 2001) 19.

23 Marcy Tilton, "The Armani Effect," *Threads* April/May 1999: 31-35.

24 "Giorgio Armani," *Spass*, 15 Mar 2007 < http://www.kleynemeyer.de/Spass/spass.html>

25 Peter Bürger, *The Theory of the Avant-garde* (Minneapolis: University of Minnesota Press, 1984) 22.

26 Rita Hamilton, "Easy and Elegant New Clothes Men Like," *Esquire* 22 May 1979: 31.

27 "Airport Sport Coats Get Armani Favour," *Daily New Record* 2/13/1992: n.p.

28 Ann Hyde, "Inside an Armani Jacket: Exploring the Secrets of the Master of Milan," *Threads* August/Sept. 1990: 27.

29 Hyde 29.

30 Hyde 27.

31 Hyde 28.

32 Marco Romanelli, "Il progetto dell'abito 1988," *Domus* 690 January 1988: 63-4.

CRAFTS AND POLITICAL ECONOMY

BEVERLY LEMIRE

JOSEPH MCBRINN

B. LYNNE MILGRAM

SECTION THREE

ELLS all Sorts of ready-made
Linnen, Shirts and Shifts of all
Sizes; Sheets, Damask, Diaper, Child-
bed Linnen of all Sorts, new and
second-hand; strip'd Cottons and
Checks, all sorts of Flannels, Bays
and Stockings, Womens Gowns
Womens and Childrens Stays, made
after the best Manner. Bodice of all

1690

...the crafts remain viable in political economies around the world...

INTRODUCTION

SANDRA ALFOLDY

Craft discourse depends upon an understanding of political economy. The crafts have fought noble battles against the tyranny of capitalism, most famously in the socialist goals of William Morris; yet they remain rooted in local, national, and international systems of exchange. Craftspeople in post-industrial nations are haunted by the question—why do it? Why build a career and lifestyle around object making, an activity that is widely considered obsolete in the twenty-first century? As the essays in section three of *NeoCraft: Modernity and the Crafts* prove, the crafts remain viable in political economies around the world for a variety of reasons. The crafts can stand as oppositional forces against global homogenization, capitalism, and mass-production; they are deeply satisfying to makers; they forge intimate connections with users and consumers; they are tools used to define national and personal identities; they are essential to tourist economies and generate governmental support for creative industries. For some, they are the only known mode of production and, occasionally, the only way to earn a modest income. The Canadian historian Beverly Lemire, the Irish art and design historian Joseph McBrinn, and the Canadian anthropologist B. Lynne Milgram provide case studies of particular moments in the political economy of craft. Ranging across centuries and cultures, these chapters establish that the crafts are a powerful force at all levels of society.

CHAPTER 6

REDRESSING THE HISTORY OF THE CLOTHING TRADE: READY-MADE APPAREL, GUILDS, AND WOMEN OUTWORKERS, C.1650-1800

BEVERLY LEMIRE

In the two centuries following 1600, the clothing commonly worn in England underwent noticeable changes in fabrics, in styles, and in the method of manufacture. Ready-to-wear apparel became a discernable and increasingly important part of a national clothing market accounting for about one quarter of national expenditure in 1688.[1] The wave of ready-made goods spread well beyond regimental storehouses and naval slop chests, serving diverse institutional customers as well as innumerable civilian markets. Implicit in this development was a re-organization of production in a trade which was as common as the shirt on men's backs, as varied as the petticoats worn by women of every class.

Technology was not the decisive force in this growing trade; reorganization long preceded any technological change, with women workers providing a fundamental advantage for manufacturers. As with many other industries, the ready-made clothing trade flourished with the massive use of a predominantly low paid female labour and the shift from guild-controlled workshops.[2] Increased manufacture of ready-made apparel marked a watershed, challenging local and national tailoring guilds, and revising patterns of work by differently organized workforces. Most ready-made clothes, like sailors' slops, were unremarkable and ephemeral, neither fashionable nor noteworthy; and the history of their production and use have been just as un-remarked until recently.[3] These commonplace articles were not the stock of new or picturesque rural cottage industries, or of skilled workshop labour. The hands which made bales of shirts, drawers, caps, gowns, bodices, and petti-

coats were equally obscured. They belonged to the generations of women working in a largely urban putting-out system. Based in London and the great southern port cities, both gender and urban anonymity contrived to make this workforce and its products at once commonplace and concealed, even as domestic, maritime and colonial markets were served. This chapter aims to redress the historic invisibility of this trade, tracing its internal development and the characteristics of women's craft work in this industry. Examining this history is critical to understanding the complex and shifting role of craft during Western economic and technological modernization.

GUILDS BESIEGED: TAILORS IN THE PROVINCES

Definitions of skill were defined by gender, and the designation of skilled status was traditionally reinforced by guild membership, an almost exclusively male prerogative by 1700. Tailors' guilds jealously guarded their privileges, even as their monopoly was being eroded in cities where the force of commercial expansion was most dynamic. In London, the challenge steadily increased from the 1550s onwards as "botchers" made "mens' apparel" without guild sanction, an offence increasingly common by 1600.[4] In June 1647, at the local Holland Fair in Oxford, the arrival of a "farren merchant" from outside the city stirred up the local Company of Taylors, who reported that the outsider "offer[ed] to sale diverse sutes of clothes ready made to the great prejudice of the Company." And though the local Lord Mayor "suppressed" the merchant,[5] this would be one of many confrontations. The tailoring trade, dependent on made-to-measure garments, was under pressure from expanded demands for clothing, along with the fact that the skills required to make common garments could be acquired through informal or domestic training. The tumult of the Civil War further eroded guild authority.[6] Try though they might, tailors' guilds could not and did not restrain competitors.

After 1660, records show unremitting campaigns in Oxford against "diverse abuses."[7] One of the principal targets of the Company's ire was a group identified as the Oxford milliners, charged with "using the trade of Salesmen," that is "selling Sales clothes" ready-made.[8] At the behest of the tailors, indictments were issued at the Petty Sessions to try to halt these sales within Oxford, and nine men were formally indicted, in 1669, with working as salesmen and infringing the Elizabethan Statute of Artificers, which required a seven-year apprenticeship before serving in a trade.[9] Their legal defence suggests the pressures engulfing this industry. In their defence they maintained that as retailers of ready-made articles, they did not fall under the scope of the legislation because "the selling of coates ready made by others is not nor can be [within] … the [Statute]." They insisted that the Elizabethan statute pre-dated the rise of their trade and that, "it is not any of the Trades mentioned in any of the Branches of the statute nor could be for that in truth … [this trade] hath not been in use about 30 years as the Present Coate fellowe and Brokers of London who deal in these comodities do assert…."[10]

Their statement describes a well-established enterprise centred on London and radiating out along the trading networks from south to north, with towns like Oxford a magnet with a growing number of people keen to buy inexpensive attire.[11] Thereafter, members and non-members of the Oxford Company of Taylors were subjected to rigorous scrutiny

as the guild tried to ensure that Oxford remained clear of ready-made garments. Nevertheless, members of the Company were routinely disciplined for "exposing to Sale old & new clothes ready made,"[12] and these sorts of trade conflicts were replayed in many other provincial centres. The Chester Merchant Taylors' Company paid out regular sums to a string of informants and city constables employed to enforce their monopoly. In common with most provincial guilds, the north-western cathedral town of Chester faced a two-pronged onslaught of incoming salesmen and local infringers. Chester's seasonal fairs drew London salesmen eager to cultivate this regional market, nettling local tailors. In 1701, three warnings were issued to visiting "Londoners & others to leave the faire & shutt down their windows"—in vain. The next year the salesmen were back at two Chester fairs, where they were again cautioned. The Londoners must have enjoyed a flourishing trade, for exasperated guild officials finally carried the salesmen before an alderman in a futile bid to rout the interlopers. Corporate threats and penalties could not stem the tide of new-style commodities, for a year later the southern salesmen were back in force, defying restraints and refusing to quit the fairs.[13]

London clothes dealers journeyed to most regions of the country. Samuel Dalling was a South London salesman active in his trade until 1699. Between the time of his death on 23 May 1699 and the taking of the inventory on 17 November 1699, six months later, his wife ran the business with a journeyman and probably some apprentices or outworkers. From the detailed surviving records it is clear that they travelled according to a schedule, attending fairs at Bristol, Sturbridge, Baldock, Maidstone, and Marlow. Although the London shop brought in half the six months' income, the fairs collectively accounted for the other half and were a significant source of profit.[14] The geographic compass of Dalling's trade was matched by others like Herbert Allen, who specialized in shirts, cravats, women's head clothes, hoods, aprons, and other accessories. His estate was valued at £2301 in 1668 on his death—an astonishing sum given the ordinariness of his stock—with debts owed by customers from Bristol in the west, Norwich in the east and Worcester in the south.[15] Provincial fairs and their myriad customers drew a steady stream of large and middling clothes dealers out from the metropolis to all corners of England.[16] Guilds could not control outside competitors or their own members, numbers of whom were also intent on changing the orientation of their trade. Stubborn repeat offenders, like the Oxford tailor Anthony Ffrankling, was indicted and re-indicted "for keeping a Sale Shop to Sell new Cloaths ready-made."[17] By 1725, Anthony Ffrankling was among twenty-two members who did not even bother to appear at meetings to answer charges.[18] These men abandoned their craft allegiance and guild protection, some adopting straight-forward retail

practices and other combining manufacture with the sale of old and new clothes. Oxford, Salisbury, and Chester typify towns swept into a new network of production and distribution of apparel, increasingly dominated by the manufacturing and distributive capacity centred on London.

Sewing for the Market: Women in the Needle Trade

Many thousands of women sewed for the ready-made trade; yet, needlewomen left few written records of their working lives.[19] Basic needle skills were the foundation of female education for the expanding generations of young women, the skills acquired through formal or informal means.[20] K.D.M. Snell maintains that the seventeenth century offered greater options for training and employment than the century which followed. However, the later seventeenth century presented finite employment choices for women, both in the capital and in provincial settings, narrowing even for daughters of middling or gentry families, while poor girls were relegated to what has been described as a "segregated sector" of employment.[21] This was no seventeenth-century golden age for working women, despite some claims to the contrary; apprenticeships were limited and employment options narrowly defined. In London, for instance, the second most prominent occupation for women after domestic service was the making and mending of clothing.[22] Some women apprenticed in the needle trades and many did not. For poor young women, however, their sex as much as an apprenticeship determined work and wages. Collectively, women were invaluable cheap labour, employable at a fraction of male wages.[23]

London attracted generations of young single migrants, more and more of whom, after 1650, were single women.[24] Ann Scott exemplifies a young newcomer to the capital and just prior to being hanged in 1685 for theft, she explained that she was "brought up … to work…with the Needle," having left Ireland confident that her extensive skills could earn an honest wage.[25] The reality of the London economy propelled many women into the less attractive and remunerative parts of the trade, with poor and irregular pay. Martha Pillah also laboured in the ready-made trade, and a stark memorial survives in her last dying words prior to execution for theft in 1717. She stated that "she was about 18 years of age, born of very honest Parents in Brewers-yard, in…Westminster: That her Friends put her out Apprentice to a Taylor, and when the Time of her Service with him was expir'd, she work'd for herself, whose chief Business then was, the making and mending Men's Cloaths."[26] Some women successfully operated small businesses making clothes, like Mary Antrobus

and Dorothy Gray, who worked as coat-sellers in 1712. But affluent women in this trade were rare, and throughout the eighteenth century, women in the ready-made trade successful enough to buy fire insurance were neither as wealthy nor as numerous as male competitors. As the ready-made clothing industry grew and domestic manufacturing expanded, women were increasingly identified with the making of clothes, a target for guildsmen and journeymen tailors with whom they competed.

The response of the guilds to the menace of ready-made clothing is instructive. Guild officials tried to quash all change, taking particular aim at needlewomen. By the eighteenth century, tailors were penalized for taking female apprentices or employing women on their boards while independent women in the trade were pressured to desist.[27] In York, for example, the Company of Merchant Taylors spent over £40 prosecuting the recalcitrant Mrs. Mary Yeoman. Across the nation, tailors' organizations assailed women workers more than a century before the well-known trade union campaign by journeyman tailors against seamstresses in the 1830s.[28] By 1700, the guilds claimed three prime grievances: the expansion of the ready-made clothing trade outside approved workshops; the employment of untold numbers of

Mary Dennis,
At the *Dial* and *Crown* in *Hounds-ditch*, near *Bishopsgate-Street*,

SELLS all Sorts of ready-made Linnen, Shirts and Shifts of all Sizes; Sheets, Damask, Diaper, Child-bed Linnen of all Sorts, new and second-hand; strip'd Cottons and Checks, all sorts of Flannels, Bays and Stockings, Womens Gowns, Womens and Childrens Stays, made after the best Manner, Bodice of all Sorts, Coats, Frocks and Petticoats. Wholesale and Retail at Reasonable Rates.

TRADE CARD, MARY DENNIS, AT THE DIAL AND CROWN IN HOUNDSDITCH, NEAR BISHOPSGATE STREET. GUILDHALL LIBRARY, CITY OF LONDON.

WOMEN WERE INCREASINGLY IDENTIFIED WITH THE MAKING OF CLOTHES FOR THE MARKETPLACE, IN COMPETITION WITH TAILORS.

women undercutting guild-made goods; and, at the higher end of the scale, the establishment of the distinctly female trade of mantua making, which produced apparel specifically for women by women. In response, journeymen tailors attempted to eliminate female competitors which insisting on the particular skills of their fraternities.[29]

Provincial guilds from York to Chester and Norfolk to Salisbury led attacks against women workers and the new style of production. Searchers employed by the guilds scoured garrets, apartments and shops for evidence and legal cases were pursued against persistent offenders, of which there were larger and larger numbers, some of the most prominent being women.[30] Oxford tailors insisted on the need "to Suppress the Mantua Makers" through Parliament.[31] Oxford, York, Chester, Norwich, and Salisbury were five of approximately a dozen cities involved in an early eighteenth-century campaign against ready-made garments, a campaign targeting women.[32] This was a decisive struggle, and its failure was as important as its inauguration. Government self-interest may have figured in their calculations, since the army and navy depended for their clothing on garret-sewn garments. Fundamentally, however, Parliament was not persuaded to defend ancient privileges, tacitly recognized the changing face of England's economy, a change embodied in the slop workers who laboured unsung in the courtyards and alleys behind the halls of Westminster.[33]

Putting-out and Making-up: Salesmen and Seamstresses

The seamstresses, slop makers, and cap makers, the "makers and menders" of clothes whose labour was so necessary, were largely reliant on low-paying, irregular employment which was deemed to suit their sex. Eric Hobsbawm notes that, "The obvious way of industrial expansion in the eighteenth century was not to construct factories, but to extend the so-called domestic system."[34] Technological innovation was only one method of industrial growth and the clothing trade followed an alternate route and persisted along this path through the next century and far beyond. Dependent on gender divisions in the manufacturing process, the trade integrated new technology, when it arrived, with a seemingly insatiable appetite for intense, low-paid sweated labour. Duncan Bythell, focusing on the nineteenth century, notes that small subcontracting and independent handicraft could both coexist with a vast, sweated sector. Indeed, sweated labour comprised part of an industrial structure which included small workshop manufacture overseen by subcontractors, as well as garret stitching.[35]

Outwork, which followed these "industrial" characteristics, was a staple component of clothes manufacturing, probably as early as 1600. The levels of skill required for some of the processes varied, perhaps to a greater degree than Bythell acknowledges. However, in all other elements his pattern of analysis can be applied to the two centuries before 1800,

as well as after. This system of production was a major intermediary step on the way to the more intensive factory/sweated labour symbiosis in place after 1850. The stimulus for the transformation of the clothing trade did not appear fully fledged in the nineteenth century as contemporary reformists and some subsequent historians believed.[36] Modernization and diversification within the garment industry predated nineteenth-century sweat shops, factories, and sewing machines; structural reorganization arose in an earlier era with the changing scale of demand for clothes that arose from growing armies, navies, and cities; and with these changes came sweated labour.

Many shopkeepers engaged seamstresses to make stock items in the back of the shops, while merchants with large contracts arranged for centralized cutting under close supervision, distributing pieces for sewing to a crew of women. Subcontracting was common, and large merchants farmed out parts of an order. At the same time, there were specialized manufacturers of single commodities—variety was a distinguishing feature of the trade—and these complementary manufacturing techniques dressed mariners, military, and civilians of many ranks.

QUILTING, QUALITY, AND MATERIAL EVIDENCE

Ready-made wares clothed "sirs" as well as servants.[37] Trade cards, advertisements, and bill heads confirm the plethora of businesses and the diversity of output over this era; and more concrete evidence can be found in the material evidence in museum collections. Given the volume of garments produced over this period, it is not surprising that identifiable examples would survive to this day; and with this in mind, I searched one of the major textile and costume collections in North America at the Royal Ontario Museum (ROM) in Toronto. Findings made there were subsequently cross-checked with the collections at the Museum of London. The costume and textile holdings at the ROM are a full and diverse representation of the major European costume and textile products, with some outstanding bodies of artifacts.[38] These eighteenth-century garments offered the opportunity to look for insights into the organization of production, as well as characteristics of ready-made clothes.

Different sorts of problems are posed by looking at garments individually or in groups, rather than considering solely written evidence. First, one must ask if extant objects are representative of the mass of eighteenth-century clothing. In fact, variations in fabric, finish and stitching were the norm before mechanical factory production; thus, I would

expect variations to some degree in surviving items from this period. Randomness in survival is also bound to be reflected in collections, as few examples of common clothing outlasted the second-hand market, and fewer still of the cheapest sort. Moreover, until very recently museums sought costly garments, rather than plebeian ware and, thus, most major museum collections are top heavy with high quality objects. But, even so, traces of new patterns of clothes production can be found in some eighteenth-century artifacts. The choice of garment to be assessed is important. For this study I examined a basic item: quilted petticoats.[39] Sufficient numbers of these garments survive to ensure a sense of their typicality, as quilted petticoats were a staple throughout this period, employed as practical insulation against the cold as well as a visible surface for decorative embellishment. Ready-to-wear petticoats were widely available in specialist shops or warehouses as the physical properties of these garments made them ideal ready-made commodities. Fitting was unnecessary, as the waistband tapes could be drawn and tied to fit. Hooks and eyes or buttons were added or adjusted as required. The dimensions of a petticoat were less related to the size of the wearer than to the width of hoops or the number of under-petticoats employed, along with the budget of the buyer. And though various colours, prints, and quilting patterns came in and out of fashion, petticoats continued as essential parts of dress up to 1800.

These garments ranged from the economical to the extravagant, and not surprisingly, more of the costly sort survived to our time. Over two dozen petticoats were studied in the ROM collection and another dozen at the London Museum, while a further dozen were reviewed from published sources.[40] Although most of the quilted petticoats were made of silk, from the first examination of these artifacts, they showed a direct connection to the ready-made trade, with standardized elements of construction and composition. Uniformity and regularity distinguish most of these garments. The top fabric was usually dyed silk or satin; the backing was linen or wool fabric, frequently glazed worsted wool, with wool batting for insulation. Linings occasionally matched the top fabric in colour, while the pocket and back openings were bound in matching tape or ribbon, as was the hem of the petticoat. Quilting techniques were particularly telling. Quilting over the top two-thirds usually followed a simple configuration of lozenge design, diamond or scallops, with various more elaborate floral motifs picked out on the bottom third. Though attractive, very little of the quilting approaches the highest levels of dexterity, and designs were notable for their fluid stitchery, with the intermediate spaces left unquilted.[41] These goods were valued for the fabric and for the novelty of the quilting, if not the perfect stitchery. Compared to the more detailed quilting found in other apparel of the period, sometimes produced by

family members for loved ones, one can perceive a standardized labour component in even the most attractive of the quilted petticoats.

Many clothes dealers offered petticoats as part of their stock and specialist petticoat manufacturers also sprang up, for example, in London and in the Manchester region, selling in bulk especially after 1750. One London manufacturer advertised in 1779 that the goods offered for sale ranged in price from six shillings for a stuff petticoat to from twenty-one to sixty shillings for satin; other dealers offered satin petticoats at eighteen to twenty-eight shillings.[42] Silk and satin petticoats, examples of which are likely in most large costume collections, were costly; however, additions to the basic quilted satin petticoat could raise the price further still. The most elaborate garment discovered in the ROM collection is a coral-coloured satin petticoat, lattice quilted, which matched the others in the sample in construction and fabric composition with one amendment. Prior to quilting, the bottom third of the skirt was festooned with highly elaborate floral embroidery, after which the piece was quilted. If ready-made, this garment represents pre-eminent warehouse merchandise. With that one exception, the rest of the collection was not distinguished by flawless or outstanding needlework; rather, these petticoats illustrate the range of new and varied designs offered to customers looking seasonally for fashionable additions to their wardrobe that incorporated the motifs then in vogue.

A critical examination of the quilting reveals that their creation did not involve weeks of work. Seams were executed in long running stitches, as was the quilting which joined the lining, wool batting, and top fabric. Approximately half of the silk petticoats follow an identical model of decoration.[43] Several others varied only in that they were plainly quilted in diamond or lattice pattern from top to bottom and would have been cheaper as a consequence.[44] Aside from the silk goods, there is another garment in the ROM collection, heavier, more durable, and made of indigo dyed worsted wool. It is very similar to one in rose worsted held in the Colonial Williamsburg Collection, illustrative of an everyday garment that is now much rarer than its silk counterpart. Such items were advertised by one petticoat manufacturer as among the "cheaper" types of stock he carried. Typically they were worn until worn out, or modified into a bed quilt; such had been the fate of the ROM's blue petticoat when it was discovered and added to the Toronto collection.[45] All the garments quilted in floral patterns, including the blue worsted, show a characteristic irregularity, suggesting that templates were not employed. Seamstresses might look at drawings or cartoons of new designs, or draw inspiration from printed fabrics. No doubt, after years of quilting, experienced needlewomen adapted and modified patterns with ease. Variety in design and fabric, speed of manufacture, and a basic competence in execution were the

hallmarks of this type of production and clearly apparent in these examples. The end results were described by the owner of a petticoat warehouse who announced that he could offer "a very large assortment of fresh quilted [petti]coats, in new and elegant patterns, never before quilted."[46]

The petticoats themselves reveal their method of manufacture. They were probably quilted on frames by more than one seamstress, with simpler elements performed by less adept hands. A 1747 description of the trade described quilting as chiefly women's work, wherein "poor Girl Apprentices" were taken on "for the sake of their Work…. However, a Journeywoman will earn 1s.-1s.6d. and 2s. a Day at it."[47] The size and value of the garments also raise questions about the circumstances in which the articles were made. Domestic manufacture in a small room was the usual site of production for shirts, waistcoats, caps, or handkerchiefs. However, the value of the yardage needed for silk petticoats exceeded that of a parcel of shirts many times over, and the logistics of quilting large items might also had their own practical challenges for garret dwellers. Manufacturers, anxious to avoid embezzlement, wanted workers under their eye so would arrange the quilting frames in a central space (the expense of maintaining a workshop was balanced by better protection of the costly fabrics in a centralized work site) as well as closer control over the design process and execution, both critical factors for business success. Quilting frames would be best assembled in workshop spaces, and advertisements from two of the prominent warehouses confirm that large workshops lay behind the public retail emporiums. One owner stated explicitly that the "elegant patterns" quilted by his workforce were "quilted under his immediate inspection."[48] An eighteenth-century commentator stated: "There have been some (and there still are such) who used to buy in the Materials wholesale, which they put out to be made up into Quilts, and so served the Shops there with, as they wanted them, by which Trade they got a great deal of Money."[49]

As the ready-made trade grew, manufacturers employed a scattered force of needlewomen, and in some branches of the industry, this pattern continued unchanged. But the trade was always differentiated and also included large-scale workshop production, overseen by owners or supervisors. Just as stock varied, so the production of clothing assumed various forms, from batch production in small and large workshops to large-scale proto-industrial putting-out. Manufacturing sites also sprang up in conjunction with textile trades over the century. From the 1760s, and probably earlier, Irish linen districts shipped shirts to London clothing manufacturers and wholesalers.[50] Likewise, in Lancashire, the manufacture of apparel developed as an off-shoot of the textile industry during the eighteenth century, initially with petticoat manufacturing.[51] There is no doubt that the transfor-

THE DISTREST POET.

THE DISTREST POET, AFTER HOGARTH, 1740, IN REV. JOHN TRUSLER, THE COMPLETE WORKS OF WILLIAM HOGARTH, IN A SERIES OF ONE HUNDRED AND FIFTY-SEVEN ENGRAVINGS, FROM THE ORIGINAL PICTURES, ...IN TWO VOLUMES, (LONDON: H. FOWKES, BETWEEN 1837 AND 1848) VOL. 1. AUTHOR'S COLLECTION.
THIS FAMOUS IMAGE REFLECTS THE GENERATIONS OF WOMEN WHO SUSTAINED THEMSELVES AND THEIR FAMILIES PLYING THEIR NEEDLE.

mation of the clothing trade incorporated most of Britain, as market centres and as points of complementary production.[52]

Contemporary depictions of these trades are scarce. However, in Hogarth's famous image, *The Distressed Poet* (1740), we are offered a glimpse of the circumstances of production for many. Usually viewed as a landlady haranguing a distracted poet, we could just as easily be viewing a wife sewing to support her family and her husband in his creative aspirations, in one of London's many attic rooms. In 1764 Sarah Sackfield was one of the managers who arranged the putting-out of sewing work to needlewomen working in their homes, and she identified an article of clothing for her employer, John Forbes, during a court hearing. Forbes and his wife owned a general clothes shop near the Hermitage Bridge, and Sackfield related to the magistrate: "I do business for Mr. Forbes (she takes a plaid waistcoat in her hand); this I can swear to with certainty: I did not make it myself, but I gave it out to be made for Mr. Forbes."[53] Women workers were not restricted to the making of shirts, handkerchiefs, and other underclothes; but they were generally channelled "into particular branches that did not compete directly with the men,"[54] many of which were poorly paid. Slopsellers, tailors, and saleswomen who did not employ workers on their premises put out pieces to be made up, employing both tailors and needlewomen in some cases, with

TRADE CARD, TIMOTHY ADAMS, AT THE OLD TUNS NEAR THE END OF GRAVEL LANE IN HOUNDSDITCH, LONDON. GUILDHALL LIBRARY, CITY OF LONDON, C.1770. *TIMOTHY ADAMS WAS ONE OF THOUSANDS OF DEALERS IN BRITAIN, EMPLOYING NEEDLEWOMEN IN THE TENS OF THOUSANDS TO STITCH THE SHIRTS, APRONS, "FLANNEL COATS" AND "WORK'D PETTICOATS" SOLD IN THESE EMPORIUMS.*

characteristic inequities in the rates of pay.[55] This was a trade soon to be made infamous in the nineteenth century, when sweating was discovered by social reformers—though sweated labour long predated the nineteenth century.[56] One slop maker calculated that c.1800, he and his partner employed from 1,000 to 1,200 workers each week to sew their shirts. When asked to be more precise about the numbers, he responded: "It is impossible to guess, I could not state the number within five hundred; we employ a great number of parishes, and how many of the poor are employed upon our work it is impossible for me to tell."[57] In the crowded rookeries of London, behind the High Street shops, and in the congested dock-sides slums, women in their thousands were absorbed in perhaps the most anonymous of industries.

CONCLUSION

Renewed population growth from 1750 onwards brought greater numbers of women competing for work into the labour market, ensuring, at best, static piece rates. Demand for apparel encouraged the development of more and larger enterprises, which also profited from the falling cost of industrially produced fabric later in the eighteenth century. Women could not address the conditions in which they laboured, except in covert acts of embezzlement or theft.[58] There was no possibility of their seeking support from the nascent trade unions, for the level of antagonism between male tailors and needlewomen barred women from participation in most labour actions. The trade was in flux, with the flash point the organization of labour. Contiguous within this process was an ongoing antagonism expressed by men in this trade towards women in the clothing trade, an antipathy framed by the implied link between skill and gender. An advertisement from William Ghrimes, Taylor and Habit-maker of Tower Hill, exemplifies the gendered demarcation. Beneath the list of garments and prices printed on his broadsheet Ghrimes included a small subscript which read: "Not made by Women, as is customary at the Warehouses, but by the best Workmen that can be got."[59] The superiority of his goods was assured, Ghrimes claimed, not just because much of his stock was not ready-made, but also because it was not made by women. The claims in this advertisement from the second half of the eighteenth century hark back to the guild campaign of over fifty years earlier and presage the tailor's trade union battle against women in the clothing industry in the 1830s. The latter campaign may have arisen at a period of trade crisis, but the economic and cultural structures which gave rise to this crusade were in place well before that time.[60] Skills were assumed to be a male

prerogative, and in the deeply contentious environment of the clothing trade, women struggled in vain to reverse this conviction.

The characteristics of production weighed heavily on women. The skills necessary in an industry producing for ever larger domestic and overseas markets were those of speed, competence, and above all, endurance. Legions of women were defined as unskilled or semi-skilled because they were adults of the other sex making apparel, regardless of the quality of the goods being made. Certainly the standard of ready-made clothes varied widely, but so, too, did the work of tailors, from the fashionable London tailors to their rural confederates, whose principal tasks involved the reseating of breeches and letting out of waistcoats.[61] Periodically, advertisements for women workers appeared at the bottom of advertisements for clothing. The stipulated requirements were for "those that can work exceeding well," in the case of a shirt warehouse, or "Journeywomen that are good 'mantua-makers,'" in the case of a warehousewomen's ad.[62] The number of women outworkers, paid by the piece, working in their own lodgings or in workshops, defies any precise accounting. The expansion of the clothing industry provided work in abundance for women over this period; and while the largely female urban work force furnished the productive impetus for the growth and expansion of this industry, the products of their labour brought new commodities before the consumers, including generations of sailors and soldiers. What Jenny Morris noted concerning a later period applied also in this era: that "the development of a sexual division of labour…went hand in hand with the advancement of the trade."[63]

The sex-specific divisions opened between men and women before 1800 would be reinforced in the nineteenth century. Inextricably tied to the common fabrics and basic finishes, the ready-made clothing trade was geared to the broadest of markets. The labour of women underpinned this industry and was the principal agency in its growth before, during and after industrialization, when sweated work would flourish in conjunction with factory production for generations. Ready-made items in popular fabrics or colours, utilitarian or stylish, were prototypes for a pattern of production, a pattern of sale, and a pattern of society, which would become the measure of the industrial age.

ENDNOTES

1 N.B. Harte, "The Economics of Clothing in the Late Seventeenth Century," in N.B. Harte, ed., *Fabrics and Fashions* (New York: Oxford University Press, 1991) 278.

2 The low cost of women's pay was critical to profitability in many industries, enabling an expansion of production and a new range of goods. See Maxine Berg, "Women's Work, Mechanisation and the Early Phases of Industrialisation in England," in Patrick Joyce, ed., *The Historical Meanings of Work* (Cambridge: Cambridge University Press, 1987) ; and *The Age of Manufactures, 1700-1820*, 2nd edition (London, New York: Routledge, 1994).

3 Recent additions to the histories of articles of dress (hosiery and shoe) include: Stanley Chapman, *Hosiery and Knitwear: Four Centuries of Small-Scale Industry in Britain, c.1589-2000* (New York: Oxford University Press, 2002) and Giorgio Riello, *A Foot in the Past: Consumers, Producers and Footwear in the Long Eighteenth Century* (New York: Oxford University Press, 2006).

4 Book of Fines, Misc MSS 119/12, pp. 161, 234, 235. Corporation of London Record Office (CLRO).

5 Ms. Morrell 6, f.137, 28 June 1647.

6 Ms. Morrell 6, f. 142, 3 January 1648. Election and Order Book 1570-1710, Oxford Company of Taylors, Bodleian Library.

7 M. Morrell 6, f. 174, 12 September 1661.

8 Ms. Morrell 6, ff. 195 v., 27 April 1669; 212v. 12 September 1676. From the use of the term "milliner" one might assume that those indicted were women; however, only one among the many charged was female. All the rest were male.

9 Oxford Petty Sessions, ff. 108, 110, 111.

10 WP B 8(7), The State of the Case of the Milliners of Oxford, 1668. University Archives, Oxford University.

11 WP B 8(7).

12 Ms. Morrell 6, f. 195 5 January 1669; f. 197 28 October 1669.

13 G22/1 Minute and Account Book, Merchant Taylor's Company, 1700-1703, Chester City Record Office.

14 PROB 32/67/129, National Archives.

15 #570, Orphans Inventories, CLRO.

16 Isaac Parker was a London-based staymaker who regularly attended the Bristol Fair, carrying with him "a quantity of Goods." PROB 3/33/138, National Archives.

17 Ms. Morrell 6, ff. 267v., 269 v., 5 May & 11 March 1696; Ms. Morrell 7, Company of Taylor's Order Book, 1710-1833, ff. 6, 8, 16 April 1711, 16 October 1711.

18 Ms. Morrell 7, f. 39 24 June 1725.

19 Artifacts made for the ready-made clothing trade can serve as indicators of patterns of work.

20 Sara Mendelson & Patricia Crawford, *Women in Early Modern England* (New York: Oxford University Press, 1998) 90-1, 218-225, 271-3; See also the testimony of witnesses on the later parochial training offered girls in metropolitan schools. *Parliamentary Papers, Report on the Education of the Lower Orders in the Metropolis* IV (1816).

21 Ilana Krausman Ben-Amos, "Women Apprentices in the Trades and Crafts of Early Modern Bristol," *Continuity and Change* 6.2 (1991): 236, 232-248.

22 K.D.M. Snell, *Annals of the Labouring Poor. Social Change and Agrarian England, 1600-1900* (Cambridge: Cambridge University Press, 1985) 311. For a critique of Alice Clark's assertions with respect to a pre-industrial

golden age for women, see Peter Earle, "The Female Labour Market in London in the Late Seventeenth and Early Eighteenth Centuries" *Economic History Review*, 2nd series, 42.3 (1989): 339.

23 Eng. Ms. WH/864, Bodleian Library. This tailor's day book kept by Humphries of North Weston, Thame, Oxfordshire from 1757-78, records the work done by him, his wife and several men, perhaps apprentices or journeymen. Mrs. Humphries's work was accounted to be worth half that of her husband at 6d.per day.

24 Roger Finlay & Beatrice Shearer, "Population Growth and Suburban Expansion," in A.L. Beier & Roger Finlay, eds., *London: The Making of the Metropolis, 1500-1700.* (London: Longman, 1986) 50-1.

25 The Proceedings of the Old Bailey: Associated Records: pamphlet, British Library, 515.I.2.(107) *A True Account of the Behaviour, Confession, and Execution of William Charley and Ann Scot...* (1685): 1-3.

26 *The Ordinary of Newgate, His Account of the Behaviour, Confession and Last Dying Speeches of the Condemned Criminals... Executed at Tyburn* (May 1717) 5. The Ordinary of Newgate was the prison chaplain, whose duty it was to provide spiritual care to prisoners condemned to death. One of the perquisites of the Ordinary's job was the right to publish the prisoner's final confession together with an account of his life. This series of publications was entitled *The Ordinary of Newgate, His Account of the Behaviour, Confession and Last Dying Speeches of the Condemned Criminals... Executed at Tyburn.* Publishing these accounts was a profitable sideline, earning the Ordinary some £200 a year in the early eighteenth century, and some 2,500 such Accounts were published in the century following the inception of the Old Bailey Proceedings.

27 The Chester Merchant Tailor's Company Minute and Account Book shows repeated prosecutions women infringing guild rights. G22/1, Chester City R.O. A prominent Salisbury official was fined 40s. at the turn of the century as a result of employing a woman in his workshop. WRO G23/1/254, 11 January 1770, Wiltshire R.O.

28 Bernard Johnson, *The Acts and Ordinances of the Company of Merchant Taylors in the City of York* (1947), pp. 84-6; G22/1, Minute and Account Book, Merchant Taylor's Company, Chester City R.O.; Barbara Taylor, "'The Men Are as Bad as Their Masters': Socialism, Feminism and Sexual Antagonism in the London Tailoring Trade in the 1830s" in Judith L. Newton, Mary P. Ryan and Judith R. Walkowitz, eds., *Sex and Class in Women's History* (New York and London: Routledge, 1983). L.D. Schwarz, *London in the Age of Industrialisation: Entrepreneurs, Labour Force and Living Conditions, 1700-1850* (Cambridge: Cambridge University Press, 1992) 191-2. For a later example of gendered division of labour see: Katrina Honeyman, "Following Suit: Men, Masculinity and Gendered Practices in the Clothing Trade in Leeds, England, 1890-1940" *Gender & History* 14.3 (2002): 426-446.

29 Merry Wiesner, "Guilds, Male Bonding and Women's Work in Early Modern Germany" *Gender and History* 1.2 (1989) presents the social and cultural context for journeymen's hostility towards women in the clothing trade at a period of trade transition.

30 Johnson, *Acts and Ordinances* 57; 70-76; 81-94. Johnson relates in some detail the pursuit of Mrs Mary Yeoman from 1699 for a period of over two years and with a cost to the guild of over £40.

31 Ms. Morrell 16, f. 31, 26 October 1702.

32 WRO G23/1/254, 14 October 1702. Salisbury Guild of Tailors, Wiltshire Record Office, Trowbridge; minutes quoted in Johnson, 158-9. For a full study of guild activity over the long eighteenth century see, Michael John Walker, "The Extent of the Guild Control of Trades in England, c.1660-1820," unpublished Ph.D.. Cambridge University, 1985.

33 A.L. Beier, "Engine of Manufacture: the Trades of London," in A.L. Beier & Roger Finlay, ed., *London: The Making of the Metropolis,* 1500-1700 (1986) 159.

34 E.J. Hobsbawm, *The Age of Revolution* (London: Vintage, 1967) 55.

35 Duncan Bythell, *The Sweated Trades: Outwork in Nineteenth-Century Britain* (London: Palgrave Macmillan, 1978) 15-16. Other studies of sweated work which concentrate on the nineteenth century clothing trade include, James A. Schmiechen, *Sweated Industries and Sweated Labor* (London: Croom Helm, 1984); Jenny Morris, *Women Workers and the Sweated Trades:The Origins of Minimum Wage Legislation* (Hampshire: Gower Publishing Company, 1986).

36 Schwarz 179-188. Schwarz suggests that the clothing trade was "very largely" bespoke even in the last half of the eighteenth century, missing the connection with the contracting of slops and the broader extension of ready-made clothing for the mass market.

37 Manufacturers were making ordinary sorts of clothing that sold within the domestic market and this trend was recognized by a commentator on clothes for the poor later in the eighteenth century. Anon. *Instructions for Cutting out Apparel for the Poor* (1789) 56. I would like to thank Madeleine Ginsburg for telling me about this source.

38 I would like to thank Adrienne Hood for her unflagging encouragement of this project and my opportunity to work as a Gervers Fellow at the ROM.

39 The description of the quilting trade used for petticoats reflects the same style of organization as with other items of apparel. *A General Description of all Trades, Digested in Alphabetical Order: by which parents, guardians, and trustees, may … make choice of trades agreeable to the capacity, education, inclination, strength, and fortune of the youth under their care…* (London: Printed for T. Waller, 1747) 117, 178-179.

40 Anne Buck, *Dress in Eighteenth Century England* (Batsford, 1979); Linda Baumgarten, *Eighteenth Century Clothing at Williamsburg* (Williamsburg: Colonial Williamsburg Foundation, 1987); and *What Clothes Reveal* (New Haven: Yale University Press, 2002); *Revolution in Fashion* (Kyoto: Kyoto Costume Institute, 1989).

41 Some examples of artifacts with these characteristics include: 931.41, 959.250.4, 976.199.97, 920.28.4B, 958.96.6, 930.107, 959.141.1 Textile Department, Royal Ontario Museum, Toronto; 54.78/2, 39.83/7, Z656, Z876, 53.146, A12978, NN8186 Costume Collection, Museum of London.

42 *The Gazetteer and New Daily Advertiser* 14 & 20 January 1779; 12 October 1779.

43 959.250.4; 931.41; 958.96.6; 976.199.97; 920.28.4B; 930.107; 932.23; 959.141.1; 975.241.91; 926.39.4; 972.286.3a. Textile Department, Royal Ontario Museum.

44 34.173/1, Z758 Costume Collection, Museum of London; 926.39.4, 975.241.91 Royal Ontario Museum.

45 *The Gazetteer and New Daily Advertiser* 14 January 1779.

46 *The Gazetteer and New Daily Advertiser* 14 January 1779.

47 *A General Description of all Trades, Digested in Alphabetical Order…* 178-9.

48 *The Gazetteer and New Daily Advertiser* 20 January 1779; 12 October 1779.

49 *A General Description of all Trades, Digested in Alphabetical Order…* 179.

50 *The Public Advertiser* 4 March 1762; 5 April 1762. For an analysis of the nineteenth-century clothing industry, which developed along side Irish linen manufacture, see Brenda Collins, "The Organization of Sewing Outwork in Late Nineteenth-Century Ulster," in Maxine Berg ed., *Markets and Manufacture in Early Industrial Europe* (New York and London: Routledge, 1991). There is also evidence of shirt production in Edinburgh for shipment to

London distributors at about this time. Contractors numbered the seamstresses in their ledger. Personal corre-
spondence, Dr Elizabeth Sanderson.

51 Lemire, *Fashion's Favourite* 190-197; A.P. Wadsworth & Julia de Lacy Mann, *The Cotton Trade and Industrial
Lancashire* (Augustus M. Kelley Pubs, 1931) 257. Five petticoat manufacturers were noted in a 1781 directory of
Manchester; while in a 1788 directory, a slopseller was noted as well. *Lewis's Directory for the Town of
Manchester and Salford for the Year 1788* (reprinted 1888), p. 6. The rise of the port of Liverpool further stimulat-
ed the regional manufacture and sale of clothing. Ms. 11936, # 553919; # 554653; # 133616; # 145588; # 148017;
133000; # 57927; Ms. 11937, # 646149; # 641729, Sun Fire Insurance Registers; Ms. 7253, # 77866, Royal
Exchange Insurance Registers, Guildhall Library, London.

52 Journeymen tailors were sought for the ready-made trade in a series of advertisements. *Northampton Mercury*
4 April 1763; 11 April 1763.

53 *Old Bailey Records*, January 1764: 54.

54 Schwarz 186.

55 PROB 32/67/129, PRO; A/FH/BH/10, GLRO.

56 *Old Bailey Records*, February 1800: 205. Francis Place and his wife Elizabeth worked in exactly this manner for
many months after he was blacklisted by his former employer for strike activity. Mary Thale, ed., *The
Autobiography of Francis Place* (Cambridge: Cambridge University Press, 1972) 114-125.

57 *Old Bailey Records*, September 1800: 500-1.

58 See John Styles, "Embezzlement, industry and the law in England, 1500-1800," in Maxine Berg, ed., *Markets and
Manufacture in Early Modern Europe* (New York and London: Routledge, 1991) 173-181. Women's patterns of
theft were linked to their areas of employment and the female networks developed in their daily lives. For a re-
evaluation of women's criminal behaviour see, Garthine Walker, "Women, Theft and the World of Stolen Goods,"
in Jenny Kermode & Garthine Walker, eds., *Women, Crime and the Courts in Early Modern England* (Chapel Hill:
The University of North Carolina Press, 1994).

59 4047, Heal Tradecard Collection, British Museum.

60 Judith Bennett proposes that historians re-examine the manifestations of misogyny not least for their serious
economic impact on women's employment opportunities and work conditions. The underlying circumstances
which restricted women from guilds, relegated them to low-paid piece work and stigmatized their labour as
unskilled should certainly recognize the cultural context in which women lived and worked, including the power
of misogyny. See Judith Bennett, "Misogyny, Popular Culture, and Women's Work," *History Workshop Journal* 31
(1991). Merry E. Wiesner discusses the concepts of unskilled labour in "Spinsters and Seamstresses: Women in
Cloth and Clothing Production," in Margaret W. Ferguson, et al., *Rewriting the Renaissance: The Discourses of
Sexual Difference in Early Modern Europe* (Chicago: University of Chicago Press, 1986) 200-5.

61 C.108/30, PRO; WH/864, Eng. Ms., Bodleian Library.

62 *The Public Advertiser* 29 March 1765; 14 January 1771.

63 Jenny Morris, "The Characteristics of Sweating: The Late Nineteenth-Century London and Leeds Tailoring Trade,"
in Angela V. John ,ed., *Unequal Opportunities: Women's Employment in England 1800-1918* (London: Blackwell
Publishers, 1986) 95.

HANDMADE IDENTITY: CRAFTING DESIGN IN IRELAND FROM PARTITION TO THE TROUBLES

JOSEPH MCBRINN

In an article on Irish crafts, published in Dublin in 1941, the artist Michael Burke lamented that the statement, "we here show our national share in the general effort to combine quality with appearance using our people's artistic instincts and resources," was not a description he could have applied to current displays of Irish design. Rather, it was a description of the *Swedish Industrial Art* exhibition held at Dorland Hall, London, in 1931, which had signalled the ascendancy of the Scandinavian model in global design.[1] Civil War and Partition had divided Ireland in 1922, creating two artificial states, alienating makers and thinkers, shattering the national connections of the Arts and Crafts movement, and creating seemingly irresolvable cultural, political, and economic tensions; however, the Scandinavian countries of Sweden, Denmark, Finland, Norway, and Iceland had used their separation as a basis for unity and developed their Arts and Crafts movements into a cohesive design tradition which fused craftsmanship and mass manufacture into what was seen, especially in Sweden's case, as "a viable form of Modernism."[2] Ever since W.B. Yeats had lauded the "national character" of Scandinavian culture in his Nobel Prize speech of 1923, the comparison to Ireland had been pointed. This was especially true since, by the 1920s, the Celtic Revival in Ireland seemed so moribund, and the comparative Scandinavian Viking Revival had successfully been transformed into a basis of a modern design culture.[3]

Modernity was characterized by the evolution of the mass-produced commodity, the emergence of the professional designer, and the global homogenization of culture throughout the Western world, all of which defined the development of political economies based on Western capitalism. It is quixotic, then, that for most of the twentieth century, Irish

design remained rooted in traditional and vernacular crafts. However, the evolution of a distinctly Irish identity in design, from the key historical point of Partition in the 1920s to the Troubles in the 1970s and after, was directly, and deliberately, shaped by two interrelated crafts revivals of the inter-war and postwar years. The handmade became a symbol of continuity, an emblem of stability, and an icon of identity; and it was harnessed by the two newly created Irish governments to create a design culture reflective of the modern era but faithful to Ireland's uniquely vibrant vernacular tradition. Both states cited Scandinavian design—which has been characterized by Jennifer Opie as based upon "craftsmanship, quality, humanity and restraint" as well as a respect for "natural materials" and a concern for responsible production and consumption—as their benchmark.[4]

This paralleled the development, between the 1920s and 1950s, of Irish folk life studies and the creation of state-owned ethnographic institutions, which took direct responsibility for peasant art especially that in the form of utilitarian craft.[5] The first modern Irish anthropologists and ethnographers, such as Seamus Ó Súilleabháin and E. Estyn Evans, emulated the methodologies of Swedish folk studies and openly acknowledged their debt to figures such as C.W. von Sydow and Åke Campbell of the universities at Lund and Uppsala.[6] Studies have revealed just how closely intertwined the evolution of folk life studies, and the crafting of a modern design culture, was in Scandinavia.[7] Seamus Ó Duiléarga, the first director of the Folklore of Ireland Society (An Cumannle Béaloideas Éireann), which was founded in 1927, hoped that a similar use of the "past" in Ireland would "bring forth from the shadows of unmerited oblivion the story of the Irish peasantry" uniting tradition and identity with modernity.[8] Karl Marx's axiom, "social existence determines conscience,"—as well as his characterization of the mechanisms of political economy and its effects upon Europe's ancient peasantries—were taken up by Irish revolutionaries, such as James Connolly, Patrick Pearse, and Roger Casement, who argued that Ireland's colonialization (and ultimately Partition) were a result of capitalist interests.[9] The solution to a political economy based on capitalism, they believed, was the restoration of a pre-colonial society, with its unique craft specializations, as had been outlined by the utopian idealizations of Marx and Engels.[10]

To understand the development and significance of craft in modern Ireland, it is necessary to consider the two distinct ways craft evolved and was characterized in relation to design: as both sign and praxis. The signification of craft evolved as handmade objects became imbued with symbolic meanings of authenticity, tradition, and heritage, and became seen as agents of transformation, changing everyday commodities into signs of modernity. Later, the application of this ideology into a practice became a matter for state

intervention; and craftsmanship was linked directly to mass-manufactured design with the aim of reinvigorating the economy and more especially—reformulating national identity.

FROM COUNTRY CRAFTS TO INDUSTRIAL ARTS: CRAFT AS SIGN

In 1974 the writer John Manners defined "country crafts" as making based upon tradition-al "skill, patience, dexterity and experience" in a "rural" context.[11] It is an image which has dominated Irish craft in the twentieth century, even though the examples Manners and other writers such as Susan Mosse, David Shaw-Smith, and Megan McManus have drawn upon are characterized by widespread urban activity and consumption.[12] Analysis of this process of signification, whereby handmade objects became symbolic of the rural and thus signs of ethnicity, reveals that modern crafts were not just commodities but rather signs understood, not by the aesthetics or technologies of their facture, but by the system in which they operated. Jean Baudrillard has characterized this shift as the change from the Marxist idea of a political economy of commodities to a modern political economy of signs.[13] In this new system the sign-value rather than the use-value of objects is given pri-macy and, as such, "country crafts" became of increasing importance for the two Irish governments who were seeking to reinvent their identities.

The main promoter of "country crafts" in twentieth-century Ireland was Muriel Gahan, who was a campaigner rather than a maker. Gahan was aware of the need to modernize Irish society, and from the 1930s, she sought to use craft as her modernizing tool. In 1929 she joined the United Irishwomen, which was founded in Dublin in 1910 to promote improved conditions for women in education and employment, especially in rural areas.[14] In the 1930s, Gahan set about reforming the society, which changed its name to the Irish Countrywomen's Association in 1935. She helped establish the Country Workers Ltd. and the Country Markets, and took over organizing the Irish Countrywomen's Association's craft display at the Royal Dublin Society's annual show, which led to a major reconfiguring of the way in which crafts were displayed and distributed in Ireland.[15] Weaving and domes-tic crafts most interested Gahan. Although she was inspired by the work and writings of English Arts and Crafts figures such as Ethel Mariet, as well as the Rural Industries Bureau which had been set up in England in 1921 to assist rural production, she set about reviv-ing, and reinventing, the native Irish, pre-colonial tradition of handmade textiles, arguing that there was "no handcraft that gives more satisfaction to the maker."[16] Gahan searched far and wide for surviving remnants of traditional handweaving in counties Donegal, Mayo,

Kerry, and Galway; and in 1930, she brought from Castlebar, in Co. Mayo, the handloom weaver Patrick Madden to give demonstrations at the Royal Dublin Society.[17] In 1935 she established the Irish Homespun Society (An Cumann Sniomhachain), which gave focus to spinning, weaving, and dyeing but also supported a whole range of other crafts. These were not isolated developments. In 1932 the Women's Institutes of Northern Ireland were founded in the North, along lines similar to the Irish Countrywomen's Association, and began rescuing "dying out" crafts, such as "homespuns" in rural areas like Co. Down.[18] In the 1940s, handweaving workshops were set up by Lillias Mitchell in Dublin and by the Scandinavian-born Gerd Hay-Edie, who had worked in England for the Rural Industries Bureau, in Rostrevor, Co. Down, in Northern Ireland.[19]

In 1930 Gahan established the Country Shop in Dublin, a retail outlet for crafts, where displays of "country crafts" were shown beside the best of modern art and design. Gahan's ability to see the possible modernity within craft is clearly reflected in her juxtaposition of traditional Irish basketwork with Alvar Aalto's plywood furniture, or with work by modern artists such as Gerard Dillon, or the painters associated with the White Stag group, who turned the Country Shop's restaurant into their weekly meeting place, and who organ-

THE COUNTRY SHOP, DUBLIN IN THE 1930S.

PRIVATE COLLECTION

ized lectures there by key thinkers on the arts, such as Herbert Read and John Hewitt.[20] Indeed, the committee of the Irish Homespun Society was made up not just of craftworkers but also prominent modern artists, including Mainie Jellett, Elizabeth Rivers, and Stella Frost. Gahan's idea of opening the Country Shop, she later recalled, was partly inspired by exhibitions of craftwork in early 1930s Belfast.[21] She was referring to the exhibitions of the inter-war craft groups, the Arts and Crafts Society, and the Fireside Arts and Crafts Society, who with the Women's Institutes of Northern Ireland, aimed to provide a much-needed platform for women's crafts in the North. These societies were dominated by thrift craft and domestic work, and developed strong links with the Irish Countrywomen's Association. Like Gahan, who argued "if we must have factories, let them work on their own lines at things that cannot be produced by the countryman in his home,"[22] they were vehemently opposed to industrial production.[23] Commercial and cultural correspondence across the border was wide and varied, and continued throughout the entire twentieth century, irrespective of the military-policed border.[24]

In 1932 the Irish Free State government published its *Saorstát Éireann: Irish Free State Official Handbook*, a manual for the new nation, in which Thomas Bodkin, lawyer and art connoisseur, made the damning indictment that modern "Irish manufactures, though excellent from a technical standpoint, are, for the most part mediocre in design."[25] In 1935, Bodkin, in a lecture, made more pointed criticisms of Irish design as "hackneyed and conventional."[26] Bodkin's statements were reiterated in his *Report on the Arts in Ireland*, commissioned by the government and published in September 1949, in which he highlighted Ireland's contribution to modern design as being in fine crafts, such as stained glass and book design, with no sustained "alliance between the arts and industry."[27] Bodkin pointed to countries such as Sweden, (that had successfully coalesced aspects of art and industry) as examples Ireland should look to for inspiration. The Irish Homespun Society had already, by the early 1940s, taken an interest in Scandinavian design and organized trips to Denmark and Sweden. They subsequently made recommendations to the government about the educational value of teaching and displaying crafts in schools and museums, as was being successfully done in Scandinavia.[28] They also donated material to the National Museum in Dublin, hoping it would form the nucleus of an Irish folk life collection; and Gahan directly approached Seamus Ó Duiléarga and Seamus Ó Súilleabháin, of the Irish Folklore Commission, about the establishment of a national folk museum.[29] In the 1940s, the Women's Institutes of Northern Ireland, backed by Esytn Evans, made a similar petition to the North Irish government to found an Ulster folk museum along lines similar to those in Scandinavia.[30]

If Bodkin's comments were little heeded in the Free State, things couldn't have been more different in the North. In 1935 the North Irish government issued a major *Report on Industrial Art* which was, in part, a response to a similar report completed by Lord Gorrell in 1932 for the Board of Trade in Britain on "good design."[31] In his evidence given to the 1935 Committee, N.E.C. Laughton, secretary of the government's Rural Development Council, suggested that "the influence of rural crafts on general design in industry is very definite indeed"[32] and that although the Rural Development Council in Northern Ireland was founded along the lines of the Rural Industries Bureau, it was neglecting the valuable lessons of small-scale industrial production based upon craft ideas, such as those successfully emerging in countries like Sweden.[33] Sir Roland Nugent, minister of commerce and leader of the Northern Ireland Senate, summed up Laughton's suggestions by concluding that "it was rather like the idea that if you could get a first-class experimental workshop in one centre, possibly on commercial lines, with weaving, smith's work, and so on," which would serve as a design workshop for industry.[34] Aside from the fostering of craft workshops as an aid to industry, the central recommendation of the 1935 report was the creation of a central "Ulster Art Institute."[35] This was, in fact, not taken up by the government; but the Scandinavian models suggested by the 1935 *Report on Industrial Art*, Bodkin's 1935 lecture, and the 1949 *Report on the Arts in Ireland* would have serious implications for the transformation of country crafts into industrial arts in the postwar era.

THE IDEOLOGY OF THE HANDMADE: CRAFT AS PRAXIS

In the late 1940s, Michael Burke, by then principal of the National College of Art in Dublin, wrote to Muriel Gahan that he was in full agreement with her ideas about the significance of crafts in Ireland and suggested the emerging postwar crafts revival should be aimed at reigniting "the spirit of workmanship" in design.[36] By the postwar years, the handmade was already firmly established as a major ideological force in both the new Irish Republic (which the Free State declared itself to be in 1949) and Northern Ireland; but rather than functioning simply as the signification of national identity, the qualities inherent in handmade objects were employed practically to rehabilitate the flagging postwar economy through their application in the design of mass-produced commodities. Thus craft, in essence, ceased being a theoretical construct signifying authenticity and became the actual praxis of state ideology. This change was focused on two key events: the 1951 Festival

of Britain in Northern Ireland, and the *Design in Ireland* report commissioned by the Irish government in 1961.

The Festival of Britain was a series of nationwide exhibitions, which aimed to refocus national identity after the war by illustrating how much Britain had developed in the century since the Great Exhibition in 1851.[37] A series of provincial shows were held in England, Wales, and Scotland; and in Northern Ireland, this took the form of the Castlereagh Farm and Factory Exhibition which drew attention to the positive relations between "Ulster Industry and Craftsmanship."[38] Sir Roland Nugent, as chairman of the Festival of Britain in Northern Ireland, hoped the exhibition would demonstrate the North's contribution to Britain's economy and thus help reposition the province within the remit of British national identity.[39] Although the Castlereagh exhibition aimed to "describe the growth of the linen industry and development of craftsmanship and skill in other local industries," the idea of the vernacular in design seemed to be a crucial nexus.[40] Central to the exhibition was a reconstruction of an "Ulster homestead of 1851," which included examples of metalwork, furniture, domestic

QUEEN ELIZABETH AND PRINCESS MARGARET TALKING TO ROBERT FOYE, A LOCAL HAND-LOOM WEAVER, ON THEIR VISIT TO THE CASTLEREAGH FARM AND FACTORY EXHIBITION ON 1 JUNE 1951.

BELFAST CENTRAL LIBRARY

utensils, and a spinning-wheel: objects which the catalogue stated were not obsolete but still in daily use.[41] The display suggested that Ulster's vernacular material culture was the root of modern industrial achievement. The image of Northern Ireland as indisputably British was crystallized by a royal visit to the exhibition. The image of Queen Elizabeth and the young Princess Margaret, who stopped to admire the "beautiful work" of the weaver Robert Foye whilst he was operating an old loom, was widely publicized.[42] The link between modern design and vernacular crafts was taken further in Nugent's suggestion that the display of local craft at the exhibition could provide Ulster with "a permanent Folk Museum," which he hoped would be "an open air display of Ulster life and traditions at Belfast castle on the model of the famous folk museums in Scandinavia."[43] The Ulster Folk Museum was subsequently founded in 1958 by an act of parliament.

Although the recommendations of the 1935 *Report on Industrial Art* had no tangible outcome in Northern Ireland, the fallout from Bodkin's 1949 *Report on the Arts* in Dublin saw the establishment of the Arts Council of Ireland (An Chomhairle Éalaíon) in 1951. Not only had Bodkin stated it was the "lack of State support that killed alliance between art and industry" in Ireland, but in Britain the staging of the Festival of Britain was providing an unparalleled opportunity to showcase British design, even in the very creation of tourist souvenirs.[44] In the 1950s, the Arts Council of Ireland would assume responsibility for the promotion of national design, which they aimed to ameliorate through exposing the public to the best of contemporary international design in a series of exhibitions, such as the 1953 *Modern Art in Finland*, one of the first major postwar displays of Scandinavian design that toured Europe and North America.[45] In 1952 the newly-formed Córas Tráchtála Teo (CTT), the Irish Export Board, assumed responsibility for design matters and under the direction of William Walsh, CTT made the promotion of "good design" a priority. In 1961 CTT invited a group of distinguished Scandinavian industrial designers and educators to prepare a report on contemporary design in Ireland.[46] The now-famous *Design in Ireland* report was published in February 1962, and its severe criticisms of Irish design were seen as "devastating"; but it immediately ushered in a high-profile period of design reform.[47] If the Festival of Britain exhibition in Belfast had stressed the craft roots of modern industrial production, then the *Design in Ireland* report sought similarly to reconnect rural handicrafts with industrial process. The report stated that the successful element in Scandinavian design, that is "a sense of quality in regard to materials and craftsmanship, and, to a considerable extent, the application of traditional forms to modern conditions," urgently needed to be assimilated into Irish design.[48] The report's main recommendation was the setting up of an Institute of Visual Arts, which would lead to an Irish School of Architecture and Design. William Walsh was greatly in favour of this and aimed to have it built in Dublin by Mies van der Rohe, with whom he held discussions in Chicago.[49] However, like the similar recommendations of the 1935 *Report on Industrial Arts* in the North, this was not taken up.

Norway was the only Scandinavian country not to be represented on the *Design in Ireland* committee. In 1962 William Walsh went to Oslo to investigate Norwegian design, where during a visit to the Plus Crafts Workshops at Frederikstad, he was inspired to establish a similar enterprise in Ireland. After securing premises in Kilkenny, the CTT set up the Kilkenny Design Workshops (KDW) in 1963 as a state-run craft consultancy for Irish design, which was believed to be "the first industrial design practice set up by a government."[50] The KDW initially defined its remit as the main Irish traditional and craft-based industries,

woven and printed textiles, ceramics, metalwork, and wood-turning; but this quickly grew to encompass new industries, such as graphic design for packaging and advertising and product design. Initially artists, rather than designers, were employed, most notably the painter Louis le Brocquy and the sculptor Oisín Kelly.[51] Early KDW publications emphasized that "attention has been concentrated on traditional products. This is where innovation starts, where a country's cultural characteristics show themselves, and where the standard for its manufacturers is set."[52] The successful linking of traditional, indigenous craft practice to industrial development earned the KDW an international reputation, and in the 1970s and 1980s, the organization undertook consultancy training in several non-Western countries, who were seeking a framework for the crafting of design.[53] Indeed, the issues raised by Irish craft in the twentieth century, far from being singular or insular, have global resonances, especially in the new, late twentieth-century, non-Western centres of mass production that have similarly marketed, to some extent, their indigenous crafts as folk artifact and tourist souvenir.[54]

HANDMADE, COVER TO CATALOGUE FOR ARTS COUNCIL EXHIBITION OF ULSTER CRAFTS IN 1980.
PRIVATE COLLECTION

In the North, to counter the growing profile of Irish design, the Council for the Encouragement of Music and the Arts, the Ulster Office, and the Arts Council of Northern Ireland (founded in 1962) ran a series of design and craft exhibitions, which were, ironically, largely made up of fine crafts and had little to do with industry. In direct response to two major KDW exhibitions, the *Workmanship* exhibition of 1977, and its followup, *Handmade for Exhibition* (which was planned for 1981 and was to tour Ireland before travelling to Denmark and Sweden) the Arts Council of Northern Ireland mounted the major *Handmade: An Exhibition of Work by Ulster Craftspeople* in 1980, which suggested that in the North, crafts were no longer relevant to industry but more directly comparative to fine arts, such as "land-

scape painting."[55] By the 1980s and 90s, a period generally considered the high point of the late twentieth-century Irish craft revival, there was an increasing move away from the idea of craft having a social function to one of plurality of individual expression.[56] For example, in the 1980s, the artist John Kindness began using recycled material in his work and explored the blurred boundaries between domestic pottery and ceramic sculpture.[57] His *Howling Dog* (1986) or *Little Horse* (1996-97) are a wry take on tradition, heritage, and the handmade. His installation, *Big Fish* (1999), in Belfast's rejuvenated docks area, recycles— physically and symbolically—the material artifacts from a former industrial location.[58] Direct comments on the Troubles have also proliferated in crafts. Andrew Livingstone's *Exterior-Interior* ceramic installation addresses the visual (and ideological) complacency in contemporary society, and Lydia Smyth has aimed to reconstruct fractured images of the Troubles through a reconfiguration of the traditional crafts of stained glass and textiles.

In 1971 the Crafts Council of Ireland (CCoI) was founded in Dublin and assumed responsibility for the crafts, which were being left behind by the KDW's increasing move towards industrial consultancy. In the North, crafts promoted by the Women's Institutes of Northern Ireland led to the formation of the government-sponsored Local Enterprise Development Unit (LEDU) in 1971, which similarly sought to reconfigure craft as a business and craftworkers as entrepreneurs. The quality of such work was questioned, as it was in the 1930s. In 1982, when the craft and design critic Peter Dormer came to review the craft situation in Northern Ireland, he thought LEDU was, in fact, ignoring the real needs of craftworkers.[59] Visiting the North at the height of the Troubles, Dormer expressed criticisms that

were timely and anticipated the formation of the Guild of Designer-Craftsmen by professional makers. In 1981 the Arts Council of Northern Ireland established a committee to conduct a major review of crafts in the North. This review encouraged the creation of a Crafts Council of Northern Ireland, as Northern craftworkers were supported by neither the CCoI or the Crafts Council of Great Britain.[60] In more recent years, the CCoI moved its headquarters to Kilkenny and, in 2000, established a National Craft Gallery (in the former KDW space). In the North, the Arts Council of Northern Ireland's *Review of the Crafts Sector in Northern Ireland* (2004) has led to the creation of Craft Northern Ireland.[61]

CONCLUSION

Whether as a means to rebuild national identity, reconstruct the economy, create industrial self-confidence and self-sufficiency, or reform design culture itself, craft has continually evolved in an Irish context to accommodate a variety of modern social, political, economic, and cultural needs. If the period from the 1920s to the 1980s saw the creation of new circumstances for the interaction of craft and design, in the 1990s this was, paradoxically, reversed. Although little acknowledged today, throughout the twentieth century, craft occupied a central position in Irish culture, in both the North and the South, and continues to play a key part in debates surrounding "gender and national ideologies."[62] In the major government reports of 1935, 1949, and 1961, which discussed Irish design, there was a consistent reference to Scandinavian design; and today, Irish designers, just like their counterparts in Scandinavia, are responding to key contemporary issues such as sustainability, recycling, and ergonomics whilst maintaining a respect for vernacular tradition.

It is regrettable that the two Irish states of the early to late twentieth-century remained divided and could not turn their cultural unity, as evidenced in Irish craft, into a movement similar to that which unified the disparate Scandinavian countries. The exigencies that tore Ireland apart in the twentieth century were not simply the result of differences, whether religious or ideological, but rather resulted from the inexorable mechanisms of the political economy of Western capitalism. Craft is a key element in understanding Irish modernity; and any study of it, no matter how brief, highlights that rather than having little presence in a culture impoverished by a century of violence, oppression, and desolation, craft has been a constant means of communication and expression, and has continually pushed the limits of individual creativity and social relevance.

Acknowledgements: The author would like to thank the assistance of Wilma Kirkpatrick; Ken Jamison; Brian McClelland; Deborah Fraser; Cara Murphy; Mike McCrory; Jack Doherty; Gareth MacAllister; Andrew Livingstone; Lydia Smyth; Irish Countrywomen's Association; National Library of Ireland; Public Records Office of Northern Ireland; and Women's Institutes of Northern Ireland.

ENDNOTES

1 Michael Burke, "Our Arts and Crafts," *The Bell*, 2.6 September 1941: 83.

2 Gillian Naylor, "Swedish Grace…or the Acceptable Face of Modernism," in Paul Greenhalgh, ed., *Modernism in Design* (London: Reaktion Books, 1990) 164-83. In 1922 the island of Ireland, which consists of thirty-two counties, was divided into two separate states. Twenty-six counties became an independent Free State until 1949, when it declared itself an Irish Republic and severed all ties with Britain and the Commonwealth. The remaining six counties in the Northeast became a small, semi-independent state, Northern Ireland, and remained part of Britain, which was itself reconfigured to become the United Kingdom of Great Britain and Northern Ireland. From 1922, Northern Ireland had its own devolved government operating until 1972, when direct rule from Westminster was reinstated due to the escalating impact of the Troubles.

3 W.B. Yeats, *Bounty of Sweden: A Meditation and a Lecture Delivered Before the Royal Swedish Academy and Certain Notes* (Dublin: The Cuala Press, 1925). For comparison of the Celtic Revival and the Viking Revival, see W. Halén, *Dragons from the North: Norwegian Silver around 1900 Including an Essay on the Neoceltic Art of Ireland* (Dublin and Bergen: West Norway Museum of Applied Art and Royal Hibernian Academy, 1995).

4 Jennifer Opie, *Scandinavian Ceramics and Glass in the Twentieth Century* (London: V&A Publications, 1989) 10.

5 For the importance of peasant arts and crafts in the Irish context, see J. McBrinn "The Peasant and Folk Art Revival in Ireland, 1890-1920: with Special Reference to Ulster," *Ulster Folklife*, 48 (2002): 14-61.

6 Seamus Ó Súilleabháin, *A Handbook of Irish Folklore* (Dublin: The Folklore Society of Ireland, 1942) vii; and E. Estyn Evans, *Irish Heritage: The Landscape, The People and Their Work* (Dundalk: Dundalgen Press, 1944) v.

7 See D.F. McFadden, ed., *Scandinavian Modern Design, 1880-1980* (New York: Cooper Hewitt Museum, 1982); Jennifer Opie, *Scandinavian Ceramics*; W. Halén and K. Wickman, eds., *Scandinavian Design Beyond the Myth* (Värnamo: Arvinius, 2003); and A.Veinola, "Beyond the Myth: Traditional Scandinavian Form – Reality or Myth?," *Form, Function, Finland.* 93.I (2004): 24-29.

8 D. Ó Giolláin, *Locating Irish Folklore: Tradition, Modernity, Identity* (Cork: Cork University Press, 2000); and S. Ó Duilearga, "Editorial," *Béaloideas: The Journal of the Folklore of Ireland Society.* III, I (1931): 104. The Folklore of Ireland Society became the Irish Folklore Commission (Coimisiúm Béaloideas Éireann) in 1935, and subsequently the Department of Folklore at University College Dublin in 1971.

9 Karl Marx, "Preface to *A Contribution to the Critique of Political Economy* (1859)," in *Karl Marx and Frederick Engels: Selected Writings* (Moscow: Progress Publishers, 1968) 181; and R. Dixon, ed., *Karl Marx and Frederick*

Engels: Ireland and the Irish Question (Moscow: Progress Publishers, 1971). This was, of course, illuminated by Britain's retaining of the Northeast counties, where capital was concentrated in heavy industry, when Ireland was partitioned.

10 Most of Marx's and Engels's observations of Ireland appeared in Karl Marx's *Das Kapital* (1867-1885: 3 vols) and Frederick Engels's projected book, following his 1856 visit to Ireland, *Labour History of Ireland*, both highlighting an impoverished agricultural inheritance and the emergence of a brutal industrial system in the Northeast. Although Engels's book on Ireland was never published, aspects appeared in his *The Origin of the Family, Private Property and the State* (1884).

11 J.E. Manners, *Country Crafts Today* (London and Vancouver: David & Charles, 1974). 11. For the characterization of Irish craft as "country crafts," see also M. McManus, "The Potteries of Coalisland, County Tyrone: Some Preliminary Notes." *Ulster Folklife*, 30 (1984): 67-77; and C. Kinmonth, *Irish Country Furniture, 1700-1950* (New Haven and London: Yale University Press, 1993).

12 See J. Manners, *Irish Country Crafts and Craftsmen* (Belfast: Appletree Press, 1982); S. Mosse, *Rural Crafts in Ireland* (New Port, South Wales: Greencroft Books, 1979); D. Shaw-Smith, ed., *Ireland's Traditional Crafts* (London: Thames and Hudson, 1984); and M. McManus, *Crafted in Ireland* (Ulster Folk and Transport Museum, 1986).

13 Jean Baudrillard, *For a Critique of the Political Economy of the Sign*, trans. C. Levin (St. Louis: Telos Press, 1981) 185-203.

14 See P. Bolger, *And See Her Beauty Shining There: The Story of the Irish Countrywomen* (Dublin: Irish Academic Press, 1986).

15 Muriel Gahan, "The Development of Crafts," in J. Meenan and D. Clarke, eds, *RDS: The Royal Dublin Society, 1731-1981* (Dublin: Gill and Macmillan, 1981) 258. Gahan's father had worked for the Congested Districts Board in the west of Ireland, in Co. Donegal, and in Co. Mayo, where Gahan spent her childhood and which influenced her greatly. She was also directly inspired by key Victorian philanthropists, such as Lady Aberdeen, Sophia Sturge, and Alice Hart; and she even attempted to revive Hart's Donegal Industrial Fund in the 1930s (Mitchell, 1997, 53). It comes as no surprise that Gahan's motto "Deeds not Words," was one coined earlier by the suffrage movement.

16 Quoted from letter from Muriel Gahan to J. Ingram, of the Linen Industry Research Association, Lisburn, Co. Antrim, N. Ireland, 24 March 1927, Muriel Gahan Papers [uncatalogued] National Library of Ireland (hereafter NLI) MS. Acc. 5350.

17 E.F. Sutton, *Weaving: The Irish Inheritance* (Dublin: Gilbert Dalton, 1980) 43-44; and G. Mitchell, *Deeds Not Words: Life and Work of Muriel Gahan: Champion of Rural Women and Craftsworkers* (Dublin: Town House, 1997) 62-64.

18 See A. Langtry and F. Laughton, "Why All Who Can Should Learn a Craft," *The Ulster Countrywoman*, 1. 2 (1935): 1; and R.J. Wright, "Home-Spuns," *The Ulster Countrywoman*, 11.8 (1935): 1-2.

19 Intriguingly, Lillias Mitchell studied briefly at Carl Malmsten's crafts summer school in Sweden, and Gerd Hay-Edie trained in her native Norway.

20 Mitchell 96. For details of the selling of Aalto's furniture in the inter-war years, see K. Davies, "Finmar and the Furniture of the Future: the Sale of Alvar Aalto's Plywood Furniture in the UK, 1934-1939." *Journal of Design History*, 11.2 (1998): 145-56.

21 Mitchell 76.

22 M. Gahan (c.1936), "Country Crafts," unpublished lecture manuscript, in Muriel Gahan Papers, NLI MS. Acc. 5350.

23 For a more detailed discussion of the crafts groups in the North of Ireland in the inter-war years see, J. McBrinn, "The Crafts in Twentieth Century Ulster: From Partition to the Festival of Britain, 1922-1951," *Ulster Folklife*, 51 (2005): 54-85; and "The Inter-War Craft Revival: A Forgotten Episode in the History of the Women's Institutes of Northern Ireland," *Ulster Countrywoman: The Journal of the Women's Institutes of Northern Ireland*. September 2006: 20-21.

24 T.M. Wilson, "Blurred Borders: Local and Global Consumer Culture in Northern Ireland," in J.A. Costa and G.J. Bamossy, eds., *Marketing in a Multicultural World: Ethnicity, Nationalism and Cultural Identity* (Thousand Oaks, London and New Delhi: Sage, 1995) 231-56.

25 B. Hobson, *Saorstát Éireann: Irish Free State Official Handbook* (Dublin: The Talbot Press, 1932) 243.

26 T. Bodkin, *The Importance of Art to Ireland: A Lecture* (Dublin: At the Sign of the Three Candles, 1935) 8.

27 Bodkin 36.

28 For details of these, see M. Gahan, *Department of Education, Memorandum*, 1946; and see *Country Workers Eighteenth Annual Report*, 1948; both in Muriel Gahan Papers NLI MS. Acc. 5350.

29 See Irish Homespun Society, "Crafts Survey," 1943, Muriel Gahan Papers NLI MS. Acc. 5350.

30 Brooke, Lady Cynthia, "Folk Museum," *The Ulster Countrywoman*, 1.11 March 1946: 1-3. Estyn Evans agreed to help the Women's Institutes of Northern Ireland, and concurred that crafts should play a central role in any Ulster folk museum; see E. Estyn Evans, "Folk Museums," *The Ulster Countrywoman*, 13.2 June 1946: 5-6. He was backed by James Stendall, Director of Belfast Museum and Art Gallery, who had made a similar proposal to the Municipal Corporation in 1929, suggesting they look at Skansen in Stockholm; Linneaus's House at Uppsala, Sweden; Bygdoy Folkmuseum, Oslo, Norway; and Den Gamle By, Århaus, Denmark as models for an Ulster folk museum; see J. A. S. Stendall "Correspondence," *The Ulster Countrywoman*, 13.3 July 1946: 2-3; and see also "Museum-Minded Scandinavia [Abstract]," *Proceedings and Journal of the Belfast Naturalists' Field Club*, Belfast (July 1946): 440.

31 *Art and Industry Report of the Committee Appointed by the Board of Trade under the Chairmanship of Lord Gorrell on the Production and Exhibition of Articles of Good Design and Every-day Use* (London: HMSO, 1932).

32 Evidence of Mr. N.E.C. Laughton to the Industrial Art Committee, 3 January 1934: 1. Minutes of Evidence taken before the Industrial Art Committee appointed by the Ministry of Education, Public Records Office of Northern Ireland [hereafter PRONI] COM/26/1/3.

33 The comparison to Scandinavian countries was made by another witness, G.H.E. Parr, in the course of the Committee's interview with Laughton, ibid. 15.

34 Ibid., 20.

35 *Report of the Committee on Industrial Art, Presented to the Parliament by Command of His Grace the Governor of Northern Ireland* (Belfast: HMSO, 1935): 35.

36 Letter from M.B. [Michael Burke/Mícheál De Búrca] to Muriel Gahan, undated c.1949, in Muriel Gahan Papers NLI MS. Acc. 5350. Burke's comments were echoed by Ivor Beaumont, the Headmaster at Belfast School of Art. See letters from Ivor Beaumont to Muriel Gahan, c.1937, in ibid. And see Michael Burke, *Craft Industries in Particular Reference to this Country*, unpublished manuscript in ibid. For the emergence of the 1950s craft

revival, see J. Turpin, *A School of Art in Dublin since the Eighteenth Century: A History of the National College of Art and Design* (Dublin: Gill & Macmillan, 1995) 383-94.

37 For the Festival of Britain, see M. Banham and B. Hillier, eds., *A Tonic to the Nation: The Festival of Britain 1951* (London: Thames and Hudson, 1976); E. Harwood and A. Powers, eds., "The Festival of Britain," *Twentieth-Century Architecture (Twentieth Century Society Journal)*, 5 (2001); and B. E. Conekin *"The Autobiography of a Nation: The 1951 Festival of Britain* (Manchester: Manchester University Press, 2003).

38 *The Festival of Britain 1951 in Northern Ireland: Official Souvenir Handbook* (Belfast: H.R. Carter, 1951): 15.

39 See letter from Sir Roland Nugent to J. Maynard Sinclair, 28 August 1950, PRONI COM/4/A/64.

40 The 1951 official brochure, *The Festival of Britain of 1951 in Northern Ireland*, Belfast: HMSO: n.p.

41 J.D. Stewart, *Ulster Farm and Factory Exhibition: A Guide to the Story it Tells* (Belfast: HMSO, 1951) 28.

42 King George VI was unable to attend, due to his ill-health. See "Queen's Entry Marked Opening of Ulster's Greatest Exhibition," *Belfast Telegraph*, 1 June 1951: 6.

43 Sir Roland Nugent, "Festival Summer," transcript of BBC broadcast, 8 November 1950, PRONI COM/4/A/69.

44 T. Bodkin, *Report on the Arts in Ireland* (Dublin: Stationary Office, 1949): 36, 41.

45 J. Turpin, "The Irish Design Reform Movement of the 1960s," *Design Issues*, 3.1 (Spring 1986): 4-21.

46 The group was made up of Kaj Frank, director of the Finnish School of Industrial Arts and head of the design department for utility ware at the Arabia Porcelain Factory; Åke Huldt , who was director of the Swedish Design Center, Svensk Form; Erik Herløw, professor of industrial design at the Royal Academy, Copenhagen; Gunnar Billmann Peterson, professor of typography and graphic design at the Royal Academy, Copenhagen; and Erik Christian Sørenson, who was professor of Architecture at the Royal Academy, Copenhagen.

47 "Towards Better Design," *The Irish Times*. 3 February 1962: 10; and see also "Scandinavian Criticism of Irish Design" on p. 1 of the same *Irish Times* issue.

48 *Design in Ireland: Report of the Scandinavian Design Group in Ireland, April 1961* (Dublin: Córas Tráchtála, 1962): 5.

49 Paul Hogan in R. Thorpe, ed., *Designing Ireland: A Retrospective Exhibition of the Kilkenny Design Workshops 1963-1988* (Kilkenny: Crafts Council of Ireland, 2005): 2.

50 N. Marchant and J. Addis, *Kilkenny Design: Twenty-one Years of Design in Ireland* (Kilkenny and London: Kilkenny Design Workshops and Lund Humphries, 1985) 19.

51 The aim of the KDW was, of course, to employ Irish designers but many early employees were from Scandinavia, The Netherlands, Germany, Switzerland, America, and England, including several now distinguished names, such as the wood-turner Maria von Kesteren, the potter Sonja Landweer, and the silversmith Rudolf Heltzel. Several of the early designers also came from Northern Ireland, including the silversmith Michael Hilliar, and the ceramicists Jack and Joan Doherty.

52 Marchant and Adis 47.

53 Thorpe 21.

54 K. Basu, "Marketing Developing Society Crafts: A Framework for Analysis and Change," in. J.A. Costa and G.J. Bamossy, eds., *Marketing in a Multicultural World: Ethnicity, Nationalism and Cultural Identity* (Thousand Oaks, London and New Delhi: Sage, 1995) 257-98.

55 *Handmade: An Exhibition of Work by Ulster Craftspeople* (Belfast: Arts Council of Northern Ireland, 1980): 1.

56 Justin Keating, "Contemporary Crafts," in T.P. Coogan, eds., *Ireland and the Arts (A Special Issue of the Literary Review)* (London: Namara Press, 1989) 234. For developments in late twentieth- century fine art see M. Catto, *Art in Ulster, 1957-1977* (Belfast: The Blackstaff Press, 1977); and L. Kelly, *Thinking Long: Contemporary Art in the North of Ireland* (Kinsale: Gandon Press, 1996). Indeed it could be argued that during the 1970s-1990s, many fine artists began to assimilate ideas of handmaking, as a conceptual rather than a purely technical element, into their practice. For instance, see the calligraphic installations which have commented directly on the political economy of the Troubles, such as Colin Darke's installation, which used Marx's *A Contribution to the Critique of Political Economy* as its ideological, and visual, medium; or Shane Cullen's *Fragmens sur les institutions républicaines IV,* which transcribed onto walls the secret communications or "comms" written by Republican prisoners during the Hunger Strike. Both were completed in the mid-late 1990s and installed in the Orchard Gallery in Derry.

57 John Kindness, "Review of Irish Ceramics: The New Tradition," in *Craft Review* (Winter 1988): 8. Wendy Steiner has recently described Kindness as "part archaeologist, part inventor, part craftsman, part social critic"; see W. Steiner, "The Recycler's Art," in M. Boal O'Kane and W. Steiner, *John Kindness Retrospective, 1986-2006* (Belfast: Switch Room Galleries, 2006) 36.

58 The docks were, of course, the site of much major industrial activity and were, in the eighteenth century, the site of one of the earliest Irish potteries, the Downshire Pottery; see P. Frances, *A Pottery by the Lagan: Irish Creamware from The Downshire China Manufactory, Belfast, 1787-c.1806* (Belfast: Institute of Irish Studies and National Museums and Galleries of Northern Ireland, 2001). In the 1990s, Kindness also collaborated with makers, most interestingly with Nicholas Mosse at his pottery at Bennetsbridge, Co. Kilkenny, on a range of tableware entitled the "Fly Tea Set," an ironic take on Mosse's iconic, traditional "country crafts" styled ceramics.

59 Peter Dormer, "Unsplendid Isolation," *Crafts*, 54 (January/February 1982): 40-41.

60 *Provision for the Crafts in Northern Ireland: An Arts Council of Northern Ireland Report.* (Belfast: Arts Council of Northern Ireland, 1981) 21. The Guild of Designer-Craftsmen functioned like its English counterpart, the Society of Designer Craftsmen (which was, in fact, the remnants of the original Arts and Crafts Exhibition Society) which had been formed in 1888. The Dublin-based Arts and Crafts Society of Ireland (which was established in 1894, had run until 1962) and the Irish Decorative Art Association (which acted like an Arts and Crafts society in the North and which had been formed in 1895) had transformed itself, after Partition, into the Arts and Crafts Society, which dissipated by the time of the Second World War, although key figures such as Eva McKee maintained workshops in Belfast until the 1960s.

61 In addition, in 2001, the National Museum of Ireland established a national folk museum, the Museum of Country Life, at Castlebar, Co. Mayo.

62 Brett 14.

ENTANGLED TECHNOLOGIES: RECRAFTING SOCIAL PRACTICE IN PIÑA TEXTILE PRODUCTION IN THE CENTRAL PHILIPPINES

B. LYNNE MILGRAM

INTRODUCTION

My conversations with artisans in Aklan province, central Philippines, emphasized to me the multifaceted nature of their work in the region's distinctive piña (pineapple fibre) textile industry. Female artisans explain in which part of the production process they specialize, how they learn different skills in order to work across the stages of production, and in which type of work environment (e.g., cooperative, individual producer) they prefer to engage. Yet, much of the recent scholarship on globalization, neoliberalism, and work has focused on the ways in which commodity production has become increasingly fragmented, especially that of transnational firms. Such top-down systems, often characterized by subcontracting and the outsourcing of jobs, employ local workers to perform singular discrete tasks that result in their having little autonomy or in feeling alienated from the work they perform.[1] Gendered analyses of the impact of neoliberal policies in the Philippines have suggested that women, who characteristically have responsibility for child care and managing households, will simply cope with such situations by taking on a double burden of work.[2]

My research with artisans engaged in the Philippines' distinctive piña textile industry suggests that responses to increased economic globalization and neoliberal policies are more complex. On the one hand, subcontracting by large-scale national and international

businesses has certainly increased throughout the country, especially with regard to crafts designed for the growing home furnishing market, such as rattan and bamboo furniture and baskets. The majority of Philippine craft production (e.g., woodcarving, weaving), however, remains rooted in rural, household-based enterprises in which artisans produce goods for local use and trade as well as for national tourist markets.[3] In this latter type of practice, artisans most often control the process of making from beginning to finish in what Ursula Franklin terms "holistic technology."[4] Since the 1980s, another equally notable development has taken place throughout the Philippines. Small-scale entrepreneurs with production expertise in specific crafts have established locally owned and operated workshops and cooperatives to take advantage of the rising demand for their particular goods.[5] When the new Philippine democratic government (1986) adopted a revised nationalist agenda that included promoting piña cloth as *the* national fabric of the country, some entrepreneurs in Kalibo, Aklan province, seized this opportunity by establishing their own collectives to produce piña garments that continue to be in demand for formal national attire, for clothing worn at ceremonial occasions, and for yardage to supply the new generation of Philippine fashion designers.[6] Artisans engaged in the contemporary piña industry usually complete only one task in the production process (fibre processing, warping, or weaving)—a system Spanish colonialists (1565-1898) promoted to develop piña textiles that could compete with European lace in vogue at that time. Thus, although piña artisans have historically produced textiles through a "prescriptive" system of technology,[7] many of the newly established Kalibo workshops organize the parameters of such a fragmented production in such a way that artisans can challenge task and class stratification that often relegates them to serving as pieceworkers. In so doing, artisans' actions challenge past research maintaining that, in prescriptive practice, workers are more likely to lose control of production and thus their autonomy as makers and traders.[8]

In this chapter, I argue that Kalibo piña artisans and entrepreneurs together, reconfigure the organization of work, space, power, and social relations to enable multifaceted technologies that cross borders and dissolve essentialist categories such as holistic and prescriptive practice. Although piña artisans work within a system of task specialization, they share knowledge of the varying processes, exercise their option to work at home, and have obtained varied benefits from employers. Through such channels of action, artisans reconfigure the nature of, and negotiate some control over, piña's prescriptive method of construction. Regarding technology as transformatory practice—as encompassing "organization, procedures, symbols and a mindset,"[9]—reveals the contradictory nature of contemporary piña production and enables analyses to reach beyond simple binary spheres.

I begin by contextualizing the circumstances of women, work, and technology in the Philippines; and I illustrate this framework with regard to piña fibre processing and weaving in two Kalibo workshops. By focusing on the innovative initiatives of female artisans and of entrepreneurs (men and women), I then explore how these actors can reconfigure arenas of technology to fashion a way of doing things that more effectively meets their needs.

GENDER AND WORK

Women's current engagement in artisanal production in the Philippines offers a particularly useful lens for the analysis of gender, technology, and economic outcomes with globalizing markets as women's workforce participation throughout the Philippines is among the highest and most varied in countries of the Global South.[10] Recent studies examining women's microactivities clearly demonstrate that women work across different spheres, including household and market, rural and urban spaces, formal and informal economic sectors, and local-to-national-to-global economic arenas.[11] Their multifaceted activities dissolve determinist ideas about discrete and bounded socioeconomic categories. As Wazir Karim argues, in Southeast Asia, women secure a "continuous chain of productive enterprises" for family and personal well-being by establishing "a repertoire of social units" linked to household, market and environmental resources; and they "unlink" themselves when situations change.[12] Women thus create an "open-ended" and "multi-focal" system of socioeconomic relations with "undifferentiated boundaries" and "varying connotations of 'space.'"[13] In the Philippines, women often cooperate to work together in capitalist production that is based on pre-existing relationships of reproduction, namely those personal connections established through kinship or community activities.[14]

Studies of development in regions of the South, clearly demonstrate that the imposition of national macroeconomic policies, along with prescriptive global systems, also contribute to the growth in women's workforce participation in both formal and informal sectors, and to the varying degrees of control women have over their labour in these spheres.[15] This research argues that, in many cases, women are disadvantaged by neoliberal policies which have fueled the gap separating rich and poor, segmented labour conditions, and often undermined women's consumption base, as men and women with less work have less income to spend.[16] In the Philippines, similar situations arose with regard to women's positions when the Marcos government introduced structural adjustment poli-

cies in the 1970s. Programs targeted larger mainstream urban-based enterprises (e.g., rattan furniture), leaving home-based, poorer rural and urban artisan trades to manage on their own. Many artisans then had little choice but to try to capture contested spaces through which to realize alternative ways to make a living.

Resituating Technology

> All craftsmen [and women] share a knowledge. They have held reality down,
> flattened to a bench; cut wood to their own purpose, compelled the growth
> of pattern with the patient shuttle. Control is theirs.[17]

Vita Sackville-West's quotation, as poignant as it is, tends to denote a category of practice justified by past precedent and essentially unchanging, in contrast to the possibilities of innovation that have been initiated, for example, by Kalibo artisans seeking options in work. In Ursula Franklin's model of the organization and cultural meaning of technology, her "holistic" sphere captures the spirit of Sackville-West's poem.[18] In holistic technology, most often associated with the notion of crafts as discussed in a number of the papers in this volume, artisans make the key situational decisions about their work as they create it. Using holistic technologies does not mean that people do not work together, but the way in which they collaborate leaves the individual worker in control of the process of making.[19] In contrast to Sackville-West's positioning of craft, prescriptive technology, more common in our Northern assembly-line practice, entails specialization by process—the task of making something is broken down into clearly identifiable steps. A separate worker or group of workers complete each step and he or she needs to be familiar, in theory, only with the skills of performing that one step.[20]

On the one hand, while the stages of piña production—fibre extraction, fibre processing, knotting fibres, warping and weaving—resonate with prescriptive practice, the fact that many women have knowledge of and may work in more than one activity when needed highlights a Philippine response that conflates the parameters of prescriptive and holistic methods. Customarily, if Kalibo artisans cannot find work as weavers, they may engage in part-time fibre knotting, winding warps, and sampling new textile designs in order to ensure ongoing income. Female artisans' knowledge of different aspects of the production process gives them the power and control to potentially operationalize opportunities and negotiate constraints on new livelihood enterprises. Regarding technology as multifac-

eted—as including "activities as well as a body of knowledge, structures as well as the act of structuring"[21]—enable analyses that do not assume that women's artisanal production will be marginalized when practiced within a skill-specific workshop format. The climate of production in many Kalibo piña workshops demonstrates that although the historical separation of tasks has been valorized, the carving of the channels through which such contemporary production takes place has not been similarly fixed.[22] As the following history and case studies of piña production demonstrate, artisans and entrepreneurs have always worked on the edge of different technologies, crafting constantly revised agendas of practice.

PIÑA CULTURE AND HISTORY [23]

Piña is a diaphanous cloth woven from the fibres of the leaves of the pineapple plant. The current revival of this cloth is focused in small workshops in the central Visayan provinces of Aklan and Iloilo, Panay Island, the lowland Christian areas of the Philippines most influenced by Spanish colonialism. It is generally thought that the pineapple, a New World plant, was brought to the Philippines in the first half of the sixteenth century by Spanish colonizers who stocked it on their ships as food. When the pineapple grew successfully in early central island settlements, mid-sixteenth-century accounts report that artisans already skilled in weaving fabrics from local plants such as banana (*abaca*) utilized the longer leaves of specific pineapple species as an additional resource for their cloth.[24] Due to the limited supplies of raw materials and to the labour-intensive character of production, piña cloth was expensive to purchase and, thus, was most often used by the wealthier elite. In the seventeenth century, Spanish missionaries, building on indigenous skills and on the new techniques introduced by immigrant Chinese and Indian artisans, encouraged artisans in Lumban, Laguna province, south of Manila to embroider piña cloth.[25] Piña cloth woven on Panay Island and embroidered in Lumban sold for triple the value of unpatterned piña.[26] Piña, most popular from the late eighteenth to the mid-nineteenth centuries was used in women's blouses (worn with a detachable shawl collar) skirts, and the now generic men's national overshirt.[27]

During this time, Manila functioned as an international port servicing the Spanish galleon trade between Acapulco, Mexico, and the Philippines, as well as hosting European and American ships involved in Asian trade. By the 1840s, piña, as well as other textiles, formed a substantial part of Philippine exports. Piña, in particular, was used locally by the

elite classes as a sign of status and was exported by the Spanish as a commodity that could rival the popularity of European lace, as noted earlier.[28] By the 1860s, European royalty received gifts of Philippine piña from loyal subjects to commemorate coronations and weddings.[29] In the second half of the nineteenth century, however, textile exports from the Philippines dwindled dramatically as economic development shifted to sugar cane. Indigenous cloth production, generally, continued to decline as less expensive British and American factory-made fabrics that signaled the move to "modernity" increasingly claimed the market for textiles. By the early twentieth-century, piña weaving had all but disappeared, reduced to a marginalized cottage industry that responded to small, irregular orders.[30]

It was not until 1988 that the Patrones de Casa Manila, a group of art dealers and designers, spearheaded the revival of the piña industry by working with both government and non-government associations.[31] Building on the wave of nationalism after the re-establishment of democratic government in 1986, artisans and entrepreneurs revived workshops in Kalibo, Aklan, the historic heart of this production, to meet demands for new piña garments. The majority of workshops are small scale, employing within the workshops proper, approximately fifteen to twenty weavers and five to seven women, whose task it is to prepare the warps. In some cases, more accomplished weavers can take the prepared warps home to weave, in this way balancing work with domestic responsibilities. In addition, some artisans, while still rooting their craft in prescriptive technology, have organized themselves into cooperatives in order to claim more control over how their enterprises are run. The following account discusses two of these establishments—the Cruz Piña Weaving Workshop and the Kalibo Multipurpose Cooperative[32]—to demonstrate how their operations move between holistic and prescriptive practice to challenge either technologies' entrenchment in the social and economic landscape.

PIÑA PRODUCTION: FROM FARM TO FACTORY

In Aklan, pineapples are not cultivated on large-scale plantations; but rather, farmers grow these plants as a secondary crop to augment their income from more lucrative cash and subsistence crops, such as rice, corn, and market vegetables. As pineapples are hardy plants, especially the Red Spanish variety grown for its longer leaves, they can be intercropped with coconut or are often grown along the side of roads in spaces that are not suitable for the primary crops noted above. Due to the fluctuating demand for piña textiles and

the fact that farmers continue to earn minimal prices for their pineapple plants, cultivators do not grow this crop in large quantities. Some farmers simply harvest the pineapple leaves to sell to dealers while others combine pineapple farming with fibre extraction. Extracting the fibres from the leaves and processing fibres in preparation for knotting and subsequent weaving are labour-intensive tasks. To extract the inner fibres, artisans use the sharp edge of a shell to scrape off the outer coarse membrane layer from the leaves; they then separate the finer inner filaments from the remaining leaf, rinse and dry the threads in the sun, and finally comb or card the filaments to align them in preparation for knotting.

As the yarns are not spun, another group of artisans knot together the short fine filaments to form longer lengths. With the current revival of piña, the task of knotting pineapple fibres together has become a popular full- to part-time income-earning activity for students, but especially for women, who can combine this work with their domestic and child care responsibilities. To maintain a high standard in the quality of the woven fabric, entrepreneurs customarily purchase knotted pineapple fibres—that they know have been finely cleaned—or they advance the extracted fibres to knotters, paying the latter for their labour. This results in a fluid system in which entrepreneurs retrieve completed knotted-fibre orders while advancing additional extracted fibre for knotting.

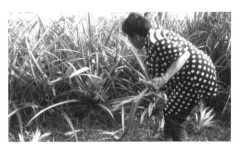

A WOMAN PICKS SELECTED LEAVES FROM THE PINEAPPLE PLANT. KALIBO, AKLAN PROVINCE, PHILIPPINES, 2003.

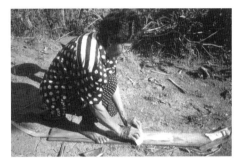

USING THE SHARP EDGE OF SHELL, AN ARTISAN SCRAPS OFF THE OUTER MEMBRANE LAYER FROM THE PINEAPPLE LEAF. KALIBO, AKLAN PROVINCE, PHILIPPINES, 2003.

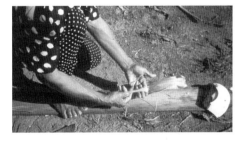

AN ARTISAN SEPARATES THE INNER PIÑA FILAMENTS FROM THE SCRAPPED PINEAPPLE LEAF. KALIBO, AKLAN PROVINCE, PHILIPPINES, 2003.

PHOTOS: B. LYNNE MILGRAM

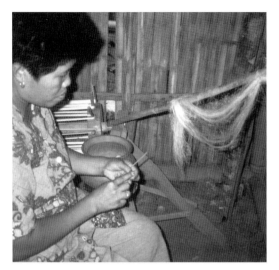

An artisan knots together the short piña fibres to form longer lengths. The knotted fibres are then carefully stored in a ceramic pot to keep then untangled. Kalibo, Aklan province, Philippines, 2003.

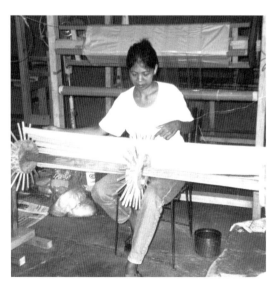

An artisan prepares the piña warp for weaving. Kalibo, Aklan province, Philippines, 2003

Photos: B. Lynne Milgram

Preparing the fifty- to sixty-metre long warps for the upright floor looms is also a specialized task that can take warpers one-and-a-half to two weeks to complete. Although some older weavers explain that they would rather prepare their own warps in order to maintain more control in weaving, entrepreneurs most often divide these tasks in order to streamline production. The artisans preparing warps are skilled in handling the gossamer piña fibres that must be weighted down with sand during warping in order to keep them untangled. This particular specialization of labour sharply distinguishes piña production from that of textile construction more commonly done on backstrap looms throughout the Philippines in rural and household-based or holistic technology.

The women who weave earn the highest income and enjoy the most flexible circumstances of work.[33] Weavers are paid per meter of cloth woven and determine their own schedule of work, the latter giving them a sense of control over their time. Some women, for example, prefer to work at night when it is not as hot and when the piña fibres are less brittle; they believe the cooler temperatures enable them to weave a smooth fabric. Weavers have specific deadlines within which to complete predetermined

amounts of yardage for particular orders, but the decision about when to weave belongs to individual artisans. Weavers, like the artisans preparing warps, work within the workshop proper and thus can more actively participate in determining the decisions that can improve their work conditions.

Such fragmented stages of production, Franklin argues, can encompass social interventions that she terms *designs for compliance* (emphasis in original).[34] Such external control from entrepreneurs and internal compliance by workers are regarded as normal and necessary for the smooth operation of a larger workshop enterprise that customarily encourages a singular way of doing things. Indeed, this infrastructure tends to be disadvantageous for artisans who work outside the workshop proper (e.g., fibre processors and knotters), as these women do not have access to the same benefits (e.g., childcare, food subsidies) as women working in-house. Yet, fibre extractors and knotters can engage in everyday forms of resistance that bring them some short term gain, if not improving their long term control.[35] On numerous occasions, entrepreneurs have told me of situations in which knotters or fibre processors had sold finished fibres to one dealer (fibres that they had received earlier as an advance from another entrepreneur), while some artisans just disappear before completing their work.

Within the current Philippine economic climate, in which the rising costs of commodities make it increasingly difficult for people to meet their subsistence needs, a similar betrayal of trust has occurred between Kalibo and Lumban artisans and entrepreneurs. Following historical prescriptive practice, Kalibo manufacturers send plain-weave piña cloth to Lumban, Laguna province, to be embroidered by artisans who specialize in this skill. Lumban artisans are paid for their labour and then send the embroidered yardage back to Kalibo for tailoring. In some instances, Lumban families purchase and tailor the piña yardage for their own clients. Kalibo piña manufacturers explain that they have encountered difficulties collecting the payments that are due for the cloth they have consigned to Lumban

USING AN INLAY OR SUPPLE-MENTARY WEFT TECHNIQUE, AN ARTISAN WEAVES PATTERNS ON A PIÑA CLOTH. KALIBO, AKLAN PROVINCE, PHILIPPINES, 2003.

PHOTO: B. LYNNE MILGRAM

embroiderers. In a number of instances, some Lumban artisans have kept the consigned fabrics and only offered partial payment in return. Situations in which artisans sell products to one buyer that have been commissioned by another or in which artisans or entrepreneurs do not pay for consigned goods, signal commodity systems in which individual actors, through their everyday actions, can, in effect, compromise the parameters of prescriptive technology.

Positioned between the demands and expectations of buyers and those of artisans, small-scale businesses are vulnerable to such interruptions in their flow of cash or materials. To facilitate the sustainability of their businesses, then, entrepreneurs and artisans negotiate mutual understandings, however tenuous, through *suki* or favoured relationships. As Davis notes, only by forming "personal networks of obligatory relationships" can those in business overcome the barriers posed by a lack of trust and a weakness in institutional credit facilities.[36] Nurturing their *suki* relations, entrepreneurs can, in theory, be somewhat more certain of receiving the products they have ordered and the sales they have been promised. Such situations, common throughout the Philippines,[37] keep small-scale entrepreneurs, distributors and workers tightly bound to each other in shifting but necessary personal alliances.[38] A similar situation can be seen in the customary practice of wealth redistribution. Here, people who are better off financially—whether relatives, neighbours, or employers—may distribute gifts at special occasions or advance credit against future work in order to promote good will. Such relationships tend to constrain entrepreneurs' opportunism and their accumulation of capital while at the same time facilitating economic leverage for artisans, as evidenced in the operation of the following piña weaving enterprises.

THE CRUZ PIÑA WEAVING WORKSHOP

In 1989 husband-and-wife team Carol and Paul Cruz, both of whom are from the central Philippines, established their piña weaving business, the Cruz Piña Weaving Workshop, in Kalibo, Aklan province. Carol, a piña weaver, works with artisans to design the workshop's distinctive cloths, while Paul oversees much of the business accounting. Their workshop supports twenty weavers who weave in-house while two additional artisans have the skills to weave high-quality cloth on their home looms. In 1995, in response to the often limited amounts of piña fibres available for weaving, and in order to meet the growing demand for piña from young designers, the Cruz workshop introduced the practice of mixing silk with

piña in cloth construction. Once the Philippine agricultural colleges developed local sources of silk, the Cruzes substituted silk for piña as the warp yarns to create what is now termed piña-seda or pineapple-silk cloth. This initiative revolutionized the piña industry. Piña-seda is easier to weave, more flexible to wear, and less expensive to produce than pure piña. The practice of combining pineapple and silk yarns has now been widely adopted by other small Aklan producers resulting in the cloth's wider availability.

Carol and Paul Cruz explain that because their trade is highly competitive, and because the fineness of piña fabric means that any flaws in the cloth are readily visible, they work with artisans to develop the latters' skills and they offer benefits (e.g., children's school tuition, fees, and food subsidizes) to encourage the artisans they train to remain with the workshop. To this end, the Cruzes operate an apprenticeship program in which artisans learn to weave increasingly complex fabrics (from abaca to piña-seda to pure piña) and upon graduation from each level, the artisan's rate of pay rises accordingly. One weaver explains that these new skills have enabled her to take on free-lance work at home when her family requires extra income.

In the Cruz workshop, as is customary in small-scale enterprises throughout the Philippines, the living-working arrangement in which artisans reside within the workshop compound illustrates another example of the blurring of holistic-prescriptive spheres. Artisans explain that most women working in the workshop, the majority of whom are single, sleep in dormitory quarters set aside for them, eat their meals in their own kitchen-dining area, and care for their children (primarily for those who live out) in a child play area at the rear of the workshop. The Cruzes own enough rice land to enable them to provide rice, the staple food, for their employees. Artisans obtain additional meals by organizing a cooperative arrangement in which they pay one weaver who lives outside the workshop to cook meals that she brings to them daily. On the one hand, the resultant overlap in living and working space certainly gives Carol and Paul Cruz more control over artisans by ensuring that these women are available for work. At the same time, artisans do not have the financial burden of paying rent, and they obtain food subsidies. Such circumstances, however, blur the boundaries between that of the beneficent employer providing food and lodging for employees and one who, through such processes, can exploit artisans' labour.

Indeed, when speaking with the Cruzes about the rate of pay for artisans, it appears that women can earn added income only by working longer hours, as yearly pay raises are irregular. In their defense, they explain that although salaries may not have risen substantially, neither had they been decreased, as has been the practice of some Kalibo workshops when the demand for piña cloth is low. In addition, weavers outline how they can

work across jobs to ensure that they obtain a consistent income. One weaver explains: "If I am not working on a special order, I can weave general-order yardage, and the artisans who prepare warps can assist to dress the loom as well as make shorter warps to engage more weavers."

In a similar initiative that the Cruzes hope will benefit both their business and the artisans in their employ, they have sponsored pineapple farmers to gain the technical skills they require to include in their operations fibre processing and knotting as well as cultivation. For example, since 1998 the Cruzes have been working with Rosa Pindug and her family, pineapple farmers, to train them to extract and process pineapple filaments from the plant leaves. Pindug explains how she has also expanded her activities into that of a microentrepreneur: "I collect harvested pineapple leaves from farmers in my village and I advance the fibres my family has processed to knotters who currently number ten women; I supervise the knotters' work and I collect the finished fibres which I then sell to the Cruz practice—relationships whose character subverts any singular understanding that there is only one way of doing things.workshop." The Cruz-Pindug exchange relation, like that between Rosa Pindug and the women she supports through work, emerges as a series of engagements between artisans and patrons that simultaneously speaks of both holistic and prescriptive values and practice—relationships whose character subverts any singular understanding that there is only one way of doing things

The Kalibo Multipurpose Cooperative

In 1992 a group of rice farmers established the Kalibo Multipurpose Cooperative as an agricultural organization that could support their cultivation by providing access to low interest loans and facilitating volume sales of their harvests to gain higher prices. In 1995, to take advantage of the growing market for piña garments, the cooperative expanded its operations by adding pineapple farming and piña cloth production to its activities. The cooperative membership currently supports eleven weavers, ten knotters, and two warpers. Unlike other workshops that enforce a division of labour more in common with prescriptive technology, the Kalibo cooperative facilitates a holistic approach, as artisans can move more freely between work in warping and weaving. Cooperative members explain that given the volatility of the piña industry, they prefer to belong to the cooperative rather than working on their own. As one weaver outlines: "By marketing our products in higher volumes, the cooperative can secure better prices for us. The cooperative can also provide us with low

interest loans for our consumption needs beyond the cash advances we might receive against our future work."

One of the challenges in piña production, as in indigenous craft production worldwide, is for artisans to maintain consistent quality in their products. Our globalized economy rooted, for the most part, in prescriptive commodity production that promises unerring consistency, is not easily duplicated in cloth production such as that of piña, regardless of the prescriptive nature of making. In their first business arrangements, the Kalibo cooperative managers consigned their cloth to intermediary traders, who took it to sell in the Divisoria Market, home to Manila's largest assemblage of textile wholesalers and retailers. Initial sales were slow as traders reported that the quality of the cooperative's cloth was not high enough to meet the competition. Cooperative managers and artisans thus decided to shift production from that of piña-seda to piña *liniwan* or pure piña. Although the former is quicker and less expensive to weave, cooperative members decided that given the keen competition from notable piña-seda fabrics woven by the Cruz workshop, for example, they could develop a more advantageous position by carving their own market niche for high quality and specialized cloth products.

In a further industry-changing initiative, Kalibo cooperative artisans developed a production line of pure piña cloth that includes not only the customary longer *liniwan* fibres as the warp, but also the shorter, coarser *bastos* fibres used as the weft. Previously, *bastos* fibres were used as stuffing for cushions and quilts. Indeed, embroiderers in Lumban explain that they prefer the piña *liniwan-bastos* cloth, because the coarser weave makes it easier for them to embroider their designs. In addition, in order to maintain a production volume that can support organization members, the Kalibo cooperative also produces goods at the opposite end of the commodity spectrum. Artisans use piña for the warp but combine this with different weft yarns such as cotton and polyester to manufacture innovative home furnishing fabrics and functional products such as place mats and utility bags. In so doing, artisans capture an emergent market for products that simultaneously speak of indigenous heritage and modernity as they package their culture in the goods they produce. The cooperative currently enjoys good partnership relations with the Cruz Piña Weaving Workshop, as the two manufacturers freely share orders to take advantage of each other's strengths.

Both scholars and the public have often decried such crossing of "aesthetic boundaries" as indicative of cultural contamination.[39] Recent studies, however, in conjunction with the expanding literature on globalization, welcome such cultural graftings by employing different analytical terms. These include "hybridity," "syncretism," "bricolage,"[40] and "creolization."[41] Like the conflation of holistic and prescriptive practice, such variability in

the materiality of piña textiles, highlights the ongoing oscillations in objects and technologies that remake material relations among people, things, and identities.

CONCLUSION

Studies that have analyzed how artisans engage different modes of commodity production in order to be competitive tend to narrowly position makers' actions in terms of economic inputs—capital, information, and innovation. This approach, consistent with our "Western" market model, argues that producers working to achieve a competitive economic advantage, must value individualism and disregard cultural constraints and social bonds.[42] As the circumstances of contemporary piña production evidence, however, artisans and entrepreneurs fashioning competitive livelihoods in this textile industry sector consolidate cultural identities and community commitments, even as they produce some differences in material well-being.[43] By conflating prescriptive and holistic technologies, they operationalize both cultural responsibilities and economically rooted components in each practice. Through their new enterprises, artisans' and entrepreneurs' work entangles economic performance with cultural expressiveness and, in so doing, crafts a diversity that characterizes capitalism's current phase.[44]

Such a meshing of technologies and social practice results not only in a greater economic return to artisans who process and weave piña cloth but also makes artisans' work more visible to consumers and generates a sense of recognition and respect for each maker, both within and outside of their communities. In this way, Philippine artisans challenge neoliberalism by drawing on local traditions as well as on new forms of organization to devise innovative structures that can preserve their economic and cultural autonomy, whether they work independently or within a workshop or cooperative context.

The opportunities fashioned by some artisans, however, do not mean that their initiatives can provide sustainable options in work and social change for all women with the advent of global capital. Such a proposition belies the tremendous structural forces at play against them, and the level to which globalization (in the form of transnational, capitalist institutions and structural adjustment policies) has transformed social and economic relations on so many levels.[45] I want to suggest, however, that the current acceleration of demand for certain crafts such as piña textiles still leaves space for artisans to maneuver in order to create better work conditions and capture a share of emerging markets.

By regarding technology as a system that entails social, material, economic and process based components, we can more perceptively situate how artisans, and people generally, have used technology to reorder and restructure social relations—the relations not only between social groups, but also between nations and individuals.[46] Conceptualizing how technology changes the nature of people's experience owes as much to the understandings and practices worked out in the contingent and compromised space of cultural intimacy as it does to the imposition of any abstract prescriptive practice.

Acknowledgements: Field research for this paper was conducted over several periods in 1998, 2000, 2001, 2003 and 2005. During each of these fieldwork visits to Aklan and Laguna provinces, central Philippines, in order to understand the complexities of the production, distribution and consumption of piña cloth products, I worked with artisan producers (from farmers to weavers to embroiders), designers, workshop owners, cooperative managers, non-government (NGO) and government officials and piña textile retailers. With each of these industry participants, I conducted structured and semi-structured interviews and engaged in extended periods of participant observation. The other research methods I employed include archival research of piña industry history and of government and NGO reports on piña workshop operations, and research of the popular media coverage documenting current industry shifts. I also interviewed selected Manila retailers who own and operate stores selling a variety of piña textiles and fashions. Financial support for this research was provided by the Social Sciences and Humanities Research Council of Canada (SSHRC) through a Post-doctoral Fellowship (1997-1999) and Standard Research Grants (2000-2003; 2004-2007) and by the Ontario College of Art & Design, Faculty Research Grants. In the Philippines, I am affiliated with the Cordillera Studies Center, University of the Philippines Baguio, Baguio City. I thank my colleagues at CSC for their generous support of my research. To the artisans who have responded to my many questions, I owe a debt of gratitude.

ENDNOTES

1 See Lynn Stephen, "Women's Weaving Cooperatives in Oaxaca," *Critique of Anthropology* 25.3 (2005): 253-278; and William Warner Wood, "Flexible Production, Households and Fieldwork: Multisited Zapotec Weavers in the Era of Late Capitalism," *Ethnology* 39.2 (2000): 133-148.

2 See Arsenio Balisacan, "Anatomy of Poverty during Adjustment: The Case of the Philippines," *Economic Development and Cultural Change* 44.1 (1995): 33-62; and Sylvia Chant, "Women's Roles in Recession and Economic Restructuring in Mexico and the Philippines," *Geoforum* 27.3 (1996): 297-327.

3 See B. Lynne Milgram, "Women, Modernity and the Global Economy: Negotiating Work and Economic Difference in Ifugao, Upland Philippines," in Gracia Clark, ed., *Gender at Work in Economic Life*, (Walnut Creek, CA: Altamira Press, 2003).

4 Ursula Franklin, *The Real World of Technology* (Toronto: Annsi, Revised edition 1999) 10-11.

5 See B. Lynne Milgram, "Reorganizing Production for Global Markets: Women and Craft Cooperatives in Ifugao, Upland Philippines," in Kimberly M. Grimes and B. Lynne Milgram, eds., *Artisans and Cooperatives: Developing Alternative Trade for the Global Economy* (Tucson: University of Arizona Press, 2000) 107-128; and B. Lynne Milgram "Fair(er) Trade for Global Markets: Capitalizing on Work Alternatives in Crafts in the Rural Philippines," in Alan Smart and Josephine Smart, eds., *Petty Capitalists and Globalization: Flexibility, Entrepreneurship, and Economic Development* (Albany: State University of New York Press, 2005) 227-252.

6 See B. Lynne Milgram, "Piña Cloth, Identity and the Project of Philippine Nationalism," *Asian Studies Review* 29 (2005): 265-278.

7 Franklin 12.

8 Franklin 12. See also Tracy Bachrach Ehlers, "Belts, Business and Bloomingdale's: An Alternative Model for Guatemalan Artisan Development," in June Nash, ed., *Crafts in the World Market: The Impact of Global Exchange on Middle American Artisans* (Albany: State University of New York Press, 1993) 181-198.

9 Franklin 3.

10 See Robin Broad, *Unequal Alliance: The World Bank, The International Monetary Fund and the Philippines* (Berkeley: University of California Press, 1988); and Rene E. Ofreneo and Esther P. Habana, *The Employment Crisis and The World Bank's Adjustment Program* (Philippines) (Quezon City, PH: University of the Philippines Press, 1987).

11 See Florence E. Babb, *Between Field and Cooking Pot: The Political Economy of Marketwomen in Peru* (Austin: University of Texas Press, 1989); and Annelou Ypeij, *Producing Against Poverty: Female and Male micro-entrepreneurs in Lima, Peru* (Amsterdam: Amsterdam University Press, 2000).

12 Wazir Jahan Karim, "Introduction: Genderising Anthropology in Southeast Asia," in Wazir J. Karim, ed., *"Male" and "Female" in Developing Southeast Asia* (Oxford and Washington: Berg Publishers, 1995) 28.

13 Karim 28.

14 See Milgram, "Reorganizing Production for Global Markets."

15 See Chant, "Women's Roles in Recession."

16 Linda J. Seligmann, "Introduction: Mediating Identities, Marketing Wares," in Linda J. Seligmann, ed., *Women Traders in Cross-Cultural Perspective: Mediating Identities, Marketing Wares* (Stanford: Stanford University Press, 2001) 12-19.

17 Vita Sackville-West, quoted in Franklin 11.

18 Franklin 10-11.

19 Franklin 11.

20 Franklin 12.

21 Franklin 5.

22 See Anna Tsing, "The Global Situation," *Cultural Anthropology* 15,3 (2000): 330, 327-360.

23 Parts of this section on the history of piña have been drawn from previously published material in Milgram, "Fair(er) Trade for Global Markets."

24 Lourdes R. Montinola, Piña (Manila: Philippines: Amon Foundation, 1991) 10-11.

25 See Marian L. Davis, "Piña fabric of the Philippines," *Arts of Asia* 21.5 (1991): 125-129.

26 Montinola 43.

27 See Linda Welters, "Dress as Souvenir: Piña Cloth in the Nineteenth Century," *Dress* 24 (1997): 16-26.

28 Montinola 13.

29 Montinola 18-19.

30 See Montinolam and Alfred W. McCoy, "The Queen Dies Slowly: The Rise and Decline of Iloilo City," in Alfred W. McCoy and C. de Jesus, eds., *Philippine Social History: Global Trade and Local Transformations* (Honolulu: University of Hawai'i Press, 1982) 297-358.

31 Government organizations involved with the piña revival include: the Department of Trade and Industry, Philippine Textile and Research Institute; Fiber Industry Development Authority; National Agricultural and Fishery Council; Aklan Agricultural College. The efforts of the Patrones de Casa Manila culminated in the establishment of The Piña Weaving Demonstration and Training Center in Balete, Aklan, province.

32 All personal names of individuals and of groups or businesses are pseudonyms

33 Artisans extracting and processing piña fibres earn approximately 150 to 200 pesos per day ($3.35-4.45 CAD) depending upon the number of hours they work. Artisans preparing the warps for the looms earn approximately 200 to 250 ($4.45-5.60 CAD) pesos per day, while weavers can earn up to 400 ($8.90 CAD) pesos per day depending upon the number of hours they work. The government-suggested daily wage for an eight-hour work-day in the rural Philippines (which can vary by region) is approximately 250 pesos per day. The average rate of exchange in 2005 was $1.00 CAD = 45 Philippine pesos.

34 Franklin 12-13.

35 See James Scott, *Weapons of the Weak: Everyday Forms of Peasant Resistance* (New Haven: Yale University Press, 1985).

36 William G. Davis, *Social Relations in a Philippine Market: Self-Interest and Subjectivity* (Berkeley and Los Angeles: University of California Press, 1973) 211.

37 See B. Lynne Milgram, "Situating Handicraft Market Women in Ifugao, Upland Phillipines: A Case for Multiplicity," in Linda J. Seligmann, ed., *Women Traders in Cross-Cultural Perspective: Mediating Identities, Marketing Wares* (Stanford: Stanford University Press, 2001).

38 Gavin Smith and Susana Narotzky, "Movers and Fixers: Historical Forms of Exploitation and the Marketing of a Regional Economy in Spain," in Alan Smart and Josephine Smart, eds., *Petty Capitalists and Globalization: Flexibility, Entrepreneurship, and Economic Development* (Albany: State University of New York Press, 2005) 51-52, 45-68.

39 Deborah Kapchan and Pauline Turner Strong, "Theorizing the Hybrid," *Journal of American Folklore* 112.445 (1999): 239, 239-53.

40 Kapchan and Strong 239-40.

41 David Howes, "Introduction: Commodities and Cultural Borders," in David Howes, ed., *Cross-cultural Consumption: Global Markets, Local Realities* (London and New York: Routledge, 1996) 5-8.

42 James Carrier, "Introduction," in James Carrier, ed., *Meanings of the Market: The Free Market in Western Culture* (Oxford: Berg, 1997) 3, 1-68.

43 Rudi Colloredo-Mansfield, "An Ethnography of Neoliberalism: Understanding Competition in Artisan Economies," *Current Anthropology* 43.1 (2002): 114.

44 Colloredo-Mansfield, "An Ethnographyof Neoliberalism."

45 See Balisacan, "Anatomy of Poverty";and Chant, "Women's Roles in Recession."

46 Franklin 3.

Invention of Tradition: Craft and Utopian Ideals

Janice Helland

Elizabeth Cumming

Alla Myzelev

Section Four

Whether it is applied on a local, global, or virtual level, the story of the crafts is often told through invented traditions.

INTRODUCTION

SANDRA ALFOLDY

Common descriptions of a typical craftsperson might include words such as "rural" or "self-sufficient," and activities such as gardening or keeping chickens. This stereotype conjures notions of the morality of craft and the joy in labour that is behind the creation of beautiful objects for all. It can also be traced back to the nineteenth-century Arts and Crafts Movement, when a romanticized ideal of medieval craft was developed to counter the grim realities of mass production and the factory system. The idea of utopia remains central to our understanding of the crafts. Whether it is applied on a local, global, or virtual level, the story of the crafts is often told through invented traditions. The chapters contained in Section Four of *NeoCraft: Modernity and the Crafts* examine three particular histories that involve national traditions, social utopias, and craft production. The Canadian art historian Janice Helland looks at the class and national political issues surrounding Irish embroidery; the Scottish craft historian Elizabeth Cumming discusses the development of the Scottish Arts and Crafts Movement; and the Canadian craft historian Alla Myzelev outlines the relationship between traditional Ukrainian crafts and the early twentieth-century avant-garde. Together, these essays indicate the tensions that existed between utopian ideals and the daily realities of craftspeople.

MAKING IT IRISH: THE POLITICS OF EMBROIDERY IN LATE NINETEENTH-CENTURY IRELAND

JANICE HELLAND

In her speech at the opening of Dublin's Decorative Art Exhibition (1888), Baroness Prochazka, manager of the Royal Irish School of Art Needlework, told her audience that embroidery was "especially interesting to ladies from a variety of points of view," particularly as a "relief from the tedium of weary hours" and as a means of "earning a livelihood."[1] This essay considers the material objects made collaboratively in Dublin's art needlework school, along with the "livelihood" earned by the producers and the relationship between the objects and their consumers. The Irish school, founded in the early 1880s, provided a space in which "gentlewomen in reduced circumstances" could find "private employment," and like its London prototype, it intended "to revive a beautiful and useful art" which, according to its aristocratic patrons, had been "practically lost."[2] Objects made by women in the school were exhibited as distinctively Irish in arts and crafts exhibitions, such as the 1888 Decorative Art Exhibition as well as in large international venues such as the Chicago World's Fair (1893), and thereby acquired an identity that paralleled the political debates of the day, specifically those which surrounded the issue of Home Rule for Ireland. In addition to "selling" Ireland, the gendered space of the embroidery workshop transgressed the boundaries of tradition when leading fashion designers incorporated embroidered panels into costumes for the rich and famous; when used specifically to advertise and endorse Irish goods, embroidery became a diverse project that celebrated and exploited, appropriated and authenticated.

The making of sumptuously embroidered panels to be worked into elegant dresses designed for wealthy patrons also complicated issues of gender and class, and established subtle hierarchies within the broadly and ambiguously defined middle class. The women who stitched expensive threads onto equally expensive materials were often "distressed ladies," not *Song of the Shirt* seamstresses whose cause was frequently taken up in the nineteenth century and whose history continues to fascinate researchers and scholars. However, between aristocrats whose biographies enthral and seduce, and sweated workers whose lives reveal despair and exploitation, one finds a shadowy space inhabited by women whose social status suggests privilege but whose economic status implies disadvantage. The Royal Irish School of Art Embroidery provides a case study that weaves its way through the political and economic tensions that existed in Ireland in the late nineteenth-century and illuminates the production and consumption of a traditional art form patronized by wealthy promoters of the cottage craft revival.

One of the 1888 exhibition's most dramatic examples of the school's work was a lavishly embroidered court train of cream coloured Irish poplin that had been designed and made for the former vicereine and indefatigable supporter of Irish home arts and industries, Ishbel, Countess of Aberdeen.[3] The distinctively Irish train had been "embroidered in gold from Celtic designs copied from old Irish manuscripts," and likely had been adapted from the panels made for the first dress the countess had commissioned from the school in 1886—in particular from the sumptuously embroidered mantle that completed the costume. This first costume, also embroidered by women in the school, was, like its more elaborate 1888 manifestation, an advertisement for Irish industry and craft, and a celebration of a Celtic past. Ishbel Aberdeen wore the train and an equally resplendent court dress (the panels for the dress were embroidered in the school) to Queen Victoria's first Drawing Room (1888), to a Dublin Castle drawing room (1893), and to social events in Canada during her husband's term as governor-general (1893-98), and thereby conflated her patronage of Irish material with performances calculated to promote the art and craft of Ireland.

This use of textile, decoration, and fashion melded together as costume was a familiar, if tokenistic, strategy. For example, for her departure after her 1885 wedding, Princess Beatrice wore a dress trimmed with Irish lace and a bonnet trimmed with white heather and therefore, according to England's elite fashion magazine, *Lady*, she paid a "pretty compliment" to Scotland and Ireland.[4] The Marchioness of Londonderry and Countess Cadogan (both, like Ishbel, Aberdeen vicereines of Ireland) patronized the Royal Irish School of Art Needlework, as did a number of other aristocrats affiliated with Ireland. This exemplifies Colin Gale and Jasbir Kaur's contention that, "embroidery is potentially one of

LADY ABERDEEN IN VICE-REGAL ROBES, C.1893.

the more lavish and expressive forms of textiles. As a handcraft, concerned almost exclusively with embellishment rather than functionality, it lends itself to the world of wealth and status."[5] However, the use of specifically Irish "embellishment" evolved as a strategy Lady Aberdeen and other aristocratic philanthropists employed and deployed to unprecedented advantage during the 1880s and 1890s. The commissioned objects emerge as material culture in this affiliation between artifact and social relationship and they surface as visual culture in their display: "The display of possessions has always demonstrated new status, protected the existing hierarchy within and between groups, and announced social standing and allegiance."[6] The artifacts also blur the boundaries between the so-called traditional, sometimes anti-modern, medium of embroidery and the stylish use of material objects to construct fashion, generally perceived of as modern. Stitching and threads, then, became a complex project that signalled ownership, wealth, status, and privilege along with subversion, rupture, and contested nation.

Recognition of the difficulties of poor women from so-called good families formed the basis of newly established embroidery workshops in Britain and Ireland by the 1870s. The Irish school continued aristocratic traditions established, for example, by the Duchess of Marlborough's Committee for the Relief of Distress in Ireland, organized during the late 1870s;[7] it also complemented campaigns to revive and promote Britain's languishing silk and woollen industries. Additional organizations sprang up under the influence of middle-class women such as Mary Power Lalor, who formed the Irish Distressed Ladies' Fund in 1886 which, within a year, had assisted over 550 women in Cork and Dublin "by means of loans and grants, and by the establishment of needlework depots."[8] These organizations came into existence conterminously with cottage craft associations, such as the Donegal Industrial Fund, which expanded opportunities available to rural women in more remote areas by offering classes that might improve or develop their technical skills and guaranteeing markets for the work.[9]

By 1881, when Dublin's school of art needlework opened, the London school employed about 140 women who managed "the whole business of the school, including the bookkeeping."[10] Similarly, the Royal Irish School of Art Needlework was founded "for the purpose of giving ladies the chance of remunerative employment in the higher branches of fancy and art needlework."[11] It was considered "one of the most successful schemes for relieving distress among poor Irish ladies."[12] Apparently, and in addition to providing employment for poor ladies, the school encouraged the participation of "Irishwomen of the poorer classes" for whom the "conditions of life are especially hard." Those who were not "ladies," were thought to benefit from employment, "mental elevation" and contact

with "artistic cultivation." According to a contemporary review of the school's work in *The Times*, although an "Irish peasant girl cannot indulge in water-colour painting, or in drawing from the round" there was an art she could practice with success: "With the needle…she is able to invade and occupy the inmost domains of fancy, and to realize images of artistic beauty." However, the "idea must be there, and the worker must have been taught to interpret it, or her skill enshrines what is far worse than a fly in amber." [13] It would seem that once a certain skill level was obtained, the school would cultivate the more artistic, albeit traditional, aspects of embroidery.

From its inception the school operated with aristocratic patronage. Countess Cowper founded the Royal Irish School of Art Needlework in Molesworth Street under the direction of Charlotte McEvoy in the early 1880s during her husband's short but eventful stint as Ireland's lord lieutenant. [14] Its initial location in Molesworth Street and its subsequent placement in Clare Street put the School in the heart of Dublin's upmarket centre, near the cultural enclave represented by the Royal Irish Academy and almost next door to the exclusive dressmakers and milliners of Dawson Street. Within three years of its opening, Lady Waterford planned reforms that promised "to strengthen the hands of the self-supporting" school, which had been "established on a similar basis to the Royal School of Art Needlework in London." [15] By 1886, with the reforms in place, the school came under the management of the immensely efficient Baroness Pauline Prochazka, an Austrian aristocrat with family ties in Ireland. [16] The school employed twenty-five women who could earn from 12s. to 28s. per week; [17] an accomplished embroiderer in London able to do the kind of "art needlework" required for dressmaking might "earn by her needle from 25s. to 30s per week." [18] However, a "competent" dressmaker might earn 12s to £1 per week with the incentive, should she be very skilled, of becoming a full-fledged "first hand" earning up to £300 per year. [19] In all instances, whether skilled embroiderer or dressmaker, the working conditions would have been much better than those of a woman employed in the sweated industries whose earnings might reach 8s. per week. [20] However, becoming a dressmaker required a lengthy apprenticeship that may not have been possible for a "distressed lady." Thus, while outstanding technical skills would have been required in order to complete the highly specialized projects categorized as "art embroidery," acquisition of these skills could have been part of the education a young middle-class woman received at home rather than in apprenticeship. On the other hand, the skills might have been acquired from precise training obtained, for example, in the Donegal Industrial Fund's classes, where Irish women could learn needlework under the supervision of expert embroiderers: "Poor ladies are chiefly employed, but classes have been started in the country districts, in which peas-

ant girls are trained."[21] The Royal Irish School of Art Needlework most likely accepted women who already had some basic skills and who understood the value of clean hands; thus, from the beginning, class would have been an issue.

Taste, as defined by late nineteenth-century connoisseurs, also played a role in dictating the kind of women who produced work at the school. For example, in its comments about the 1888 Decorative Arts Exhibition (Dublin), the *Lady's Pictorial* commended the "good work done by the Royal Irish School of Art Needlework in educating and developing artistic taste in embroidery."[22] The school, then, produced luxury goods for wealthy consumers while, at the same time, it promoted buying Irish. Alice Hart of the Donegal Industrial Fund, who had a close working relationship with the school, concurred and was praised in the press for her commitment to Ireland: "Dublin shopkeepers, who are much inclined to look askance at native products, and dub all their wares 'Parisian', have learned from the enterprise, artistic taste, and self-devotion of an English lady that Ireland possesses 'resources' in her own industries and materials, which may be turned to good account for the welfare of the destitute and unemployed."[23] Hart, herself, stated that Irish women should wear Irish-made underlinen, and English and Irish dressmakers should relinquish their "senseless predilection for French goods."[24]

Regardless of the apparent inclusion of some "peasant girls," the political dimensions related to the founding of the Irish school resonated problematically within the expansion of the Ladies' Land League, which sought land reform and rent relief for Irish tenants.[25] *Queen*, a journal devoted extensively to fashion and the comings and goings of the "Upper Ten Thousand," announced the establishment of the League in Ireland early in 1881: "The Irish movement will be led by the wives of the local leaders of the existing league, and will devote themselves to the collection of funds." This was done "in anticipation of Government action against local branches of the Irish National Land League."[26] On the other side of the political debate about land reform, Irish "gentlewomen" in financially precarious situations could look to the "Association for the Relief of Ladies in Distress through Non-Payment of Rent in Ireland" also founded in Dublin in 1881.[27] These activities coincided precisely with the founding of Dublin's art needlework school and dovetailed with the organization operated by Mary Power Lalor; thus, women who were already skilled undoubtedly would have qualified for a place in the school, or they might work out of their homes and sell their products through Power Lalor's ostensibly non-partisan association. Employment in the school, however, brought the advantage of making high-profile, elaborate objects, such as Lady Aberdeen's Celtic extravaganzas, Emily Leslie's black satin court train decorated with British birds "portrayed, so true to nature that they would bear the crit-

Chasuble embroidered at the Royal Irish School of Art Needlework, *Art and Handicraft in the Women's Building of the World's Columbian Exposition* (Chicago, 1893).

icism of an ornithologist,"[28] and ecclesiastical embroidery such as the chasuble commissioned by a "patriotic" cardinal from the United States and subsequently exhibited in the Chicago World's Fair.[29] The school was always under royal patronage and thus uneasily paralleled the more radical Ladies' Land League in its practices, even though the groups employed remarkably similar strategies. For example, during an 1881 meeting of the Irish Ladies' Land League, the women decided to appeal for gifts of books and for funds to supply furniture "for the cells of the persons expected to be arrested under the Protection Acts"; they had raised £147.[30] The following year, the Countess of Fitzwilliam organised a bazaar in aid of "distressed Irish ladies"; she elicited the patronage of Queen Victoria and the Prince and Princess of Wales and procured the services of prominent aristocrats including Mary, Duchess of Teck and Alice, Countess of Bective, both of whom worked in stalls selling goods.[31] The bazaar raised £2000.[32] Obviously, the allure and glamour of fame and fashion was then (and is now) a lucrative force.

The Royal Irish School of Art Needlework used these kinds of venues to sell work as well as to advertise for commissions: bazaars served as exhibition spaces and thus displayed work to advantage while, at the same time, they provided various organizations the opportunity to raise funds. In addition to participating in the Countess of Fitzwilliam's 1882 bazaar, the school exhibited objects in a show and fancy fair held in Dublin's Exhibition

Palace organized in aid of the Masonic Orphan Schools. The embroideries, some of which were designed by members of the school's committee, proved competent, elegant, and traditional.[33] Much of the work done in the school represented a continuation of tradition to the extent that patterns were copied from earlier embroideries and reproduced for the late nineteenth-century consumer. There was an emphasis placed upon decoration that represented "natural flowers" with grounds "not too brilliant" and threads of "subdued tint"; there was to be "no crude colouring."[34] A "handsome piece of work" displayed in one of its earliest exhibitions, introduced the style that would become the school's proto-type: a "border with a design of Indian flowers, through which various animals and birds were introduced, worked in subdued colours and outlined in gold."[35] For the most part, then, the opulent embroidery produced in the school stayed very much within a conserva-tive, almost generic, style that replicated the already established and avoided experimen-tation. However, the conflation of style with fashion or with national Celtic identity pushed the boundaries of the traditional and brought embroidery together with modernity. Consequently, the characteristics of the objects can be seen as multifaceted; they resist facile categorizations that deny the complexity of their display and consumption.

Ishbel Aberdeen's display of support for Irish textiles and embroidery materialized dur-ing her 1886 Garden Party when she appeared in her Celtic dress embroidered by "poor ladies" in the Royal Irish School of Art Needlework. The use of Irish poplin, an expensive material woven from silk and wool, indicated support for an industry that, in 1886 in Ireland, was able to employ only 130 workers;[36] the embroidery spoke of encouragement for women who needed the small income derived from expert albeit poorly paid skills. Aberdeen's Garden Party dress expanded concerns for "buying local" out into the con-struction of a specific kind of Ireland, one identified with "salvaging" ancient customs and Celtic art.[37] She thus brought Irish and Celtic together in a resplendent performance cal-culated to attract, exhibit, promote, and sell. Every press review celebrated Ishbel Aberdeen's costume: a "robe and mantle of the richest ivory-coloured Empress poplin, beautifully embroidered by hand, in gold, with interleaf decorations" based upon designs in the *Book of Kells*.[38] The costume, designed by the curator of the Irish Academy and made by renowned Dublin dressmaker Mary Sims, ostensibly replicated a bridal gown worn by a twelfth-century Irish "princess" as portrayed in a mid-nineteenth-century paint-ing.[39] To complement the promotion of Irish-made fabric, Lady Aberdeen fastened the rich-ly embroidered mantle with a Tara brooch and the gold-embroidered shoulder piece with a fibula brooch. Her chatelaine bag and keys replicated objects in the collection of the Royal Irish Academy; even her stockings were Balbriggas stockings embroidered with sham-

rocks, her shoes Irish leather fastened with Irish harp buckles. Her white poplin parasol, trimmed with Limerick lace, sported an Irish yew stick and Tara brooch handle.[40] The dress articulated Ishbel Aberdeen's keenness for displaying Irish cloth and Celtic motifs on her own body and cast Aberdeen as a dramatic player in the exhibiting and selling of Ireland. The *Irish Textile Journal* complimented her endeavour to support Irish trade:

> One great benefit that I believe will be derived from this experiment is—and it will not require an ancient "seer" to prophesy it—that many ladies and gentlemen who look with contempt on Irish-made textiles, and would wear in preference anything with a foreign name or trade mark, however inferior or expensive, will learn that they have been all their lives misled by prejudice, or labouring under one of those extraordinary hallucinations prevailing amongst even the peasantry and other poorer classes, to value an article all the more that it has come from "furrin parts."[41]

This intensification of aristocratic intervention into the relationship between fashion and industry mirrored the revived interest in cottage crafts and began early in the 1880s (possibly with Alice, Countess of Bective) and the woollen industry. She had asked women attending a conversazione she organized to "appear in dresses from materials of English, Scotch, Irish or Welsh manufacture;"[42] she, herself, wore court dresses made from British materials to Drawing Rooms and during public appearances. However, unlike the traditional fashionable but silent apparitions of courtly fashion, Lady Bective and her supporters literally took to the public stage in a campaign directed toward the encouragement of British wool industries when they participated in a meeting of well over seven hundred people gathered in London's Mansion House.[43] Emily Mitford, who directed her philanthropic energies toward the silk industry, performed her allegiance, as did Bective, on her own body as well as in fancy fairs and bazaars.[44] She wore, to the first Drawing Room of the 1882 season, a train of pale blue satin (Manchester manufacture) lined with Surah of the same colour (Macclesfield manufacture) over white moiré antique and silk (Spitalfields manufacture). The fashion columns, possibly at her request, included the provenance of all the materials of Mitford's court costume; similarly, they included, in the description of the Princess of Wales's costume, an attribution of the "new material of golden brown woollen" to English manufacture.[45] Thus fashion, although its usefulness was debated at this time, became a great force in British and Irish trade.

The Royal Irish School of Art Needlework flourished during the 1880s: it successfully

participated in exhibitions and began its high-profile foray into making embroidered panels for dresses that graced the pages of leading fashion journals such as *Queen*, the *Lady's Pictorial* and, slightly later, *Gentlewoman*. The fabulously wealthy and influential Lady Londonderry frequently wore dresses that incorporated embroidered panels made by Irish women: she wore an ivory poplin costume of Irish manufacture made by an Irishwoman when she arrived in Dublin as vicereine,[46] and an ivory dress of satin and Irish lace to her first drawing room;[47] another costume, sketched for *Lady's Pictorial* in 1888, included a waistcoat of white satin embroidered with forget-me-nots by the Royal Irish School of Art Needlework.[48] In 1897 she wore a court dress of white duchesse "embroidered with lilies and love knots in tinted silks by the students at Viscountess Duncannon's Garry Hill School of Needlework"; thus she gave her support to a rural cottage industry as well as to the urban needlework school, albeit a cottage industry operated by another peer.[49] Lady Lurgen attended a court ball wearing a satin

"GOWN MADE FOR H.R.H. THE DUCHESS OF YORK," *QUEEN*, 18 SEPTEMBER 1897.

TORONTO REFERENCE LIBRARY

dress embroidered with cornflowers at the Royal Irish School of Art Needlework.[50] Even Mary, Princess of York, when she visited Ireland in 1897, wore a dress of Irish poplin with a deep yolk "of exquisite gold thread and sequin transparent embroidery" made by Lady Duncannon's cottage workers at Garry Hill [51] and another dress embroidered in forget-me-nots and rosebuds at the Royal Irish School of Art Needlework.[52] Switzer & Co, Dublin's elite department store, patronized the school by displaying dresses decorated by women at the school during the annual Irish Industries Association exhibition in 1897; one dress, sketched for *Gentlewoman*, closely resembled the Countess of Fingall's 1898 court dress

Left: "An unique model at Messrs Switzer & Co.,
Ltd., Grafton Street, Dublin," *Gentlewoman*,
21 August 1897, 17.

Toronto Reference Library

"Dresses worn at the Dublin Drawing Room,"
Countess Cadogan and the Countess of Fingall,
Queen, 12 February 1898, 286.

Toronto Reference Library

worn to a Dublin Castle drawing room. Beatrix, Countess Cadogan, the current vicereine of Ireland, wore a costume embroidered in two shades of lilac and silver spangles to the same drawing room.[53]

Slightly later, in 1898, Beatrix Cadogan, like Ishbel Aberdeen before her, used an embroidered dress to transform herself into an emblem of Ireland for her exalted Dublin Castle guests. She wore a spectacular green satin dress embroidered at the Royal Irish School of Art Needlework that sported a rich trail of green velvet shamrocks on the skirt and shamrocks, each outlined with silver, on the bodice. However, Irish soldiers serving in the British army did not have the same privilege. The wearing of shamrocks by Irish soldiers had been banned for some time when Lady Cadogan displayed her proclivity for the symbol: "In 1897 one soldier had committed suicide when dismissed from the army for, among other things, wearing shamrock," and a year later, the year of Beatrix Cadogan's ball, Irish parliamen-

Countess Cadogan's Gown for the St. Patrick's Ball, *Queen*, 26 March 1898, 558.
Toronto Reference Library

tarian, William Redmond, was "suspended from the Commons for protesting at a sailor's getting fourteen days' punishment for wearing shamrock."[54] This brutal disparity signals the distance between patrons and workers, highlights the problem of authenticity, and acts as a reminder that despite intentions, the women who so intensely promoted the work of the Royal Irish School of Art Needlework participated in what was fundamentally a colonial project, even with its component of Irish aristocrats and its not-for-profit stance. Thus, while high-profile events like drawing rooms, fancy balls, and the Princess of York's

intensely publicized visit to Ireland provided patrons of the school with an opportunity to promote Irish industry while at the same time maintaining their roles as fashion trendsetters, they could not sustain the project. The school closed in 1915.[55]

Dresses made from the finely woven poplin that draped so elegantly promoted an industry in decline in the late nineteenth-century; sumptuously embroidered panels signified the special, one-of-a-kind costume made by highly skilled and underpaid hands. At the same time, the commissioned panels on Irish material suggested "distressed lady" or peasant girl willing to learn proper feminine skills that reified her place in a threatened hierarchy: better needlework than rebellion. The site of production became a gendered space defined by class and tradition; the objects became fashion; the embroidered panels suggested wealth and privilege, but they also implied skilled handwork and artmaking. Thus, embroidered textiles "communicate relationships and mediate progress through the social world; their diffusion bridges cultural boundaries and connects centres with peripheries."[56] The ambiguities evident in this relationship between material object and its cultural use suggest that the needleworker and her product existed between the dichotomies of modern and anti-modern, particularly when her traditionally crafted object became affiliated with identity, consumption, and fashion.

ENDNOTES

1 *Lady's Pictorial* 25 February 1888: 194.

2 "School of Art Needlework," *The Times* 7 January 1874: 12. The London school had been founded in 1872.

3 *Queen* 24 February 1888: 252.

4 *Lady* 23 July 1885: 654.

5 Colin Gale and Jasbir Kaur, *The Textile Book* (Oxford: Berg, 2002) 8.

6 Richard Grassby, "Material Culture and Cultural History," in *Journal of Interdisciplinary History* (Spring 2005): 596.

7 *Queen* 15 January 1881: 77. Frances Marlborough was the daughter of the Marquess of Londonderry and was thus familiar with Irish politics and society; the Duke of Marlborough accepted the Irish viceroyalty in 1876 and, along with the Duchess, sought to promote Irish trade.

8 *Queen* 17 December 1887: 793. Sales of the work were "for the benefit of aged and distressed Irish gentlewomen who, through non-payment of rent, have for the past five or six years been left utterly destitute" (ibid. 817). Ireland's mass agrarian movement for land reform particularly affected women from the land-owning class whose social status did not actually translate into wealth.

9 See, for example, Janice Helland, "Exhibiting Ireland: The Donegal Industrial Fund in London and Chicago," *Revue d'art canadienne/Canadian Art Review (RACAR)*, XXIX, 1.2 (2004): 28-47.

10 The Duke of Albany as quoted during his speech at the opening of the Glasgow branch of the school in the *Glasgow Herald* 16 October 1882: 4.

11 *The Times* 23 May 1889: 5.

12 Geraldine, Countess of Mayo in *The Times* 4 December 1893: 7.

13 *The Times* 23 January 1884: 7.

14 Countess Cowper relinquished her role in the school when she and her husband left Ireland but as late as 1889, she was still linked to the school as a patron along with other former vicereines like the Countess of Aberdeen and the Countess of Carnarvon.

15 *The Times* 23 January 1884: 7.

16 Baroness Prochazka had moved to Kilkenny in 1886; she directed the school for twelve years. Nicola Gordon Bowe and Elizabeth Cumming, *The Arts & Crafts Movement in Dublin and Edinburgh, 1885-1925* (Dublin: Irish Academic Press, 1998) 183.

17 *Queen* 18 December 1886: 742.

18 Margaret Bateson, "Women's Part in Manufacture," *Queen* 21 November 1896:980. By comparison, spinners in cotton mills, at this time, might earn "by piece-work, 14s. to 15s. per week" Bateson, *Queen* 31 October 1896: 844.

19 J. E. Davis, "The Modern Dressmaker," *Woman's World* 1888: 555.

20 Investigations into the sweating system in England took place in 1888 and found, for example, that "a Hungarian girl…worked from a quarter to seven in the morning to half past eight at night, for from 3s. to 8s. per week." The investigating committee also found that women were often "employed in sweating dens after midnight" *Queen* 28 April 1888: 499.

21 Alice Hart, "The Women's Industries of Ireland," *Queen* 18 December 1886: 742.

22 *Lady's Pictorial* 25 February 1888: 194.

23 *Queen* 24 April 1886: 435.

24 Hart 742.

25 See Janet K. TeBrake, "Irish Peasant Women in Revolt: the Land League years," *Irish Historical Studies* 28.109 (1992): 63-80, for a discussion of the Ladies' Land League. The land movement was seen as "means to a political end…land agitation provided a stepping-stone to national independence" TeBrake 63.

26 *Queen* 15 January 1881: 67.

27 *The Times* 30 December 1881: 4.

28 Emily Leslie wore the dress and train at Queen Victoria's first Drawing Room of the 1882 season. *Queen* 11 March 1882: 201.

29 *The Times* 6 March 1893: 11.

30 *Queen* 12 March 1881: 248. Parliamentarian and land reformer Charles Stewart Parnell, for example, was arrested in October 1881.

31 The Duchess of Teck was the mother of the future Duchess of York (later Queen Mary); Irish-born Alice Bective was the daughter of the Marquis of Downshire. Both were stalwart supporters of British and Irish home arts and industries.

32 *Queen* 27 May 1882: 463; and 10 June 1882: 507.

33 *Queen* 22 April 1882: 337.

34 *Lady's Pictorial* 25 February 1888: 194.

35 *Queen* 22 April 1882: 337.

36 The *Irish Textile Journal* blamed the imposition of a prohibitive tax of 60% of the fabric's value on Ireland's export of poplin to America for the decline of the industry 15 April 1886: 37.

37 Lady Aberdeen's enormous garden party staged in the grounds of Dublin Castle took place within three months of her arrival in Dublin in February 1886 as wife of the recently appointed Lord Lieutenant and represented the beginning of her dedication to the promotion of Irish art and industry. She placed an announcement in newspapers and journals stipulating that all those attending must wear material of Irish manufacture *Irish Textile Journal* 15 April 1886: 37.

38 *Illustrated London News* 5 June 1886: 600; and *Irish Times* 24 May 1886 5.

39 *Lady's Pictorial* (20 May 1886): 497. Major Robert McEniry was resident museum curator from 1872 to 1890. I thank Siobhán O'Rafferty, librarian, Royal Irish Academy for this information. The design owed its inspiration to Daniel Maclise's painting of Aoife's dress in *The Marriage of Strongbow and Aoife* (1854).

40 *Irish Times* 24 May 1886: 5; and *Irish Textile Journal* 15 June 1886: 65.

41 *Irish Textile Journal* 15 May 1886: 55.

42 *Queen* 28 January 1881: 80.

43 "Encouragement of Woollen Industries," *Queen* 18 February 1882: 139.

44 Emily Mitford, the daughter of Lord Egerton of Tatton and wife of the Hon. Percy Mitford worked tirelessly to encourage women to buy English silk. See, for example, "Our Silk Industry," *Queen* 28 January 1882: 70-72, for a discussion of Mitford's activities.

45 *Queen* 25 February 1882: 159.

46 The Marquess of Londonderry followed the Earl of Aberdeen as lord lieutenant of Ireland.

47 *Lady's Pictorial* 12 February 1887: 162.

48 *Lady's Pictorial* 5 May 1888: 487.

49 *Queen* 15 May 1897: 962.

50 *Irish Society* 19 March 1898: 354.

51 *Gentlewoman* 21 August 1897: 7.

52 *Queen* 18 September 1897: 542. The dress was made by Switzer & Co.

53 *Queen* 12 February 1898: 286. Both dresses were made by Switzer & Co.

54 James Murphy, *Abject Loyalty: Nationalism and Monarchy in Ireland During the Reign of Queen Victoria* (Washington, DC: The Catholic University of America Press, 2001) 278.

55 Anthony Symsondson, "Art Needlework in Ireland," *Irish Arts Review* 10 (1994): 135.

56 Grassby 593.

PURE MAGIC: THE POWER OF TRADITION IN SCOTTISH ARTS AND CRAFTS[1]

ELIZABETH CUMMING

"To watch the corn grow, and the blossoms set; to draw hard breath over ploughshare or spade; to read, to think, to love, to hope, to pray—these are the things that make men happy…. [T]he world's prosperity or adversity depends upon our knowing and teaching these few things; but upon iron, or glass, or electricity, or steam, in no wise."[2] This attack on Victorian materialism came from the pen of John Ruskin (1819-1900). In *Modern Painters* he criticized industrialization, the "great mechanical impulses" of the age as a "mere passing fever, half-speculative, half-childish," a headlong rush to change the world "at a hundred miles an hour," making "stuffs a thousand yards a minute" which would "not make us one whit stronger, happier, or wiser." Manufacturers with their "grand inventions for conquering (as they think) space and time, do, in reality, conquer nothing; for space and time are, in their own essence, unconquerable, and besides did not want any sort of conquering; they want using. A fool wants to shorten space and time: a wise man, first to gain them, then to animate them."[3]

Encouraged by such words, the Arts and Crafts movement is often seen as a romantic reaction to the industrial revolution. In Scotland, a country which owed so much of its new prosperity to urban industry, the movement evolved earnestly, but also gently, as idealism turned into practical achievements. Although the designs of William Morris were widely admired, his stormy pursuit of revolutionary principles found little support. Here, dreams became reality through mutual co-operation. But the sense of romance, and indeed spirituality, penned by Ruskin (whose father, after all, did come from Edinburgh) would find

echoes in the writings of such practical, no-nonsense men as the textile manufacturer James Morton (1867-1943), director of the family textile firm of Alexander Morton & Co., and the Ayr architect James Archibald Morris (1857-1942), whose working life embraced both membership of the Art Workers' Guild in London and a long-term directorship of a Kilmarnock engineering company. These men, like many others, worked in industry. The movement in Scotland from the 1880s onwards ran with manufacture and engineering, and sometimes even absorbed the latter's functionalist aesthetics as part of its quest to return beauty to everyday experience. The Edinburgh architect Robert Rowand Anderson (1834-1921), leader there in the 1890s of a major Arts and Crafts training school, recognized that machinery was the "only true constructive art that has been produced since the decline of medieval architecture."[4] Arts and Crafts designers celebrated modernity and engaged, essentially, with ideas of perfection.

Perfection was far from a measure of constraint. It required recapturing something of the deep beauty of the past in the present age as well as looking forward with confidence. In this, the constants of space and time, agents of imagination, were the working tools of tradition. This essay examines how such tools were used to positive effect through design to build the future. This project took many forms. Most obviously, space and time were united in the general and widespread concept of organic growth, which could be applied to culture as well as to the natural world. There are a number of texts written by Scots which illustrate

TITLEPAGE, *THE BOOK OF SPRING*, FIRST VOLUME OF *THE EVERGREEN: A NORTHERN SEASONAL*. PUBLISHED BY PATRICK GEDDES AND COLLEAGUES, EDINBURGH, 1895. DESIGN BY CHARLES MACKIE.

this development over a forty-year period. In the mid-1890s, the botanist Patrick Geddes (1854-1932) was deeply involved in the renewal of Edinburgh's Old Town. He was also the publisher there of *The Evergreen: A Northern Seasonal* (1895-6). A cultural activist and a man most famous as a town planner, he understood the organic interplay of the arts and sciences. In *The Book of Autumn* (1895), the second volume of *The Evergreen*, he described the idea of cultural progress in terms of growth and renewal, paying tribute to the French theorist Hippolyte Taine: "'Life the green leaf, say we, and Art the flower.' All the great flowers of literature and art rise straight from their rootstocks, each deep within its soil."[5] These words were to be adapted by Charles Rennie Mackintosh when he wrote in 1902:

> Art is the Flower. Life is the Green Leaf.
> Let every artist strive to make his flower a beautiful living thing, something that will convince the world that there may be, there are, things more precious more beautiful—more lasting than life itself.[6]

Growth in nature was linked to intellectual and also spiritual development. A little later the leading stained glass artist Douglas Strachan (1875-1950) could refer to "the mission of beauty, not as a sensuous luxury, but as a spiritual force…. [O]n this rock alone can a Modern Tradition be founded."[7] Design, he said, was simply "the expression of thought," and modern tradition could emerge intuitively in the hands of men and women of imagination.[8]

Although tradition might now emerge passively in some hands, new ideas had been sparked at an astonishing rate from the late 1880s. Arts and Crafts reformers including artist-designers, manufacturers, and industrialists formed committees to work together on essential improvements: to decorate public buildings, organize craft classes, and through new ideas in education, completely revise the training of architects, artists, and designers. The writings of Ruskin illustrate a continuity of thought essentially distilled from that of the eighteenth-century Enlightenment with its moral emphasis on the collective duty of each individual within society. In design education, urban renewal, and the implementation of conservation principles design reformers engaged directly with the world about them. In all three areas, the definition of tradition was important, bringing with it a fresh reconsideration of time. Arts and Crafts practice generally had rejected the superficiality of the Victorian-style revivals and instead sought out a true and proper understanding of the past in order to move forward. Not for nothing were the words of John Dando Sedding, "there

is hope in honest error, none in the icy perfection of the mere stylist," an aphorism carefully written out by architect and designer Charles Rennie Mackintosh in 1892 (as part of an invitation card to a Glasgow School of Art Club meeting) and 1901 (in both English and German as a line block print).

When, in 1895, William Macdonald and biologist J. Arthur Thomson outlined their ideals in *The Book of Spring*, the first volume of *The Evergreen*, they wrote that the past offered itself as a base for the future, where materialist squalor, a necessary by-product of fast urbanisation, could be replaced. They referred to the creation of their utopia, as a City Beautiful "in which joy inhabits and righteousness has a chance of increase."[9] The materialism which had bred squalor over the last century could be overturned. They focused on Edinburgh, "our own, unique in the world…paved with history, echoing with romance, rich in an unbroken intellectual tradition—what might not this city become!" Here tradition was a creative tool of endeavour, a means of formulating new ideas rather than something to be rejected as irrelevant.

Thus the return of beauty and tradition to everyday life was considered to be a "roots-up" approach, starting with the encouragement of the individual—with the Victorian principle of self help a key component—and a gradual building towards a collective achievement. This took many forms: from urban regeneration (which included modernizing restored or new buildings with mural art) to encouraging amateur and professional crafts with which to improve and personalize the domestic environment. In all four Scottish cities of Glasgow, Edinburgh, Dundee, and Aberdeen, societies were formed to organize teams of artists and craft classes. Little by little, throughout the late 1880s and the 1890s, homes were modernized through the addition of craft objects in metalwork or wood, made or bought by their users. By 1902 Francis Newbery, the director of the Glasgow School of Art and a man active in various societies in Edinburgh as well as in his own Glasgow, could write that "if beauty be seen and felt in things lowly, there exist the possibilities of its further appreciation in higher things; and a city, whose citizens have beautiful things in their houses, may hope to exact from civic authorities a recognition of the truth that, as the house is, so shall the city be."[10] There were echoes here of *The Evergreen*.

The 1890s was a decade of ambition, optimism, and progress. One element of renewal through Arts and Crafts work was the overhaul of design education. Newbery, who had been appointed to Glasgow in 1885, soon began to build on the success of his predecessors. Partly because of its sheer size and placing as "Second City of the Empire," Glasgow saw major educational advances in the 1880s, especially in terms both of curriculum and opportunity. Newbery built on principles learnt in London and now revitalized through a

number of contacts with local curators, architects, artists, and manufacturers. He fostered a new design ethos, which embraced both craft and manufacture and empowered the individual artist designer. Teaching at the Glasgow School of Art was grounded in draughtsmanship and technical skills, proficiencies which gave the student an easy familiarity with line, scale, and space, and released the imagination. In addition, the study of the human figure was extended by Newbery far beyond the normal life drawing class. The designer and educator Walter Crane (1845-1915) became a regular visitor to the School of Art throughout the later 1880s. Partly inspired by Crane, figural work by the early 1890s was considered appropriate to both the medium and overall concept of an object, and was the principal element not only of textile design but also of illustration, mural painting, metalwork, and china decoration. Within the applied arts, decoration was an integral part of the design, not some superficial ornamentation. Industrialists and architects served as School governors and assessors. This was the education which, supported by men as diverse as architects William Leiper (1839-1916) and William Forrest Salmon (1843-1911) and publisher Walter Blackie (1860-1953), gave rise to the art movement known as the "Glasgow style."

The "Glasgow style" had a number of creative components. It was essentially based on the physical values of form and space and was partly the result of the School's commitment to architectural form, partly due to manufacture requirements, and partly due to the machine aesthetic at large in this modern city of heavy and industrial engineering. Within this evolution of the Glasgow style was Crane's emphasis on teaching designers and architects about the importance of unit spacing. Crane's book *Line and Form* (1900) was written after his involvement with Glasgow had ended, but its principles drew on dialogue with Newbery's School. He referred in his book to the necessity of "controlling boundaries, spaces and plan," a design approach which was applied to every area of design, and not only to graphic work and textiles.

A sense of personal identity was always an essential element of teaching in Scotland. The best educators released the full potential of each artist. The textile artist Jessie Rowat (1864-1948) had married Newbery in 1889. A School graduate, she was appointed teacher, heading her own embroidery department from 1894. The Newberys were as much theorists as artists, designers, or educators. In 1897 Gleeson White interviewed her for *The Studio*. She spoke of the importance of individuality to the artist, stating that "the greatest thing in the world" was for "a man to know that he is his own, and that the great end in art is the discovery of the self of the artist." [11] For her, modern designers should simply be "the sum of tradition," but they should also use ideas in a contemporary way, "*that* for

our fathers, *this* for us." She noted the importance of every aspect of design, each contributing complementary qualities and related values to both concept and final product. She equally valued space and materials, as "material, space, and consequent use discover their own exigencies and as such have to be considered well."[12] The idea of natural growth was here within an object's design, its maker working in tandem with external ideas. Her embroidery designs (often, but not always, made by herself) for dress collars or belts, cushions and other domestic items use natural, inexpensive fabrics to which silks and sometimes glass beads are applied in simple, linear patterns, which reveal and release much of the intrinsic materiality. Newbery's textiles are concerned with boundaries and a dialogue of space, surface and form—just as much as the furniture of Charles Rennie Mackintosh. Mackintosh's buildings, interiors, furniture, and metalwork of the later 1890s also work with space as a positive and unifying intellectual element.

Jessie Newbery's approach to design has a strongly Celtic element within it. Artists in Scotland (and particularly in the west) have long been concerned with dialogues of common sense and romance, with values of tactility and absence. Here space is at once physical and intellectual. From prehistoric standing stones and illuminated manuscripts to the recent visual poetry of Ian Hamilton Finlay, there has been an urge to express such ideas. The endlessness of Celtic interlace bonds infinity to the expression of line and colour. In 1907, when a Pan-Celtic Congress was convened in Edinburgh, Patrick Geddes contrasted the Celt "rich in all save money" with the Saxon "poor in all save paper wealth." Art for him was stimulated by material poverty. Part of a Celt's identity was his imagination, seen in "gorgeous mass books, windows, imagery and sculpture." The Celt's sense of beauty was stimulated by the world of nature: "zone of mist, sunrise, sunset gloom…the wonderland of Atlantic space."[13] Fluency between physical and abstract space was important.

The art of combining intellectual space (which of course could conflate periods of time and loosen their linearity) and the surviving elements of tradition took a number of forms in 1890s Scotland. Design in Glasgow was one example. The revitalized Old Town of Edinburgh—the city which was the focus of the energies of Geddes's circle—was a different mix of old and new. Geddes engaged in what he called "conservative surgery," the careful recording and restoration of buildings and the creation of open spaces to benefit the health of the citizens. These spaces, whether developed as gardens or as paved courtyards, were for communal living. The same sort of care was given to new individual structures, their forms and detailing. Their architects—notably Sydney Mitchell (1856-1930) and Stewart Henbest Capper (1860-1925)—provided structures designed for modern comfort but also imbued with a vibrant sense of the past.

COLLAR, MADE AND EMBROIDERED TO HER DESIGN BY JESSIE NEWBERY, C.1900. LINEN WITH SILK THREADS AND GLASS BEADS.

One the first experiments in Edinburgh was Geddes's redevelopment of Short's Observatory (purchased in 1891) in the Lawnmarket into what he termed the Outlook Tower. As a botanist, Geddes here turned his microscope on the city and the world. He created the world's first "sociological laboratory," with the Tower both a symbol and a means of measuring the city. It was a modern, multi-layered museum dedicated to the local and regional, to the national, the European, and (on the ground floor) the global. Right at the top, the local and the current could be studied, quite magically, on the table of its camera obscura. The Tower was a living museum, but it was also keenly romanticized. It was a visual icon for the entire Edinburgh movement. An unknown illuminator captured it (and various other historic neighbourhood buildings, including the crown of St. Giles Cathedral) in an illuminated page, drawn in the manner of a sixteenth-century French manuscript. Children, including those of the Geddes family, were then much involved in sowing seeds, growing bulbs, and planting flowers in the gardens of the newly cleared spaces in the Old Town. The sense of planting the seeds of progress, literally and symbolically, was expressed in the manuscript's words: "Yet endure / And plant again the fragrant closes / Their children's children shall love Roses."

Patrick Geddes advocated a broad outlook for urban architecture in which society would play a more responsible role. He talked and wrote of the synergy of life and of cultural growth. Nowhere

YET ENDURE, AND PLANT AGAIN THE FRAGRANT CLOSES, THEIR CHILDREN'S CHILDREN SHALL LOVE ROSES. PAGE ILLUMINATED BY AN UNKNOWN ARTIST, C.1895. INKS AND WATERCOLOUR ON PAPER.

is this more visible than in the new buildings of the 1890s which synthesized tradition and modernity. Of these, the most remarkable is the complex called Ramsay Garden, where the 1730s house of the pastoral poet Allan Ramsay was wrapped in a completely new building. It was intended as a massed development for mixed occupation, with a variety of apartments for all ages. When the second, northern section was completed in 1893-4 by Sydney Mitchell, it would also have an attached student hall of residence. It might be described as a vertical village arranged around a central "green" or courtyard. The concept built on Mitchell's earlier designs for Well Court (1883-6), a community housing development in Edinburgh's Dean Village, and his popular "Old Edinburgh Street," a themed section of the Edinburgh International Exhibition of Industry, Science and Art of 1886.

The first, southern section was built to designs by Stewart Henbest Capper in 1892-3. Capper, a classicist who took up architecture relatively late, had already worked on property next to the existing Geddes home in James Court, creating the first of a number of self-governing student hostels in the area. Another hostel was Burns House in the Lawnmarket. There Capper provided a triple-gabled façade above two-storey oriel windows. Below each is a carved sandstone corbel representing the reunion of the arts and sciences—the intellectual, the scientist and the craftsman. At Ramsay Garden, Capper presented a rich encyclopaedia of Scots building details from the eighteenth and nineteenth centuries: sash and casement windows, crow-step gabling, stair towers, and jettisoned upper bays. It is the work of an architect who could cleverly combine forms and decoration. Such a play of varied forms underlined the domestic functionalism of the interiors but also was, quite literally, a "sum of tradition." The complex is a white harled edifice with red sandstone dressings which still has a magical presence at the very heart of the city. It was quite different from its grey stone surroundings. *The Studio* magazine reported: "The grey old metropolis of the North had been getting greyer year by year with freestone and slate, when suddenly, on the east slope of the Castle Hill, a bright-hued pile arose, shocking, with its red roofs and gilded spire, the devotees of drab." [14]

The Geddes family took the best apartment at number fourteen and moved in during 1893. On its walls the Celtic revival artist John Duncan (1866-1945) painted murals illustrating "the evolution of pipe music," with Charles Mackie (1862-1920) and Mary Hill Burton (1857-1900) contributing pastoral scenes illustrating the seasons. Mitchell's section to the north housed apartments and both the University Hall residence and a School of Art. The students' common room was painted by Duncan, Helen Hay and Helen Baxter in 1895-6 with what Geddes called "the vastest and most elaborate Celtic illumination in the modern world." [15] The scenes from Celtic myth and legend were Symbolist, linked by bright

Ramsay Garden, Edinburgh. South section designed by
Stewart Henbest Capper, 1892, built 1892-3.

interlace patterning. In 1896 Geddes and J. Arthur Thomson's guide to these dwelt on the theme of time, echoing St. Columba's words on the walls of the room, "as it hath been, so shall it be." This neatly summarized Geddes's stand on the continuity of culture. The paintings were:

> pictures of imagination, of magic and romance. Yet they were gravely chosen withal, and for reasons manifold: poetic, historic, academic, even personal to the student's life of which they shadow forth the possible stages. But what if they be but dreams? "We are such stuff as dreams are made of." What if they be but magic and romance? These things are not ancient and dead, but modern and increasing. For wherever a man learns power over Nature, there is magic; wherever he carries out an ideal into Life, there is Romance.[16]

Magic could transfer the past into the future. This was also a key to the work of the Old Edinburgh School of Art. While nurturing a modern school of Celtic art (in metalwork, leather, book design and so on), this school had a second string to its bow: namely, the collection and active preservation of the past. School staff and students assembled photographs and engravings and other records or relics of Edinburgh's Old Town. Lectures were given on its history and new, relevant city work, such as Duncan's Witches' Well (1895), made and sited in a wall on the east edge of the Castle esplanade. Recording and broadcasting historical evidence was a key part of Edinburgh's wider antiquarian work. Henbest Capper's massed form and use of white harling (pebble dash) and detailing at Ramsay Garden added a third dimension, and also the fourth (time), to the recently published recording of indigenous building types by architects David MacGibbon and Thomas Ross in *The Castellated and Domestic Architecture of Scotland* (1887-1892). The School married the new Celtic art with the recording of historic material culture.

The Old Edinburgh School of Art was small scale and independent, the product of a group of individuals committed to culture. Others in the city were simultaneously and, in the end, more lastingly, pursuing the national expression of tradition within design and architecture. There had been calls in the late 1880s for "an Academy of Architecture and the Arts of Decoration to correspond to the already existent Royal Scottish Academy."[17] This school, to be called the School of Applied Art, would champion a nationalist approach in artistic design and offer an alternative view of tradition to that of Glasgow designers. It was based in a scrupulous, almost archaeological, dissection and understanding of histor-

ical precedent. The promoter of the new School was the architect Robert Rowand Anderson.

But Rowand Anderson was as much a modernizer as a traditionalist. He wrote that "we must put ourselves in line with the science of the day…. [T]hen we may look forward to erecting buildings fitly representing the ideas and wants of an age with a constant succession of ever-varying expression and beauty—with natural dignity, and not artificial picturesqueness." He was an advocate of a more integrated approach to art, craft and architecture. Unlike Newbery, however, Rowand Anderson had no admiration for the government's Department of Science and Art. As he made clear in his address at the opening of the School of Applied Art, the Department's South Kensington system had moved away from its initial goal, the "encouragement of design as applied to arts and manufacture," into a school confined to the teaching of drawing and painting. The new school was for "imparting an accurate knowledge of the various phases of art which must be used more or less by a large number of industries, and which cannot be obtained at present in any existing school."[18] Drawing, as at Glasgow, remained vitally important within education, but so, he argued, was the careful study of Scotland's past.

The School of Applied Art, intended for the training of architects and those involved in "the constructive trades," opened in the Royal Institution on Princes Street in Edinburgh on 21 October 1892. Apart from architecture and crafts of the built environment, its taught subjects included typography, silver and goldsmiths' work, bookbinding and lithography. It was fuelled by a "desire to recover the good old traditions of Art, as the only hope of making real progress" and to produce beautiful design. A library of designs was also developed which included examples from Paris, as Scottish workmen were considered to have "no sense of artistic refinement." This introduced a European flavour, offering a union of broader internationalism bonded to a strict sense of Scottish values. But this was an architecture school thoroughly Arts and Crafts in its outlook and curriculum. Classes in architectural draughtsmanship, decoration, furniture, plaster and woodcarving, and silver chasing and engraving were held, partly accommodated in new workshops opened opposite the Institution at 3 Hanover Street in 1896. The School took it on itself to shape a "national character because there is in Scotland an art of the past with a distinctly local colouring capable of being developed and applied to the wants and necessities of the present day."[19] This fine School was absorbed into the new Edinburgh College of Art when it was founded in 1907, and for the next thirty years, it steered a "traditionalist" approach to design, which was based on a close knowledge of the inherited past. This is particularly relevant to Canada as, encouraged by Henbest Capper's work in Edinburgh and lectures in the mid-

1890s, two School students would shortly after follow him to Montreal, and also like him, take up chairs in architecture at McGill University and contribute much to Canada's native architecture. These students were Ramsay Traquair (1874-1952) and Percy Erskine Nobbs (1875-1964). Ramsay Traquair, son of a leading muralist and craftworker, Phoebe Anna Traquair, had been one of the first bursars appointed to Rowand Anderson's National Art Survey from 1895, which sought to record specimens of historic Scottish craftsmanship. The first surveys were of the furniture of the Duke of Hamilton at Holyrood. In 1921 the first of four volumes of the *Art Survey* would be published, making it a rich resource for many architectural practices throughout the country. The students' intellectual dissection and understanding of history was likened by Rowand Anderson to anatomy lessons for the medical student. The drawings were to serve as part of an ongoing archive. Such a training and respect for the crafts positioned them well to work with their adopted new cultural landscape.

There was a further area where tradition empowered the future of design, and that was in the area of building conservation. A number of key architects were involved in this area, including John Honeyman (1831-1914), founder and senior partner of the Glasgow firm in which Charles Rennie Mackintosh worked. His office, like that of William Leiper, encouraged high standards of craftsmanship and good design and also led to the development of Arts and Crafts attitudes and practice. Honeyman's career included public and commercial buildings as well as west-coast private houses but also church work across Scotland. Many of the churches he worked on were for the Free Church. The scrupulous attention to detail, together with the beautiful simplicity of structure, were qualities also to be found in the work of John Keppie, his partner from 1888, and indeed that of Mackintosh.

Honeyman, like Leiper, introduced fine wrought metalwork into his buildings although there was no partnership with one specific firm of decorators. Like Geddes and Francis Newbery, he also had spent time in London, and through contacts—and above all through his active membership of the Society for the Protection of Ancient Buildings—he knew many London designers and firms. He chose his craftsmen with care, particularly for the figurative glass in his churches and for domestic work, especially in the 1890s. Honeyman contracted Scots but also London artists, such as Selwyn Image, to design windows. In conservation, Honeyman's practice was committed to the careful repair of old structures and to detailed research. His key building restorations were of Glasgow Cathedral (1890-1), where he was consultant architect, St. Michael's Church in Linlithgow (1894-6), Iona Abbey Cathedral (1902-5), and Brechin Cathedral (1900-2). Another building restorer, this time mainly of domestic architecture, was Robert Lorimer (1864-1929), probably the most

celebrated Arts and Crafts architect and furniture designer Scotland produced. Lorimer worked best with surviving buildings of the seventeenth century, restoring, building anew, and designing sympathetic furniture. He had trained in Edinburgh in Rowand Anderson's office and with G.F. Bodley in London. He started out in his Edinburgh-based career by restoring Earlshall, a seventeenth-century tower house in Fife, between 1890 and 1894, learning the rudiments of building by working with an old historic structure, much as almost a half century earlier William Morris had studied embroidery by unpicking its stitches. Little wonder that his new domestic architecture was craft-based, engaging local craftsmen to contribute woodwork, stonecarving and ironwork to beautify his houses and church work.

Lorimer had a thirty-year career devoted to working with traditional building types, which climaxed in the building of the Scottish National War Memorial between 1924 and 1927. The Memorial was a massive exercise in collaboration. More than seventy artist craftsmen and women contributed to its creation, augmenting a building and site in which materials were of paramount importance. Lorimer mixed the coolness of cut and carved stone and bronze with the warmth and humanity of carved wood. On the exterior, the warm colours and vibrant textures of reused rubble walls were partnered by carefully selected new ashlar and contrasting sharply dressed stone. The two sections of the Memorial, the Hall of Honour and the Shrine, were intended to serve as a place of record and remembrance and as a sanctuary.

The Shrine interior, especially, was a close partnership of craft designers but was dominated by the work of husband and wife Alice (1877-1934) and Morris (1881-1973) Meredith Williams and of Douglas Strachan. It has layers of craft: sculpted bronze reliefs of soldiers, sailors, and airmen by the Meredith Williams rise to Douglas Strachan's seven narrow windows topped by seven signs of the zodiac carved to his design by George Salvesen. The pivotal and focal point is the suspended carved figure of St. Michael, modelled by Alice Meredith Williams after an outline design by Strachan and carved with their customary care by the brothers William (1851-1935) and Alexander (1861-1946) Clow. The figure was the nearest that Lorimer came to providing an icon. With its immense wrought-iron support chains by Thomas Hadden (1871-1940), the figure crosses boundaries of jewellery and sculpture.

As the artist who also designed and made eight light windows in the Hall, Strachan partnered the modern-Gothic nature of the Shrine design with tall lancet windows of remarkable fluency. In these he combined lyrical colours with rhythmic leading and mixed realism and allegory, bringing together portraits of members of the Armed Forces with a narrative of life. The window scheme is in three sections devoted to the origin (including scenes

from the Book of Genesis) and overthrow (the Book of Revelation) of war, with a central group of subjects illustrating peace and praise. Strachan's style is dynamic, angular, and modern but also deeply contemplative. He was responsible for much of the spiritual dimension of the Shrine.

The craft-based approach to the visual arts was larger than vernacular revivalism. It looked to the past for understanding and inspiration, but its adherents also looked forward, building for the future. One architect outside the cities of Glasgow and Aberdeen and both a modernizer and a conservationist was James Morris, already mentioned as a member of the Art Workers' Guild. Returning to Ayr in the mid-1890s after a decade in London, he founded the (short-lived) Scottish Society of Art Workers in 1898. His designs for buildings, furniture and metalwork have a tight control yet also the imaginative use of space, form and function so typical of an engineering mind. Morris was a thoughtful, man who wrote in his last book, *A Romance of Industrial Engineering* (1939), of "the fundamental truth that the solvent of the present often lies in a knowledge of the past."[20] He was passionately committed to building restoration, involving himself in excavations at Crossraguel Abbey from the early 1880s, and in 1910-3, led the restoration of the Old Brig of Ayr. A Ruskinian writer, in his sixties Morris spoke and wrote on Alloway and the preservations of the memorials to local bard, Robert Burns, a personal passion. He also built up a major collection of Ayrshire white work, the beautiful artistic embroideries made by the women of the county until the craft was finally destroyed by industrial development in the late 1850s.

The safeguarding of the past and its traditions was all-important in the inter-war years. In an essay, "The Soul of Cities," first written for publication in 1925, and partly republished the next year in Harry Peach's anthology *Craftsmen All*, the Earl of Crawford and Balcarres related the present to past and future, as part of process through time:

> Our descendants will profit by our forethought or suffer from our neglect, judging us as we judge the earlier figures on the vanished pageant of urban life. What better work can we achieve than make their path more easy, their homes more intimate, their public buildings more noble, their gardens more green.... [O]f all earthly ideals that of the perfect city is the most romantic and inspiring, for it comprises the happiness of our race and the welfare of those who follow.[21]

The Earl and Countess were supporters of historical continuity, of the legacy of the past, and specifically of the crafts, with Lady Crawford, a prolific embroiderer, stitching

bedcovers in various historic techniques for their home, Balcarres. A romance of history and place, the Earl's essay expressed his hopes for the wider environment and for culture.

The political climate in Scotland was also partly responsible for the drive by a few key members of the upper classes (working alongside architects) to preserve historic buildings. In the 1920s, the founding of the Scots National League, the National Party of Scotland, the Scottish National Movement, and, not least, Glasgow University's Scottish Nationalist Association, led to the formation of the Scottish National Party in the spring of 1928, less than a year after the opening of the National War Memorial. Nineteen thirty-one saw the creation of the National Trust for Scotland to hold land, building, and chattels "for the benefit of the nation." The Duke of Atholl (1871-1942) had played a key role in the shaping of the National War Memorial, and he served as first President of the National Trust, while Sir Iain Colquhoun of Luss (1887-1948) (who, as chairman of the Association for the Preservation of Rural Scotland, had argued for a National Trust) was its first chairman. He wanted a Trust to protect, to preserve but not "mummify" the built environment. The earliest test case was the Palace at Culross, Fife, which, together with more modest houses also of early seventeenth-century date, was identified as "one of the oldest backgrounds of Scottish burgh life." The Trust bought the property, and the government's Office of Works was to pay for repair, restoration, and future maintenance.

The fourth Marquess of Bute (1881-1947), with a keen interest in and deep knowledge of Scottish history and culture, was already much involved in the rescue and publication of Scots archive material, particularly in west Scotland. He worked with various architects, including James Morris, in the acquisition and repair of property in Ayrshire. Lord Bute's 1936 lecture, *A Plea for Scotland's Architectural Heritage*, published by the National Trust for Scotland, called for the systematic, classified recording of Scotland's old domestic houses and a substantial government grant to be made available for this purpose. His call to arms was to save the "old dignity" of the country. Lord Bute was a man long committed to Arts and Crafts principles and work, best seen perhaps in the tapestries made at his private Dovecot Studio founded in Edinburgh in 1912 and staffed with weavers from the Morris company workshops at Merton Abbey. Now he declared that it was "the working man who, of all people, takes the greatest interest in our ancient buildings, and well he may, for he is best able to understand the solidity and care with which they are built and the excellence of workmanship."[22]

It would be simplistic, however, to think of Scotland as a country divided plainly by the 1930s into factions of antiquarians and progressive modernists. There were many in all the

arts who combined such apparently disparate views into vibrant new cultural ideologies, using modernism to update the vernacular. This applied to literature and poetry but also architecture. Basil Spence (1907-76), whose centenary is being celebrated this year, is but one example of an architect who was a modernist but who respected the imagination and workmanship of Scottish Arts and Crafts and the intuition and continuity of native culture. In the 1930s, there was also a deep sense of modern craftspeople working as inheritors of the past. The illuminator Ailsa Craig (1895-1967) author of the 1948 textbook *The Design and Spacing of Lettering*, had trained with Robert Anning Bell at Glasgow School of Art and taught there through the 1930s. Her work was principally for church and commemorative commissions. Interviewed for the *Glasgow Herald*, she spoke of the importance of St. Columba, the "artist-saint of Iona," and the legacy of Celtic art. Her interviewer, fellow artist Nan Muirhead Moffat (1897-1989), found that,

> in the age of machinery, it is delightful to find arts and crafts still being carried on without the aid of mechanical contrivances. And it is pleasant to suppose that the lively interest in lettering exhibited by the present-day art student is an echo of those traditions which from earliest time have associated the West of Scotland with the ancient art of lettering and illumi-nation.[23]

The place of the past in modernity thus continued, but tradition had worked its magical spell to greatest effect through the Arts and Crafts years.

ENDNOTES

1 This essay reviews material recently published in the author's book, *Hand, Heart and Soul: The Arts and Crafts Movement in Scotland* (Scotland: Birlinn Ltd., 2006).

2 John Ruskin, *Modern Painters*, part IV, chapter xvii, § 35, London, 1856.

3 Ruskin 35.

4 Robert Rowand Anderson in his Presidential Address, Section of Architecture, *Transactions of the National Association for the Advancement of Art and its Application to Industry: Edinburgh Meeting 1889* (London, 1890) 153.

5 "The Sociology of Autumn," in *The Book of Autumn*, second volume of *The Evergreen: A Northern Seasonal* (Edinburgh: Geddes, 1895) 31.

6 "Seemliness," a lecture given in Glasgow in 1902. Published in Pamela Robertson, ed., *Charles Rennie Mackintosh: The Architectural Papers* (Wendlebury and Glasgow: White Cockade Publishing and Hunterian Art Gallery, 1990) 220.

7 *A Lecture on Design and Craft delivered by Douglas Strachan, Head of Section of Crafts at the Edinburgh College of Art, March 2 1910* (Edinburgh, 1910) 24.

8 Strachan 24.

9 "Proem," in *The Book of Spring*, first volume of *The Evergreen: A Northern Seasonal* (Edinburgh: Geddes, 1895) 13-4.

10 "The Work of Ann Macbeth," in *The Studio* 27 (1902): 49.

11 "Some Glasgow Designers," in *The Studio* 22 (1897): 48.

12 "Some Glasgow Designers," 48.

13 Notes for an untitled lecture with Strathclyde University Library archives section, T-GED 5/2/24

14 Margaret Armour, "Mural Decoration in Scotland, Part I," in *The Studio* 10 (1897): 103.

15 Geddes's account was first published in his booklet, *The Interpreter: Of Seven Pictures, of Black and White* (Edinburgh, 1896) 14.

16 Geddes 14.

17 Presidential Address, Section of Architecture, *Transactions of the National Association for the Advancement of Art and its Application to Industry, Edinburgh Meeting MDCCCLXXXIX* (London, 1890) 154.

18 Presidential Address, 154.

19 Typescript of address by Robert Rowand Anderson on the occasion of the opening of the School of Applied Art, 21 October 1892 (Royal Scottish Academy collection archive).

20 James A. Morris, *A Romance of Industrial Engineering* (Glasgow: Glenfield & Kennedy, 1939) 5.

21 Lord Crawford, "The Soul of Cities," in Harry Peach, *Craftsmen All: Some Readings in Praise of Making and Doing* (Leicester: Dryad Handicrafts 1926) 181-2.

22 *A Plea for Scotland's Architectural Heritage: Speech delivered in Edinburgh by the Most Hon. The Marquess of Bute, K.T., May 1936* (Edinburgh, 1936) 7-8.

23 Nan Muirhead Moffat, "Ailsa Craig: Calligrapher and Illuminator," in *Around the Studios 1939* (Milngavie: Heatherbank Press, 1982).

UKRAINIAN CRAFT REVIVAL: FROM CRAFT TO AVANT-GARDE, FROM "FOLK" TO NATIONAL

ALLA MYZELEV

This research tells the story of the merging between the avant-garde and craft, and between the visual arts and handicrafts in early twentieth-century Ukraine and in Russia. This change in the style of craft, from traditional "folk" to innovative abstraction, brought to the forefront the traditional debate about the role of the crafts in relation to "high art." Rooted in the British Arts and Crafts Movement, and especially in the position of its main proponent, William Morris, the original "art versus craft" debate looked at the position of handicraft in society and criticized the reasons behind its traditionally inferior and secondary role. Morris proposed to raise the profile of handicraft based on the degree of creativity and the skill that went into the production of the objects.[1] In addition, these craft objects, according the proponents of the craft revival, could be no less didactic than paintings and taught the viewer or the consumer about social values, such as the beauty of manual labour and moral virtues. The key issue for this discussion of the production of avant-garde embroideries in the Russian Empire is the idea that manually produced objects could become "vessels" of social ideas.[2] Similar to a painting that could bring forward an artist's ideas through the subject matter or lack thereof, craft objects could express ideas of innovation in terms of technique and context, social change and amelioration.

In late nineteenth-century Russia, craft revival efforts merged with attempts to prevent peasants from migrating to the larger cities and becoming part of the rapidly growing proletariat. The official tsarist ideology of pan-Slavism coincided with, and to some extent caused, the increased interest in Russian tradition, which in turn brought about a concern

for traditional handicrafts and motives. While many European countries attempted to revitalize the indigenous crafts of the peasants who were making goods for their own consumption and occasionally for local sales, in Russia, assistance was aimed at those peasants who had already participated in the commercial exchange of goods. *Kustari* were handicrafts people who worked at home with the purpose of selling their products on the market.[3] Most of these owners of small workshops were also peasants, who kept some cattle and worked on the land. Nevertheless, after 1861 and during the industrialization of Russia, the *kustari* became increasingly dependent on the intermediaries who brought them raw materials and sold their products in markets. This situation was disadvantageous for craftspeople, since most of the revenue remained in the pockets of the middle people.

The first attempts at assisting the *kustari* were undertaken as early as the 1870s. A report ordered at that time concluded that about seven and a half million peasant *kustari* depended on their handicrafts to help survive in winter and, in some instances, throughout the whole year. Their condition was desperate, the report continued, and they were in need of immediate government assistance.[4] While the study written between 1874 and 1886 confirmed the need for centralized and localized bodies of assistance, it took the governmental bodies until 1888 to actually start taking steps towards helping *kustari*.[5] Therefore, from the early 1870s, when the problems of peasant crafts became part of the political and social debate until the late 1880s, it was a group of Russian landed elite who were preoccupied with educating, providing work, and promoting *kustar* production.

By the 1900s, although private workshops continued to function successfully and many new ones were being established, the *kustar* revival phenomenon in Russia became too complex and widespread to survive without considerable government direction and support.[6] Piotr Stolypin's (1862-1911) reforms of 1906 introduced the idea of individualism to the peasantry. The possibilities of independent land ownership without the help of the village collective (*obshchina*) meant that additional income was needed by families in the winter months. The increasing reorganization and interference of government bodies in the life of villagers allowed for more encouragement of craft production.[7]

An organized form of control, support, and encouragement was needed, especially because interest in the Neo-Russian style and in Russian folklore gave way to interest in the Neo-Gothic and the *Stil' modern* (a Russian version of Art Nouveau). Although in many respects *Stil' modern* relied on the national revival movement—for example, on architectural elements, imagery, and colours—many proponents, particularly in the field of design, based their work on European models, especially from Germany and the Austro-Hungarian Empire. Yet for many Russians, the fact that *kustar* production evoked a great interest in

Europe and the United States made this branch of national revival appealing enough to continue supporting it and purchasing its art works.[8]

The main sponsoring governmental body of *kustar* industries, the Chief Administration of Agriculture and Land Tenure (G.U.Z.I.Z.), was founded in 1905, but only in 1909 was this organization entrusted with enough power to make a difference.[9] From 1909 until World War I, G.U.Z.I.Z. spent almost 800,000 rubles annually on *kustar* undertakings, such as the funding of exhibitions, training of craftspeople and purchasing necessary equipment for industries and workshops.[10] However, receiving subsidies from such organizations as G.U.Z.I.Z. meant also giving up independent decision making, about which traditional crafts were revived and by what means. In the context of the Ukraine, or as it was called then, Malorussia, reviving peasant handicrafts under the auspices of G.U.Z.I.Z. was directly equivalent to trading Ukrainian culture and heritage for Russian.[11] With the raising of the national consciousness in Europe and the subdivision of the Ukraine, many of the nobility who had estates in the Ukraine became involved in Ukrainian culture.

As in the organization of the *kustar* revival in other countries, such as Russia, Poland, and Hungary, in the Ukraine it mainly consisted of privately owned and operated workshops and of schools and shops organized by larger institutions. This organizational framework included a charitable component, such as *zemstvos* (elected district councils in pre-revolutionary Russia) or specifically organized societies like the Kiev Kustar Society. The latter, organized in 1906, played a major role in bringing Ukrainian handicraft to the forefront of the craft revitalization process throughout the Russian Empire. Many of its members, such as Khanenko Davydova (incidentally its first president), and Gudim Levkovich were also involved in local craft production on their own estates. The society provided an outlet mostly for small local production and gave single *kustari* the opportunity to promote and sell their work. It participated in a number of local, national, and international exhibitions, and had a large sales warehouse in Kiev.[12] The Society had a close relationship with the administration of the Kiev Applied Art and Science Museum, especially with its director, Mikola Biliashivsky. An untiring advocate of the preservation of the Ukrainian national heritage, Biliashivsky led the organization of the first South Russian Kustar Exhibition, an event that gave significant impetus to the development of craft revitalization and interest in Ukrainian craft in general. For Biliashivsky, Ukrainian peasant art was unique because Ukrainians were "highly gifted and with a strong leaning towards, beauty. They possessed a rich stock of artistic forms of expression, the result of the work of centuries, and this was a valuable asset to the fine aesthetic sense."[13] Interestingly, very little description of what constituted traditional Ukrainian style existed; most scholars relied on either illustrations or

GUTSUL DISPLAY AT THE FIRST SOUTHERN RUSSIAN
EXHIBITION OF APPLIED ARTS, KIEV, 1906.

PHOTO: THE STATE MUSEUM OF UKRAINIAN-DECORATIVE FOLK ART

common knowledge acquired from travelling and reading. Therefore, one may conclude that the organizers of the First South Russian *Kustar* Exhibition and the second one (which followed three years later, in 1909, at the same venue) considered practically everything that peasants made to be traditional Ukrainian art. The main criterion for the acceptance of the objects was whether or not they possessed the characteristics of the Ukrainian style, namely traditional motifs. Authentic artifacts, then, meant those that were produced in the villages and that had a certain traditional look. This understanding of what constituted traditional motifs and how these motifs were to represent the Ukraine started to change in the early 1910s, mostly because of the involvement of such artists as Natalia Davydova, Alexandra Exter, and Evgenia Pribyl'skaia, who mediated between the avant-garde and craft-revival circles.

NATALIA DAVYDOVA AND THE DAVYDOV FAMILY

Davydova was one of the key figures of the craft revival movement in the Ukraine. Her embroidery workshop in Verbovka was one of the first, if not the first, craft revitalization workshop that was founded in the Ukraine in 1900. In the first South Russian *Kustar* Exhibition two women *kustari* from Verbovka were awarded medals: V. Prozorova was awarded the silver, and D. Bondarenko, the bronze.[14] By 1907, the Verbovka workshop employed two hundred embroiderers working on furniture covers and upholstery, throws, and wall hangings in the traditional Ukrainian style. Due to her knowledge of art, folklore,

and her organizational talents, Davydova became the president of the Kiev Kustar Society in the first year of its existence and was re-elected as vice-president for the next several years.

The memoirs of Verbovka guests confirm that Natalia Davydova helped local women with designs and determined what objects should be produced and in what quantities.[15] In 1909, in the second South-Russian *Kustar* Exhibition, Davydova received a silver medal for her efforts in organizing the exhibition. In addition, the jury honoured masters from Verbovka for their "works in the characteristic Ukrainian style."[16]

In 1912 Davydova opened a dying shop in Verbovka and several embroidery workshops in nearby villages. The products of the workshops were on sale in Kiev, Odessa, and St. Petersburg, and were sold abroad in Turin, Berlin, Leipzig, and Rotterdam.[17]

Natalya's husband, Dmitry L'vovich Davydov (1870-1929), was the grandson of the Decembrist Denis Davydov and one of the two favourite nephews of Tchaikovsky.[18] A high-

ly cultured nobleman, Davydov was well respected as a government official and as an amateur poet. After his marriage, the couple turned their Verbovka estate near Kamenka into an inviting centre of European and Ukrainian cultural traditions. Among those who liked to spend time there were Alexandra Exter and composer Arthur Rubinstein. The soirees of the couple were well known, and their house "was highly reputed and evoked high degree of interest" among the cultural elites, mainly because of Davydova's interest in and knowledge of visual arts and music.[19] Visitors to Verbovka remembered her as "beautiful, serious, interesting, and musical—a real socialite in the true meaning of the word."[20]

Davydova's education, social background, and artistic connections allowed her to develop into an important figure in

EMBROIDERIES FROM THE VERBOVKA KUSTAV WORKSHOP AND FURNITURE MADE AT SUVKI, C.1912.

artistic circles. She attended Kiev Art College in 1902, together with Alexandra Exter, Alexander Arkhipenko (1887-1964), and Alexander Bogomazov (1880-1930). Although hardly any of her art can be traced now, it seems she was mostly interested in designing jewellery, fashionable clothes, and accessories.[21] As well, many aspects of her life remain unknown. As is the case with many women designers, it is hard to identify the objects Davydova made on the basis of her designs, although we do know that she exhibited her paintings between 1900 and 1907 in the Mir Iskusstva exhibitions.

EVGENIA PRIBYL'SKAIA AND HER WORK IN SKOPTSY

Another workshop led by professional artists was organized in the village of Skoptsy, and in the Poltava province, by Anastasia Semigradova (1879-1932) in 1909. For the first time in the history of the Ukrainian Craft revival, Semigradova actually decided to invite a professional artist to lead the workshops. In October 1910, she asked Evgenia Pribyl'skaia (1887-1948) to move to Skoptsy to lead the rugmaking and embroidery industries. Pribyl'skaia studied academic arts at the Kiev Art College (Kievskoe Khudozhestvennoe Uschilische), and between 1908 and 1910, she independently investigated antique Ukrainian art by drawing motifs for textiles, especially embroidery from the collections of *riznitsa* at the St. Sofia Monastery, Kiev-Pecherskaia Lavra, and others. She was also commissioned by Poltava Zemstvo to make sketches from antique rugs.[22]

While working in Skoptsy between 1910 and 1916, Pribyl'skaia, like Elena Polenova before her, combined her professional knowledge with research and an increasing understanding of the traditional handicrafts.[23] The production of the workshops received a silver medal in the second All-Russian Kustar Exhibition in St. Petersburg in 1913, and a gold medal in the Kiev Agricultural Exhibition for rugmaking and embroidery revival.[24] In 1911 Semigradova opened a school in Skoptsy.[25] It is often noted by scholars of Ukrainian avant-garde art that Pribyl'skaia discovered several peasant artists who, due to her encouragement, became professionals after the 1917 October Revolution. Among those who are usually considered "discovered" are Hannah Sobachko-Shostak (1883-1965), Paraska Vlasenko, and Natalia Vovk.[26] Undoubtedly, Pribyl'skaia provided some training and encouragement to local artists, but it is important to remember that it was the combination of the village school and the craft workshops that created an appropriate climate for several local amateur artists to continue their art education. Only in 1913, three years after Pribyl'skaia started her work in Skoptsy, did she notice young artists capable of designing motifs. The

most talented of these was Hannah Sobachko (1883-1965), who used colours well, and soon undertook designing compositions on paper for embroidery. Sobachko, in her desire for experimentation, went significantly further than other folk artists working in Verbovka and Skoptsy. Influenced by Pribyl'skaia, her friend and mentor, Sobachko's art evolved from colourful stylized compositions (adhering to the realism of flowers and leaves in the early 1910s) to the schematic representation and conscious two-dimensionality

EMBROIDERED CLOAKS MADE AT THE SKOPTSY WORKSHOP AND A WOMAN'S JACKET OF DYED CANVAS MADE BY THE SUNKI KUSTARI, 1913. *RUSSKOE NARODNOE ISKUSSTVO*. PETROGRAD, 1914.

PHOTO: THE VERNADSKY NATIONAL LIBRARY OF THE UKRAINE

of such compositions as *Flowers* from 1918 and *Holiday Ornament* from 1919. Suprematist work, designed by Genke-Miller and possibly embroidered by Sobachko, was exhibited in 1916 in Paris, along with other of Sobachko's designs. Reportedly, Kandinsky was touched by her work, and even Matisse claimed: "Not you, but we need to learn from you—you have a great national art of icon painting and the unique folk art of Hannah Sobachko."[27]

CRAFT REVIVAL DURING WORLD WAR I

The years between 1915 and 1919 became especially important in the development of the peasant craft revival in the Ukraine. Starting from the early years of World War I, the Kiev Kustar Society decreased its activity, primarily due to the mobilization of the peasants, and the need to change the lines of production from luxury and surplus goods to the objects that were necessities on the front line. However, some workshops continued to exist,

despite calls for "personal asceticism and the promulgation of antisumptuary laws."[28] Russia's involvement in the war also brought a surge in nationalism: for instance, the Union of Russian Women sponsored a competition "to design four types of women's clothing…with the conditions that they adhere to the spirit of a strictly Russian period, follow pre-Petrine models that are generally accessible, [and] use only Russian fabrics."[29] Clearly, such contests served as instigators for the *kustar* industries to continue working. An additional impetus for the craft revival and the consumption of locally produced objects was the fact that imports of fashion items became very limited. Moreover, the court and higher classes wanted to emphasize that, despite Russia's precarious position on the war front and its unstable economic situation, some aspects of life had not changed. While living in St. Petersburg and attending the Tsar's court, Leon Trotsky observed, "Lady-in-waiting Vyrubova says that in no other season were such gowns to be seen as in the winter of 1915-1916, and never before were so many diamonds purchased."[30] This increased interest in fashion, combined with the ramifications of the rapidly changing and vibrant art scenes of wartime Kiev, Moscow and St. Petersburg, brought about major changes in the style of the crafts produced by some Ukrainian revival industries. The involvement of avant-garde artists in craft production brought about a change in both technique and design. It is important to understand two major points about the avant-garde activities that were taking place in the early twentieth-century Ukraine. First, many early avant-garde exhibitions happened in the Ukraine and only then moved to Russian capitals. Second, many innovative artists, such as the Burliuk brothers or Alexandra Exter, had close social ties with the leaders of the revival workshops. As in the situation in Russia a few decades earlier, where Polenova and Mamontova, Tenisheva and Maliutin had social ties and shared similar aesthetic goals, Exter, Davydova, and other artists had a shared interest in new artistic styles and in their significance for peasant life.

THE UKRAINIAN AVANT-GARDE MOVEMENT BEFORE WORLD WAR I

The years immediately preceding World War I were tremendously important for the development of the Russian and Ukrainian avant-garde. In the early 1900s, the Ukraine in general and Kiev in particular were considered artistically backward. Impressionism remained the most innovative movement between 1905 and 1907. Moreover, Kiev played only a secondary role in the development of artists and styles. Odessa and Kharkov were much more active; by the middle of the decade, artists started to experiment with Post-Impressionist

styles. The situation started to change when Nikolai Pimonenko (1862-1912), an art instructor and a practicing landscape artist, gathered together a group of young artists, including Alexandre Bogomazov, Alexandra Exter, Natalia Davydova, Alexander Arkhipenko, and Aristarkh Lentulov (1882-1943), at the recently founded Kiev Art School.[31] From 1905 on, these Ukrainian artists attempted to bring new techniques and meaning to the stale provincial artistic scene. David, Vladimir, and Lyudmila Burliuk experimented with pointillism, while Kandinsky explored colours in the Fauvist style. He participated annually in the exhibition of the Society of Artists in Odessa between 1900 and 1910.[32]

While the main impetus to experiment with forms and styles of painting was inspired by visiting other European countries and learning about their artistic styles, some aspects of the subject matter and motifs were clearly inspired by Ukrainian traditional art. The Ukrainian striving for independence and the distinct artistic styles connected to it were exploited to their fullest by avant-garde artists. For instance, Burliuk named the style of the group "Gilea" (established in 1910), "Kazak-Tatar Futurism," or the "Malorussian Style."[33] Such a use of Ukrainian history and the unique style related to it helped Burliuk to differentiate Gilea from other avant-garde groups, mainly those being established in other parts of the Ukraine, as well as in Moscow and St. Petersburg. Burliuk used traditional colours and plant motifs, for example, in *Time* (1916) and combined those elements with contemporary architecture and innovative turbulent composition. The use of indigenous, well-known Ukrainian motifs was emphasized in the painting *Merry-go-Round* (1916) by Marina Siniakova. The artist depicts women wearing traditional Ukrainian costumes with plant motifs, derived from Ukrainian ceramics, to convey the message of the precarious life of Ukrainian peasantry.

An interest in Ukrainian art and the desire to educate peasants about art brought about a continuation of the tradition of Russian Wanderers. Ukrainian art patrons organized exhibitions of well-known Russian and Ukrainian artists, such as Repin and Arkhip Kuindzhi (1842-1910), in the Ukrainian villages. These events were accompanied by lectures and were followed by dances and fireworks. Often the lecturers and audiences spoke Ukrainian rather than official Russian, while the events themselves turned into celebrations of nationalism. These exhibitions were prohibited in 1906.

Since, in the Ukraine, artistic innovations were frowned upon, not only by the authorities but also by the majority of collectors and lovers of art, artists such as the Burliuk family, Alexandra Exter and others turned to Moscow and St. Petersburg as well as to Western Europe. Exter left Kiev for Paris, where she hoped to continue her formal art education; but she soon became disappointed in academic art teaching. Her artist friend, Sergey

Lastrebtsov, introduced her to the leading French avant-garde artists of the day, such as Picasso, Braque, and Léger.[34] Meanwhile, in Moscow, the exhibit *Blue Rose* opened with paintings by Burliuk and Exter, along with those of many Russian Symbolists. It proved somewhat disappointing for more innovative artists, since there were very few paintings in newer styles. Then, by the end of the year, Burliuk formed a group "Stefanos" and organized an exhibition financed by his family at the Stroganov School of Art.[35] Later, in October 1908, Exter, Burliuk, and Nikolai Kul'bin (1868-1917) organized the exhibit, *Lanka* (Zveno, Link) in Kiev.[36] For this exhibit, artists distributed an avant-garde manifesto written by David Burliuk, "The Voice of Impressionists in Defense of Painting." Along with paintings, Exter exhibited one piece of embroidery and two pillowcases.[37]

However, perhaps the most influential event occurred in Odessa. On 4 December 1910, a sculptor and art patron, Vladimir Izdebsky (1882-1965), with the help of David Burliuk and Vassilly Kandinsky, opened an International Exhibition, the *Salon of Izdebsky*. The first of its kind in the Russian Empire, this exhibition aimed at showcasing new art to a Russian audience. Similar to the annual Salon in France, the exhibition consisted of 746 works, including those of the French and Russian Impressionists, members of *Mir Iskusstva*, and the more controversial French and Russian painters, Georges Braque, Felix Vallotton, Franz Marc, Vassilly Kandinsky, and Georgy Narbut.[38] In 1910 the Salon travelled to Kiev, St. Petersburg, and Riga. Due to its avant-garde slant and international emphasis, the exhibition received mostly negative press reviews.[39] Yet, for the artists living in the Russian Empire, especially those of a younger generation and those who could not travel to France, it was an inspiring and influential experience: "[W]e are longing for work (after the French)," wrote David Burliuk to Kul'bin.[40] The Russian avant-garde writer Benedikt Livshits had an even more intense experience: "Izdebzky's exhibition played a decisive role in the change of my artistic taste and principles…."[41]

The second Salon, also organized by Izdebsky and located in Odessa, concentrated on the development of new art in the Russian Empire. Participation in this exhibition was, in effect, a proclamation of political and artistic commitment to the avant-garde. Most participants were members of the new generation of artists who left behind *Mir Iskusstva* and the Neo-Russian style for more abstract forms and expressions of meaning.[42] Almost all exhibitions of the new art included what the participants considered "primitive sources" or "folk art." The second Izdebsky Salon exhibited children's art, while the exhibition in St. Petersburg, *Treugol'nik - Venok* (Triangle-Garland), as the title suggests, brought together the painting of two avant-garde groups, including the works of the unknown peasant artist-primitivist Pavel Kovalenko.[43]

National motifs of the craft revival, especially its colours and techniques, inspired avant-garde artists. Indeed, their experimentations went beyond painting and sculpture. Designing objects to be made by peasants offered a new possibility for exploring line, form, and depth in three-dimensional objects. It also provided the opportunity to create practical objects that could not only change art but that could also change everyday life. The idea of the total artwork and the unified change conceived by the Arts and Crafts Movement was attractive to those who had rejected "the art of yesterday, the art of weak slaves of nature."[44]

FROM FOLK TO AVANT-GARDE

Four women artists, Natalia Davydova, Alexandra Exter, Evgenia Pribyl'skaia, and Hannah Sobachko, were instrumental during the brief period of the merger of the *kustar* industries with the Russian and Ukrainian avant-garde, before the peasant revival degenerated into the dogmatic kitsch that continued to be produced well into the 1980s.[45] Alexandra Exter, who knew Natalia Davydova from the time they both attended the Kiev College of Art in the early 1900s, became enthralled with Ukrainian peasant art. Between 1905 and 1909, she made a few expeditions to rural Ukraine to study peasant motifs, and during those years, she was a member of the Kiev *Kustar* Society. However, by 1911, her name was not on the list of the Society's members, perhaps due to her increasing interest in other styles of art and her many trips to Europe, especially Paris. In 1915 Davydova asked Exter to become the artistic director of the embroidery workshop in Verbovka.[46] Exter's and Davydova's collaboration on the design and execution of the objects brought the idea of mutual influence between the avant-garde and folk art to its extreme. The objects that were designed by the most innovative artists were executed, mostly in embroidery, by local peasants in the Verbovka workshops. Both the traditional and avant-garde production of the workshops was displayed at two exhibitions in Moscow. The first, which opened on 15 November 1915 at the Gallery Lemersier in Moscow, included forty items by Exter, embroidery designed by Xenia Boguslavskaia, and Natalia Genke, and designs for pillow-cases and scarves by Ivan Puni.[47] In addition, Georgy Yakulov exhibited four handbag designs, eleven embroidery designs, and other items. Kasimir Malevich designed two scarves and a pillowcase.[48]

It is hard for the contemporary scholar to know the reaction of the local embroiderers in Verbovka or Skoptsy to the designs presented to them. If, during the peasant art revival

phase, the general purpose was to teach a craftsperson something considered relevant to his/her life (yet perhaps forgotten over decades of industrialization) the merging of non-representational art and the *kustar* revival increased the gap between the designer and maker. While researchers have noted that avant-garde artists in Russia and the Ukraine (for instance, Malevich, Natalia Goncharova (1881-1962), Exter, Popova, and Rozanova) were interested in and influenced by "folk" art, their backgrounds, their personal vision, and their ability to transform visual impressions into unique forms brought those initial influences to new levels. Horbachov compares the compositions of Malevich to the "stable order of the peasant ornamental 'tree of life.' [Yet in the artist's compositions, this order] has been dramatized, dynamited, and stirred up in the head-crushing speed of the twentieth century."[49] However, this sense of the modernity of the new century had a different impact on local peasants. It is not my intention to argue that they remained in the primordial stillness of "folk," but that the modernism of Malevich's interpretation, his personal expression through abstract form so characteristic of modernist movements, differed significantly from the world view of the local employees of workshops. The reason for this significant difference lies in the way of life, social circles, and perhaps educational opportunities available to Malevich, Exter, or Popova, opportunities that local artists, such as Evmen Pshechenko or Hannah Sobachko, did not have. For example, Pshechenko started creating sketches for embroidery and works on paper while helping his wife, who worked for Davydova and Exter in the early 1910s. For the 1915 exhibition in Moscow, he exhibited three embroidered pillows and thirty-two sketches for embroidery.[50] The catalogue mentioned that Pshechenko's works were "examples of contemporary peasant ornamentations."[51] It is in his and other peasant artists' works that one feels a real expression of the peasant revival ideal: the desire to connect the life experiences of the workshops' employees with new artistic influences and modern life.

Yet, as one can see from the introduction to the catalogue of this exhibition, the main goal for Exter was to allow "artists from different art movements the opportunity to explore a variety of formalistic approaches."[52] The exhibition included 280 objects, among them, "Glorious panels of fabrics embroidered with all kinds of patterns; soft materials, table-cloths, ladies' accessories, blouses, scarves, belts, and purses piled on stands; underfoot thick carpets with soft smudged designs, and around the walls of the rooms all kinds of cushions."[53] For the audiences used to the shocking strategies and scandalous appearances of the new art, the exhibition at the Lemersier Gallery contained little in the way of either surprise or dismay. According to the exhibition reviews, it recalled "a fairy-tale, exotic garden."[54] It is hard to explain why such innovative exhibitions did not produce the

Alexandra Exter, Woman's Theatre Bag, silk embroidery. Verbovka, 1915.

desired effect of novelty. Perhaps one of the reasons lay in the well-established stereotype of "folk" art that, by 1915, had been utilized for at least forty years. The audiences and critics perceived peasant or "folk" handicrafts as inherently conservative and traditional, and were unable to comprehend the meaning and significance of such innovations. As Exter claimed in her speech read at the opening in Kiev of the 1918 exhibition of Pribyl'skaia's and Sobachko's work:

> Evgenia Ivanovna Pribyl'skaia originally based her work on folk ornaments (embroidery, rugs). She started with the framework of the traditional folk art principles, to advance, after studying for several years, to works conditioned by rhythmic harmony and disharmony of line and colour. The study of the original folk art enabled her to preserve her own style while acquiring greater creative freedom. The works exhibited here are Ukrainian in character, legible to contemporary artists who have approached this style directly, tackling it as a problem of colour, rhythm, and complex structure. After following the development of the local traditional ornament and after absorbing the tartness and freshness of coloured Easter eggs, Pribyl'skaia achieved in her work a sense of movement and dynamism. Her drawings are related to Matisse's: inspired by the East, by its ornaments and colours, Matisse aims at a complete merging of the rhythm and movement of the ornament on woven cloth with the object represented in it. Pribyl'skaia, familiar with the Western art culture and aware of contemporary trends, could not bypass the way shown by Matisse, but she adapted it to her own needs and temperament. ... G. Sobachko is outstanding proof that folk art always remains folk art, but that, in order to continue and grow, it has to develop and feed on new sources.[55]

Indeed, one can see that "folk art evolved organically on the basis of timeless, internal formal laws that owed nothing to the transitory style of ornaments language of a given era."[56] In other words, even combined with a non-representational, cutting-edge style, folk and decorative art still looked familiar, homey, and backwards; consequently, it failed to stir up an emotional reaction.

Only a few weeks later, on 17 December 1915, Puni, with the help of Boguslavskaia and Malevich, initiated an exhibition, *The Last Futurist Exhibition 0.10*. This was the first time that the term Suprematism was used, although only in relation to the works and ideas of

Malevich, who summarized the principles of the new movement in the article "From Cubism to Suprematism."[57] The exhibition, which was located in the Art Bureau of Dobychina, exhibited Malevich's famous *Black Square* along with forty other works.[58] The reviews of the exhibition varied from enthusiastic support to sharp rejection and shock.[59] While this exhibition was going on in Petrograd, in Moscow the Industrial Arts exhibition featured "Art Nouveau fabric designs and Russian revival-style dishes, vases and ceramic mythological creatures…dress designs, pillows, lampshades, handbags, and decorative appliqué by Yakulov, Exter, Puni, and Boguslavskaia."[60]

After the 1916 exhibition, *Nol'-Desiat'*, many avant-garde artists, among them Popova, Rozanova, Udal'tsova, and Pestel, turned to Suprematism and joined Malevich in preparation for the publication of a new journal, *Supremus*. The program of the Suprematist movement emphasized the inclusion not only of paintings, but also of other forms of art: embroidery and fashion, with printing on textiles among them. From 1915 to 1917, Malevich and Exter continued to visit Verbovka, to design and teach local craftspeople. Douglas mentions that 1916, although an incredibly difficult year politically and militarily for Russia, was enormously significant and productive for non-representational avant-garde crafts: "Hundreds of designs were produced by virtually every member of the avant-garde, and their work was shown at several major exhibitions. In 1916 and 1917 designs for fabric decoration make up a large proportion of all the Russian avant-garde work done on paper."[61]

On 6 December 1917, Exter and Davydova organized the second *Verbovka* exhibition in the Mikhailovka salon. The alternative title was *The Second Exhibition of Contemporary Decorative Art*.[62] Almost all artists who considered themselves Suprematists exhibited designs executed by Verbovka and Skoptsy *kustar* artists. About four hundred pieces of embroidery, book-coverings, pillowcases, ribbons, handbags, *naboika*, and dolls were made by local artists of peasant milieu.[63] Malevich contributed designs for pillowcases, ribbons, and bags.

Between 1915 and 1917, Verbovka workers not only produced designs provided by avant-garde artists but also created fashion items from the designs of Natalia Davydova herself. After the October Revolution, Davydova left Verbovka to live in Kiev, where she became involved in a number of cultural activities. In 1919, along with Bogomazov, A. Petritskii, V. Meller, and Genke, she became the head of mass education at the Kiev *gubernia*. As a head of the department, she participated in organizing one of the first exhibitions in the still-independent Ukraine, an exhibition of contemporary country art held in 1919.[64] Included in this exhibition were designs, embroidery, sculpture, and woodcarvings from the collections of Davydova, Pribyl'skaia, and the warehouse of the Kiev Kustar Society.

This event also advanced the careers of Sobachko, Vlasenko, and Ivan Gonchar, who became well-regarded artists in the early 1920s. From 1919 on, a section of the All-Ukrainian Educational Group started publishing a weekly, *Mystetstvo*, which featured the latest news about avant-garde art.

In the early years of the Communist regime, the design of utilitarian goods and clothing went hand in hand with experimentation in art, not only because this tradition had existed in previous years but because the new ideology emphasized the important role of applied art and design in the development of new models of life. Traditional Ukrainian costume, regarded as a symbol of national roots a few decades earlier, gave way to the use of new fabrics, designs, and forms. It is known that the Verbovka workshops continued until 1919. Embroidery based on the designs of Udal'tsova, Rozanova, Puni, Malevich, and others was displayed in the seventh exhibition of the Department of Visual Arts of V.T.S.V.B. by the Commissariat of Public Education in Moscow. The following year, Exter, Pribyl'skaia, and Genke-Miller worked with fashion designer Nadezhda Lamanova (1861-1941). They experimented with new trends, such as the traditional forms of Ukrainian costume, mostly made of rectangular pieces of fabric that allowed for infinite variations. As decoration for these simple forms, they used embroidery as insets for both wide and narrow borders, the embroidery representing either traditional motifs or simplified, modernized ornaments. This return to more traditional forms signified the first backlash against the realism of the revolutionary era. Yet even traditional embroidery combined with innovative fashion created atypical,

EVGENIA PRIBY'SKAIA, SILK EMBROIDERY. SKOPTSY, 1915-1916.

unique dresses, blouses, skirts, and so forth. Such experimentation was continued from 1920 on by an organization called Kusteksport, a subdivision of the Department of Export, an association of *kustari* that produced objects for export from the Ukraine. Kusteksport played a role in creating work and income for *kustari*, who, after the October Revolution, found themselves in a desperate, uncertain situation but continued to represent Ukraine and Russia abroad. Although, according to its mandate, the association strove to create

fashion for the masses, the nature of *kustar* production was such that it was possible to create only individual pieces. Many workshops that began in the early twentieth-century became *arteli* (co-operative associations) and supplied fabrics, *naboika*, lace, embroidery and other handicrafts for professional designers to create fashions. Often these fashions, for which artists such as Stepanova and Rodchenko provided the designs, were created in an innovative style. Lamanova, Davydova and Pribyl'skaia also worked with Kusteksport. This collaboration lasted at least until 1925, when Lamanova received memorable mention and Davydova a gold medal for fashion design at the International Exhibition of Arts in Paris in 1925.

THREE EMBROIDERIES BY XENIA BOGUSLAVSKAIA, 1916. *STOLITSA I USAD'BA* 56. 15 APRIL 1916.

PHOTO: THE VERNADSKY NATIONAL LIBRARY OF THE UKRAINE

The story of the revitalization of the crafts in the Ukraine offers a new way of understanding avant-garde art in the Russian Empire. Not only did avant-garde artists aspire to change the traditional ways of painterly expression, their collaboration with the peasant craft workshops shows that they sought to transform not only painting but also fashion, crafts, and other aspects of culture. Even more significant, these artists not only adapted traditional motifs and images to their perspective, they also offered these non-representational motifs to the peasants to become part of their artistic language and therefore their daily life. These mutual exchanges continued the trend toward the involvement of professional artists in the production of handicrafts, as well as the creation of the study collections of peasant art, emphasizing the degree of reciprocal negotiation and influence between craft and the avant-garde.

Endnotes

1 Chris Miele, ed., *From William Morris: Building Conservation and the Arts and Crafts Cult of Authenticity, 1877-1939* (New Haven; London: Yale University Press, 2005).

2 For a discussion of how three-dimensional objects can convey the ideology of their producers, see S.K. Tillyard, *The Impact of Modernism, 1900-1920: Early Modernism and the Arts and Crafts Movement in Edwardian England* (London: Routledge, 1988) 20-22.

3 Salmond gives the definition of *kustar* as "peasant craftsman." Wendy Salmond, *Arts and Crafts in Late Imperial Russia: Reviving the Kustar Art Industries, 1870-1917* (Cambridge: Cambridge University Press, 1996). The definition that I am using here is based on the article in *Bol'shaia Rossiiskaia Entsiklopedia*, 1997, s.v. "*kustar*," 20 Feb. 2006 <http://www.cultinfo.ru/fulltext/1/001/008/067/809.htm>.

4 A. A. Modzalevskii and K.N. Mescherskii, *Svod Materialov Po Kustarnoi Promyshlennosti V Rossii* (St. Petersburg, 1874) 16.

5 *Trudy kommissii po issledovaniiu kustaroi Promyshlennosti v Rossii* (St. Petersburg, 1879-90) 17.

6 Salmond mentions that by 1909, there were approximately two million *kustari* in the Russian Empire. See Salmond 144.

7 Judith Pallot, *Land Reform in Russia, 1906-1917: Peasant Responses to Stolypin's Project of Rural Transformation* (Oxford and New York: Claredon Press, 1999).

8 Salmond 144-45.

9 It has been suggested that by 1910, there were at least two million embroiderers in Ukraine.

10 From 1909 to 1914, it doubled its subsidy. G. U. Z. I. Z., *Obzor Pravitel'stvennogo Sodeistviia Kustarnoi Promyshlennosti* (St. Petersburg, 1913), 36-40; and I.A. Kriukova, "Narodnoe Iskusstvo I Zemskie Organizatsii (1908-1917)," in Yuri Sternin, ed., *Russkaia Khudozhestvennaya Kul'tura Kontsa XIX-Nachala XX Vekov*, vol. 4 (Moskva, Sovetskii Khudozhnik, 1984), 450.

11 Ukrainians consider themselves a distinct nation on the basis of the belief that they are descendents of the Kievan Russia population. Constant feudal fights led to the Tatar-Mongol conquest from which Ukraine emerged in the fourteenth century as part of Lithuania and Poland. Yet Ukrainians fiercely fought for independence, especially from the Polish nobility, who attempted to turn them into servants. The Cossacks formed a military group in the seventeenth century and succeeded in gaining independence. However, after a few years, the Ukraine was forced to seek protection and signed a treaty with Russia. About one hundred years of relative autonomy turned into heavy pressure for assimilation and economic sanctions after Ukraine joined Sweden in the fight for independence and was defeated in the Battle of Poltava in 1709. By the end of the eighteenth century, the Ukraine was considered one of the most assimilated Russian provinces, while the western parts of the Ukraine were under the rule of the Habsburgs' Austro-Hungarian Empire. Similar to other countries in the region, the Ukraine turned to the past from the mid nineteenth-century to try to revive its language and to support claims for independence. For more information on the history of the Ukraine, see Myroslav Shkandrij, *Russia and Ukraine: Literature and the Discourse of Empire from Napoleonic to Postcolonial Times* (Montreal: McGill-Queen's University Press, 2001).

12 The Society exhibited with the Russian section at the International Exhibition of Industry and Trade in Turin in 1911, where it received a silver medal and participated in The Second All-Russian Kustar Exhibition in St. Petersburg and in an All-Russian Arts and Industries Exhibition held in Kiev, both in 1913. *Godovoi Otchiot Kievskogo Kustarnogo Obschestva* (Kiev: Kievskoe Kustarnoe Obschestvo, 1910); Salmond 206.

13 Mikhail Biliashivsky, "The Part of Little Russia," in *Peasant Art in Russia*, Special Autumn Number of *Studio* (1912): 15.

14 Guseinov, Gregory. *Gospodni Zerna: Khudozh'no-Documental'nyi Zhyttepys*, vol. 6. (Kryvyi Rig: Vydavnychyi Dim, 2002) 119.

15 Karol Szymanowski, *Pis'ma* (Kraków: Polskie Wydawn. Muzyczne, 1984-1989).

16 Evgenia Shudria, *Podvyzhnytsi Narodnogo Mystetsva* (Kyiv: Redaktsiia visnyka "ANT," 2003) 30.

17 Verbovka branches were opened in Birka, Bovtyshtsa, Krasnocel'tsy, and Bondurovo. Yuri L'vovich Davydov was in charge of the workshop in Bondurovo. See Guseinov 122-123.

18 Decembrists were members of the uprising against the Tsar that took place on 14 December 1825. Dmitry's wife, Natalia Mikhailovka Davydova (1875-1933) was from the well-known Ukrainian family of Gudim-Levkovich. A few members of the family were patrons of the arts and active participants in the revitalization of peasant handicraft.

19 Jaroslaw Iwaszkievicz, *Spotkania Z Szymanowskim* (Krakow, 1976) 26.

20 Guseinov 106. Also see C. Khetova, *Arthur Rubinstein* (Moscow: Sovetskii Khudozhnik, 1971) 58.

21 She is referred to, however, as the first Ukrainian professional fashion designer. She also represented Ukrainian fashion in Europe in 1917-1920 and was involved in the Western European School of Fashion Design in the early twentieth-century. For more on that, see Sergei Shestakov, "Vzaemovplyv Professiinogo Ta Narodnogo Mystetsva Na Pryklady Tvorchosti Hanny Sobachko, Vasylia Dovhoshii Ta Evmena Pshechenka," in Mykhailo P. Selivachov, ed., *100 Rokiv Kolektsii Derzhavnogo Museiu Ukrains'kogo Narodnogo Decorativnogo Mystetsva* (Kyiv: 2002) 171-80. Finally, we know that Davydova left the Ukraine in 1919 and lived in Germany and then Paris until 1935, yet we do not know under what circumstances she died.

22 Shestakov 172.

23 Salmond 185.

24 Shudria 32-33.

25 Shudria called the school "Vyschshee Nachal'noe Uschilische," 120.

26 The idea of discovery was mentioned by Alexander Noha, Gregory Guseinov, V. Biliashivsky, and Gregory Kovalenko.

27 Quoted in Guseinov 124.

28 For more on the fight against luxury goods consumption during World War I, see "Modoborchestvo," *Solntse Rossii*, 329.23 (May 1916): 14. Quoted in Salmond 178-79.

29 Quoted in Salmond 178-79.

30 "The lack of bread and fuel in the capital did not prevent the court jeweller, Fabergé, from boasting that he had never before done such flourishing business," continued Trotsky. Quoted in Lionel Kochan, *The Making of Modern Russia* (Baltimore; London: J. Cape, 1962) 243.

31 The Art School was opened in 1900.

32 *Odess'kyi Listok*, II, X, 1905. Quoted in Olec' Noha, *Ukrainskii Avanhard 1907-1917* (L'viv: Uviko, 1994) 3.

33 Noha 29.

34 Later, Exter also met the Italian Futurist painter and writer Ardengo Sofficci (1879-1964), who in turn introduced her to the Futurist ideologist and artist Philippo Tommaso Marinetti (1876-1944), and Futurist writer and philosopher Giovanni Papini (1881-1956). See Georgy Kovalenko, *Alexandra Exter: Put' Khudozhnika* (Moscow: Galart, 1993) 180.

35 The main participants were David, Vladimir and Lyudmila Burliuk, Mikhail Larionov, Natalia Goncharova (1881-1962), Aristarkh Lentulov, Vladimir Baranov (1888-1942), Exter, and others.

36 The participants were David and Vladimir Burliuk, Exter, Baranov, Bogomazov, Piotr Bromirsky (1886-1920), Goncharova, Larionov, Lentulov, and others.

37 Catalogue numbers: 262-64. Kovalenko 180. Often catalogues of the exhibitions use the word "embroidery" without clarifying whether the artist only designed the motif or actually executed it too.

38 Among participants were Kees van Dongen, Maurice de Vlaminck, Albert Gleizes, André Derain, Maurice Denis, Henri Matisse, Jean Metzinger, Paul Signac, Henri Rousseau, Émile-Othon Friesz, Sergei Larionov, Alexandre Lentulov, Mikhail Matiushin, and Vladimir Burliuk.

39 *Odess'kyi Listok* 2 November 1909; O. Fedorov, *Odesskie Novosti* 12 September 1909. Review of the Kiev exhibition in *Kievskaia Pechat'*, Kiev (28 February 1910) and of St. Petersburg's exhibition: Ilia Repin, *Berzhevye Vedomosti*, St. Petersburg (1910) 15.

40 Nikolai I. Khardzhiev, *K. Malevich, M. Matiushin. K Istorii Russkogo Avangarda* (Stockholm: Almqvist & Wiksell International, 1976) 27.

41 Benedikt Livshits, *Polutoroglazyi Strelets. Stikhotvorenia. Perevody. Vospominania* (Leningrad: Sovetskii Pisatel', 1989) 311-312.

42 Among participants were David Burliuk, Alexandra Exter, Mikhail Larionov, Goncharova, Vassilly Kandinsky, Nikolai Kul'bin, Alexandre Lentulov, V. Barv, V. Markov, and V. Tatlin.

43 Noha 27.

44 *Salon 2 1910-1911; Mezhdunarodnaia Khudozhestvennaya Vystavka* (Odessa, 1910).

45 Many handicraft industries continued to exist after the revolution as peasant co-ops and later as part of local industrial factories. Their imagery reflected the ideas of the Socialist regime including designs created during the booming years of the craft revival as well as political figures such as Lenin, or soldiers of the Red Army. For more on the development of craft after the 1917 Revolution, see Andrew L. Jenks, *Russia in a Box: Art and Identity in an Age of Revolution* (DeKalb: Northern Illinois University Press, 2005).

46 Shestakov 174.

47 Participating in the exhibition were Xenia Boguslavskaia, Maria Vasilieva, Natalia Genke, Natalia Davydova, Kazimir Malevich, Lubov Popova (1889-1924), Evgenia Pribyl'skaia, Evmen Pshechenko, Ivan Puni, Hannah Sobachko, Alexandra Exter, and Georgy Yakulov Severiukhin. Leikind did not list Malevich as a participant of the exhibition, while Douglas and Shestakov mentioned Malevich's designs. Malevich's catalogue raisonné cites at least two designs on display. See D.I. Leikind and O.L. Severiukhin, eds., *Zolotoi Vek Khudozhvennykh Ob'Edinenii V*

Rossii i USSR 1820-1932 (Petersburg: Izdatel'stvo Chernysheva, 1992) 85; and Andrei Nakov, *Kazimir Malewicz: A Catalogue Raisonné* (Paris: A. Biro, 2002) 427. According to Dmytro Horbachov, Exter had asked Popova, Rozanova, Malevich, Puni, Boguslavskaia, K. Vasilieva, Genke, Yakulov, and N. Udal'tsova to create designs and participate in both Verbovka exhibitions in 1915 and 1917. Dmytro Horbachov, "Oleksandra Ester U Kyevi I Parizhe," *Vsesvit* 10 (October 1988): 168-76. The following exhibition reviews and announcements were published: "Intersnaia Vystavka," *Vremia* (26 October 1915): 2; "Vystavka Vyshivok," *Vechernee Vremia* 17 November 1915: 4; Iskry (Annual Supplement of *Russkoe Slovo*) (1915): 358; *Moskovskii Listok* 10 November 1915: 3; L. B., "Vystavka Decorativnogo Iskusstva," *Zhenskaia Zhizn'* 22 November 1915: 21; V. Dudareva, "Vystavka Sovremennogo Decorativnogo Iskusstva," *Zhenskoe Delo*, 23 (1915): 15-16; S. Glagol', "Vystavka Sovremennogo Decorativnogo Iskusstva," *Vremia* (1915): 2; M. Virtin, "Priklandoe Iskusstvo," *Zhurnal dlia Khoziaek*, (December, 1915): 1-2.

48 Charlotte Douglas, "Suprematist Embroidered Ornament," *Art Journal* 54.1 (1995): 42.

49 Dmytro Horbachov, "Kievskii Treugol'nik Malevicha: (Pimonenko-Boichuk-Bogomazov)" (paper presented at the conference Malevich. Klassichesky Avangard Vitebsk, Russia, 1998) 35.

50 Shestakov 175.

51 *Katalog Vystavki Sovremennogo Decorativnogo Iskusstva. Vyshivki I Kovry Po Eskizam Khudozhnikov* (Moskva, 1915) 2.

52 Katalog, 1915, 2.

53 Quoted in Salmond 179.

54 For the reviews of exhibitions see: S. Glagol', "Vystavka Sovremennogo Decorativnogo Iskusstva," *Utro Rossii* (1915); M. Liakhovskaia, "Vystavka Sovremennogo Decorativnogo Iskusstva," *Mir zhenschin* 15.16 (1916): 30; Yaakov A. Tugendkhol'd, "Vystavka Sovremennogo Decorativnogo Iskusstva," *Russkie Vedomosti* 15 November 1915.

55 Translated by Nada Soljan. Reprinted in full in: Marijan Susovski, ed., *Ukrajinska Avangarda 1910-1930* (Zagreb: Muzej Suvremene Umjetnosti, 1991) 209-10.

56 Salmond 185.

57 For more on this exhibition and its significance for the Suprematist movement see Charlotte Douglas and E.F. Kovtun, "Kazimir Malevich," in "The Russian Avant-Garde," *Art Journal* 41.3 (Autumn, 1981): 234-241.

58 The Participants included: Nathan I. Altman, Boguslavskaia, Vassilly Kamenskii, Ivan Kliun, Malevich, Mikhail Menkov, Vera Pestel, Lubov Popova, Ivan Puni, Olga Rozanova, Vladimir Tatlin, and Nadezhda Udal'tsova.

59 For more on the exhibition *0,10* and the critical review of it, see Katalog Poslednei Futuristicheskoi Vystavki 0,10 *(Nol'-Desiat')* (Petrograd, 1915); V.G., "Vystavka 'Nol'-Desiat'," *Vechernee Vremia* 20 January 1916; Igor E. Grabar, "O Sckuchnom: Na Lektsii Futuristov," *Den'* 14 January 1916; E. F. Koftun, "K.S. Malevich. Pis'ma k M. V. Matiushinu," *Ezhegodnik PO Pushkinskogo Doma na 1974 God*, (1976): 177-95; M. Matiushin, "O Vystavke Poslednikh Futuristov," *Ocharovannyi Strannik: Al'manakh Vesenii* (1916): 17; A. Rostislavov, "O Futuristicheskoi Vystavke," *Rech'* 9 January 1916.

60 *Katalog Vystavki Khudozhestvennoi Industrii* (Moscow, 1915).

61 Douglas 43.

62 "Po Vystavkam," *Rannee Utro* 8 December 1917: 3. Boguslavskaia, Davydova, Exter, Malevich, Udal'tsova, Pestel, Popova, Puni, Rozanova, and Yakulov participated.

63 Shestakov 176.

64 Reviews and mentions of the exhibitions appeared in *Vesti* 31 (1 May 1919): 4; *Iskusstvo* 4 (June 1919): 83.

CRAFT, THE SENSES, AND NEW TECHNOLOGIES

DAVID HOWES

TANYA HARROD

LOVE JÖNSSON

MIKE PRESS

SECTION FIVE

*There is no doubt that
the future belongs to the
virtual spaces of craft.*

INTRODUCTION

SANDRA ALFOLDY

The impact of new technologies on the crafts is generating much discussion and debate, particularly as academic and government funding programs increasingly support research into the virtual possibilities of for crafts. Although the positive results from this new area are undeniable, some craftspeople and designers have expressed reservations over the loss of the immediacy of touch in creation and the irony of craft seeking salvation through technology. Indeed, the use of computers in craft does create a range of problems, from the often gendered nature of computer language and the Western progress-based assumptions of programming to the lack of universal access to digital technologies. However, the effects of computers on traditional technologies amaze and delight artists and audiences alike. There is no doubt that the future belongs to the virtual spaces of craft. Section Five of *NeoCraft: Modernity and the Crafts* opens with the Canadian anthropologist David Howes, who reminds us of the importance of the senses in craft production and reception. No matter how dazzling our new technologies, craft is sustained by its sensory power. British craft writer Tanya Harrod, Swedish craft writer Love Jönsson, and Scottish professor of design Mike Press navigate the rapid growth in new technologies, helping us to understand the various roles occupied by craft and craftspeople in our digital age.

SENSORY BASKET WEAVING 101

DAVID HOWES

Perhaps no craft enjoys a humbler reputation than that of basket weaving, especially in academic circles. "Basket Weaving 101" is a derogatory label typically applied to introductory-level college or university courses, like "Anthropology 101." Being a professor of anthropology, I have always found this characterization to be grossly misleading as to the content of my "Intro" course, which covers kinship, religion, economics, politics, and aesthetics, among other topics. At the same time, there is no course I would like to teach more than basket weaving, precisely because of its pedagogical value. For in many cultures, the weaving of baskets is a practical and cosmological or symbolic art of the highest order; and the study of a culture's basketry can be the source of many insights into its organizational structure and cardinal values.

So where does basket weaving's reputation as a Mickey Mouse sort of subject, best suited to the academically challenged, come from? Part of the answer has to do with the conventional Western hierarchy of the senses (with sight opposed to touch as mind is opposed to body), which heaps honours on vision as "the noblest sense" while relegating touch to the lowest, most "primitive" rung of sensory existence. This privileging of vision in turn informs the ranking of painting as the finest of the arts and basketry, along with all the other so-called handicrafts, as belonging to the opposite, "manual" (or crude) end of the value spectrum. A moment's reflection reveals the spuriousness of this classification: a painter needs more than a "good eye" to paint, just as a weaver needs more than dexterous fingers to produce a fine basket.

In this essay, I would like to introduce the reader to the pedagogy of basketry in a traditional Amazonian society: namely, the Tukano-speaking Desana Indians of the Colombian

Northwest Amazon. I want to show how basketry belongs as much to the intellectual culture of the Desana as to their so-called material culture. addition to contesting the intellectual/material dichotomy, which informs a host of other dichotomies, such as aesthetic/practical, art/craft, and so forth, I want to call into question the visual/manual dichotomy, which seems to me to be at the root of all the misperceptions embedded in conventional anthropological and museological analyses of the crafts and arts. Such analyses typically begin and end as exercises in typology: that is, they concentrate on analyzing the form or style of a given class of objects, with little or no

regard to their "sense." It is precisely to the sense of things that we must attend, however, if we are to arrive at a comprehensive understanding of the dynamics of craft production, circulation, and consumption; hence the emphasis in what follows on the sensography (as opposed to mere typology) of basketry.

SENSOGRAPHY

The notion of sensography—or "sense description"—is an offspring of the sensorial revolution which is currently sweeping the humanities and social sciences.[1] This revolution came at the end of a long series of turns, beginning with the "textual turn" of the 1970s, which gave us the idea of cultures as "texts" to be read, followed by the "pictorial turn" of the 1980s, which generated the burgeoning field of "visual culture" studies, and so forth.[2] Each of these new paradigms yielded many insights into the nature of culture, but such insights were always conditioned by the sensory and other biases embedded in their respective points of departure: namely, the verbocentrism of the textual turn, the ocular-

centrism of the visual turn, and so on. The sensorial turn—or rather, revolution—while building on these earlier paradigms, also corrects for their excesses by emphasizing the necessity of attending to the interplay—the relations *between* the senses, and between the various faculties (speech, reason, aesthetics, etc.).

Within my own discipline, anthropology, the sensory revolution is predicated on the recognition that the senses are constructed and lived differently in different societies, such that:

> When we examine the meanings associated with various sensory faculties and sensations in different cultures we find a cornucopia of potent sensory symbolism. Sight may be linked to reason or to witchcraft, taste may be used as a metaphor for aesthetic discrimination or for sexual experience, an odour may signify sanctity or sin, political power or social exclusion. Together, these sensory meanings and values form the sensory model espoused by a society, according to which the members of that society "make sense" of the world, or translate sensory perceptions and concepts into a particular "worldview." There will likely be challenges to this model from within the society, persons and groups who differ on certain sensory values, yet this model will provide the basic perceptual paradigm to be followed or resisted.[3]

The anthropology of the senses is particularly germane to material culture studies, since every artifact embodies a particular sensory mix. It does so in terms of its production (given the particular sensory skills and values that go into its making), its circulation (given the way its properties appeal to the senses and also carry meanings), and its consumption (which is conditioned by the meanings and uses people perceive in it according to the sensory order of their culture or subculture). In short, artifacts embody specific "ways of sensing," and they must be approached through the senses, rather than as "texts" to be read or mere visual "signs" to be catalogued. Otherwise put, things have sensory as well as social biographies.[4]

In Western museum settings, artifacts are pre-eminently objects for the eye. Often, in fact, it is only the most visually striking artifacts which are put on display. Less visually prepossessing objects are hidden in the museum storeroom, no matter how rich their auditory, tactile, or olfactory intricacies. (If they are "nothing to look at," they must be consigned to obscurity). Susan Stewart has noted that modern museums are "so obviously so, one

might say, naturally, empires of sight that it barely occurs to us to imagine them as being organized around any other sense or senses."[5] The same holds true for the artifacts displayed, which become so evidently *visual* signs that it is difficult to attribute any other sensory values to them. Within the museum's empire of sight, objects are colonized by the gaze.

Within their cultures of origin, however, visual appearance usually forms only one part of an artifact's sensory significance. The sensory values of an artifact, furthermore, do not reside in the artifact alone but in its social use and environmental context. This dynamic web of sensuous and social meaning is broken when an artifact is removed from its cultural setting and inserted within the scopic regime of the museum. Cracking open the glass display cases and seeking to reconstruct the "web" linking artifacts to the sensory model of their culture of origin will also allow us to comprehend artifacts in their social, sensory, and environmental integrity. A brief introduction to the Desana sensory model follows.

Sensory Cosmology of the Desana

The Desana, who number some 600 people, constitute one of roughly twenty forest tribes belonging to the Eastern Tukanoan linguistic family. They live in the Vaupés territory of the Colombian Northwest Amazon. Together with the Pira-Tapuya and the Tkano proper they compose a phratry, meaning the three tribes look to each other for spouses. It is forbidden to marry within one's own tribal unit given the "supreme law" of tribal exogamy, and the men of these three tribes therefore practice what is called sister-exchange: a Desana man should marry a Pira-Tapuya or Tukano woman, a Pira-Tapuya man should marry a Desana or Tukano woman, and so on. Descent is traced in the male line, and the wife goes to live with the husband on marriage. Tukanoan people subsist on hunting, fishing, gathering, and cultivating cassava and manioc.

For the Desana, all sensory phenomena are interconnected, a perception heightened by their ritual ingestion of hallucinogenic plants. According to their understanding of the nature of the cosmos, the Sun gives life to our world by infusing it with "colour energies." Each of these colour energies embodies a different set of values and potentialities. Red, for example, exemplifies the power of female fertility. Everything in the world contains a combination of these colour energies, which may be visible, as in the colours of flowers, or invisible, as in the rainbow of chromatic energies said to animate human beings. (Only

the shaman is able to perceive the latter with the aid of the hallucinogenic vine and his special rock crystals.)

These life-giving colours form a primary set of sensory energies for the Desana. Secondary sets consist of such phenomena as temperatures, odours, and flavours. Odours are believed to result from a combination of colour and temperature. Flavour, in turn, arises from odour.

The Desana understanding and use of these sensory phenomena or *qualia* is complex and extensive. As regards odour, the Desana are extremely attentive to the odours in their environment, calling themselves *wira* which means, "people who smell." They hold that each individual has a "signature" odour. This underlying odour can be altered by changes in emotional states, by lifecycle changes such as pregnancy, or by changes in diet. Tribes or extended kin groups are said to share a similar characteristic odour which permeates the area they inhabit. Even when this living space shows no sign of human habitation, the tribal scent is said to still be present. In fact, when travelling through their rainforest environment, the Desana will continually sniff the air in order to detect the scent of the peoples inhabiting the region, as well as the odours of different Amazonian animals and plants. As the Desana move through the environment, they say that they lay down what they call "wind threads," or scent trails, which can, in turn, be discerned by other people and animals.

Odours for the Desana are not simply indicators of presence, however, or of emotional state or dietary preference. Like colours, odours are believed to embody key values. One particular odour associated by the Desana with a range of items including deer and palm trees, for example, conveys the notion of male fertility. The odours of certain kinds of ants and worms, by contrast, are associated with feminine forces. Such perceived olfactory similarities make possible a variety of ritual substitutions. During certain ceremonies, for example, ants or worms may symbolize women, whose odour they share. They also necessitate utmost attention to olfactory interrelations, as it is considered highly dangerous to combine odours (or colours) embodying contrasting forces indiscriminately. This is particularly emphasized in Desana cuisine, in which great care is taken to blend food odours harmoniously, not in order to create pleasing dishes, but so as to preserve the proper order of the cosmos.

The intensely multi-sensory nature of the Desana cosmic model means that every floral aroma, every bird song, every flutter of a butterfly suggests a particular cosmic value to the Desana and may be grouped together with other similar values in order to create a sensorial classificatory system which cuts across species boundaries. The synaesthetic nature

of the Desana cosmos means that one sensory phenomenon readily suggests another phenomenon in a different perceptual field, if not a whole train of sensations. An odour will bring to mind a colour; a colour, an odour, along, perhaps, with a temperature and a vibration. A particular design or arrangement of colours used in Desana art, for example, will evoke odours, flavours, and other sensations customarily linked to those patterns and will arouse a host of related cosmological values. A good example of this is the synaesthetic associations the Desana make with a certain kind of flute. The sound of the flute is said to be yellow in colour, hot in temperature, and masculine in odour. The vibrations it produces are said to remind people of correct child-rearing practices.[6]

Sensory Basketry

The Desana sensory model is also reproduced in their basketry. Tukanoan basketwork can serve a variety of purposes. In fact, it includes not just baskets but also mats, fans, sieves, fish traps, and even houses, which may have walls of interwoven palm leaves. Aside from its practical functions, basketry plays an important symbolic role in Tukanoan culture. The process of weaving basketwork is compared by the Desana to the life process. The act of procreation is likened to pressing grated manioc through a sieve. The fetus is said to float in the "river" of the amniotic fluid wrapped up in a plaited mat. The act of splitting a cane in three and interweaving the three standards to form an open lattice-work grid pattern of hexagonal elements (see p. 217) symbolizes the relationship between the three intermarrying tribes which make up a phratry. In keeping with this, *suári*, the term for "to interweave" also means "to copulate" and "to intermarry." When shamans are undertaking a curing ritual, they often invoke magical woven screens which will admit only healing colours. The cosmos itself is conceptualized as a weaving of threads of light and wind, and the entire Tukanoan tribal territory is understood to have the form of a hexagon formed by rivers, with the six angles being identified with six huge waterfalls. In the woven pattern of their basketry, the Desana thus perceive the outlines of their universe and are constantly reminded of the supreme law of exogamy.

All the sensory elements of their basketwork have meaning for the Desana. The different colours, odours, and textures of the reeds, vines, wood fibres, and palm fronds which are used in basketry refer to elements of Tukanoan mythology, sexuality, and ecology. The red, yellow, and brown colours employed are respectively symbolic of male fertility, female fertility, and maturity. When a basket turns from green to brown in the process of drying,

it is said to represent a transformation from immaturity to a state of procreative ripeness. As regards odour:

> Many basketry artifacts are associated with specific smells pertaining to their raw materials…. In general, it can be said that baskets and other artifacts made from vines have a stronger odor than those made from reeds or from palm leaves; indeed, reeds and palm fronds often have a dry, sweetish odor whereas vines can have an acrid, pungent smell and a bitter tasting and irritating sap. Splints, leaves, fibres and bark have odors that are said to be pleasantly sweet. The important point about these observations is that odors and their many categories are often mentioned by the Indians when discussing mate recognition and selection. There can be no doubt that pheromonal characteristics are well understood by the [Desana].[7]

The textures of the different materials used in basketry in turn reference different ecological zones and work activities. Vines, which come from the forest depths, are coarse to the touch and often thorny: they are associated with hunting and gathering activities. They are used to make sturdy carrying baskets. Reeds, which come from the riverbanks, are smooth and are associated with the horticultural activities (mainly women's work) which go on in open country near secondary growth. They are used to make trays and sieves.

The geometric patterns of the different weavings reflect patterns the Desana see in their hallucinogenic visions, such as the hexagon. Beyond this, the shapes of different baskets, trays, and mats refer to such culturally charged concepts as food, wombs, animals, and constellations of stars. The seeping of water, smoke, and other fluids through the baskets and trays stands for the dynamic relationship between the Tukano and their environment. Baskets thus constitute more than mere containers: they are mediators.

The mythological dimensions of Tukanoan basket weaving link basketry to the origin of civilization itself. In one myth, a woman appears out of the forest carrying a baby with a glistening, colourful body in a plaited mat. (The baby is the personification of the hallucinogenic vine, *Banisteriopsis*.) The men fall on the child, dismember its body, eat it, and experience a vision of the proper order of the cosmos and society. Whereas the men had committed incest, indulged in cannibalism, and consumed foods indiscriminately in the state of nature in which they lived prior to the appearance of the woman, henceforth they would both regularly ingest the hallucinogenic vine on ritual occasions and conduct themselves as law-abiding social beings. In another myth, two young men, who are searching for

spouses but know nothing about marriage rules, are instructed by their grandfather in how to split canes into three parts and interweave the standards to make fish traps. In this way, the youths are introduced to the model of the three intermarrying tribes of a phratry. This myth both establishes weaving as a masculine craft and underscores the symbolic interchangeability and exchangeability of basketry and women.

The aesthetics of Tukano artifacts lies not in the perfection of their form, but in their ability to evoke fundamental cultural ideals through all of their sensory attributes:

> [Tukano art] is never an end in itself; it can never be more than a means through which the highest cultural values and truths can be expressed. For this reason, artistic and technical skill are not of the essence.... What counts is not form but content; not performance but meaning.... In fact, shamans warn people not to be too form-perfect; not to be too impressed by appearances.[8]

The Tukano make no attempt to conserve their artifacts, as they value meaning rather than form. Whatever happens to the artifacts, the ideals and meanings they embody will remain untouched.

Tukanoan basketry is not greatly valued by first-world collectors and tourists because of its unassuming appearance. The subtle combinations of smell, texture, shape, and pattern, and the myriad cultural meanings which these encode, are usually beside the point for collectors, who look primarily for visual display. In this regard, the more ornamented and colourful baskets of certain neighbouring Amazonian peoples are much more to the taste of foreign buyers.[9] This emphasis on the visual reflects the role an Amazonian basket will play when it enters Western culture: it will above all be something to *see*. In this essay, by contract, we have seen how Desana basketwork is really to be sensed.

ENDNOTES

1 See David Howes, *Sensual Relations: Engaging the Senses in Culture and Social Theory* (Ann Arbor: University of Michigan Press, 2003); and David Howes, *Empire of the Senses: The Sensual Culture Reader* (Oxford: Berg, 2004).

2 See David Howes, "Scent, Sound and Synesthesia: Intersensoriality and Material Culture Theory," in Christopher Tilley, Webb Keane, Susanne Küchler, Michael Rowlands and Patricia Spyer, *eds., Handbook of Material Culture* (London: Sage, 2006).

3 Constance Classen, "Foundations for an Anthropology of the Senses," *International Social Science Journal* 153 (1997): 402.

4 See David Howes, "Scent, Sound and Synesthesia: Intersensoriality and Material Culture Theory."

5 Susan Stewart, "Prologue: From the Museum of Touch," in Marius Kwint, Christopher Breward and Jermy Aynsley, eds., *Material Memories: Design and Evocation* (Oxford: Berg, 1999) 28.

6 This account of the Desana sensory order is woven together from the analyses presented in Constance Classen, *Worlds of Sense: Exploring the Senses in History and Across Cultures* (London and New York: Routledge, 1993); Constance Classen, David Howes and Anthony Synnott, *Aroma: The Cultural History of Smell* (London and New York: Routledge, 1994) and David Howes, *Sensual Relations: Engaging the Senses in Culture and Social Theory* (Ann Arbor: University of Michigan Press, 2003), all of which in turn derive their substance from the classic ethnography of Gerardo Reichel-Dolmatoff, *Amazonian Cosmos* (Chicago: University of Chicago Press, 1971) and Gerardo Reichel-Dolmatoff, "Brain and Mind in Desana Shamanism," *Journal of Latin American Lore* 7.1 (1981): 73-98.

7 Gerardo Reichel-Dolmatoff, *Basketry as Metaphor: Arts and Crafts of the Desana Indians of the Northwest Amazon* (Los Angeles: Occasional Papers of the Museum of Cultural History, 1985) 24.

8 Gerardo Reichel-Dolmatoff, *Shamanism and Art of the Eastern Tukanoan Indians* (Leiden: E.J. Brill, 1987) 17.

9 Reichel-Dolmatoff, *Basketry as Metaphor* 40.

OTHERWISE UNOBTAINABLE: THE APPLIED ARTS AND THE POLITICS AND POETICS OF DIGITAL TECHNOLOGY

TANYA HARROD

Just before his death in 1976, Mao Tse-Tung was asked what he thought of the French Revolution. He reflected for a few moments and replied: "Its far too early to tell." No one has felt the same about the exponential growth of new media applications since the 1980s. The literature is extensive and diverse—understandably so. Any cultural commentator, any historian, any artist will inevitably want to have their say. This is because the computer revolution increasingly affects the creation and, certainly, the manipulation, storage, and distribution of all media. Texts, still and moving images, sound, and spatial constructions all become data. Back in 1979, Jean-François Lyotard predicted that "anything in the constituted body of knowledge that is not translatable into digital language will be abandoned and the direction of new research will be dictated by the possibility of its eventual results being translated into computer language."[1] Lyotard appears to have been correct; new media is shaping the very nature of knowledge.

A walk round any art and design college enables us to test this assertion. We may see resistance to new media, through experimentation with "old" materials like bamboo or rubber or retrospective forays into letterpress printing.[2] It would, however, be hard to imagine vehicle design without evident use of 3D software, rapid prototyping, and Computer Numeric Controlled (CNC) milling machines. New media dominates research projects for reasons that will become apparent. It is also, to an extent, being explored and exploited by applied art practitioners. This may seem surprising. After all, applied art, painting and carving, and constructing sculpture, for that matter, all rely on touch and sensitivity to real as

opposed to virtual materials. If applied artists use new media at all, it would be, one might imagine, in straightforward, functionalist ways.

What do I mean by "functionalist" ways? An obvious example would be the use of software to create files of information to transmit to fabricators, say for a large architectural commission abroad. The design for the etching of a glass screen can be swiftly sent from an artist's studio to a glass workshop in Hong Kong, for instance. Another functional use would be the hard labour involved in using a Computer Aided Design (CAD) system with artful rendering and lighting effects to create presentation drawings for a client. Silversmiths, for instance, make use of this kind of software. Another functionalist use would be to scan a drawing, do some Adobe Photoshop* work and then print it out on a textile with a large format ink-jet printer. Perhaps in those instances, we can utter the clichéd protest, "the computer is only a tool"—a very powerful tool, perhaps—but only a tool. Of course, once we get beyond the basic functionality, this isn't a very useful observation, any more than to say "don't worry, its only a camera" or "don't forget, its only a violin."[3]

We all know that the computer is not just a tool and that even the creation of a humble presentation drawing is a massive intervention in the ways we work and think, affecting the thought processes of artists with a traditional graphic and materials-based training. Using software like 3D Studio** is hard labour, at least at first. On the other hand, being able to print or laser cut intricate designs on cloth or leather has ushered in a new ornamentalism in fashion textiles comparable to the successive developments in textile printing and dyeing in the nineteenth century. It would be more accurate to say that a computer is hundreds of tools, with the desktop functioning as workbench. Sharing tools or information about tools imparts a kind of "commodity camaraderie"[4] among groups of users and creators of software. There are debates about free access to tools through open source coding, with Linux operating system users supporting a gift economy in which status accrues through inventiveness freely distributed.

But we also know that there is huge potential for creativity beyond functionalism as applied artists engage with an increasing range of softwares, starting with the ubiquitous Photoshop, with 3D and animation softwares, and all the various CAD systems—and with a great range of CNCs for milling, engraving, and routing, with rapid prototyping or solid imaging machines, with computerized jacquard looms and dobby looms, and dedicated large-format jet printers with automatic colour separation for printing on textiles. All of these have engaged makers at various levels—sometimes in dramatically visible ways—as with Fred Baier's witty quoting of CAD "primitives" in his furniture design; and sometimes

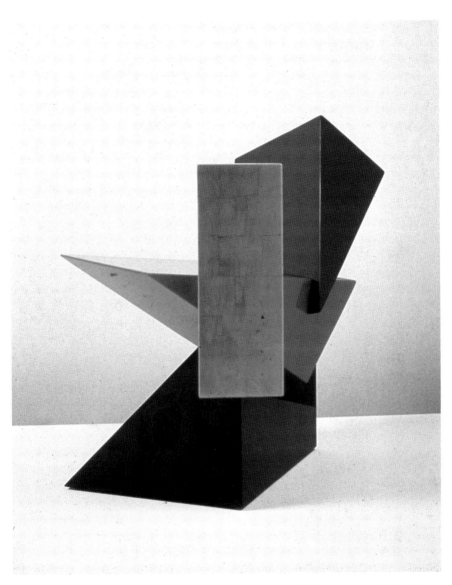

Fred Baier, *Chair*, 1992. Polyester, lacquered, quoting CAD "primitives" (Crafts Council).

less obviously, as with Rosa Nguyen's creation of decals using heavily pixelated images of other ceramic pieces as surface decoration for her ceramics. This is quite apart from the more complex areas of creative research, such as textile artist Jane Harris's work on the 3D computer graphic animation of cloth[5] and the Edinburgh TACITUS project co-led by the jeweller Anne Marie Shillito to develop software and tools for applied artists using a haptic interface and a haptic tool: a force-feed-back mechanism that allows the user to touch, feel, and manipulate three- dimensional objects and to draw three dimensionally in a virtual environment. TACITUS demonstrates the seamlessness of new media, for haptic tools are chiefly used in surgical training to simulate the sensation of cutting through skin and muscle with a scalpel.[6]

This seamlessness can be surprising, even shocking. A couple of years ago I was browsing the TACITUS site. Intrigued by the haptic technology that underpins the project, I clicked on www.reachin.se, who supply their hardware and software. Reachin's links—click!—took me to the Haptics Community Web page, and then—click—I was on the United States (US) Navy's Office of Training Technology site. Final click, and I had arrived at the Institute of Creative Technologies, a five year project funded by the US Army to enlist the resources of the digital movie and games industry to aid the military in creating "immersive learning environments where participants experience the sights, sound and circumstances they will encounter in real-world scenarios while performing mission oriented training."[7] Just four clicks.

New media's ubiquity takes in both the macro implications of the World Wide Web and the micro detail embedded in software. For instance, it has often been observed that much current software—Photoshop for instance—encodes a whole range of current cultural norms. Lev Manovich in his invaluable *The Language of New Media*, discusses Photoshop and its implications for authorship. Because it naturalizes a model of authorship as selection, he sees it as a new form of control, "soft but powerful."[8] In the present cultural climate the God-like author—creating a work from scratch, inventing new ways to see the world—can appear curiously anomalous. It is difficult to think of a figure more "authorial" than the painter Francis Bacon. But the focus of Martin Harrison's recent, ground-breaking *In Camera* is Bacon's library of images: the piles of paint-stained art books, postcards, and images torn from magazines that littered the floor of his studios.[9] It is an approach—authorship as selection—that is inspired by the visual economy of new media.

The software at the heart of new media makes us think and work in certain ways. It is subtly coercive. Take hyper-linking: the way we negotiate websites and databases via linked nodes, branching in tree-like fashion. There is a positive aspect to this process of moving

from node to node. It could be argued that it is akin to Roland Barthes's idea of a "writerly" reading of a text. We seem to be choosing our path actively. Indeed, we might reflect that Barthes and Foucault's reflections on the "death of the author" and the "birth of the reader" (of 1968 and 1969) predate, prophetically, new media and our current hypertext environment. But does hypertext provide us with a truly "writerly" experience? The negative argument is advanced by Manovich. When we read a book, we make links intellectually, drawing on memory and experience. We can move around the text, skip, go back, or go straight to the final page. Reading a book is very different from the linear experience of watching a film. Hypertext and databases do appear to allow us to choose our path by clicking on linked nodes; and each path is, in theory, unique. But this is a physically externalized process. The process of reading, on the other hand, is a psychological, unobservable mental process. With hyper-linking, as Manovich points out: "We are asked to mistake the structure of someone else's mind for our own."[10] The situation is assessed in more extreme form by techno-theorist Sadie Plant: "At the end of the twentieth century all notions of artistic genius, authorial authority, originality and creativity become matters of software engineering."[11]

With this problem of control in mind, should designers and artists write their own software? The digital artist Casey Reas thinks that they should. He argues that software should be seen as a kind of material or sensation: that different softwares have different qualities or atmospheres like, say, oak as opposed to limewood; or rigid as opposed to flexible materials; or like the quality of light in London as opposed to New York.[12] It is, for instance, possible to look at a car and know which software package was used in its design. Cars currently seem to look more homogenous, shaped as they are in a CAD environment. This suggests a kind of technological determinism in which a visual culture is created by a prevailing technology. In this world of pervasive computing, even objects that have not been designed digitally, like the work of the British silversmith Michael Rowe, have nonetheless a CAD aura. The relationships between process and product can be hard to disentangle. For instance, we know that the architect Frank Gehry does not create his designs digitally: he makes physical models and he draws. But his work could not be realized without the aid of new media at the fabricating stage. Similarly, architects' current interest in the writings of Gilles Deleuze on *le pli* and in folding, pliant forms could not be physically accomplished without powerful software.[13] Indeed we might ask, without such software would these interests have had a chance to develop?

Manovich argues that Photoshop has institutionalized a range of cultural practices. Some, like collage (in the form of the copy and paste command), belong to early modern

avant-garde strategies exemplified by Rodchenko's poster for Vertov's film *Cinema Eye* of 1924. Some effects, which involve seamlessly morphing and merging pre-existing visual and aural material, suggest something else. Take, for instance, digital compositing software like Adobe After Effects. These allow the layering of a number of moving image sequences and stills into a single sequence and surely belong to a new kind of cultural logic that we might call postmodern. But Lev Manovich finds the aesthetic roots for compositing elsewhere. He compares compositing to Victorian combination prints made by experimental photographers like Henry Peach Robinson and Oscar Reijlander.[14]

Indeed, there is a sizeable literature on postmodernism's "Victorian Afterlife," arguing that the storage and ready availability of digitized visual information has surprising affinities with Victorian aims and aesthetics.[15] For an example of virtual reality, Victorian-style, we can do no better than a 1859 chromolithograph published by the Arundel Society, based on a water-colour recreation of the Arena Chapel in Padua just after its completion, showing

The Interior of the Arena Chapel, 1956, Arundel Society chromolithograph by Vincent Brooks of a water-colour by Mrs. Higford Burr.

Photo: Tanya Harrod

Dante and Giotto in conversation.[16] We share the nineteenth century's propensity for visual borrowing and image manipulation, a free and easy way with typefaces and replicating processes, and the Victorians' ambitious programs to make available taxonomies of ornament for practical applications, exemplified by Owen Jones's monumental *Grammar of Ornament*. Jones's ambitious *Grammar* anticipates projects like Ted Nelson's *Xanadu*, which proposes to digitalize and link the totality of published texts.

Some of the hardware (especially CNC machines) recall, in their automata-like complexity, Victorian mechanical devices. For instance, Benjamin Cheverton's 1828 reducing machine in the Science Museum in London, in effect, makes a smaller sculpture from a larger "file" (in the form of a larger sculpture).[17] Its autogenic accuracy seems to anticipate solid object printers, rapid prototyping machines that print out a wax model, layer upon layer. In effect, the automata-like machines which delighted Regency and Victorian drawing rooms[18] vanished into the factories only to re-emerge as CNCs. Witness the crowds which gathered round the Fused Deposition Modelling (FDM) machine in action at Ron Arad's retrospective, *Before and After Now,* held at the Victoria and Albert Museum in 2000.

I want to say a little about the writing that might shape a critical discourse for the fine and applied arts and

Benjamin Cheverton's Reducing Machine, Science Museum.

new media. The dominant metalanguage in this area is characterized by futuristic cybertalk inspired by fiction writers in the mould of William Gibson. Indeed Gibson has, rather like Philip K. Dick, invented a language that now runs through a species of fictional writing. How to describe it? It is extreme and at times appears to eroticize new media. But it can also be neo-Platonic in inspiration: hungry for disembodied worlds where the "meat" (to use Gibson's phrase) is left behind and pure reason reigns in an airless empyrean.[19] Far preferable is the feminist take on the new media that optimistically identifies spaces of resistance and transformation, with new media offering mutable identities and unanticipated possibilities. Such writing—Sadie Plant's *Zeros and Ones* for instance—seems particularly apposite because it suggests the unanticipated possibilities that similarly abound in the ways in which artists and makers interact with new media.

Another, more relevant, area of literature is exemplified by one important book: Malcolm McCullough's *Abstracting Craft: The Practiced Digital Hand.* It seeks to humanize new media, in particular the use of computer-aided design, by comparing its complexities reassuringly with the tacit skills embodied in traditional craft practice. Its careful step-by-step approach will surely become a model for ongoing, practice-based research by digitally inclined applied artists. It suggests a template for craft and computing as bedfellows. Invoking craft softens and humanizes computing. And invoking computing has political and poetic possibilities for the crafts. It indicates the very real contribution makers can offer program writers, by collaboratively working on more accessible software.

McCullough writes elsewhere of the inarticulate traditions of craft, particularly striking in traditional crafts like wheelwrighting or the repetitive throwing of pots. This inarticulacy encompasses any making, tool-using activity—from wielding a paintbrush to raising a piece of silver—that draws on tacit knowledge. Currently, the wordlessness associated with confident artistic creativity is perceived as highly problematic. As McCullough puts it, the crafts, on the whole, have lacked notation.[20] And the taciturn tendencies of the highly skilled practitioner are also problematic in the higher education environment. As one educator put it, "the effect of the undocumented tradition is to leave us in the academic stone age."[21]

As we have seen, one of the features of computing, embodied in software, is to objectify mental processes. As Lev Manovich points out, mental processes of reflection, problem solving, recall and association, are all externalized in computing, in software menus and their interactive links. Thus the step-by-step, highly structured nature of computer work can be measured and recorded. This is useful in a culture where creativity itself has to be audited. In a world where the research outcomes of artists and applied artists have to be

explicit, transparent, accountable, thoroughly documented, and readily subjected to peer review and external verification, projects involving computing help make interior, unobservable processes public. There is a positive side to this. The plotting of tacit knowledge (through, for instance, motion capturing a skilled silversmith at work) is valuable and fascinating, as revolutionary in its way as Eadward Muybridge's recording of animal locomotion. And there is a downside. I think we all know that there is an illiberal potential embedded in new media. The new media, as Joseph Weizenbaum of MIT Media Lab observed, arrived just in time to shore up old democracies marked by increasing control and surveillance. Academic audit culture forms a neat condensed example of this surveillance.[22]

But now I want to move away from the politics to the poetics—to a creative engagement with new media through the production of "otherwise unobtainable" images and objects. For instance, creative engagement with new media may well be characterized by a different kind of time consumption (a different "chronomanuality," to use Mole Leigh's useful phrase)[23] and by a far more collaborative activity. There is the potential to spend more time conceptualizing and less time making. Computing work is paradoxical. Sitting designing, for instance, a 3-D object on screen, is extraordinarily time consuming; and, indeed, time worryingly flies by as the designer is drawn on, step-by-step and click-by-click. But one applied artist I interviewed[24] also suggested that designing this way stretched him conceptually and later, in production, allowed endless editing of a piece. This idea of ceaseless editing has not been known in the production of objects before. Prints are edited. Think of the multiplicity of states of a Rembrandt etching. But with a Rembrandt etching, we lose the series of states unless an impression is taken from the plate at each stage. The plate is altered irrevocably. But with Photoshop or CAD software, each state can be saved. There is no identifiable original and no final outcome.

What is of particular interest is the way in which artists, applied or otherwise, wisely, wilfully, tend to do low-tech things with this high technology. They operate as outsiders with something of a hacker mentality. For as Steward Brand pointed out, "media wins, artists lose."[25] Trying to operate as a pure artist at the cutting edge of the new technology is arguably risky because the technology moves so fast, fuelled by more urgent activities such as mass entertainment and war. Brand suggests that new media is intrinsically collaborative and anonymous and ephemeral. Who now remembers the show of artists' holograms held at the Royal Academy in the late 1970s? As Brand points out what we do remember are the white-light holograms on our credit cards.

So the guerilla tactics of applied artists make sense, pushing computer numeric controlled machines to make mistakes and celebrating the constant slippage between the per-

fection of the file and the translation into production, when the algorithm meets the material. There is a countercultural aspect to these interventions. A few years ago, images scanned in and printed out on transfer paper in monochrome on a laser printer could be sprayed with polyurethane to make ad hoc decals or transfers for ceramic surface decoration, because of the serendipitous fact that the toner in the printer contained iron. This was a discovery made by ceramicists, now no longer possible because the chemical makeup of the toner in laser printers has changed.

There is a sense in all this of irreverent experimentation. There is Ann Sutton's use of a programmable dobby loom in which the computer instructs the loom with her design. Some of the excitement is when the yarns have their say, responding unexpectedly to the file.[26] Sutton is a pioneer in this field, joining the Computer Arts Society in the 1960s and learning the programming language BASIC at about this time. Then there is Janis Jefferies's "memory work" embodied in her Poznan factory pieces in which scanned photographs, Photoshop interventions, and digital printing on linen set up tensions between text and textile, digital and tactile. Again, the texture of the woven cloth disrupts the file's perfection.[27] Obviously we engage differently with these two artists; and their involvement with new media is not necessarily the key to understanding their work, although in both cases the new-media dimension leads us to reflect on authorship, authenticity, and the aura conveyed by the processes of translation.

GEOFFREY MANN, *SHINE*, CANDELABRA, *NATURAL OCCURENCE SERIES*. NYLON PROTOTYPE, 25.0 X 25.0 X 7.0 CM.

But textiles appear ready for anything, as Sadie Plant points out in *Zeros and Ones*, where Jacquard looms (in any case prophetic of computing) interweave multiple functions: combining software and hardware; displaying cloth as material and an information storage system, as a product and a process. The artist Esther Parada has described the computer as an electronic loom strung with a matrix image into which she can weave other material. And what about this gendered algorithm: p1, pup1, p1, p2tog, y2rn, p2tog, p1, pup1, p1?[28] But textiles are just one area of applied art responsive to the new technology, albeit one which is incredibly rich and suggestive.

The applied arts have only just begun to exploit the new media. Soon there will be a generation of makers for whom working with computers is not a discovery but a second nature. We are still at the stage where the technology in itself provokes interest. For instance, capturing information and printing it out through rapid prototyping has resulted in haunting, memorable objects. I am thinking of Annie Catterell's use of magnetic imaging to map her own beating heart, and Geoffrey Mann's use of a 3D laser scanner to capture the light reflected off a silver candelabrum as well as the object itself. But, as Peter Lunenfeld has observed, objects like these may retrospectively seem to belong to the category "media of attractions."[29] Rather as with early cinema, they are partly of interest because of the strangeness and novelty of the technologies used in their production.

I'm going to end with some work made by a young silversmith, Drummond Masterton,

DRUMMOND MASTERTON, *MAP DRAWN FROM MEMORY*, 2001. PENCIL ON PAPER.

PHOTO: DRUMMOND MASTERTON

while he was still a student at the Royal College of Art. His interrogations of what John Ruskin called "the anatomy of mountains" involve maps of loved places drawn entirely from memory and reflection but then translated into CAD files. Masterton then creates rapid prototypes translated into the final object using traditional silver investment casting and patinating skills. The strange end result, *Memory Scapes* of mountains recalled, not so much in tranquillity but in a mood of loss and exile, could not have been made in any other way. "Otherwise unobtainable": that seems to be an important ingredient of the ideal new media-applied artwork.

Masterton's *Et in Arcadia Ego*, a meditation on Poussin's great painting and on war, is a CAD translation of the Ordinance Survey map of the Scottish coast at Coulport. It has been milled by a CNC in Cibatool: a pre-cast resin. At Coulport the navy has a secret nuclear submarine base for its four trident-carrying vessels. Viewed from above, looking down through glass printed with map contours, reveals a landscape with submarines, each cast in silver

from a CAD model reduced by a power of 50,000. These undoubtedly beautiful but deadly machines are, on occasion, seen in the Firth of Clyde, lending an air of dread to a serene landscape.

These are striking examples of new media placed in the service of the applied arts. Masterton stresses that the new technology paradoxically led him to reflect more deeply on old learning: on Leonardo's drawings of rocks and water and on the mysteries of Fibonacci series, named after another Leonardo, of Pisa not Vinci. Computing enabled Masterton to embrace an adventurous state of mind and new ways of looking as well as of making.

DRUMMOND MASTERTON, *MEMORYSCAPE*,
2001. CAST SILVER.

PHOTO: DRUMMOND MASTERTON

DRUMMOND MASTERTON, *ET IN ARCADIA EGO*, 2001. MILLED CIBATOOL, CAST SILVER AND PRINTED

GLASS.

PHOTO: DRUMMOND MASTERTON

Endnotes

1 Jean-François Lyotard, *The Postmodern Condition: A Report on Knowledge* (Manchester: Manchester University Press, 1979, 1984).

2 See Anne Odling-Smee, *The New Handmade Graphics: Beyond Digital Design* (Brighton: Rotovision 2003).

3 As pointed out by Colin Beardon, in Colin Beardon, ed., *Digital Creativity: Proceedings of the First Conference on Computers in Art & Design Education (CADE '95)*, (Brighton: University of Brighton, 1995).

4 Peter Lunenfeld, *Snap to Grid: A User's Guide to Digital Arts, Media, and Cultures* (Cambridge: MIT Press, 2001) 3-7.

5 Jane Harris, "Surface Tension: The Aesthetic Fabrication of Digital Textiles," diss., Royal College of Art, London 2000.

6 Ann Marie Shillito et al., "'Tacitus' Project: Identifying Multi-sensory Perceptions in Creative 3D Practice for the Development of a Haptic Computing System for Applied Artists," *Digital Creativity*, 12.4 (2001).

7 See, for instance, Jonathan Gratch and Stacy Marsella. "Tears and Fears: Modeling emotions and emotional behaviors in synthetic agents" 15 Mar 2007 <http://www.ict.usc.edu/publications/agents01-emotion.pdf>

8 Lev Manovich, *The Language of New Media* (Cambridge: MIT Press, 2001) 129.

9 See Martin Harrison, *In Camera Francis Bacon: Photography, Film and the Practice of Painting* (London: Thames & Hudson, 2005).

10 Manovich 61.

11 Sadie Plant, *Zeros & Ones: Digital Women & the New Technoculture* (London: Fourth Estate, 1997) 194.

12 Unpublished paper given at *Pixelraiders 2*, Sheffield Hallum University, 2004.

13 Gilles Deleuze, *The Fold: Leibniz and the Baroque*, trans. Tom Conley (Minneapolis: University of Minnesota Press 1992).

14 Manovich 153.

15 John Kucich and Dianne F. Sadoff, eds., *Victorian Afterlife: Postmodern Culture Rewrites the Nineteenth Century* (Minneapolis: University of Minnesota Press, 2000).

16 Tanya Ledger (Harrod), *A Study of the Arundel Society 1848-1897,* diss., University of Oxford, 1978.

17 Charles and Dorrie Shinn, *The Illustrated Guide to Victorian Parian China* (London: Barrie & Jenkins, 1971) 24-26.

18 Jay Clayton, "Hacking the Nineteenth Century" in John Kucich and Dianne F. Sadoff, eds., *Victorian Afterlife*.

19 See, typically, William Gibson, *Neuromancer* (London: Harper/Collins 1995).

20 Malcolm McCullough, *Digital Craft: Applied Arts and Technological Saturation* (London: Royal College of Art, 2004) 9-10.

21 Quoted in Kate Bunnell, *Integrating New Technology into Ceramic Designer Maker Practice*, diss., CD-ROM, Aberdeen: The Robert Gordon University, 1998.

22 For audit culture, see Cris Shore and Susan Wright, "Audit Culture and Anthropology: Neoliberalism in British Higher Education," *Journal of the Royal Anthropological Institute* 5.4 (December 1999).

23 Mole Leigh, "Chronomanual Craft: Time Investment as a Value in Contemporary Western Craft," *Journal of Design History* 15.1 (2002).

24 Drummond Masterton. On his work see below.

25 Stewart Brand, *Creating in Textiles and New Technology* (London: Crafts Council 1994) 88.

26 Ann Sutton, *No Cheating: Serial Woven Series* (Winchester: Winchester School of Art, 1995).

27 Victoria Mitchell, ed., *Janis Jeffries: Selvedges: Writings and Artworks since 1980* (Norwich: Norwich School of Art and Design, 2000).

28 It is, of course, part of a knitting pattern.

29 Lunenfeld xviii-xix.

Rethinking Dichotomies: Crafts and the Digital

Love Jönsson

In her final book, *Regarding the Pain of Others* (2003), the late Susan Sontag makes a committed and thoughtful analysis of the history of visual representations of war and cruelty. Resting on a solid base of arguments drawn from art history, politics, and psychology, she maintains that photographic documentation often functions as a witness, and plays a crucial role in raising public awareness of atrocities. It is worth noting that when defending photography's testimonial character, she reassesses and partly retracts some of her earlier standpoints. In her 1977 book, *On Photography,* she put forward the idea that even if a photographic documentation may initially seem to make an event more real, it will, after repeated exposure, also make it *less real.*[1] In the later book, however, she arrives at the conviction that an event can hardly be said to become less real, or less urgent, only because it is made the object of an image. Mass media's endless circulation of images does have a distancing effect, but it does not render the depicted incidents themselves unreal or less significant. "What is the evidence that photographs have a diminishing impact, that our culture of spectatorship neutralizes the moral force of photographs of atrocities?" she asks with fervour.[2] Furthermore, she criticises the popular postmodernist view of our world as one where representations are assumed to have become more real than reality itself. This perspective is provincial, she argues; it merely mirrors the viewing habits of a small population "living in the rich part of the world, where news has been converted into entertainment."[3]

Susan Sontag's observations are important, and may even be used as an entry point into a discussion on the relationship between the crafts and the virtual. In this field, too, we are faced with the problem of the real and its various representations, and our reac-

tions to them. At the heart of the matter is the question of whether the existence of an elusive, immaterial world of representations and simulations makes us less inclined to engage with its physical counterpart. Is it that technological development has provided us with a set of views that on the one hand seems to enhance the "realness" of physical work and objects, but on the other simultaneously threatens to diminish their symbolic value and power? Are the crafts being left behind as the possibilities offered by computer technology to make and manufacture elaborate designs have evolved with unpredictable speed? Will computer-aided design and production in the near future be apprehended as more real: that is, more easily accessible, more contemporary, more important?

In trying to answer these questions, one needs to remember that society has room for almost everything. Hence, the introduction of a new phenomenon does not inevitably lead to a total abandonment of its predecessor or earlier equivalent. The popular image of a straight line of development in which characteristics of earlier phases are successively wiped out may suit a certain modernist view; but it fails to encompass the dynamics of human society. Traces of the seemingly bygone will always surface, claiming their territory and challenging the idea of a coherent present. One of the great lessons from postmodernist thinking is precisely that opposites are likely to coexist; old forms live on simultaneously with the emergence of new ones.

The invention of the synthesizer did not, in general, prevent people from playing and appreciating acoustic instruments. The introduction of the compact disc did not stop the production of vinyl albums, nor did it stop music connoisseurs from buying them. The typewriter and the telephone, and later on the word processor and e-mail, did not make us give up handwriting altogether. These examples could be multiplied. Rather than being obliterated, older means of creating, manufacturing, or communicating live on together with new ones. And in general we do not have to make definitive choices between them. In any given moment we can choose the one(s) that suits us the best.

Of course, our views of the differences between old and new phenomena are also bound to change over time. In the nineteenth century, followers of the crafts conceived of the industrial production of their day as an antithesis to the values that they themselves defended. Looking back at this historical epoch today, however, one is rather tempted to underline the high level of craftsmanship, and the labour-intensiveness, that marked a large part of early industrial production. It comes as no surprise that a lot of craftspeople today show a fascination for this heritage and the complex relationship between craft and industry it comprises. This tendency to re-address the history of industry from a position within the crafts has been noticeable, not the least in ceramics. Marek Cecula, Neil

Brownsword, Clare Twomey, Paul Scott, and Pekka Paikkari can be mentioned as makers who, in recent years, have approached these issues in personal and diverse ways. Their work goes to show that craft and industry are not antithetical to one other, nor mutually exclusive. When looking upon the question of craft and digital technology, one ought to keep this condition in mind. Rather than focusing on the issue of new technology as something alien and threatening, one should be aware of the complexity in the way in which the crafts interact with it. A grid of interlocking meanings is currently being woven between the handmade and the digital, the physical and the immaterial. When trying to grasp this development, it will not do to look only at one facet of the field.

In Scandinavia, a substantial part of the crafts has for the last few years been marked by a desire to engage with materials and objects in a direct and genuinely hands-on manner. In Sweden, young craft and design collectives, such as Uglycute, We Work In A Fragile Material, and Front have been influential in their search for design and production methods that acknowledge handmaking and an expressly physical handling of materials. Through their collective structures, often open to others, these groups also emphasize the social aspects of making. Needless to say, there has been a corresponding movement within a broader part of the arts, with a large group of artists wishing to interact with reality and everyday social life.[4]

These movements in the crafts could easily be interpreted as a reaction against technological development and its "virtualization" of concepts such as place and participation. But even if, at first glance, the revival of small physical communities and fundamental craft materials and methods seem to correspond to a hunger for the real, as opposed to the virtual, a closer scrutiny often shows that the two fields are more and more intertwined. These young makers are not Luddites; on the contrary, they are often perfectly at home with technology. This is yet another indication that it is time to rethink old dichotomies. If in the history of modern crafts, technology has been looked upon as something mute, anonymous, and distancing, other features of it are underlined today.

One example of how a crafts-based approach may put emphasis on values that we are not accustomed to associating with technology can be found in some makers' use of digital designing aids and rapid prototyping. In a recent project, *Sketch Furniture*, the crafts-oriented Swedish design group, Front, used motion capture software to record sketches of pieces of furniture made by hand in the air.[5] Front is a group of four members, all trained in industrial design. In earlier ventures, they investigated how material and form can be shaped or altered randomly by external forces, such as the actions of animals, explosions, pressure, and changes in temperature.[6] The group's focus, however, is not so much on

Front (Sofia Lagerkvist, Charlotte von der Lancken, Anna Lindgren, and Katja Sävström), chair, table, and lamp from the *Sketch Furniture* series, 2006. Plastic.

Photo: Front

experimenting with materials per se as on creating utilitarian objects that carry unexpected stories and emotions, and enhance physical interaction.

In *Sketch Furniture*, the recorded 3D files of drawings made in the air were turned into real pieces of plastic furniture through rapid prototyping. The soft and improvised contours of the finished pieces, corresponding very clearly to the "human touch" present in the preceding design process, implicitly question the image of technology as cold or inhuman. The digital tools are here used to render something immaterial material. Rather than distancing us from reality and sensuous experience, this process gives an opportunity to document, visualize, and get to know the dynamics of real-time improvising. Most striking in Front's *Sketch Furniture* project is the way in which the movement of a hand, a quick human gesture, is echoed in an object's physical here-and-now. The same effect is, of course, known from the crafts, where the mark of the maker in many ways remains a crucial point. Still, Front's sketch project is not about imitating the effects of handmaking but about scrutinizing its concept from the perspective of digital technology. The project expresses an interest in correspondences and transferences; and the same goes for a lot of other contemporary undertakings in craft, design, and art that set out to combine the hand with the digital. In practices like these, technology is approached with the same curiosity and enchantment as is physical reality.

A very different form of "rapid prototyping" was carried out in *Translations*, a project performed in 2005-06 by the young Swedish crafts group, S U B. The group is composed of three members, trained in ceramics, glass, and metal respectively. Their project consisted of public sessions in which participants were invited to bring objects from their home and describe them in words. Without having seen the actual objects, the craftspeople made rough clay models of them on the basis of their owners' oral descriptions. The descriptions had to be centred on form: the owner of the object was not allowed to reveal what kind of object it was, nor its area of application. Each modelling session was completed in five to ten minutes. As a means of documentation, a photograph was taken of the original object and the resulting physical "translation" of it.

These juxtapositions of real objects and their "ghost" versions (to borrow a term from Pop artist Claes Oldenburg's œuvre) often have humorous qualities. In the clay models, elegance is replaced with clumsiness, proportions are distorted, and well-known everyday utensils transformed into something alien. One of the issues the makers set out to explore was the communication process that formed the basis of the project and the relationship between the different stages of perception, transmission, and rendition. More than anything else, the clay models provide evidence of how limited we are in our ability to relate

S U B (Sissi Westerberg, Ulf Samuelsson, and Benjamin Slotterøy), clay model with original object from the *Translations* series, 2005.

Photo: S U B

words to visual experience, let alone adequately render the supplied information. The project accommodates an underlying questioning of the possibility of our intellect and language to give a thorough record of the world. Thereby, even though it is a small and limited project, *Translations* says something important about the character of human, sensuous experience. There are values and knowledge that cannot be pinned down and translated into another medium.

Returning to the question of technology, it is worth noting that S U B's project seems to take on the character of an inverted version of the design process. Several of the objects that were brought along to the sessions are industrially made products. Needless to say, they represent the final step of a long and complex process of design and manufacture. In *Translations*, this process is made to go backwards. The once-finished piece here symbolically returns to a primitive, less complicated stage. In the clay model, the thing becomes

its own imaginary prototype. When making these alien "prototypes," the S U B group to some extent attempts to uncover hidden or overlooked properties in the things. In this view, the misunderstandings that give birth to unexpected forms are truly meaningful. In a text about the project, the group talks about trying to create an experience suggestive of how one looks at an object as a child, as if seeing it for the first time, not knowing what it is.[7] Is it perhaps all about finding the "real" thing, the thing in itself, devoid of the super-structure of references and recognition that usually guide our understanding?

The *Translations* project may be interpreted as a metaphorical commentary on repre-sentation and simulation, concepts well known from the world of media and technology. From one perspective, the makers' lack of success in achieving models that are true to the originals forms a critique of representation in general. Furthermore, the result may be regarded as a defence of a special kind of knowledge and experience of things that cannot be transmitted only through facts and figures.

From another view, however, the project seems to acknowledge the dynamics of rep-resentation itself, including the condition that it is not only a process of imitation, but also of discovery. The visualisation of abstract information does not lead us away from the real thing; it may actually make us return to it with fresh eyes. Does this not tell us something about the possible relationships between the crafts and new technology?

Even in *Translations's* simple set-up, based on clay and hand modelling, there are hints about a wider range of issues. This tendency might be said to be typical of a large part of contemporary crafts. Questions linked to theoretical debates and technological challenges surface even in projects that are noticeably down-to-earth. There are no isolated gestures today; everything is connected.

Finally, another example of how traditional crafts are intertwined with the application of new technology—and how to answer the challenges it poses—is of course the fact that the Web has become a popular forum for the field. The majority of today's craftspeople (and not least the followers of grass-roots crafts movements: knit-outs, "radical craft," "extreme craft," to name but a few) consciously use the Web for communication, documentation, and self-promotion. Consequently, these movements cannot unambiguously be inscribed into an account of anti-modern or anti-technologic ideals. Parts of their work may be regard-ed as oppositional towards technology, through their use of basic craft methods and a rhet-oric that often expresses discontent with contemporary societal issues. Still, they readily seize the advantages of information technology, using it as they please.

The Houston-based street crafts group, Knitta, is one of many initiatives that bring together age-old crafts methods with Web-based communication, all under a socially

informed agenda. By putting knitted covers on lampposts, park benches, antennas, etc., thereby providing the objects with a temporarily softer and more colourful appearance, the group seems to criticize the cold and sterile environment that characterizes public places. Their hand-knitted "cozies" symbolically make up for the streets' lack of aesthetic stimuli and the anonymity of urban life, as well as serving as conspicuous, sensuous ads for the group itself. Borrowing a graffiti vocabulary, these knitters set out as a tag crew, using aliases and "bombing the inner city with vibrant, stitched works of art."[8] With the slogan "Warming the world, one car antenna at a time," they humorously acknowledge the utopian dimension in their work, while keeping it all at an unpretentious, everyday street-level.

At the same time as the group is making the streets a bit cozier, with the help of yarn and knitting needles, it is, however, also using another means. And this is one far more distanced from the physical and the sensual, namely our omnipresent virtual space: the World Wide Web. Even if the "bombing" of local cityscapes with knitted covers forms the core of the group's activities, it is mainly through its well-structured website that it spreads its message to the world. Of course there is no real conflict here. No one today is likely to raise an eyebrow over the fact that a crafts group has a website; rather, the opposite is the case. A representative of a leading Swedish textile network recently noted, with regard to the physical character of textiles versus the network's dependence on its Web-based forum, that "despite the tactile nature of the artform…Fiber Art Sweden also communicates immaterially. This is no contradiction."[9]

Still, it may seem odd that craftspeople, often engaged in a life-long project of metaphorically "warming the world" through their work, have in recent years so dedicatedly embraced allegedly "cold" computers and the communication technology they offer. Remember that in general, technological development has always been regarded as a threat to the crafts. Furthermore, it is not long ago that computer technology was widely seen as the mark of a cold and dehumanized society, and as a danger to the individual.

It is a truism that the common view of computers and their role in society has changed dramatically during the last decades. If information technology was earlier perceived as a means through which authorities and corporations could execute control, the development of the user-led Web, file-sharing, and open-source software has made it clear that its functions are more complex. Rather than being authoritarian, the Web has been shown to foster non-institutional ideals. The extent to which the Web and its development is really governed by grass-roots movements may of course be disputed, but the major point here is that information technology has taken on an everyday character that not many people could foresee only ten to fifteen years ago. And it is the way that people *are taking hold of*

it and using it that has made this change. What we can learn from this is that is it not enough to ask how information technology has influenced our lives. One also needs to be aware of the way in which the global collective of Internet users have changed the general understanding of how this technology functions and what it implies.

Turning once more to the crafts, the example of the Web is a reminder that the all-pervading question today should perhaps not be how the crafts will be affected by digital technology. Rather we ought to ask how the means through which craftspeople start using this technology for their own purposes—perhaps mixing it with age-old traditions, subverting its applications and giving them new symbolical values—will influence and alter our appreciation of it.

ENDNOTES

1 Susan Sontag, *On Photography* (New York: Farrar, Strauss & Giroux, 1978 [orig. 1977]) 20: "An event known through photographs certainly becomes more real than it would have been if one had never seen the photographs…. But after repeated exposure to images it also becomes less real."

2 Susan Sontag, *Regarding the Pain of Others* (London: Penguin, 2004 [orig. 2003]) 94.

3 Sontag, *Regarding the Pain of Others* 98.

3 A Scandinavian-based view of the art scene from this perspective is given in Sara Arrhenius, "Body Contact: Hungering for the Real," in Daniel Birnbaum & John Peter Nilsson, eds., *Like Virginity, Once Lost: Four Views on Nordic Art Now* (Lund: Propexus, 1999) 11-35.

5 Presented online at "Front News: Front in Japan," *Front*, 5 Jan. 2007 <http://www.frontdesign.se/>. The project was carried out in the fall of 2006.

6 Some of Front's projects are discussed in Henrik Most, "On Craft as a Boundary Wrecking Ball," in Love Jönsson, ed., *Craft in Dialogue: Six Views on a Practice in Change* (Stockholm: Iaspis, 2005) 24.

7 Unsigned presentation text in "Projekt," *SUB:Sissi, Uffe & Benji*, 5 Jan. 2007 <http://www.s-u-b.se>.

8 Quoted from "About," *Knitta, Please – Houston, TX*, 4 Jan. 2007 <http://www.knittaplease.com>.

9 Margareta Klingberg, "Textile Matter Fuels Passion," in Monica Nilsson, ed., *Fiber Art Sweden* (Stockholm: Fiber Art Sweden, 2006) 107.

HANDMADE FUTURES: THE EMERGING ROLE OF CRAFT KNOWLEDGE IN OUR DIGITAL CULTURE

MIKE PRESS

BEYOND iCRAFT

> Do you appreciate handmade arts and crafts? Are you the owner of a computer, a PDA, or, an iPod? If so, SafariPod probably has a product that will make you smile…today, and every day. Just because we use computers, like digital music, and keep our important information on a pocket gadget doesn't mean we have to strip our lives of things a little warmer, a bit more personal. At SafariPod we are adding back a touch of humanity to our otherwise sterile environments. We hope you appreciate the effort.[1]

What better companion for your iPod* than a hand-carved wooden plinth in the shape of a rhino or elephant? Or if you wish to celebrate the launch of Apple's new operating system—the OSX 10.5 "Leopard"—then Kenya's SafariPod craft workshop could also ship you a traditionally crafted black leopard made especially in its honour. iCraft. It had to happen sooner or later.

Let me emphasize at the outset that I have no problem with an enterprise that seeks to use the craft skills of Kenya to exploit Western gift markets, thereby creating much-needed employment and foreign earnings. And in the semiotic smorgasbord that is contemporary consumer culture, we should not be surprised that some people exercise their consumer-given right to dock their iPod on a small wooden baboon. Indeed, in the dying

light of liberal democracy, such small rights blaze all the more brightly. However, such iCraft does highlight the question of craft's relationship to digital culture. Is it solely to provide a little light, handmade decorative relief in our technologically saturated lives?

In terms of material culture, crafted objects and digitized objects appear to arise from different worlds and constitute wholly different types of objects. Jayne Wallace uses the typology of the "gadget" and the "non-gadget" to differentiate between them. According to her: "Most if not all electronic, or digital appliances have a lifespan, governed not by a technological defect of the appliance, but by its function or usefulness becoming usurped by another, newer, faster, 'better' one. Such appliances are often referred to as gadgets."[2] According to Wallace, while gadgets are not enduring in terms of personal significance, "non-gadgets"—such as jewellery—are more emotionally engaging, significant, and enduring. The object is intertwined with its owner's identity, with an attachment based on personal significance. While we can have our loved one's name etched into the stainless steel of an iPod's casing, it's highly doubtful if the exchange of iPods would ever catch on at wedding ceremonies. The ring is mightier than the Pod when it comes to personal significance. In the culture of craft, production is holistic, the pace of technological change is slow, and objects are conceived to be heterogeneous. In the culture of the digital gadget, production is fragmented, the pace of technological change is rapid, and objects are conceived to be homogenous. Different worlds.

But these worlds are beginning to collide, and through this collision a new value for craft thinking, processes, and knowledge is beginning to emerge. Our digital culture has been both defined and constrained by "the culture of the gadget," but now craft is beginning to explore creative strategies and approaches that open up new possibilities of form, meaning, and significance in our digital culture.

I suggest that there is evidence of a new model of craft practice emerging—small certainly, but potentially highly significant—which is in many cases being pursued by makers who have difficulty embracing "the c-word" as a descriptor for their practice. But craft it most certainly is, and enriched by other words:

○ *Engaged*—practice that is engaged with issues far beyond the cozy, cloistered environment that the late Peter Dormer described as craft's *salon de refuse,*[3] and recognizes how craft knowledge can contribute to solving problems in other fields.
○ *Investigative*—practice that is inquiring and systematic in its methods, embedding tacit knowledge within frameworks of formalized investigation.

○ *Transparent*—practice that seeks clarity and transparency in its methods and outcomes, thereby enhancing the knowledge base of craft in a contemporary context.

○ *Cross-disciplinary*—practice that makes connections with other specialized fields, drawing upon and contributing to their knowledge and expertise.

○ *Innovative*—practice that demonstrates craft's ability to develop innovative and creative solutions that can be transferred and applied elsewhere.

In other words, craft is demonstrating its power and value as distinctive knowledge that adds value and meaning to our world, and thus is beginning to define itself in terms of knowledge, as opposed to a particular class of objects in our material culture. We can see this knowledge applied in interactive computing, medical physics, and industrial design. We can see the products of this application in hospitals, interaction design studios, and even in outer space.

This chapter is concerned with placing such practice into context, describing relevant examples, and providing a theoretical framework. It is argued here that craft knowledge is too important and too unique to be limited to the domain of the handcrafted object. This knowledge provides a key to humanizing technology and addressing the politics of work and consumption.

THE QUIET REVOLUTIONARIES

Crafts must be made of natural materials, preferably in beige. Crafts must be made by hand. Crafts must be functional. Crafts must be the work of one person, perhaps featuring visible thumbprints or surface imperfections to prove it. Crafts must be in the artisan rather than the fine art tradition. Crafts must be rural. Crafts must be untouched by fashion. Crafts must be easily understood. Crafts must be affordable, even if, like Morris's work, affordable mainly by Oxbridge colleges, Anglican churches and collectors. Above all, crafts must provide a solace in a rapidly changing world.[4]

The crafts in the United Kingdom (UK) and elsewhere are undergoing a quiet revolution. Not the sort of revolution where a mob of silversmiths armed only with planishing hammers scale the railings outside Buckingham Palace, or irate potters impale Tony Blair on their fettling tools; although these are not ideas wholly without merit. Change in the crafts

is always necessarily a quiet, understated affair. For one thing, the paucity of media interest in the crafts ensures that change is never likely to hit the national headlines, and for another, craft makers have never really been ones to blow their own trumpet. Today's quiet revolution of craft is most obviously about technological change; about makers raiding the creative potential of digital technologies for new processes, media and creative strategies. It is also about practitioners defining their practice outside the traditional domain of the handcrafted object for the gallery market—and locating themselves increasingly in new media and other creative practices.

The words above, written by Sir Christopher Frayling, characterize the popular view of crafts up to the 1970s, based on the conception of craftmakers such as Bernard Leach or William Staite Murray—(an amiable traditionalist with a passion for hand coiling who wore old cardigans and probably kept chickens). The craftmaker of the twenty-first century is a very different person: young, fashionable, with an art college degree, wearing designer knitwear, and with, at best, only a passing interest in poultry.

Just as the culture of craft has undergone a revolution, so too have its processes and professional concerns. Wired by digital technology and fired by new conceptual directions and passions, contemporary craft connects with the technological and cultural challenges of its age. Within the university sector, we have established craft's value as a distinctive form of knowledge that has uses and relevance far beyond the traditional concerns of craft. We have a newly articulated emerging knowledge base, new forms of creative and cultural hybridity that are transforming craft, new definitions of practice, and new technological opportunities that we can embrace. Craft, therefore, offers huge promise as a set of culturally and economically relevant practices that could help to humanise this dangerous new century that we have recently entered.

Paul Greenhalgh (1997) has argued that "if we are to advance from our present sorry state, we need to clarify the role of all of our cultural forms, including the crafts…helping us to integrate (machines) into our way of making and thinking."[5] His call to arms for the crafts to embrace the machine, finally abandon its culturally redundant opposition to technology, and in so doing to redefine itself, has been taken up with some enthusiasm in the decade since his words were written. But in a sense, we should not be surprised that it has. At the core of Greenhalgh's argument is the idea that craft as an "oppositional, anti-industrial" activity is based on a misreading of craft's history. Craft has therefore always held within it a technological opportunism that is perhaps now more manifest, simply on account of the richer technological opportunities that abound in all creative practices.

The clearest evidence of craft's *quiet revolutionaries* at work is to be found in cases where makers have integrated digital process seamlessly into their creative practices. In some cases, the makers work entirely through the software to create pieces that may require only minimal hand finishing, while others interweave Computer Aided Design (CAD) and Computer Aided Manufacture (CAM) and workshop processes together.

Christoph Zellweger uses digital processes to design and make his *Rhizome* pieces almost in entirety. Recently shortlisted for the Jerwood Prize in Jewellery, Zellweger comes from a highly tradi-tional Swiss-German gold-smithing background and has an international repu-tation for his work. His *Rhizome* series apply three fairly straightforward processes: one is creating intricate 2D designs on AutoCad, then outputting this to a computerized waterjet cutter that forms the pieces in natural rub-ber, after which they are individually laser engraved. His material enquiry chal-lenges existing media and explores the invention of new media. His work con-siders very carefully the nature and meaning of ornament as a carrier of

CHRISTOPH ZELLWEGER, *RHIZOME CHAIN*, 2006. NATURAL RUBBER, LENGTH 70 CM.

PHOTO: CHRISTOPH ZELLWEGER

information and as an identity-giving device. He explores contexts for his work rooted in present-day cultural phenomena. These objects do not involve much, if any, craft in their physical making. But without Zellweger's craft knowledge, these objects would not exist. So while craft is invisible in the making, it is highly visible in the idea.

Justin Marshall is a ceramicist who seeks to push software to its limits—and a little beyond. One of the aims of his work has been to produce forms and surfaces that would

have been impossible or impracticable to produce without the use of computer technology. Surfaces he has developed were produced by applying a tool within the 3D modelling software which had been developed for an unrelated purpose. In this way, he creatively subverts the software, employing it for a new use. As he explains:

> I hope to demonstrate in my projects that digital technologies, approached in the right way, can be relevant and useful to the ceramicist. Without the aid of computer technologies not only would the objects I have made been impossible to physically produce, they would also have been impossible to imagine. The employment of digital technologies transformed and extended my way of thinking about making as well as my physical practice. So these technologies become an intrinsic part of my mental and physical creative praxis.[6]

Drummond Masterton is also in the business of making 3D forms that would either be impossible or impracticable to realize using conventional non-digital means. But he introduces a new theme to the discussion: that of developing a creative relationship with computerized machines in the workshop and understanding how to use and extend the tools of digital manufacture. Masterton creates objects that take advantage of the unique mark- and form-making qualities of Computer Numeric Controlled or CNC machines. His work aims to be a testing ground for concepts formed from his experiences in the real world, whether primary or through mediated sources. The "objects" he creates are realizations, understandings, or questions that relate to present beliefs. As he says himself: "I prove my world through the objects that I design and produce just like a scientist might test his theories through experiments."[7] Masterton is no longer concerned with handcrafting his ideas into solid forms, primarily because the process would be too difficult or too time consuming. A large part of his work is therefore to understand how the machines he uses to create his "objects" work. He develops this understanding through an intense process of testing numerous machine settings, adjusting large segments of machine code, and changing or making tools for the machine to use.

Zellweger, Marshall, and Masterton are examples of makers who have gained fluency with digital tools as an integral part of their creative process, and have used this to augment and extend their craft knowledge to produce objects that simply could not exist otherwise. Craft and digital culture therefore collide to create a new aesthetic or range of physical possibilities for craft practice.

What distinguishes these "quiet revolutionaries" from many other makers who have integrated digital processes within their practice is that they have an explicit research agenda that is embedded with their creative practice. This has arisen because of the new research culture within art and design education in the UK that has provided incentives and funding for research in creative disciplines. From the early 1990s, UK art and design schools were provided access to research funding, and the intervening period has witnessed definitions of practice-centred research emerging that have significantly moved forward innovation and research in the practice of craft. Marshall and Masterton, along with pioneering craft researcher Katie Bunnell, are members of the Autonomatic research group at University College Falmouth. As they explain:

> We do research that explores the use of digital manufacturing technologies in the creative process of designing and making three dimensional objects…. As creative researchers we have a basic urge to invent new ways of making things, to ask "what if?", "so what?" and "what next?" Through our individualistic and autonomous approach to using digital technologies we hope to inspire other designers and makers to approach digital technologies with a creative mindset.[8]

Locating craft practice within a doctoral and post-doctoral research framework has clearly begun to develop, articulate, and apply a knowledgebase for craft in the twenty-first century. Furthermore, it is beginning to define a new relevance and value for craft knowledge far beyond the world of craft itself. In so doing, there is an emerging group of craft-based researchers who are boldly going where no maker has gone before.

It's craft, Jim, but not as we know it…

> British design experts from Sheffield Hallam University are the brains behind a revolutionary robotic arm helping NASA refine its safety in the wake of the Columbia shuttle disaster. The artificial joints of the robot arm exactly replicate the workings of a human limb.[9]

In July 2005, the Discovery Space Shuttle rocketed up through the skies over Florida, carrying onboard a fifty foot-long robotic arm for use on the International Space Station. All

the mechanical principles for this arm were developed through a doctoral research project undertaken in Sheffield by Graham Whiteley, under the supervision of Chris Rust. NASA scientists at their Jet Propulsion Laboratory adapted the Sheffield prototype with plastic "muscles" to develop a system that will play a vital role in future space exploration.

Graham Whiteley's Ph.D. was entitled "An Articulated Skeletal Analogy of the Human Upper-Limb"; essentially, he was tackling prosthetic design research through a methodology that made considerable use of craft techniques, such as physical prototyping and drawing. The research output comprises a thesis that was structured as an annotated sketchbook and a series of models and components. While Graham would not describe himself today as a "craftmaker," his background is in 3D design in which he proved his remarkable craft skills and knowledge through furniture and automata. His ability to research in the disciplines of medical physics and aerospace engineering demonstrate not only his own personal versatility and talent but also the value of the "lost arts" of craft to the practice of research in these disciplines. As he and his supervisors explain:

> The making techniques used are familiar in industrial design practice, where the production of high quality prototypes is a normal method of advancing the product development process. However this approach is relatively unusual in the context of medical physics research where emphasis is placed on the analysis of data, often through mathematical models. The use of practical craft skills to represent a hypothesis and allow a rich set of evaluations could be regarded as a lost art in many fields of the physical sciences today.[10]

In December 2006, the British Broadcasting Corporation (BBC) reported "What's being billed as the world's most advanced bionic hand has been fitted to a man in Scotland. Separate motors individually power the five fingers on the i-LIMB hand. This allows a better grip and a more realistic look and feel."[11] This was yet another outcome of Whiteley's research, which was developed further by the robotics company that he has since established.

Peter Walters is another doctoral researcher who is rooted in a craft-based approach to design, and whose research is connected with issues far from the conventional concerns of craft. Walters has been working alongside clinicians investigating how design can tackle the problem of misconnection errors in surgery. Like Whiteley, physical prototyping and model making are central to the research process. While Walters uses CAD in his design

processes, his research has been concerned with striking a new and appropriate "human-centred" balance between physical and digital design. As he argues: "the valuable practical knowledge which may be derived through *hands-on* engagement and manipulation of physical prototypes and materials must be retained as an essential human element in design."[12]

John McGhee's doctoral research at the University of Dundee explores the use of 3D visualization techniques to enhance medical scan data, particularly in the field of Magnetic Resonance Imaging (MRI) and Computive Tomography (CT) scanning. The work has focused on how these scans might be combined with the digital 3D visualization tools commonly used by artists in the computer animation and games industries. The aim of his research is to evaluate whether improved imagery might offer a greater understanding of illness and disease among different patient groups.

Like Whiteley and Walters, McGhee's background is in 3D design, and he brings a craft background, sensibility, and approach to his research. However, while their skills and knowledge are rooted in craft, they have moved well beyond the conventions of craft practice in terms of the application of their knowledge.

Research by jeweller Jayne Wallace retains not only a concern with applying craft knowledge but also a concern with exploring how the crafted object occupies a new role in our digital age. Her doctoral research addresses the question of how jewellery can make use of embedded technologies to enhance communication. She has taken this project way beyond a prosaic and limited focus on product styling to engaging with the very significance of applied arts objects and craft processes to our culture. Wallace rightly observes that it is jewellery—more so than writing, language, or technology—that defines and signifies the first defining period of human civilization; and it is jewellery that could define our transition into a new phase of history and culture. As she explains:

> It is important to state what this research is and what it is not. It is not about inventing new mobile phones or PDAs, which are worn in a novel way on the body. This research is about the design and application of wearable digital technology using the methods and perspective of a Contemporary Jeweller. It is anticipated that the research will test the appropriateness of Contemporary Jewellery as a creative strategy in the further development of such technologies. Furthermore it will define new design methodologies, which will bridge the roles of Designer and Jeweller. If successful this research will enhance the relevance of Contemporary Jewellery and estab-

John McGhee, 3D interpretation of the human kidney derived from MRI (Magnetic Resonance Imaging) scan data, 2006.

Photo: John McGhee

lish its value as a source of knowledge in a post-industrial age. Jewellery is a defining signifier, it was in the Middle-Upper Palaeolithic age and this research can demonstrate that it still is today.[13]

What is significant is that her research has already attracted considerable interest from the HCI (human computer interaction) community and has been published in specialist books and journals in that field. A recent paper co-authored by Wallace in the *Journal of Personal and Ubiquitous Computing* drew upon her research to develop the idea of enchantment as a key to future interaction design:

> Our particular approach has been to explore relationships between people and technology in a number of cultural contexts, from the pre-industrial culture of the Trobriand Islanders to the media-saturated youth sub-cultures of Europe, with a view to documenting their enchantments with technology. From the perspective of HCI and Interaction Design, this has proved useful. For example, identifying the depth of a design as central to the experience of enchantment and provisionally characterising depth in terms of a set of sensibilities facilitated our exploration of digital jewellery. It heightened our perception of qualities, such as paradox and being-in-play, in contemporary non-digital jewellery, which are not yet well developed in digital jewellery. In addition to contributing to the design of enchanting digital jewellery, we can see this approach and the specific sensibilities identified being useful in other interaction design projects where the experience of enchantment is important.[14]

While Jayne Wallace is demonstrating craft's contribution to the field of interaction design, Jane Harris is using craft knowledge to define a new creative medium. She makes virtual textiles, which are viewed in the form of projected digital movies, the fabric flowing and twirling around disembodied human forms in a highly dynamic way. As she explains: "The intention is to create an autonomous work, a highly 'crafted' digital piece, where the CG (computer graphics) medium truly evolves as a medium in its own right, the object remaining onscreen."[15]

But can we classify a digital movie of swirling pixels as craft? Over ten years ago Harris was one of the country's leading textile makers, and her whole thing was about wearability and flow. In 1990 she was quoted in *Crafts* magazine as saying: "I make cloth that

JANE HARRIS, SCREEN CAPTURES OF DIGITAL TEXTILES, 2006.

PHOTO: JANE HARRIS

become clothes that are also sculptures."[16] So form, movement, and structure were all central elements in her work, and of course a very high degree of craft skill and knowledge.

In 1995 she started her Ph.D. at the Royal College of Art, her objective being to explore these very same issues of movement, structure, and form in the context of virtual textiles. Harris began to explore and apply sophisticated 2D and 3D CG systems that were at the time being used in the emergent digital animation industry. Using downtime in central London CG studios, she developed a highly innovative body of work that defined new directions for practice-based doctoral research in craft and design, and attracted significant interest from galleries and museums. Interestingly, her work has succeeded in bridging the fine art/craft divide, having been exhibited in London's Institute of Contemporary Arts and the Victoria & Albert Museum, together with the Fine Arts Museums of San Francisco. Harris explains how this research-based practice shifts her from being a "lone practitioner" and opens up new areas of application:

> Software and hardware tooling has become more accessible and it has been possible to apply established material skills, within a broader frame of research and visual art practice. This has necessitated a shift from working as a solo maker, to collaborating and working with a range of individuals, institutions and industry. Most recently an Innovation Award supported 3D CG animation and "real-time" enquiry of textile/garment forms working within contemporary and historical contexts. This funding enabled collaboration with the Museum of London, fashion designer Shelly Fox, 3D CG computer graphic operator Mike Dawson, movement designer Ruth Gibson and Vicon motion analysis…. The use of 3D CG in representing "historical" dress, for example, has explored bringing to life a garment form within a museum context and the values of this kind of exercise. Once textiles and dress enter this type of environment, there are constraints on the handling of such objects. So for example, garments won't be worn again and various handling policies are required.[17]

The makers described above are demonstrating the unique value of craft knowledge to the modern world. Their outcomes may not be "craft" in the conventional sense, but the processes they apply in solving the very diverse problems and contexts they are working within derive from the knowledge, methods, and philosophies of craft. Rooting craft in a

research framework, far from constraining craft, provides new possibilities of creative liberation and empowerment. Hazel White is a jeweller whose research engages with digital process and new forms of interaction design. Her description of this, from the maker/researcher's perspective, is particularly insightful:

> Using CAD has created a new dialogue within my practice. On the one hand, the possibilities offered by the computer and the computer-controlled machine have been irresistible, allowing me to explore imagery and ideas in a different "reality" from sketchbook and materials. As a maker the struggle with the authenticity of the process and artifact has made me continue incorporating the handmade into the process. The issue of authenticity is a self-imposed anxiety, the consequence of a craft education. Nevertheless, questioning authenticity is crucial in order to establish a discourse about my place within the production of visual art and craft. The anxiety, or tmesis, has to be contextualised: to the craft maker, the unknown is something we step into every day. The investigation of digital processes has emphasised the lack of significance I have previously given my own craft skills, by taking them as a given, and assuming that everyone approaches new tasks with the same knowledge. This is a consequence of the tacit nature of craft knowledge: because the maker does not enumerate the skills they have gained from many experiments, test pieces and failures, the value of applying that knowledge and methodology to other areas is not, at first, apparent. The recognition of the value of applying tacit craft knowledge to new scenarios has been an empowering experience.[18]

THE RISKY CRAFT OF PIXEL RAIDING

So what does all this mean for craft in the twenty-first century? Essentially, it means that we have to look at it in new ways. "The nature and art of workmanship" by David Pye was first published in 1968.[19] In a nutshell, it argues why all that useless beauty that craft makers create is so vital to humanity, but it also gives us very useful concepts to understand what lies behind that useless beauty. Pye deliberately did not use the term "craft," referring instead to "workmanship." He draws our attention to confusions in the definition of craft. Does it mean handmade, he asks? No, he immediately answers, as most things that

craftmakers create are not produced by hands but with tools of some sort. The few exceptions include basket weaving and slab building in ceramics. So he argues that whether things are made by hand is not really the point; rather, it is the type of workmanship, which we bring to any task, of which he argued there are two types.

workmanship of risk	workmanship of certainty
individual production	mass production
unpredictable—risky	predictable
production by skilled person(s)	production by a system

The workmanship of certainty refers to the domain of industrial production and industrial design. It is about predictability. When designers at kitchenware manufacturer, Richardson, design the kitchen knives we see on the right,[20] their concern is to design, prototype, and test repeatedly until the product can be manufactured with 100% certainty. *The worksmanship of risk* is a realm where individuals, not entire industrial systems, hold the key to success. When knifemaker Grace Horne is making her disc knives, shown on the left, any momentary mistake on her part could ruin the product. So every new beginning, every new product is a risk. Pye's definition of "craft" is not the extent to which an object is made by hand, but the extent to which it involves the workmanship of risk.

Peter Dormer introduces another way of differentiating craft from non-craft product. It is consistent with Pye's but extends the perspective somewhat: Dormer looks beyond workmanship to knowledge.

personal knowledge	distributed knowledge
tacit knowledge objects	require different knowledges
knowledge from experience	tools embody knowledge

He says there are two types of knowledge: *personal knowledge* and *distributed knowledge*.[21] Dormer's personal knowledge is much the same as tacit knowledge: highly individual, based on and arising from our experience. The maker we see on the left is in the process of acquiring that tacit knowledge: learning the feel of her chosen material and how it interacts with the tools she is using. Distributed knowledge has two central ideas to it. First, in our age today, any single object requires many different knowledges to bring it into being. A person could probably learn how to assemble the iPod shown on the right,[22] but to make one from scratch would require expertise in electronics, plastics technology, software design, materials science, interaction design, etc. The second idea is that many products, like the iPod, embody other people's knowledge. We do not need to learn typography, graphic design, and photography to make a PowerPoint** presentation, as the software embeds all this knowledge. What we do is to apply our tacit knowledge of how to use this tool to this piece of distributed knowledge and hope we produce something that engages an audience.

Craftmakers are experts in two things: the workmanship of risk, and how to apply their tacit knowledge to the tools, systems, and opportunities created by distributed knowledge. Craft practice within a research framework begins to reveal the potential application and value of this approach as well as the dynamic ways in which craft researchers can explore new technological opportunities and problem areas. Craft presents us with the oldest

knowledge there is: the most adaptable, the most fluid knowledge that our culture has produced—knowledge about making things. Wedded to the most contemporary technology, this knowledge is enabling makers to assert a vital new relevance and value for craft.

ENDNOTES

1 SafariPod - Hand Carved Technology Art From Kenya. Advertisement. 6 Dec. 2006 <http://www.safaripod.com>

2 Jayne Wallace and Mike Press, "Craft Knowledge for the Digital Age: How the Jeweller Can Contribute to Designing Wearable Digital Communication Devices," *Proceedings of the 6th Asian Design Conference Japan, 2003.*

3 Peter Dormer, "The salon de refuse," in Peter Dormer, ed., *The Culture of Craft* (Manchester: Manchester University Press, 1997).

4 Sir Christopher Frayling, quoted in John Millard & Tony Knipe, *Art and Craft Made and Designed for the Twentieth Century*, exhibition catalogue (Sunderland: Northern Centre for Contemporary Art, 1987).

5 Paul Greenhalgh, "The Progress of Captain Ludd," in Peter Dormer, ed., *The Culture of Craft* (Manchester: Manchester University Press, 1997) 114.

6 Justin Marshall (2003), unpublished artist statement.

7 Drummond Masterton (2003), unpublished artist statement.

8 Presented online at "autogreet," *:-autonomatic-:*, 19 Jan. 2007 <http://www.autonomatic.org.uk>

9 "Innovations Report," *British designers lend hand in NASA space mission*, 19 Jan. 2007 <http://www.innovations-report.de/html/berichte/physik_astronomie/bericht-47116.html>

10 Chris Rust, Graham Whiteley, and Adrian Wilson, "Experimental Making in Multi-Disciplinary Research," *Design Journal* 3.1 (November 2000): 21.

11 "BBC News." *BBC NEWS | Health | Bionic hand gives realistic grip*, 19 Jan. 2007 <http://news.bbc.co.uk/1/hi/health/6193681.stm>

12 Peter Walters, *Knowledge in the Making: Prototyping and Human-Centred Design Practice*, diss., Sheffield Hallam University, 2006.

13 Wallace and Press 1.

14 John McCarthy, Peter Wright, Jayne Wallace and Andy Dearden, "The Experience of Enchantment in Human–Computer Interaction," *Personal and Ubiquitous Computing*, 10.6 (September 2006): 369-378.

15 Jane Harris, "Empress's New Clothes," paper presented as part of installation, Museum of London, London (February-March 2004).

16 Margot Coatts, "Jane Harris" *Crafts Magazine* May/June, 1990: 24.

17 Jane Harris, "Empress's New Clothes," Challenging Craft conference, Gray's School of Art, the Robert Gordon University September 2004, 19 Jan. 2007 < http://www.challengingcraft.org/>

18 Hazel White, "Hybrid Practice—Challenging Traditional Craft Boundaries: Authenticity: Anxiety: Autonomy,"
 Challenging Craft conference.

19 David Pye, *The Nature and Worksmanship of Craft* (Cambridge: Cambridge University Press, 1968).

20 Image *Knife Resharpening 3* by Andy Ciordia <http://www.flickr.com/people/ciordia/>
 Creative Commons licence - Attribution-NonCommercial 2.0

21 Peter Dormer, "Craft and the Turing Test for Practical Thinking," in Peter Dormer, ed., *The Culture of Craft*
 (Manchester: Manchester University Press, 1997) 137-157.

22 Image *iPod* by Oliver Lavery <http://www.flickr.com/people/oliverlavery/>
 Creative Commons licence - Attribution-NonCommercial 2.0

NOTES ON CONTRIBUTORS

Sandra Alfoldy is assistant professor of craft history at NSCAD University, Halifax, Nova Scotia and is the author of *Crafting Identity: The Development of Professional Fine Craft in Canada* (McGill-Queen's University Press, 2005). She is convenor of the November 2007 conference NeoCraft: Modernity and the Crafts in Halifax, Nova Scotia.

Grace Cochrane is curator of the exhibition and symposium *Smart Works: Design and the Handmade* and is former senior curator of Australian decorative arts and design at the Powerhouse Museum in Sydney, Australia. She is the author of *The Crafts Movement in Australia: A History* (NSW University Press, 1992).

Dr. Elizabeth Cumming is a freelance art historian and an Honorary Senior Research Fellow at the University of Glasgow. A former keeper of the Edinburgh City Art Centre and lecturer in design history at Edinburgh College, she has written widely on aspects of Scottish art and design since 1850. Her latest book is *Hand, Heart and Soul: the Arts and Crafts Movement in Scotland* (2006).

Neil Forrest models ceramic ornament that invokes the new reality of contemporary architecture. His exhibitions *Scaff*, *Thicket,* and *Wurzelwerk* explore prototypes for a detached ornament of layered assemblies that produce field decoration. Forrest has exhibited, lectured, and published in North America, the United Kingdom, Europe, and Asia, and is currently professor of ceramics at NSCAD University, Halifax, Nova Scotia.

Tanya Harrod is visiting professor in the Department of Design History at the Royal College of Art, London. She has curated and published extensively on the crafts, including her prize-winning book, *The Crafts in Britain in the Twentieth Century* (Yale University Press, 1999). Her current research includes a biography of the potter Michael Cardew (for Yale University Press) and an examination of the meaning of the handmade (for Reaktion Books). She is co-editor of *The Journal of Modern Craft* (Berg, forthcoming, 2008).

Janice Helland is professor of art history and women's studies and Queen's National Scholar at Queen's University, Canada. She is the author of *The Studios of Frances and Margaret Macdonald* (1996) and *Professional Women Painters in Nineteenth Century Scotland: Commitment, Friendship, Pleasure* (2000). Her new book, *Marketing Craft, Making Fashion: British and Irish Home Arts and Industries 1880-1914* is forthcoming from Irish Academic Press (2007).

David Brian Howard is associate professor of art history and chair of the Historical and Critical Studies Division at NSCAD University, Halifax, Nova Scotia. He has published numerous articles on the history, politics, and theory of modernism in the United States and Canada after World War II and has curated a critical retrospective exhibition of the Canadian modernist painter Arthur F. McKay.

David Howes is professor of anthropology at Concordia University, Montreal, and general editor of the Sensory Formations Series from Berg Publishers of Oxford. He is the director of the Concordia Sensoria Research Team and director of the Culture and Consumption Research Group. Dr. Howes is the author of several books, including *Empire of the Senses: The Sensual Culture Reader* (Berg, 2004) and *Sensual Relations: Engaging the Senses in Culture and Social Theory* (University of Michigan Press, 2003).

Love Jönsson is a critic and writer, contributing to dailies, magazines, and exhibition catalogues in Sweden and abroad. From 2003 to 2005, he was project manager of Craft in Dialogue, a Swedish governmental project supporting international exchange. He is the editor of the anthology *Craft in Dialogue: Six Views on a Practice in Change* (2005) and teaches at The School of Design and Crafts at Gothenburg University. He lives in Gothenburg.

Beverly Lemire holds the Henry Marshall Tory Chair in the Department of History and Classics and the Department of Human Ecology at the University of Alberta in Edmonton. She is the author of *The Business of Everyday Life: Gender, Practice and Social Politics in England, c.1600-1900* (Manchester University Press, 2005), co-editor of *Women and Credit: Researching the Past Refiguring the Future* (Berg, 2002) and editor of *Dress, Culture and Commerce: The English Clothing Trade before the Factory, 1660-1800* (Macmillan, 1997).

Joseph McBrinn is lecturer in history of art and design at the School of Art and Design, University of Ulster, Belfast, Northern Ireland. He has written widely on historical and contemporary Irish crafts and design, including entries in the *Dictionary of Irish Biography* (2007), "The Crafts in Ulster 1951-2005," *Ulster Folklife*, vol. 52 (2006) and "The Peasant and Folk Art Revival in Ireland 1890-1920," *Ulster Folklife*, vol. 48 (2002), and is currently writing a history of the crafts in the North of Ireland.

Bruce Metcalf is a studio jeweller and writer from the Philadelphia area. Metcalf has written extensively about issues in contemporary craft in numerous domestic and foreign publications. He is currently co-writing the first history of twentieth-century American crafts with critic Janet Koplos.

B. Lynne Milgram is professor of anthropology at the Ontario College of Art and Design, Toronto. Her research on gender and development in the Philippines has been published in a number of edited volumes and in journals. Her recent co-edited books include (with K.M. Grimes) *Artisans and Cooperatives: Developing Alternative Trade for the Global Economy* (University of Arizona Press, 2000) and (with R.W. Hamilton) *Material Choice: Refashioning Bast and Leaf Fibers in Asia and the Pacific* (UCLA Fowler Museum of Cultural History, 2007).

Alla Myzelev is a postdoctoral fellow at the University of Western Ontario. Her main research interests are the history of design and applied arts and the role that women played in these histories. Her co-edited volume *Collecting Subjects: Meaning and Pleasures of Material Culture* will be published in 2008 by Ashgate Press.

John Potvin is assistant professor of eighteenth and nineteenth century European art at the University of Guelph. Dr. Potvin's first book (forthcoming with Ashgate) is *Bodies, Boundaries and Intimacy: Material and Visual Cultures Beyond Male Bonding, 1880-1914*. His second is a co-edited volume of essays, *Collecting Subjects in Britain, 1750-1920: The Visual Meanings and Pleasures of Material Culture*, which explores the nexus of subjectivity and collecting specifically as it relates to the much-neglected areas of craft, design, and fashion.

Mike Press is professor of design policy, Duncan of Jordanstone College of Art and Design, University of Dundee, United Kingdom. He is the author of many articles on design, and co-author of the books *The Design Experience: The Role of Design and Designers in the Twenty-First Century* (Ashgate 2003) and the forthcoming *Design Against Crime* (Ashgate 2007). In addition, he maintains the blog *Hand Made Theory*, dedicated to issues in craft and design (www.handmadetheory.blogspot.com/).

Larry Shiner is professor emeritus of philosophy at the University of Illinois at Springfield and the author of *The Invention of Art: A Cultural History* (University of Chicago Press, 2001), *The Secret Mirror: Literary Form and History in Tocqueville's Recollections* (Cornell University Press: 1988), and numerous articles in the areas of aesthetics and philosophy of history. His most recent essay, "The Aesthetics of Smelly Art," is forthcoming in the *Journal of Aesthetics and Art Criticism*.

INDEX